FIREARMS OF THE ISLAMIC WORLD

IN THE TAREQ RAJAB MUSEUM, KUWAIT

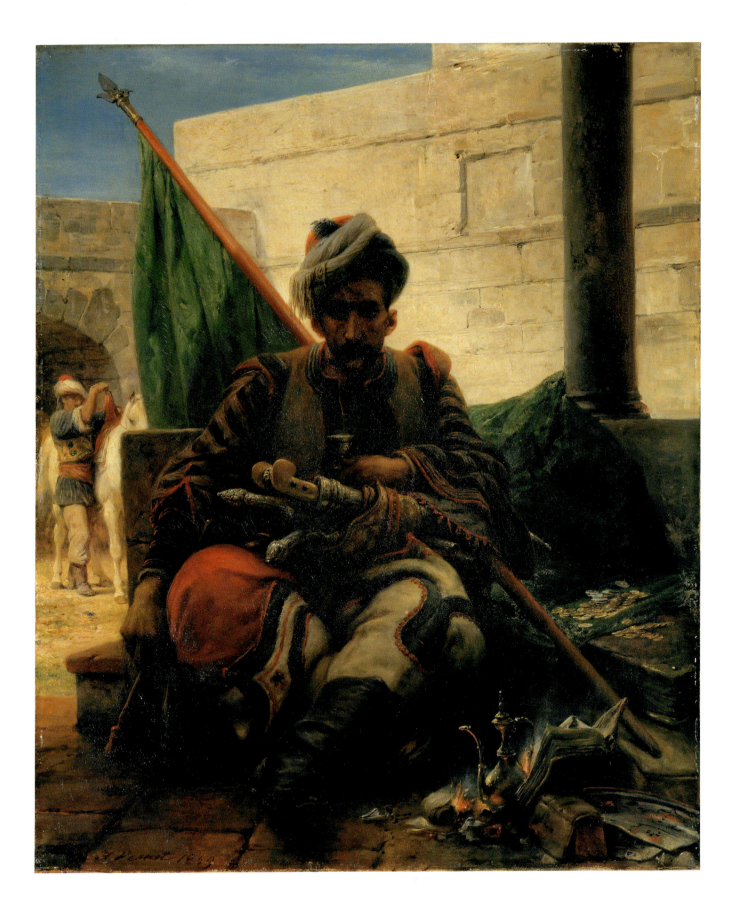

FIREARMS OF THE ISLAMIC WORLD

IN THE TAREQ RAJAB MUSEUM, KUWAIT

Robert Elgood

I.B.TAURIS PUBLISHERS
LONDON • NEW YORK

FRONTISPIECE A *bashi bazouk* armed with Balkan pistols and a *yataghan*. Emile-Jean-Horace Vernet, 1860. Vernet was able to observe these Turkish troops in 1854-5 when they fought in the Crimean War. Reproduced by permission of the Trustees of the Wallace Collection, London.

Published in 1995 by
I.B.Tauris & Co. Ltd
45 Bloomsbury Square, London WC1A 2HY

ISBN 1-85043-963-X

A full CIP record for this book is available from the British Library

Library of Congress catalog card number: 95-060077
A full CIP record is available from the Library of Congress

Studio photography by Edward Reeves, Lewes, East Sussex, England
Designed and typeset by Karen Stafford, DQP
Map drawn by Sarah-Jayne Stafford
Index by David Harding

Colour origination and printing by Saik Wah Press Pte. Ltd, Singapore

CONTENTS

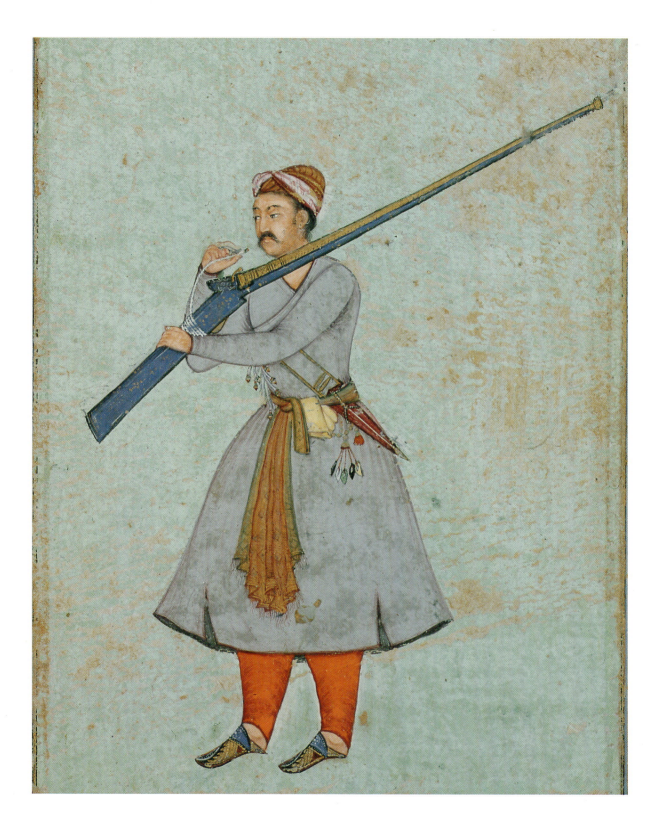

FOREWORD

I AM GLAD TO write a foreword to this book for two reasons. First, I admire the considerable research and work, not to say the boldness of approach, that has gone into its compilation; second, I believe I may have played a part, albeit a very small one, in its inception. In 1979 I was invited to prepare a review of a new work entitled *Islamic Arms & Armour*, edited by Robert Elgood, who was unknown to me and appeared to be a newcomer to the world of arms and armour. That book consisted of articles by several of the world's leading authorities. It was a scholarly production, handsomely illustrated and well assembled – altogether a great credit to its editor. However, I had one reservation. Among all the stories and pictures of the splendid bladed weapons so popular in the Islamic world, there was hardly a mention of a firearm. Surely, I asked, there was someone who could provide a study of the weapon, many of whose early models and developments were due to the gunmakers of the Near East. Whether Robert took this criticism to heart I do not know, but certainly he has made every effort to put the matter right himself and this book is the result – the first historical survey of Islamic firearms.

An officer with a matchlock over his shoulder, blowing on the match to ignite it. Mughal, signed in *nasta'liq* script *Tirayya*, c. 1585. Gouache heightened with gold on paper. Collection Frits Lugt, Institut Neerlandais, Paris.

No one could have tackled a more difficult task. Unlike the history of firearms in Europe, there are no easily available and readable books written by contemporary authors living in the various countries that came under Islamic rule. To a large extent, information has had to be extracted and evaluated from a vast corpus of secondary sources – early travellers' accounts, historical essays, museum catalogues and articles from obscure learned journals. The bibliography to this book gives some idea of the extent of those archives. The problem has always been the vast territories over which the followers of Islam have spread their influence: from Central Asia, along the countries bordering the Mediterranean to Spain, south past the Red Sea to northern India, east to the frontiers of China, and north to the gates of Vienna. Islam thus stood at the crossroads of Asia, Africa, Europe and India. Arabic became the common language of the peoples who lived between Baghdad and Cordoba, and a multitude of cultures was absorbed into the Islamic world.

Any writer dealing with Islamic firearms in general, therefore, has to consider the products of arms centres as far apart as Kubachi, Isfahan, Damascus, Algiers and Delhi, each with its own characteristic form of mechanism and style of decoration. It cannot be wondered at that in the past no one has committed himself to such a searching examination of all these crafts. It is noticeable that this reluctance to be involved with firearms, or for that matter to acknowledge any artistic merit in them, is

reflected in the attitude of organisers of international exhibitions. *The Arts of Islam*, arranged in London in 1976, for instance, included examples of fine swords, daggers and axes, but not a single firearm. Not only has the history of Islamic firearms been largely ignored but the art of the goldsmiths, jewellers, steel sculptors and wood inlayers who decorated the guns has received scant attention.

Of course the subject has not been entirely neglected by previous writers. The guns of certain separate regions and races have been described in the dissertations of such specialists as Professor David Ayalon on the Mamluks, Professor Z. Zygulski on the Levant and Robert himself on the Arabs. But there has always been the need for an overview to place things in perspective: it was a very obvious gap in our knowledge of history which the present volume sets out to fill.

It forms an impressive introduction to a catalogue of the firearms in the Tareq Rajab Museum. One can remark here how strange it is that Islamic scribes of the past and their counterparts of today seem to have regarded the gun as anathema, and only recently have modern collectors shown an interest in the arm. Tareq Rajab has set an example which it is hoped will be followed by others of his countrymen. For his part, Robert has laid the foundations for future studies of Islamic firearms. I congratulate him.

Howard L. Blackmore,
former Deputy Master of the Armouries,
H.M. Tower of London.

PREFACE

THE 150 ISLAMIC FIREARMS of the Tareq Rajab Museum are important because no other such permanent collection of this quality and quantity has been made since those of the great private collectors of the late nineteenth century, such as the 4th Marquess of Hertford, Henri Moser Charlottenfels and Frederick Stibbert. Their collections are also now in permanent museums. Tareq Rajab is very much in the same tradition and is to be congratulated in having had the foresight to amass the collection at a time when such pieces were still available. It is the work of many years and it would be a difficult and lengthy task today to form a collection of such excellence. As a former Director of Antiquities, Kuwait, he has an eye for original condition and a collector's love of Islamic art in general, as can be seen in his private museum. His Islamic firearms form merely a small part of his total collection, a remarkable achievement for one man, even with the partnership of a wife as knowledgeable, energetic and devoted to the collection as Jehan. Together they have brought a rare discrimination to a fascinating collection that has no parallel anywhere in the Middle East.

Islamic firearms are a much neglected field of scholarship, particularly since the importance of firearms in shaping the history of the Near and Middle East cannot be denied. Historians have largely concerned themselves with the effect of the adoption of firearms on Islamic society and the political conse-quences, usually within a limited area and period. One thinks in particular of David Ayalon and his outstanding study *Gunpowder and Firearms in the Mamluk Kingdom*. Mamluk society intensely disliked firearms and resisted their adoption virtually until the overthrow of their state. The book dissects the reasons for this, but offers limited direct information on the appearance or origin of the weapons themselves, which is what the arms historian primarily seeks. In the absence of reliable, detailed, descriptive evidence, a problem which is not confined to Mamluk Egypt, it becomes extremely difficult to attribute dates to surviving pieces which may indeed be from the earliest firearms era. The only possible way forward for Islamic arms study is to combine the evidence provided by history and the objects themselves.

Islamic firearms is a wide subject encompassing gunpowder, cannon and hand firearms, since the appearance of the first two are indicators of the likely date of arrival of the third. Cannon founders in the fifteenth century both in Europe and the East commonly made arquebuses (and in the East occasionally gunpowder as well), because early handguns were seen as small cannon and were therefore made of cannon bronze. Guns described as having 'copper' barrels were in use in Central Asia in the sixteenth century and were regarded then as inferior to iron barrels on matchlocks. Indeed, the distinction between small cannon and hand-held guns is extremely confused in the accounts of contem-

porary witnesses. This problem is compounded for the historian by the transfer from one region to another of names which may or may not describe identical objects and which, in an age before standardisation, allowed considerable variation in appearance and looseness of terminology.

Any study of the development of Islamic firearms is obliged to look beyond the Islamic world – to China and the Far East; to Europe; and to early India. All three regions have in the past been given the credit for the invention of gunpowder and firearms. The fragmentary evidence raises questions faster than it provides solutions. These matters may seem rather distant from the interest of collectors of Islamic firearms, and yet even in the more recent past knowledge is patchy for most scholars and collectors of Islamic weaponry. For example, as Claude Blair has observed, the precise dating of Islamic pistols is extremely difficult.[1] In addition, the centres of manufacture are little known, particularly those supplying the Ottoman armies, and it is frequently impossible to relate an existing object to a specific place of manufacture. The issue is more complicated than that, however, because Islamic firearms are frequently made in one or more places and assembled, sometimes with cherished parts such as barrels being re-used, and then decorated elsewhere. In view of the extreme mechanical conservatism that existed throughout the Islamic world, many attributions are made on the basis of decoration which may be merely 'skin deep' in terms of reflecting the place of origin. Inevitably all this makes it difficult accurately to assess the surviving pieces, which are in fact the evolved descendants of long manufacturing traditions. For example, the muskets of Fez were already famous in the sixteenth century. In his book *Historia della Guerra fra Turchi e Persiani*, published in Venice in 1594, Minadoi refers to 'li schioppi lunghi che si fabricano in Algier e si chiamano Sciemete'.[2] 'Long guns from Algiers' of that date, if they have survived, are not usually firmly identifiable by twentieth-century scholars. Scholars are, however, familiar with coral-encrusted firearms of the eighteenth century from Algiers, such as the fine examples owned by HM Queen Elizabeth II now on loan to the Tower of London, the long gun in the Dresden Rustkammer or the examples in the Tareq Rajab Museum, all of which are of comparable quality. Very little is known of the history of Algerian firearms in the intervening years. The same could be said of the arms production of every other Muslim country. Familiarity with western expansionism in the Near and Middle East has masked the truly international and infinitely greater mercantile role of the peoples of the region. For example, Indians and Armenians established large and sophisticated trade networks across the Near East which were regarded with awe by the British and Dutch trading companies. The trading activities of these mercantile groups are not, for the most part, well documented and their involvement in the arms trade was often covert. In the absence of the archival material that underpins Western arms history (the Ottoman archives excepted, which have yet to be comprehensively examined on this subject), the Islamic arms historian is obliged to rely on anecdotal evidence. Even the history of the export of European firearms to the Islamic world is inadequately documented[3] though it has been argued that the huge trade in export arms (and iron tools) world-wide funded and brought about the Industrial Revolution. It is beyond the scope of this catalogue of the pieces in the Tareq Rajab Museum to remedy this situation and the author's intention is merely to place the objects in their historical context. History can explain why a firearm with the distinctive form of one region may appear with the surface decoration of another region, indicating an end user far removed from the original place of manufacture. A comprehensive survey of Islamic firearms remains to be written.

If the rulers of the Islamic world are to preserve their past history and culture, of which they have every reason to be proud, they must themselves acquire collections of this kind and make them accessible to the Islamic peoples of the world. It is no exaggeration to state that national stability is based on people's deeply rooted sense of personal, cultural and state identity and that history and education have an important role to play in this process. The onerous financial burden of preserving the past increasingly requires the resources of the state rather than reliance on the initiative of far-sighted private individuals.

I should like to thank a number of people who have helped with the preparation of this book. Tareq and Jehan Rajab have been both kind and generous and I am grateful to them for giving me the opportunity to work on their collection.

The encouragement of my wife Dr Hettie Elgood has also been essential and I am grateful for the mature tolerance shown by my children: within the family writing is a selfish and anti-social activity. Thanks are also due to a number of old friends,

including Hamid Asmail at Semiramis in Gray's Market, London, who some years ago persuaded me to write a part of the catalogue of the collection and who has contributed so much to the success of the Tareq Rajab Museum; and to Jonathan Barrett, arms and armour expert at Wallis and Wallis who did the initial catalogue some years ago and organised the photographs of the guns. It is only fair to him to say that I have greatly benefited from his work, but have expressed my own views and take responsibility for them. Thanks to Dr Zia Shakeb, who did all the translations of inscriptions on the objects in the collection; to Dr Rosie Llewellyn-Jones for generously making available her research notes on Claude Martin; Dr Anna L. Dallapiccola, who read the section of text dealing with early Indian weapons in the Vedic texts and offered helpful advice; to Toby Falk, Sue Stronge and Dr Linda Leach, who gave expert advice on illustrations; to Sarah Barter Bailey and Philip Abbott, the Librarians at the Tower Armouries, who have been invariably kind and helpful, as has M.J. Pollock, the Librarian at the Royal Asiatic Society; to Dr

Maurice Forissier for information on French gunsmiths exporting to the Levant and for kindly showing me the collection at the Musée d'Art et d'Industrie at St. Etienne, as did Dr Reinhard Sänger at the Badisches Landesmuseum, Karlsruhe. I am very grateful to Holger Schuckelt at the magnificent Dresden Rüstkammer, who provided efficient and reliable answers to my enquiries regarding the Oriental collection in his charge. Thanks are also due to Michael Baldwin at the National Army Museum and to Tulin Coruhlu at the Askeri Museum, Istanbul. James Lavin generously sent me a copy of Puype's book on Dutch trade guns and answered a query regarding the 1594-1652 inventory of the Real Armería. Finally, I must thank the distinguished members of the Meyrick Society who have given advice or discussed points, in particular Claude Blair, Anthony North, Howard L. Blackmore (who also wrote the foreword to this book) and William Reid. The last two very kindly read the manuscript at short notice and produced some useful comments and additional references.

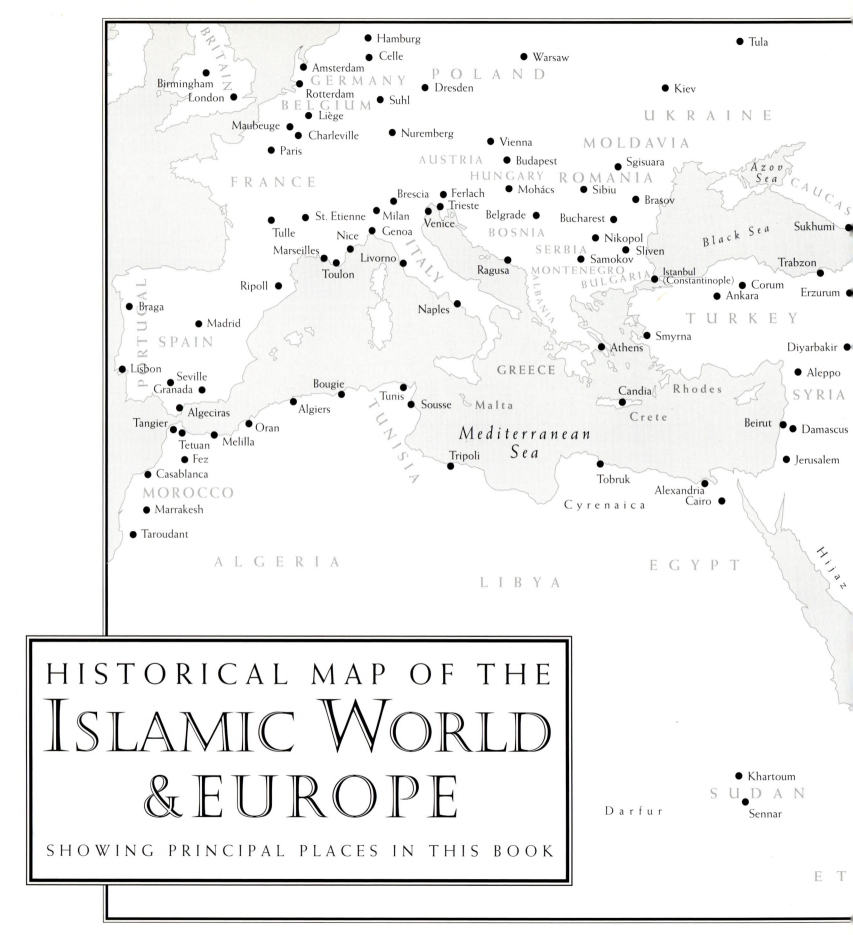

HISTORICAL MAP OF THE
ISLAMIC WORLD
&EUROPE

SHOWING PRINCIPAL PLACES IN THIS BOOK

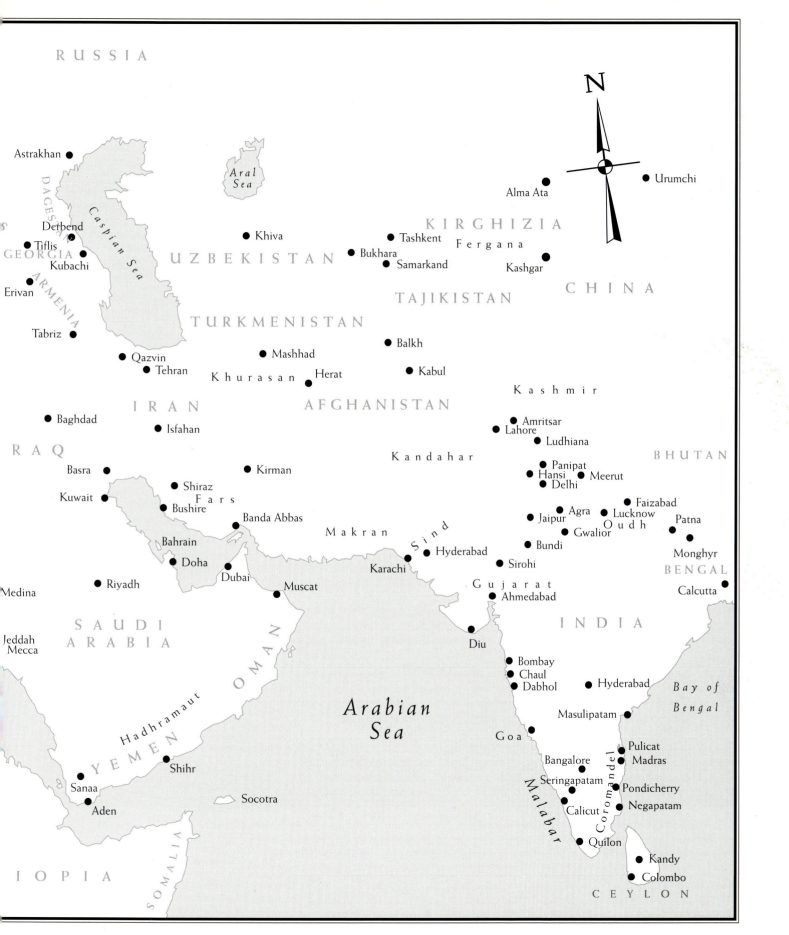

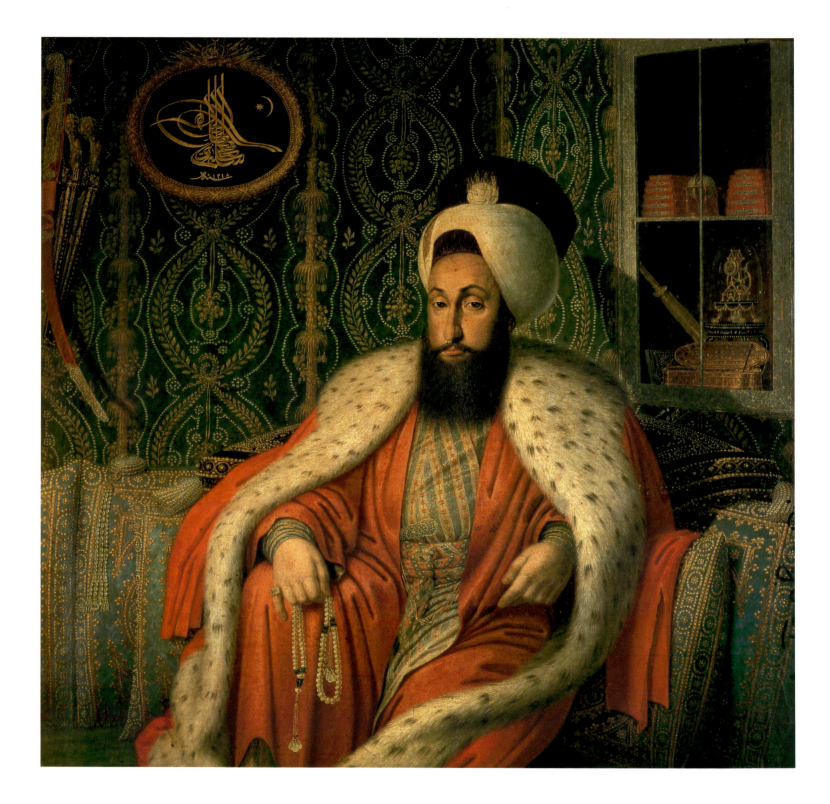

FIREARMS OF THE ISLAMIC WORLD

THE DOMINANCE of the Ottoman Turks in Europe and their victories over the Aq Qoyunlu, the Safavids and the Mamluks in the late fifteenth and early sixteenth centuries can be largely attributed to their successful adoption of firearms. By their example and by their gifts of firearms as part of a deliberate policy designed to assist Muslims against non-Muslims, the Ottoman Turks caused the spread of firearms through the Islamic world and India. The Venetians made considerable efforts to supply Uzun Hasan, the Aq Qoyunlu Turcoman ruler of Iraq and western Iran with guns because they were eager to find an ally against the Ottomans. A succession of ambassadors were exchanged between 1464 and 1474, and Venice supplied some firearms and cannon founders, but in 1473 Uzun Hasan suffered a

defeat and died four years later.[1] With his death passed any great interest in firearms in Iran, with the result that the Iranians paid a high price for their neglect in 1514. The Ottoman army had assimilated the cannon and the arquebus and used them with great effect in the fifteenth and sixteenth centuries to defeat the armies of Syria, Egypt, Iran and Eastern Europe. The bitter complaint of the Mamluk Amir Kurtbay when brought before Selim the Grim after the battle of Marj Darbiq in 1516 proves the decisive role of firearms:

> ...you have brought with you this contrivance artfully devised by the Christians of Europe when they were incapable of meeting the Muslim armies on the battlefield. The contrivance is that bunduq which, even if a woman were to fire it, would hold up such and such a number of men. Had we chosen to employ this weapon, you would not have preceded us in its use. But we are the people who do not discard the Sunna [practices] of our Prophet Muhammad which is the jihad [Holy War] for the sake of Allah with sword and lance. And woe to thee! How darest thou shoot with firearms at Muslims?[2]

Sultan Mahmud I (1143-68/1730-54) in his private chamber. Hanging on the wall are his French flintlock pistols with blue and gilt barrels and diamond-studded stocks. He has a Persian-style sabre (*shamshir*) similarly decorated with diamonds. Topkapi Palace Museum, Istanbul/Giraudon/Bridgeman Art Library, London.

The statement might serve as the epitaph for all the traditional societies of the *dar al-Islam* that were unwilling or unable to adapt to new technology in a changing world. One reason for the neglect of firearms was that the Prophet Muhammad himself had been an archer and encouraged his followers to practise archery, a skill held in great esteem, an act of religious merit. The Egyptian historian Ibn Ayas's description of the funeral of an Ottoman prince in 1513 indicates very clearly the importance of the bow above all other weapons: 'On his bier they put his turban and his bows, which they broke, this being the custom of the country.' When Sultan Mahmud I (1143-68/1730-54) revived archery as a sport he was highly praised, for it was 'the greatest glory in the eyes of the believers and those rulers are extolled and their piety is to be praised who have given renewed life to the practices of those who lived in earlier times'.[3] Another reason for the retention of the reflex bow was that in the hands of a trained archer it was extremely effective. In modern times it has been calculated on the basis of practical experience that armed with the reflex bow, an archer could be expected to hit a man on a horse at a range of 250 yards once every four arrows, assuming calm weather conditions.[4] A trained archer could get off six aimed shots per minute without difficulty and the arrow would penetrate most armour at one hundred yards. At extreme range, approximately five hundred yards, the arrow had greater penetrating power than the arquebus ball. This apparent parity conceals crucial differences in the two weapons. The physical effort in drawing a powerful bow limited the amount of times a strong man could use it in a day. The archer was forced to stand erect and expose himself to counter-fire when he shot. Dampness could have an adverse effect on the composite bow's performance. The construction of the composite bow took a long time and required great skill. Last but by no means least was the length of time it took to train a skilled archer as compared with an arquebus man in a period of expanding national military commitments and high mortality.

There is, however, an obvious reason why the Ottoman troops took to firearms, which the Mamluks considered a filthy and obnoxious innovation. The structure of power in the two societies differed. The janissary elite in the Ottoman army were merely an instrument of power in the hands of the sultan and his advisers, hand-picked from amongst slaves, trained to obedience and utterly dependent on the Sultan for preferment; while the elite of the Mamluk army itself ruled and could resist the introduction of anything which threatened its traditional values. The ill-disciplined and self-indulgent attitude of the later Mamluks is described by Ayalon.[5]

With the passage of time, the failure of the Turks to keep up with the West's military development was in turn central to their decline as a great power. As the champion of Islam and the holder of the caliphate, the Ottoman failure was disastrous for her Islamic neighbours, who looked to her as a military exemplar. It was not that the Ottomans lacked the technical skill to manufacture firearms or an awareness of their increasing dominance on the battlefield. Like the peoples they defeated in the Near East, the Ottomans disliked firearms and tried to compensate for any shortcomings with raw courage and a remarkable ability with the sword; but from the mid-sixteenth century onwards the armourers' names appear in the Ottoman court registers, the workshops of the empire were industrious and able, and the quality of the work done was high. As late as the siege of Vienna in 1683 a Christian observer could still describe the Turkish musket as a fine weapon, one that would shoot further than his own. Furthermore, the religious concept of al-*muqabala bil mithl*, of matching like with like, specifically authorised the adoption of the military innovations of the enemies of Islam. The Ottoman system did not encourage tactical innovation or the development of complex infantry manoeuvre on the battlefield, which would have meant discarding the entire tradition of Ottoman military practice. Nor were there any great, innovatory commanders on the Ottoman side to match those of Christendom. The Turks were invariably obliged to follow the West's lead in military developments. The introduction of the flintlock into general military use meant that a trained man could shoot three rounds per minute, a considerable advance over the old clumsy matchlock. Its appearance, together with the bayonet, occurred during the last two decades of the seventeenth century and brought about a military revolution. The ability to multiply that rate of fire by manoeuvre so as to get more men into the firing line in the shortest possible time was essentially what European infantry drill was concerned with in the following century. As the efficiency of the European army increased in these matters so the percentage of casualties of those involved in battle rose.

Other causes for the decline in effectiveness of the Ottoman army can be found, such as the slowness of the Ottomans to see the value of standardising parts and calibres, particularly of artillery. Standardisation was itself a product of increasing Western mechanisation unmatched in the East. It was not a manner of waging war with which the Ottoman armies could compete. The elements of Ottoman warfare considered valuable by the West were adopted, but the reverse was rarely the case. The recruitment of Hungarian *huszars*, of Albanian *stradiots* and Croatian *pandours* into the army of the Empress Maria Theresa and their effective service in the War of the Austrian Succession brought to Western Europe a novel aspect of Ottoman warfare. The Turkish failure to develop the same flexibility and to modernise their armies was a reflection of their leaders' failures to challenge traditional orthodoxy until the reforms inaugurated in the nineteenth century, particularly by Husayn Avni Pasha in 1869. This conservatism led inexorably to the domination of the entire region by the Western powers.

But it would be wrong to attribute this state of affairs solely to a disparity in weapons technology. The root cause lay in the failure of the Ottomans to alter and to modernise the administrative and financial base by which the state was governed and the decreasing effectiveness of the Ottoman army in the late seventeenth, eighteenth and nineteenth centuries was primarily a reflection of this. In this respect the Ottomans' problems were little different from those of the other Muslim states in the region. The most significant result of the introduction of gunpowder and firearms in the Near and Middle East was that it altered the balance of military power between the nomadic and sedentary peoples of the area in favour of the latter, and in doing so was a decisive instrument of social and political change.

fernus laborib; in uiris eratatib; uo
bis implis. **O** lite uram manifesta
bitis probitatem rammi nurtus ui
tutem **E** in eratatis attialetis a
more r mialore ad qurretis laudem
r honorem **U** nde nobilissime do
mine si p milla de guerris r conflictib;
obseruetis doctrina eta **E** etalia de ui
lis r moribz tigris nobili regi alex
adro d'macedonea fraru r chistori pr
philosophu aristotilem philoso
plorum principe quod'ta exarta q in lib'o
de secretis secretoru r prudencias regu ple
nius fuit r eta tp me uob milla fir
mia gero fiduciam q habituris I ten
r questium honorem r gram Et incel
regnando cum deo r tota celesti mili
cia gloriam sempiternam Quoel
teris concedit qui sine fine uiuit
r regnat **U** Amen.

CHAPTER ONE

NAFT AND MOORISH SPAIN

ANY HISTORY of Islamic firearms must begin with naft,[1] the purest form of Mesopotamian bitumen. Besides a long-standing belief in its medicinal value it has the peculiarity of attracting fire from a distance without direct contact and when mixed with ingredients to make it more combustible and adhesive (such as sulphur, fats, oils, etc.) it formed the essential ingredient of 'Greek fire'. Al-Tarsusi gives the formula for various types of naptha in the twelfth century, including one 'suitable to be thrown with the Mangonel'.[2] This was used as a missile in warfare with conspicuous success against ships, wooden siege equipment, wooden towns and closely packed troops. The Muslims made use of it against Crusaders and Mongols. As a weapon it was known as naft and a large syringe with a copper tube (naffata, zarraka) was invented to discharge the naft in the form of a jet. This was operated by a naffat or zarrak. Greek fire was also thrown in clay pots (kurura), and by various types of bows and catapults. The use of bottles filled with incendiary material and fixed to arrows was

known in the Arab world as Chinese fashion (siham khita'iyya). A fascinating survival at the castle of Bir is reported by travellers in the late seventeenth and eighteenth centuries: 'In the castle, the principal things we saw were, first a large room, full of old arms: I saw there Glass bottles to be shot at the end of the arrows; one of them was stuck at the end of an arrow with four pieces of tin by its sides, to keep it firm'.[3] Maundrell goes on to describe other archaic weaponry. The English traveller Pococke visited Bir in the mid-eighteenth century and describes the same objects, including leather lamella armour. Both attest to the extreme age of the contents of the castle and it is reasonable to assume that these were Timurid or possibly Mongol.

In about 1230, saltpetre became known in the region.[4] Partington produces evidence that it was known in Egypt in 1225.[5] Zygulski wrote that 'it can be taken as proven that the basis of Greek fire was saltpetre'.[6] The assertion is extremely questionable and assumes that the Byzantines kept the existence of saltpetre from their Arab neighbours from the seventh century or earlier until the thirteenth. Certainly the Chinese had used saltpetre for fireworks and rockets for centuries and the secrets of its preparation passed from China to Persia (together with other vital technology such as paper making and steel milling) where it was known as Chinese salt (namak-i cini). In Arabic the notion of

The earliest European depiction of a gun. From the manuscript *De Notabilitatibus, Sapientis, et Prudentia* (1326) of Walter de Milemete. By permission of the Governing Body of Christ Church, Oxford.

salt persisted in names such as *milh al-ba'it* (literally sea salt) or Chinese snow. It was known by this name in Egypt in 1248, suggesting a direct transmission. Saltpetre was at first added to the igniting powder of fireworks – known as naft. Very soon afterwards the word naft is transferred to gunpowder.[7] The nineteenth-century historians Eliot and Dowson argue that the Arabs learnt the manufacture of gunpowder from India. They also argue that though the Persians possessed saltpetre in abundance, the true home of gunpowder was India. Joseph Needham is firmly of the opinion that the Chinese discovered gunpowder.[8] He is the best known exponent in the West of a case that was made by a number of Chinese scholars before him. Fernand Braudel follows this line.[9] Needham states that the Chinese produced gunpowder with saltpetre, sulphur and crushed charcoal in the ninth century AD and suggests that the first firearms were produced by the Chinese in the eleventh century. He is also clear that the Chinese invented the metal-barrelled handgun, made of copper or iron and called khotun.[10] An excavated example in the museum in Beijing is dated 1351/2.

The first printed formula for gunpowder appears in China in AD 1044. The Mongols brought a primitive form of firearm from China, known there as a firelance (*huo-ch'iang*), when they conquered Iran. The Chinese invention of gunpowder and the subsequent transmission of the technology through Iran and India to the Arab world is entirely plausible, and this view is now generally accepted.[11] From there it became known by Arab alchemists such as Hasan al-Rammah (died 1294), who produced the first clear description in the Middle East of how to make gunpowder; and to Europe, where men like Roger Bacon and his teacher Albertus Magnus had a known interest in Arab science. Bacon is often credited as the inventor of gunpowder but this depends on a questionable reconstruction of his formula from his coded writings. The actual product of these early scientists were firecrackers which made a noise like thunder and a flash like lightning. Fireworks were what the Chinese had been making for some centuries and their initial interest was probably in creating a fuse for 'Greek fire' ignition. Practical experiments on the efficiency of the various formulae recorded in the thirteenth century suggest that some of the results were extremely feeble as an explosive mixture.[12] Other early Chinese experiments were made in pursuit of a formula for toxic smoke or fumes.

It appears that while the raw materials and the knowledge were available in the Near and Middle East, gunpowder's practical military application was either not appreciated or not greatly valued and was not developed until taken to Europe. An example of this can be seen in the accounts of contemporary Arab writers in Mamluk Egypt which, though not entirely unambiguous, suggest a lack of comprehension of the importance of the technology. Since the ingredients of what we know as gunpowder were ground and mixed with a pestle and mortar it is not difficult to imagine the inspiration for the earliest cannon. The adoption of cannon occurs at different times in different parts of the Islamic world, whilst hand-held firearms follow later. This reflects the speed at which new technology could be appreciated and utilised, and also the haphazard survival of reliable written evidence from the period. In the frontier societies events can be described in two languages and can therefore often be cross-checked. Furthermore, these societies were more open to theoretical and practical innovation and the transference of technology. For this reason, Moorish Spain is a useful source of evidence. The area was also wealthy enough to master the technology involved and had an ancient metal-working tradition.

MOORISH SPAIN

The word *barud* first appears in 646/1248, used locally to mean snow of China or saltpetre, while the term naft is used in Moorish Spain from 724/1324. In the same year the first reliable references to a cannon appear from a number of contemporary Muslim poets. At the siege of Huescar north-east of Granada, a town held by the Christians, the attacking Muslims used 'the great engine which functions by means of naft'. This apparently shot a red hot iron ball, *kurat hadid muhmat*, against the walls. When fired, the ball threw out sparks and fell on the besieged like a thunderbolt. This incident, unnoticed by Western arms historians, is the earliest known use of cannon in Europe and the fact that it was in Muslim hands is surely of the greatest significance.[13] Two years later, in 1326, the Council of Florence appointed two officials to manufacture 'missiles or iron bullets and metal cannon' (*pilas seu pallectas ferreas et canones de metallo*).

This Muslim account corresponds very closely to the description of what occurred when Alfonso XI besieged the then Moorish port of Algeciras in 743/1343. In his account, the Royal Chronicler, inaccurately stating that these things were appearing for the first time in the Peninsula, tells of how there rained down upon the besieging army great balls of iron and 'arrows so long and thick that a man could only with great effort raise them from the ground',[14] by means of 'thunderclaps' (*truenos*) from within the city. They were propelled with such force that many flew over-head and fell harmlessly behind the attacking army.

And being very near the city, the Christians went about fully armed day and night, and suffered many casualties: they received many arrow wounds and many stone wounds and many lance wounds; and there were thrown at them many stones from their engines, and many stones of iron which were hurled by thunderers, and of which the soldiers were sorely afraid, for whatever member of a man they touched was carried away as if cut from him by a knife: and however slightly one might be wounded by them, he would soon be dead, for no surgery whatever could save him: firstly because they came burning like fire and also because the powders by which they were launched were of such a nature, that any wound they entered, was mortal; and they flew with such a speed that they would pass through a man fully armed.[15]

This corresponds closely to the other early references to cannon in Western Europe, which show that they were in use in the second quarter of the fourteenth century. English cannon (*ribaudequins*) were used at the battle of Crécy though they were not expected to do much more than frighten the horses of the French cavalry and annoy the Genoese crossbowmen who served the French as mercenaries. As in the societies of the Middle East, where the highly-trained horseman was the aristocrat of the battlefield, the French writers of the time were indignant at the employment of such a device against humans. Such an attitude had also been taken against the crossbow when it first appeared. Anna Comnena remarked, in words that were to be echoed about the introduction of firearms, that it was a 'truly diabolical machine' of such power that 'the unfortunate man who is struck by it dies without feeling the blow'. At the second Lateran Council in 1139 the use of the crossbow as a weapon was prohibited amongst Christians, although allowed against unbelievers. This decision was confirmed by a decree of Pope Innocent III.

It is not till the end of the fifteenth century that the terms *barud*, meaning gunpowder, and naft, now meaning cannon, were firmly distinguished. By this time the Muslims were on the defensive, the Granadines using fort artillery and the Castilians siege artillery and catapults, as can be seen from accounts of the siege of al-Bayyazin at Granada in 1486. The Spaniard P. de Alcala, writing in his *Vocabulista* the Arabic words used in Granada in 1501, describes types of cannon and catapults but does not refer to hand-held firearms, though the Arabs certainly had handguns. These appear in the Maghrib in the early sixteenth century. A Maghribi presented an arquebus (*bunduqiyya*) to the Mamluk Sultan Qansuh al-Ghawri (906-22/1500-16), saying that the weapon had appeared in the lands of the Ifrandj and was in use in all the lands of the Ottomans and of the Gharb. The era of personal firearms was firmly established.

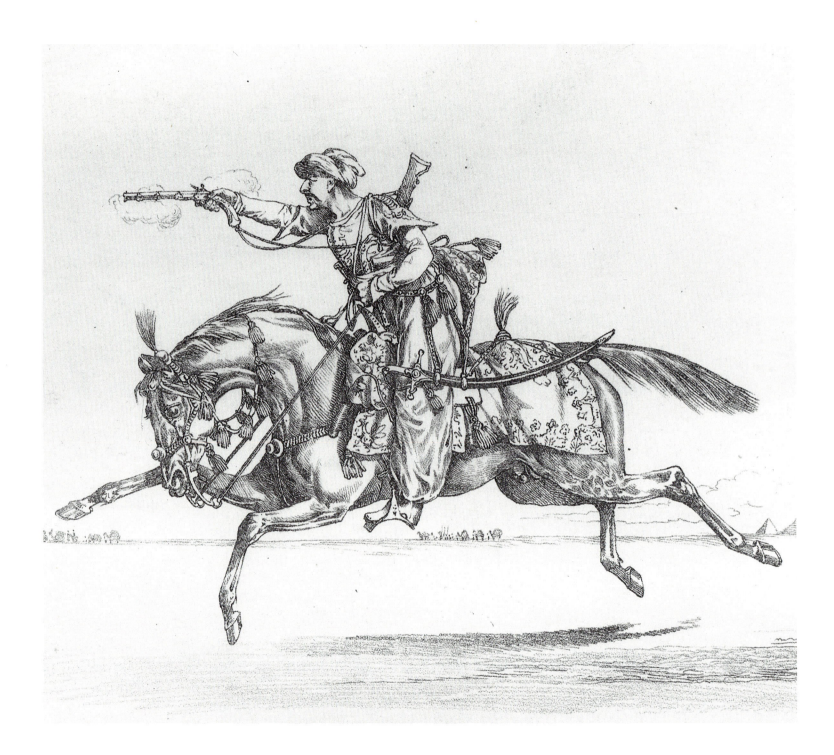

THE MAMLUKS AND THEIR SUCCESSORS IN EGYPT

I N THE MAMLUK sultanate of Egypt, the adoption of firearms differed greatly from that of Muslim Spain. The word *barud*, meaning gunpowder, was rarely used until the early sixteenth century and it did not replace naft until the Ottoman conquest in 1517. As in Spain, the mangonel (*manjaniq* – a military engine for hurling stones) was the principal siege instrument, the cannon playing a minor role from its adoption in the fourteenth century. The writings of two Arabs, al-Qalqashandi and Ibn Khaldun describe events that plausibly suggest that cannon were in use in Cairo from 1365 and in Alexandria in 1376 and were common in Egypt and Syria in 1389.[1] Since the Venetian cogs which carried trade goods to and from Egypt were armed with artillery from the 1370s, the existence of cannon from that date in Cairo seems rather to be expected.

There is evidence of handguns in Mamluk Syria in 1432. De la Brocquière describes the Meccan pilgrims' return to Damascus: 'In front, and around, were about thirty men – some bearing crossbows, others drawn swords, others small harquebuses, which they fired off every now and then.' The idea that firearms were in the hands of guards assigned to the pilgrim caravan seems entirely plausible and consistent with developments in the Ottoman state. These guards may, of course, have joined the caravan in Anatolia. The translator's use of the word 'harquebuses' is an anachronism, but there seems little doubt that these are

A *mamluk* horseman. Note the European pistols. Print published in London, 1823. Courtesy of the Director, National Army Museum, London.

firearms in the Mamluk state. Jacques Coeur, a Levant trader from Marseilles, was accused by his enemies in France in 1451 of shipping guns and other weapons, specifically cuirasses, mail shirts, crossbows and axes, to Alexandria as gifts for the Mamluk Sultan in order to buy pepper without paying customs dues. The precise nature of these guns is not clear.

The Mamluks only became seriously intent on introducing cannon into their defences when the aggressive activities of the Portuguese forced them to respond. Towards the latter part of the fifteenth century cannon were increasingly to be found in the Mamluk state, but the mangonel survived until the fall of the dynasty. The Mamluks used their artillery infrequently in sieges and not on the battlefield until very late. This was entirely due to their desire to resist all changes to the structure of a traditional military society.

In 1497, the German knight Arnold von Harff visited Cairo during a pilgrimage and his writings provide a very clear picture of Mamluk military attitudes at a time that with hindsight can be seen to be critical for the dynasty. Von Harff met two German *mamluks*[2] who obtained permission to show him round the Citadel:

> As one enters the first gate there is on the right hand a large building, in which are many large rooms, wherein the young Mamelukes have thirty-two masters, who teach them writing, reading, fighting with lances, also to defend themselves with the buckler, shooting with the hand bow at a target, and all kinds of feats of skill. I saw five hundred young Mamelukes in this building...[3]

Firearms receive no mention in the list of traditional *furusiyya* skills (military exercises) nor are they mentioned in the description of the building itself. Von Harff describes a three-day siege of the citadel involving rival Mamluk factions in 1498 'with light artillery, since they have few heavy guns in the country'.[4]

In the same year that von Harff arrived in Cairo, four Portuguese ships sailed from the harbour at Belem at the mouth of the Tagus under the command of Vasco da Gama. Their mission was to sail round the Cape of Good Hope which Bartolomeu Diaz had discovered in 1487 and to proceed up the coast of East Africa to the coast of India. The Captain-General's ship flew a flag on which was painted a large Christian cross and all the ships carried cannon. The Mamluk response was remarkably prompt. In the final years of Mamluk rule it had become apparent that the mangonel, which had for centuries co-existed with cannon, was obsolete. Under Sultan al-Ghawri (906-22/1500-16), large numbers of cannon were cast in a new foundry (*masbak*) in southern Cairo and were placed in the ports of the Red Sea and the Mediterranean, which were largely defenceless against the Portuguese and Ottoman naval cannon. The Arab chroniclers of the Hadhramaut recorded the arrival of the Portuguese off their coast with anger: 'In this year (*radjab*) the vessels of the Frank appeared at sea *en route* for India, Hormuz, and those parts. They took about seven vessels, killing those on board and making some prisoner. This was their first action, may God curse them.'[5]

Despite the immense efforts of the Mamluks, the Portuguese, who had penetrated the Red Sea as far as Jeddah, utterly destroyed the Mamluk fleet in 915/1509.[6] In desperate straits, Sultan al-Ghawri sought Ottoman assistance. The Ottomans responded and sent a convoy consisting of 30 ships carrying timber and 300 cannon, which was intercepted and captured by the Knights of Rhodes. In 916/1511, aid in the form of 400 guns and 40 qantars (approximately 2 tons) of gunpowder reached Egypt.

Arquebuses are referred to in the Mamluk sources as *al-bunduq al-rasas* (literally, the pellets of lead).[7] In later times *bunduqiyya* is used to mean a handgun while *rasasa* meaning a cartridge, was derived from *rasas*. A considerable trade in firearms by the Venetians (in Arabic, *al-bunduqiyya*) is a likely reason for the Arabic word for a firearm. The Mamluks were very fond of hunting and kept game reserves. Besides using the traditional weapons of sword, lance and mace, large animals were also killed with the bow and the crossbow. The latter shot lead, clay and stone pellets (*qusiyy al-julahiq*). Birds were hunted with a blow pipe (*zabtana*) with special pellets (*bunduq*) being carried by a designated official, the *bunduqdar*.[8] (The Arabic *bunduq* was taken into Hindi as *banduq*, the common word for a matchlock or musket in India.)

The problem for the Mamluk nobility was that large masses of arquebus men altered the nature of warfare. Not only did such a soldier have to give up his bow but also his horse, two areas of skill on which the Mamluks prided themselves. Many of the Mamluks were Qipchaq Turks, steeped in the military tradition

of Central Asia. Neither marching nor being carried in ox carts had any social cachet and as a result arquebus units were composed of low-class recruits, which further alienated upper-class sympathy towards firearms. The rigid class structure of Mamluk society even divided arquebus units into two entirely separate levels – black slaves (abid)[9] and the sons of Mamluks (awlad nas). The Mamluk response to the military necessity of introducing arquebus units into their army was to keep the numbers low and to recruit the units from sections of the population as far removed from themselves as was possible.

It is argued by Ayalon that the arquebus was first introduced into Egypt in 895/1490 under Sultan Qa'it Bay. There is a contemporary account of his inspecting his new troops and instructing them to learn the proper handling of al-bunduq al-rasas before leading them against the Ottomans in northern Syria. Since it was customary before despatching a large military expedition to review the army, this account appears very likely.

Qa'it Bay's son, Sultan al-Nasir Muhammad, (901-4/1495-8) tried to raise the social standing of the black slaves of his arquebus unit and to increase their numbers. The Mamluk amirs resented this and forced the fourteen-year-old ruler to disband the unit and to promise not to reconstitute it.

In 916/1510 Sultan Qansuh al-Ghawri made a fresh attempt to raise an arquebus unit and to renew furusiyya training, emphasizing the traditional warrior skills. The diverse social composition of the arquebus unit led to its being called al-askar al-mulaffaq, the motley army. Within its ranks were foreigners and artisans. The Sultan was put under strong pressure to disband the unit, which in theory he did in 1514 although it in fact continued to exist because it was urgently needed. The successful integration of firearms into their army by the Ottomans and their victories at Chaldiran (1514) and Marj Darbiq near Aleppo (922/1516), at which Sultan Qansuh al-Ghawri was killed, convinced the Mamluks that they should emulate Ottoman tactics. A defensive position with cannon and handguns was prepared at Raydaniyya,[10] covering Cairo. The new Sultan Tuman Bay received a letter from the Ottoman Sultan Selim in which he stated that he intended to become the ruler of the East and the West, like Alexander the Great. The Knights of St John in Rhodes sent Tuman Bay artillery experts.[11] Eighty cannon were reputedly purchased from Venice by the Mamluks.[12] A dispatch sent by Selim I

to Damascus after the battle says that the Mamluks had employed Frankish arquebusiers.[13] However, when the battle began these preparations proved no match for Ottoman firepower comprising 300 gun carts (top arabasi) chained together, arquebusiers (piyade tufekci), supported by units which included sipahis[14] and 12,000 elite cavalry (mir u sipah) wearing superb arms and armour. Within a year the Ottomans had defeated the Mamluks with the aid of the very firearms that the Mamluks had so decisively rejected.

Habit played a decisive part in the locations used by the gunpowder manufacturers for their dangerous work. In Cairo in the sixteenth century they were located close to the Bab Zuwaila and the mosque of al-Mu'ayyad, the quarter of Cairo called al-Basittiyya; in other words, at the very heart of the city. This was the centre of activity for their guild. In 1671, an accidental explosion caused dreadful damage and claimed several victims, one of whom was the daughter of Yusuf Bey, the head of the craftsmen. The Pasha then ordered the trade to move to al-Mahmudiyya, next to Rumaila, but once the shops of Basittiyya had been reconstructed the merchants simply moved back to their old location, much to the relief of the inhabitants of Rumaila. In 1703, after a second explosion, the trade was definitively moved to Rumaila. Finally, in the eighteenth century, all the merchants and manufacturers of gunpowder were installed in the Mahmudiyya, where they presented a minimum amount of danger to the population.[15]

Following the Ottoman victory, the local population tried to enrol in the army but found its ambitions frustrated by the Mamluks, who formed a powerful class below the Ottoman officials who administered the region. During the period of Ottoman domination arms continued to be produced in Cairo. In the sixteenth century superb luxury sabres were produced and there are many references to traditional weaponry to be found in the futuwwa manuals.

As far as is known, the guns used in Egypt in the seventeenth, eighteenth and early nineteenth century were the same as those used in Turkey during this period, though the decoration almost certainly differed. A description by Marsigli at the beginning of the eighteenth century provides a clue: 'Most guns are decorated with silver inlay and coral and the janissaries of Cairo in particular embellish the stock with ivory, mother-of-pearl and coral.'

Examples from a group of guns with the stocks entirely covered with sheet ivory are to be found in most of the major museum collections.[16] In his catalogue of the Khalili Collection, Alexander questions the date of 1680-1720 suggested for this group by Missillier and Ricketts, arguing that it cannot be sustained because the Khalili example is dated 1191 (1777-8). However, this date appears on the barrel, which does not bear any resemblance to the decoration and style of the barrels usually found on these guns, and the possibility of an earlier eighteenth-century date remains. Some examples in the Armería del Palacio Real, Madrid, are said to have been presented to King Carlos III by the Ottoman sultan in 1787. The suggestion by them that these were made for a sultan's guard is possible, particularly in the light of the large numbers held in Istanbul, though the primary question as to where these guns were made, rather than used, remains. The barrels and locks vary and, if they are those originally assembled when the stocks were made, indicate that the craftsmen made use of existing material. However, enough examples survive to suggest certain standard characteristics, pointing to the construction of lock, stock and barrel at the same time. The decoration of the stocks follows high quality Turkish and Balkan aesthetics: solid ivory butts, applied bands with studs on the stock, and brass- and ebony-headed tacks in patterns. These guns differ in the extensive use of ivory and also in the large limpet-like metal settings with glass or paste jewels set in them. This is not a motif that commonly appears on Turkish and Balkan guns, though Missillier and Ricketts catalogue a gun (no. 49) with these as Ottoman Turkish. It closely resembles the ivory-clad guns under discussion in all aspects except that the stock is covered with chased sheet silver. The possibility that these guns reflect Egyptian taste, itself influenced by the janissaries from Turkey and the Balkans stationed there, cannot be excluded. Indeed, Gille catalogued the example in the Tzarskoe-Selo Museum as 'Fusil Egyptien – Très-belle arme de Mamelouk'.[17]

Referring to Cairo, Evliya Chelebi, the seventeenth-century Turkish traveller, mentions 160 archers and bow makers (*yaygilar* and *okular*), whose guild had three patron saints; 300 sword makers (*kilgiyan*); 65 lance makers (*mizrak demerengisi*), and other craftsmen, but there are no mentions of firearms in the *futuwwa* literature. Chelebi refers to a mere 75 gun makers (*tufenkciyan*) and 18 gunpowder merchants, without any patron saint. This changes dramatically in the eighteenth century. The Mahkama

1. A Syrian or Egyptian flintlock gun, c. 1820.

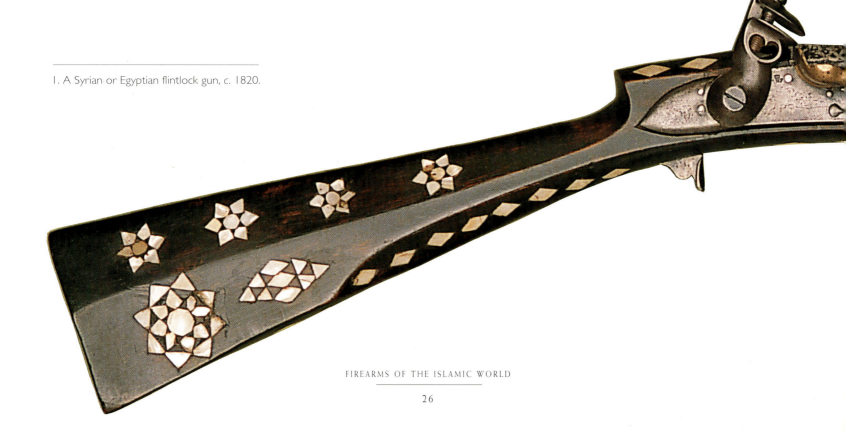

documents show only three guilds of firearm makers and gun-powder makers (*tufakgiyya*, *bunduqiyya* and *barudiyya*); but the numbers of the classic arms makers mentioned have shrunk to a total of five artisans, while the firearms-related artisans appear with great frequency in the documents. By 1801 there is only one guild of armourers for *armes blanches* and another for gunmakers.[18] However, the decline in the number of guilds does not necessarily mean a decline in the quality of the weapons produced, though there is evidence of a feeling of provincial inferiority. Pococke, who was in Cairo and Alexandria in the mid-eighteenth century, noted that: 'For all arts, they are reckoned much inferior here to what they are in Constantinople, which makes everything esteemed that comes from that place.'[19]

The people of Cairo regarded their pistols as greatly inferior to those of Istanbul, whose people in turn certainly regarded the products of Western Europe as superior to their own manufactures; anyone who could afford to bought European firearms. In the eighteenth century British goods such as cloth, tin, iron, lead and hardware had reached Egypt largely via Marseilles or Leghorn. As the Napoleonic wars continued large quantities of British merchandise, including arms, arrived in British vessels. In 1812 the French consul at Cairo reported that all the warehouses of Asia and Africa were stuffed with British goods which flowed in so cheaply that in Egypt native manufacturers were being compelled to close down.[20]

Mamluk power under the Ottomans was at its height in the third quarter of the eighteenth century, but came to a bloody end on the battlefield against Napoleon and his French veterans when they invaded Egypt in 1798. Napoleon's official despatch to the Directory from Cairo on 24th July describes how 'The Mamelukes had a magnificent force of horsemen, covered in gold and silver, armed with the best carbines and pistols of London and the best sabres of the East and mounted on perhaps the best horses of the continent.' These men were defending similar values and suffered a similar fate to that of their forebears who were defeated by the Ottomans in the early sixteenth century. Napoleon wrote that 'The Mameluke cavalry showed great bravery; they were defending their fortune, and there is not one of them on whom our soldiers have not found 300, 400 or 500 louis of gold. All the wealth of these people was in their horses and arms...' This appreciation is confirmed by the account of Captain Vertray who took part in the campaign:

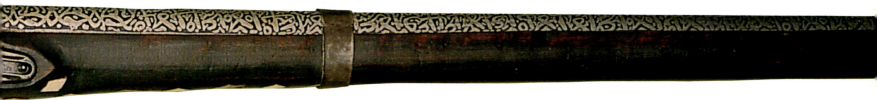

2. A nineteenth-century Arab pistol barrel.

The luxury of the Mamelukes was great: they all wore muslin under their shirts and silk pelisses. As for their arms, they were encrusted with ivory and precious stones. They were armed to the teeth, and carried four or five pistols in their belts. Their curved sabres cut like razors and cut off the head at a blow.

The steady discipline and accurate volley fire of the veteran French troops prevented the Mamluks from getting to close quarters with their swords, and the latter paid a high price for their reckless bravery, which nevertheless won the admiration of the French. The French also defeated a force of Albanians who had been sent by the Ottoman Sultan to throw them out of Egypt. An Albanian officer from Kavalla, Muhammad Ali, took over the command. When the French withdrew two years later Muhammad Ali used his position to assume power and obtained formal recognition of his *de facto* position as Governor from the Sultan. He smashed the power of the Circassian Mamluks with utter ruthlessness in 1226/1811 and an era of Albanian military domination of Egypt began. Muhammad Ali's realisation that Egypt would only flourish if the technical discoveries, the military practices and the education systems of the West were introduced, made him a formidable modernising force, with an impact beyond Egypt. Having secured Egypt, Muhammad Ali launched campaigns to extend his power using a newly conscripted army: in Arabia, where he defeated the Al Sa'ud and Wahhabism; the Sudan; and, at the request of the Sultan, in Greece, which was struggling to throw off Ottoman suzerainty and gain independence. In return for his son Ibrahim Pasha's successful suppression of the Greeks, Muhammad Ali requested the Porte to recognise him as ruler of Syria and, when the Sultan refused to grant this, sent an army under Ibrahim Pasha, who proceeded to take it by force in 1832. Ibrahim defeated an Ottoman army that was sent to stop him and the road to Istanbul lay invitingly open, but the Great Powers of Europe intervened in support of the Ottoman Sultan. In 1833 the Sultan formally recognised Muhammad Ali as Governor of Syria, where Ibrahim Pasha ruled for the next seven years until a popular uprising forced him to evacuate the region.

Writing of the principal European imports in Cairo in 1831, Lane describes 'firearms, and straight sword blades (from Germany) for the Nubians'; and under exports to Sennar and the neighbouring countries he records 'the straight sword-blades mentioned before', and firearms.[21] Burckhardt refers to the same trade in blades fifteen years earlier. Writing a little later, Gerard de Nerval describes how, to complete his Arab costume, he bought pistols in Cairo which 'generally proved fatal to whoever pulled the trigger'.

In the mid-nineteenth century, the Khedive's guards were armed with elegant percussion rifles from Liège. In 1866-7, the Khedive Isma'il sent a military mission to Europe to buy modern weapons to replace the muzzle loaders used by the Egyptian army. At the Exposition Universelle in Paris in 1867, the American Remington rifle was unanimously selected by an international panel of experts as the best military rifle in the world,

and in due course the Egyptian army acquired Remington rifles and breech-loading Krupp guns left over from the Franco-Prussian War of 1870. Remington's 1883 Catalogue gives a list of military rifles which includes a special 'Egyptian rifle'. Samuel Remington arranged the sale with Isma'il Pasha and the two men became friends. Remington was given a sabre by his new friend and, when the rifles arrived on the date specified in the contract, a parcel of land in Cairo. In order not to offend the Khedive, he was obliged to build a small marble palace on the site, but it was a long way from Mudville, USA, and he never lived in it.[22]

These rifles were very different from the arms that Egerton found for sale in the bazaars of Cairo towards the end of the nineteenth century, which were presumably being sold for use. The stocks are, on the basis of Egerton's description, typically Ottoman and without particular distinction, but the barrels are of interest: '...the [musket] barrels appear to differ in character, according as they are made in Iran, Baghdad, or Damascus, and they are often inlaid with silver patterns and inscriptions...the [pistol] barrels terminating in dragon-heads...'[23] The pistol barrel (Catalogue no. 2) in the Tareq Rajab Museum is probably from this group. The decorative elements are to be found on gun barrels from the seventeenth and eighteenth centuries.[24] However, the uncertain working of the dragon-head muzzle and the crowded and tentative silver arabesques strongly suggest that the design is derivative and that the pistol barrel is either provincial work or a later copy.

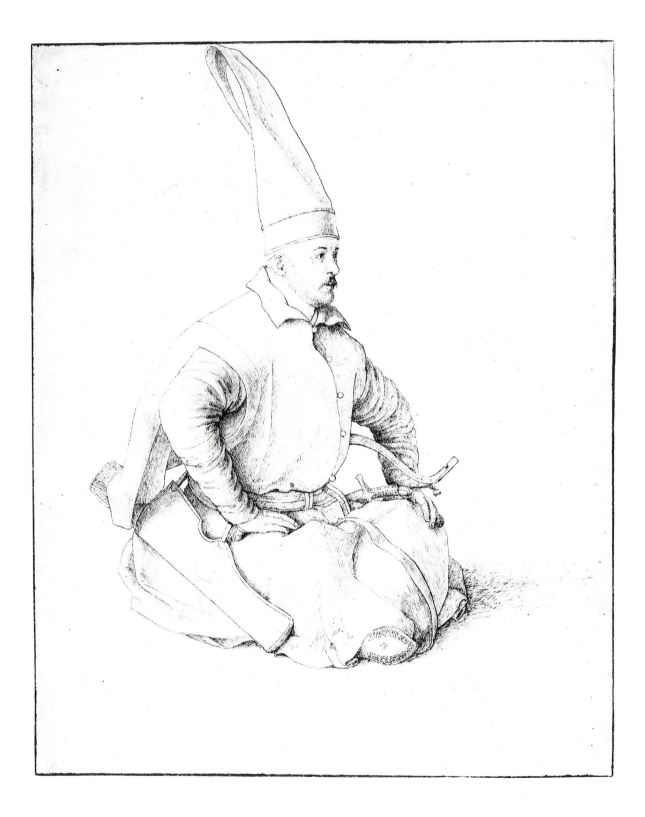

THE OTTOMANS

T HERE IS a continuing debate as to the precise date at which the Ottomans first began to make use of firearms, which they would probably have first encountered in the Balkans. Indeed, much of the Balkans is so closely involved in the transmission, development and manufacture of Ottoman firearms that the work produced there is usually regarded as Turkish. The Hungarians had firearms themselves from 1354.[1] The Venetians took firearms to the Balkans in the mid-fourteenth century at the time when the Ottomans had conquered Gallipoli (1352) and were poised to enter the region. War between Hungary and Serbia in 1354 led to Serbia's collapse and facilitated the Ottoman advance. Besieged Constantinople could offer no effective resistance in the Balkans to Sultan Murad I, who in 1365 transferred his capital to Adrianople (Edirne) in Europe. From 1378 cannon were in use in the western Balkans and were being manufactured in Dubrovnik[2] (Ragusa), from where they were sent to try and stem the Ottoman advance. Venetian and Genoese cannon were also supplied to the anti-Ottoman forces. The historians Daskalov and Kovacheva state that the Turks used cannon successfully at the battle of Nicopolis in 1396. The arguments for this were previously considered by Wittek,[3] who concluded that firearms were not used by the Turks on that occasion. There is, in fact, a gap between historical evidence and probability. The oldest cannon in the German History Museum, dated AD 1400, was manufactured in Bosnia, an area noted for gun production, and even before this date documentary evidence shows that cannon were being made in Sgisuara, Sibiu and Brasov in present-day Romania.[4] Mayer lists a surviving iron cannon made (*amal*) by 'Hasan ar-Rumi, known as al-'Ulji, that is, of Christian origin, in Jumada II, 767' (AD 1366).[5] The first cannon foundry in the Balkans was built in Dubrovnik in 1410, although the wrought-iron cannon of the previous century continued to be produced.[6] The new cannon were made of cannon bronze, 88-92 per cent

Portrait of a janissary with a bow by Gentile Bellini, who was in Istanbul with a diplomatic mission, 1479-81. Fine pen and Indian ink. British Museum.

copper and 12-18 per cent tin.[7] The demand for firearms was very great and Dubrovnik and Venice became the major suppliers of much of the region.

Wittek offers evidence of the use of firearms by the Ottomans at the battle of Kosova in 1389 and at the first Ottoman siege of Constantinople in 1395-1402, while pointing out that the sources are late and therefore cannot be relied on. His conclusion is that prior to 1400 the Turks had no knowledge of firearms.[8] Modern Turkish historians have argued that the Turks adopted firearms in the fourteenth century, and the most recent summary of their views is given by the modern arms historian Coruhlu.

Firearms had certainly been introduced by the reign of Mehmed I (1413-21), and arguably earlier.[9] It is certain that in 1424, while defending Antalya, the Ottomans killed their besieger the Qaramanoghlu Muhammad Beg by a well-directed cannon ball,[10] though at that time these weapons can usually have made little difference to the outcome of any conflict and catapults were the principal siege instrument. Of particular interest is the siege of Hexamilion on the Corinthian Isthmus in 1446 because it shows that the guns were cast on the spot and that a supply of copper was carried by the Ottoman army for this purpose. By 1453 the ineffectiveness of cannon was a thing of the past – a huge cannon made by Urbanus of Transylvania for the Ottomans played an important part in the final siege of Constantinople. Mehmed Fatih, 'the Conqueror', built up the most powerful artillery in Europe so that at the siege of Belgrade in 1456 it was said that the Sultan had 'bombarde tanto grande et tanto sterminate che in vero in natura humana non foro facta mai simile' (cannon so big and so destructive that in truth, to human knowledge none like them had ever been made).[11]

Field guns seem to have entered the Ottoman forces shortly before the battle of Varna in 1444[12] and were certainly used in the second battle of Kosova in 1448. In this battle the Hungarians possessed bombards which they call *sciopietae*. (*Schioppetto* is the earliest name for a handgun.) The distinction between a cannon and a handgun is often uncertain in witnesses' accounts.

The arquebus is said to have been introduced to the Ottomans during the Hungarian wars of Murad II in about 1440-43, though more flimsy evidence exists of an earlier use in the Dardanelles in 1421 and Salonika in 1430.[13] Two hundred Italians armed with heavy arquebuses were serving with the Hungarian forces in 1428 when they attacked the Ottomans occupying the Serbian fort of Golubac.[14] In the same year the Small Council of Dubrovnik decided to have thirty 'Puscas sive schiopos' made from bronze. The contract, still in existence, indicates that the Council had received a bronze handgun with an octagonal barrel on which they modelled the first Dubrovnik arquebuses. The original was probably Venetian. From surviving documents we know that arquebuses were of three sizes. In Dubrovnik, in the mid-fifteenth century, the large handguns called *puschon* weighed over 25 kg. There were also references to 2 *puschoni* in 1453 weighing 135 lb. Smaller handguns weighed 6 kg. on average.[15]

The crossbow was the main infantry missile weapon in Italy in the first part of the fifteenth century and had been since the thirteenth, but there were still some companies of English archers to be found in Italy. Walter of England was employed with ninety fellow archers in 1431 by the Venetians; while John Clement and Godfrey Reynolds with thirty archers were under contract to Florence. The Genoese crossbowmen were predominant in Italy but there was a civic obligation for Venetians to learn to shoot with the crossbow and it was the standard weapon of garrisons and town guards. Francesco Sforza and his cousin Michelotto Attendolo, who commanded the Venetian army between 1441 and 1448, had handgun units; and Colleoni and the Venetian infantry commander Diotisalvi Lupi were also associated with the new weapon at this time. By the mid-century the Milanese could claim the ability to put 20,000 men into the field armed with handguns, while Francesco Sforza had so many handgun men in action at the battle of Caravaggio in 1448 that they could not see each other for the smoke the weapons created.[16] The appearance of handguns was therefore a gradual process in Italy as in Ottoman territory, with traditional missile weapons continuing in use beside the new; both Ottomans and Italians were equipped with the arquebus in reasonable numbers by the middle of the fifteenth century.

By the two reigns of Mehmed Fatih (1444-6 and 1451-81), the use of the arquebus by the janissaries, the elite Ottoman infantry partly recruited from boys of Christian origin,[17] was firmly established. The medieval Ottoman army had largely consisted of *timar*-holding cavalry (*sipahis*) armed with bow, lance, sword and mace, but was obliged to change when it encountered German

infantry armed with arquebuses. The rise in the number of janissaries over the next 200 years is directly related to the rise in importance of firearms. According to one estimate, in 1475, when the *kapi-kulu* cavalry numbered 3,000 and the janissaries 6,000, there were 22,000 *timar*-holding *sipahis* in Rumelia and 17,000 in Anatolia. A century later the *kapi-kulu* cavalry and the janissaries had doubled their numbers but the numbers of provincial *sipahis* remained constant. The janissaries were organised into a corps or *ojak*, literally a 'hearth'. This was composed of three unequal divisions which themselves divided into numerous companies or *orta*. One of the specialist janissary units was the Cebeci Ocagi or armourers, whose duty was to make and repair guns and other weapons which were the property of the state.

The gradual supersession of the first primitive handguns by more efficient (and accurate) arquebuses can be seen in military usage in the Italian campaigns of this time. The process of evolution was slow. In 1482 in the preparations for war with Ferrara, the Milanese contingent was issued with 1,250 handguns, 352 arquebuses and only 233 crossbows.[18] Italy was a major producer of matchlocks, made in Milan and Brescia. Because these were principally military issue and undecorated relatively few have survived in Europe. There is rather greater variety in Turkish collections, which may with study lead to a better knowledge of the European weapon to which it is so closely related. *Schiopette*, bombards, gunpowder and other material of military significance were shipped from Ascona in 1465-7, apparently for sale in Istanbul and Pera.[19] Three Christian gunsmiths are recorded in a village in Herzegovina at the time of the first Ottoman census in 1477 and the Turks also recorded captured Serbian gunsmiths. By a policy known as 'istimalet' (literally, to make use of) the Ottoman conquerors attempted to win the support of the peasants against their former masters. Modern excavations inside the Smederevo fortress revealed a store room for arquebuses, including fifteenth-century examples.[20] Arquebuses reported to be from the period of 1480 can be found in the military museum in Belgrade.

After the defeats incurred in the Cilician campaign of 1485-91 against the Mamluks, Bayazid II (1481-1512) increased the numbers and effectiveness of the janissaries. Their numbers, however, still remained relatively small. At the time of Suleyman the Magnificent (926-74/1520-66), when the Ottoman empire was at its zenith, the janissaries numbered only 12,000-15,000 men.[21] Bayazid II also improved the field artillery and all the main types of weaponry and techniques involved in waging war using gunpowder which were available to the Ottomans at this time. The results of these measures can be seen in the crushing defeat of the Safavids at Chaldiran in 1514; of the Mamluks at Marj Darbiq and Raydaniyya in 1516 and 1517; and of the Hungarians at Mohács in 1526. In these battles firearms played the decisive role. A double page miniature painting in the Ottoman manuscript known as the *Suleymanname*,[22] which was completed in 1558, shows a line of chained field artillery at the front of the Ottoman army; behind this every other janissary fires while his neighbour loads his own gun in what is clearly an established drill. Wittek cites Spandugino, who wrote soon after 1510 that the janissaries had only recently learnt the use of muskets. Since the Turks had been using handguns for many years it is clear that Spandugino is referring to a technical advance. The fully-developed matchlock is said by Guilmartin to have been widely in use in the Spanish army by 1500 and it is probably to this that Spandugino refers.[23]

The musket came into popular usage in the mid-sixteenth century. The major difference between a musket and an arquebus was one of weight since both were generally matchlocks, the arquebus coming to mean a light gun which could be fired without a rest. The word 'musket' probably comes from the Italian '*moschetto*', a fly, by which name a crossbow bolt was formerly known. The precise meaning of the many names used to describe the various types of early firearms is often unknown and changes from country to country and according to date. It is therefore often not clear what specific firearm is being referred to, a problem compounded by the lack of standardisation and the inaccurate usage of technical words by contemporary chroniclers. The earliest handguns were ignited by a match being applied by hand to the vent. In time a simple mechanism was conceived to retain the lighted match and to convey it to the vent, which allowed the user to keep hold of his weapon with both hands. The earliest evidence for this is a painting in the Austrian National Library, dated 1411[24] showing the forerunner of the gunlock. The Turks were very slow to abandon the use of the hand-held match. Illustrations show Turkish arquebusiers with the match wound round the right wrist with the lighted end held in the right hand. As late as 1637 a European witness could describe

how the Turks 'clutch the stock of their pieces in the left hand, while with the right they apply the match...'[25]

It appears to be widely agreed that the matchlock first appeared in Germany bearing the name *hackenbuchse*. When it was exported, the French derived the word *hacquebute*, the English haquebut or hakbut and the Spanish *hacabuche*. It was used in Europe from the 1470s until the mid-sixteenth century.[26] The word means 'hook gun' and is named after the hook or lug which projected under the barrel to be hooked over a battlement or embrasure so that the firer escaped the unpleasant recoil. A good example with a wooden fullstock and a hook, but no priming pan, dating from circa 1470, is in the Museum of Art and History in Geneva. The first arquebuses differed little from the hand cannons they replaced. According to Lavin, the Spanish word *arcabuz* derived from *hacabuche*, or from *escopeta* (in Italian *schiopetto*), which were contemporaneous. The term arquebus (Italian *archibugio*) appears to come from *arcabuz* as Bernal Diaz del Castile makes clear in his description of the conquest of Mexico in 1519-21 when he refers to arquebusiers or 'escopeteros as they were called then'.[27] The Turks used the word *tufek*, which Wittek states was first used in Ottoman literature in 1465. He concludes that the word is derived from *tuwek*, the blowpipe used to kill small birds.[28] Although the evidence appears to be missing, it must be assumed that the earliest Ottoman guns were 'hook guns' and followed the Christian development of firearms as they evolved into large matchlock long guns of considerable weight. The early Ottoman handguns of this period were extremely heavy and remained so long after the Christian version of the weapon had been reduced to more manageable proportions.

The earliest type of European matchlock had a straight butt that continued the axis of the barrel. The gently curved butt appeared in Europe in the first half of the sixteenth century but the Turks and the other nations that followed their example in the East continued with the straight stock based on the German late fifteenth-century style. In view of the diversity of countries that supplied arms to the Ottomans it would be strange if there are not exceptions to this statement, but in general it holds true. Germany was an important manufacturer of firearms, particularly in Nuremberg and Bohemia, the former becoming the major producer and exporter of wheellocks, which were not adopted by the Turks. Charles V and his successor Philip II of Spain pre-

ferred to obtain German guns, but whilst luxury guns with wheellocks developed in Germany, the standard military weapon across Europe remained the arquebus or matchlock – so the Muslim forces were not at first greatly disadvantaged. The manufacture of arquebuses is discussed by Giovan Matteo Cicogna in *Il Primo Libro Del Trattato Militare*, published in Venice in 1583, from which it can be seen that the firearms produced in Germany and Bohemia provide the benchmark by which other countries' products are judged:

> All kinds of arquebuses are made in a great many parts of the world, especially in Germany; and it seems that all kinds of barrels made in Bohemia for arquebuses large and small, both wheellock and matchlock, enjoy excellent reputations; and that good barrels are made in Nuremburg too. In Spain they make excellent guns for rough fighting. But leaving aside the discussion of these far away foreign places, we shall discuss those made in Italy, where, if the need arises, a man can procure arms in great variety and quantity, for arsenals, or for arming a fortress, or for armies to be led into combat. In the environs of Brescia, in the Trompia valley, there is a place called Gardone, where they make all kinds of good and perfect arquebuses, large and small, even very long ones for fowling, and all manner of others now in use, and these are also mass-produced in that place.[29]

The excellent arquebuses of northern Italy did indeed reach the Turks, who referred to them as *Talyan tufenkler*. An Englishman, Edward Davies wrote in *The Art of War*, which was published in London in 1618-19, of the excellence of firearms from Milan, which he recommended above all others 'for they be of tough and perfect temper, light, square and big of breech, and very strong where the powder doth lie...'

The German town of Suhl also had a considerable export trade in gun barrels and may have induced the Ottomans to copy the practice of inlaying the stock, usually walnut, with white and green stained staghorn. An illustration entitled 'janissary off to war' was drawn by Nicolas de Nicolay, who accompanied the embassy of d'Aramont to Istanbul in 1551 and published an account of his travels at Lyon in 1568.[30] In his book Nicolay

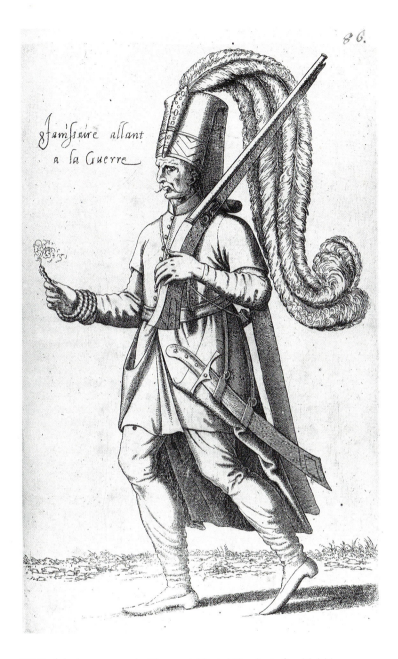

86.

Janissaire allant a la Guerre

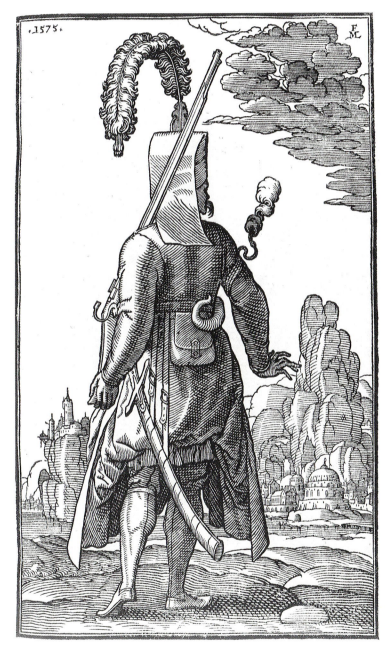

.1575.

F M L

LEFT 'Janissary off to War' after a drawing by Nicolas de Nicolay, who accompanied the embassy of d'Aramont to Istanbul in 1551 and published an account of his travels at Lyon in 1568. British Museum.

RIGHT A janissary armed with a matchlock. Woodcut after Melchior Lorichs of Flensburg, 1576, from *Wolgerissene und geschnittene Figuren...für die Mahler, Bildthawer und Kunstliebenden...* Lorichs joined the entourage of Ogier Ghiselin de Busbecq, ambassador of the Holy Roman Empire to the court of Sultan Suleyman in Istanbul. His many portrayals of the Ottoman army were intended to warn Europe of the strength and discipline of the Ottoman forces. British Museum.

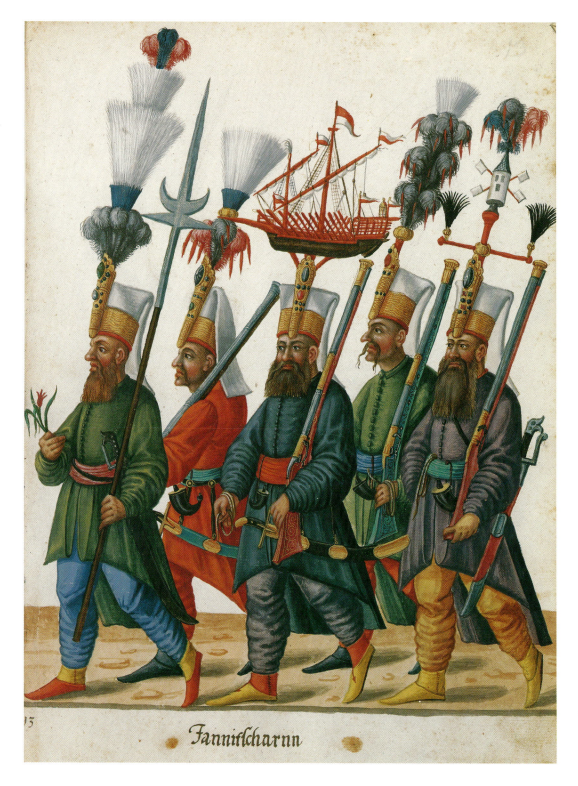

Fannitfcharnn

Book illustration c. 1590, showing janissaries on ceremonial parade. Austrian National Library, Vienna.

refers to the janissaries *'de harquebufes longuettes, defquelles ils'aident affez bien.'*[31] The gun illustrated has a curved five-sided wooden stock with a raised strip on the side, with what appears to be a button – an early example, but a feature found on Suhl stocks which is in fact a patch box with a spring clip. The drawing of the ignition mechanism shows clearly a long sear lever, a cock and a pan. The disc showing on Nicolay's drawing below the pan is possibly a wheellock mechanism as there appears to be a 'v'-shaped object under the cock which can only be a spring. However, discs which are purely decorative can also be seen on matchlock guns of this date and were a characteristic of Saxon sixteenth- and early seventeenth-century makers.[32] It is possible that the positioning of these discs directly under the pan was intended to give the appearance of a wheellock. Alternatively it is a brass medallion indicating the town of manufacture or town armoury. A late sixteenth-century matchlock taken from the Turks and now in the Royal Danish Kunstkammer[33] has a decorative disc of this type. A sear-lock musket which has all these characteristics is in the Tøjhusmuseet, Copenhagen.[34] This superior example was made at Suhl in 1607 and is certainly more sophisticated than what one would find fifty years earlier, but the military matchlock changed very slowly and the particular details on the Nicolay drawing point to a German origin for the gun which is supported by historical evidence. If the disc illustrated is indeed a wheellock, the presence of the lighted match indicates that it is defective and that the gun is being used as a matchlock.

The adoption by the Ottomans of the German stock shape is certain and it is reasonable to see German influence in the evolving decoration of the better examples which reflected Ottoman aesthetics. There are obvious injections of German baroque and rococo influence later, in the form of applied pierced brass. Ivory was used as an inlay material in Ottoman art in all periods. In the late sixteenth century the Ottomans developed the use of mother-of-pearl[35] and tortoiseshell as inlay materials in wooden objects of all kinds, such as quivers, furniture and gun stocks. The technique remained popular and was widely followed throughout the empire until this century. Some fine examples in the Moscow Kremlin appear to be done by Turkish craftsmen in the latter half of the seventeenth century, although Dutch artisans were also present in the service of the Tsar.[36] The wood used to make the stocks of the janissaries came from the forests of Ada Bazari. The striped hardwood that is found on Ottoman and Caucasian guns, particularly of the eighteenth and nineteenth centuries, was called *sarma agagdzi* in Turkish and came from Moldavia. Its effect was often artificially created by wrapping a cord round the shaped stock and igniting it, creating a scorched pattern. This technique was also commonly employed at the same period by the Liège gunmakers[37] who exported firearms to the region. Circassian walnut, maple and pear are the woods most commonly used for Ottoman stocks.[38]

Because the arquebus was slow to load and cumbersome it was not popular with the Ottoman *sipahis*. A corps of mounted arquebus men was in existence briefly in Egypt, the result of a *firman* (written order) of 1524 issued by Suleyman the Magnificent shortly after the Ottoman conquest,[39] and independently the Persians tried a similar experiment. Neither unit lasted long and the concept had to wait until the latter part of the seventeenth century before it was adopted by Muslim armies. The merits of combining mobility and firepower were recognised by Camillo Vitelli and Cesare Borgia in Italy in the 1490s, who both created mounted handgun and arquebus units.[40] The same concept was devised by Lazarus von Schwendi when commanding the forces of the Emperor Maximilian II on the Hungarian front 1564-8. Besides urging the emperor to enlist professional Italian and Spanish arquebusiers to counter the fire of the janissaries, he favoured the use of *Schuzen zu Ross* – horsemen equipped with the arquebus.[41] Schwendi describes the janissaries as numbering about 12,000 arquebusiers, using the long arquebus which they managed excellently. Other Christian observers agreed. Later in the sixteenth century the janissaries were recorded in Venetian reports between 1571 and 1590 as virtually all armed with the Ottoman matchlock, which was described as being made with a longer barrel than was normal amongst the Christians and loaded with large bullets *come li barbareschi*.[42] *Barbareschi* was the name Europeans gave to the people of the Maghrib, which included Tripolitania, Tunisia, Algeria and Morocco. There is a fine sixteenth-century Turkish matchlock barrel (with a rear peepsight and a grooved foresight, round at the breech with a tulip-shaped muzzle) in the Victoria and Albert Museum, London, which has been mounted by a French gunsmith on a wheellock arquebus from the Royal Cabinet of Arms of Louis XIII (Inventory number 3).[43] The length of the barrel is 58 inches (and may be compared with that of

No.3 in the Tareq Rajab Museum). The Spanish arquebusier Balbi describes the Turkish muskets as 'nine palms long'.[44] Turkish matchlocks had a range of 500 to 600 paces according to sources.[45] Christian accounts of Ottoman marksmanship, for example at the siege of Malta in 1565, give full if reluctant praise. An Italian wrote in 1583: 'We see the Turkish arquebuses and their most excellent gunpowder shoots much further than ours and have much more penetration because they are longer and have better gunpowder.'[46] This view was tested in 1974 on late fifteenth-century handguns, which were found to be reasonably accurate at a range of twenty yards. The burning rate of black powder imposes an upper limit on muzzle velocity, small quantities burning less efficiently than larger charges so that the larger bore would prove advantageous. It was found that increased muzzle velocity could be achieved by progressive lengthening of the barrel.[47] This fact is of major importance in considering the effectiveness of firearms throughout the Islamic world where there was a tendency to produce guns with extremely long barrels, at least by Western standards, and whose owners always exhibited far more skill than Western observers expected in view of the roughness of the workmanship. However, the sources agree that the Turks were slow to load and did much better in situations such as sieges where a rapid rate of fire was not required, rather than on the battlefield. Under siege conditions the Ottoman forces consistently shot better and further than the Christians.

Considerable efforts were made by Christian rulers and popes to stop the arms trade with the Muslim states – latterly the Ottomans. The frequency of these interdicts indicates the scale and importance of the trade. A general papal prohibition against trade with the Muslims was in force from long before the invention of firearms. A Bull was issued by Pope Eugenius IV dated 1444, and another in 1527 by Pope Clement VII threatening excommunication against Christians who carried to the Muslims horses and arms, iron, tin, copper, sulphur, saltpetre and the materials for warship construction. Nevertheless Francis I, King of France, who numbered among his titles that of 'Rex Christianissimus' or 'Most Christian King', spent much of his reign in close military alliance with the Ottomans against Charles V, Holy Roman Emperor, and used the alliance to further his territorial ambitions in the Italian wars and to extract favourable trading rights from the Porte. France was granted capitulations in 1536.[48]

3. A late sixteenth-century Ottoman barrel taken from an eighteenth-century Algerian miquelet gun. (See p. 77, No. 3a)

The French alliance became an important part of Ottoman policy as a counter to the Habsburgs. A good example of this co-operation can be seen in 1543 when Sultan Suleyman put at France's disposal one hundred and ten galleys under the Turkish Admiral Barbarossa, which combined with a French fleet and laid siege to Nice. Having captured the town, which the French prevented their allies from sacking, they failed to capture the citadel due to French failure to provide adequate supplies of gunpowder. The Ottoman fleet then wintered at Toulon.[49] They then sailed to Barcelona, bombarded it and returned to Istanbul, sacking coastal cities in Tuscany, Naples and Sicily *en route*. The French were extremely inefficient about supplying their allies with arms and munitions and it was Barbarossa's practice to seize them instead from the towns that he sacked. During the same period, Suleyman led an army into Hungary to defeat Archduke Ferdinand of Austria, who in 1544 declared illegal 'all traffic with the Ottomans in victuals, firearms, gunpowder, saltpetre, lances, armour, cuirasses, iron, tin and lead.'[50] This declaration was partly caused by the arrival of a small force of French artillery in Hungary to join the Ottoman army.

The Ottomans relied on Europeans for the transmission and often the construction of firearms and it is claimed that many Jews fleeing the Spanish Inquisition in the sixteenth century brought the latest Spanish gun-making skills to the Turks.[51] The Spanish had no great heavy cavalry tradition and it was common for aristocrats to enter the infantry (the word itself comes from the Spanish), where they naturally accepted the role of firearms

and interested themselves in their development. An attempt by Louis XI to raise a force of infantry armed with the bow came to nothing, and apart from Gascon infantry the French kings relied largely on foreign mercenaries – Genoese crossbowmen and, in the fifteenth century, Swiss pikemen.[52] The French were obsessed with the military potential of the armoured and aristocratic knight on horseback[53] and were much less interested in the possibilities of firearms in the hands of infantry. The two tactical concepts met in the Italian wars at the battle of Pavia in 1525 where six or seven hundred Spanish arquebusiers enfiladed the French cavalry, ensuring the defeat and capture of Francis I. France was not likely to be of great assistance to their Ottoman allies in the transmission of firearms technology to counter Spanish and German expertise.

Little is known of early gunmaking in France and there are very few guns of French make dateable before 1550. George Vigile, an artillery expert from Languedoc, came to St Etienne, an area already well established as an arms manufacturing centre, in 1537. He had been ordered by Francis I to organise the manufacture of matchlocks and wheellocks. Handguns produced in the region prior to this date are preserved in the Musée d'Art et d'Industrie and it was also known to have manufactured crossbows in the fifteenth century.[54] The firearms produced in France appear to have been subject to German rather than Italian influence, and German design is apparent in both the decoration and mechanism of French firearms until the 1580s. The extent to which Ottoman-French military co-operation affected the development of firearms in Ottoman lands is therefore difficult to judge, but there can be no doubt that when sacking the coast of the Spanish territory of Naples and Sicily the Ottomans acquired large quantities of booty, including the most up-to-date Spanish and Italian firearms available. Military co-operation continued in

the Mediterranean under Henry II of France and a joint fleet occupied Corsica for France in 960/1553. The sultan offered military help to the Lutheran princes in the Low Countries and other lands subject to Spain, and when Elizabeth I of England became the champion of Protestant Europe against Philip II of Spain both sultan and queen regarded the other as a useful ally.[55] The sultan granted capitulations to the English in 1580 as a sign of this rapprochement and from this period the English began to replace the French in Istanbul.

The Dutch Calvinists were also fighting Catholic Spain and the nationalistic but semi-piratical 'sea beggars' adopted the slogan 'rather the Turk than the Pope' in 1574.[56] The Dutch attitude resulted in their being granted capitulations in 1021/1612. English and Dutch mercantile development in the early seventeenth century owed much to the opening of the Levant to them by the Ottomans. The English sold lead and bronze obtained from the dissolution of the monasteries to the Turks by the boat load and also provided large quantities of tin from Cornwall, essential for the casting of bronze cannon and not available within Ottoman territory. The Ottomans experienced the effect of new European weapons on the battlefield and bought arms of all kinds from European traders in Istanbul. For example, Sir Thomas Sherley describes how in the early seventeenth century, 'the English keepe 3 open shoppes of armes and munition in Constantinople. Gunpowder is sold for 23 and 24 chikinoes[57] the hundred... Muskettes are sold for 5 or 6 the peyce.'[58] The scale of this trade can be seen from the cargo of an English ship seized at Melos by the Venetians in 1605, which 'contained 700 barrels of gunpowder, 1,000 arquebus barrels, 500 mounted arquebuses, 2,000 sword blades and a barrel full of ingots of fine gold.'[59] The inclusion of gunpowder in these accounts points to a considerable shortage in Istanbul during these years because the capitulations

granted to Queen Elizabeth of England by the sultan in 1601 specifically excluded gunpowder from the goods in which English merchants might deal.[60] Gunpowder was being shipped in large quantities at this time from the ports of the Ottoman empire to Istanbul. English travellers reported that four galleys brought loads from Alexandria in 1596; and in 1609 eight carried gunpowder from Alexandria and Tripoli to Istanbul.[61] In the mid-seventeenth century a well-informed observer wrote that only small quantities of gunpowder were produced in Istanbul and that it was mostly imported from Europe, though the most highly esteemed came from Damascus.[62]

The Ottomans were very aware of the importance of controlling the raw materials – lead, iron, copper, etc. – from which weapons, particularly firearms, were made. Often the mines were also centres of manufacture. Within the Ottoman empire, lead came from the silver mines of Serbia and Bosnia; iron from Bulgaria and copper from Anatolia. The Ottomans carried large quantities of lead on campaign in order to cast bullets. The great variety of calibres made it difficult to carry a sufficiently wide range of ready-made bullets and it was the custom to distribute lead bars to the troops for them to cast their own.[63] This is part of an old tradition, described by Rycaut:[64] 'The Grand Signior going in Persia to the wars, according to the ancient custom of other Sultans, bestows a largess on the Spahees, of 5000 Aspers a Man, which they call Sadak Akchiasi, or a donative for buying Bows and Arrows; also to the Janissaries.'[65]

The 'match' used by the Ottomans was known as *fitil* or *fitil otu* and was made of cotton impregnated with a combustible such as sulphur, available in Anatolia, though saltpetre was not found within Ottoman Turkey. It was, however, common in the countries of the Ottoman empire – the Balkans, Syria, Iraq and Egypt.

The peoples of Bosnia and Serbia, Germany and Italy, and later England, France and Holland were an essential and continuing part of the Ottoman military machine. Often Christians served in the army in specialist units such as the *tayfa-i efrenciye* or Corps of European Ottoman artillery; and artillerymen of European descent served the guns in 1048/1638 when the Ottomans besieged and retook Baghdad from the Iranians. Ottoman (*Rumi*) cannon and arquebus experts took service themselves in other countries: Arabia, particularly in the Hadhramaut and Yemen, and India, where they were highly valued and welcomed.

Firearms in Ottoman Turkey in the sixteenth and seventeenth centuries were provided by Algeria, Hungary, the Balkans and Western Europe. The importation or manufacture of firearms was always a state monopoly with state workshops established in Istanbul, but the prestige of imported weapons was high and demand very great. Captured weapons were re-used by the Turks, particularly the barrels, but whatever was utilised was stamped and decorated, as surviving pieces in the Askeri Museum in Istanbul demonstrate.[66] The matchlock in the Dresden Rustkammer, thought to be the earliest surviving Ottoman firearm, has been tentatively identified in the inventory of 1606.[67] The barrel is European and attributed to Venice, though the stock and its decoration are sixteenth-century Turkish. It is a heavy weapon, with a cock that falls forwards. Sultan Suleyman (1520-66) was responsible for enlarging the State workshops and increasing production, which coincided with a large increase in infantry armed with the *tufeng*. The Balkans was always an important Turkish source of guns, both imported and produced locally, and peasants, particularly from Bosnia and Albania, trained in the use of firearms and *tufeng-endaz*. In the war of 1593-1606, even little Ragusa was asked to supply musketeers to the Ottoman army.[68]

In 1610 a military order was sent commanding that the master gunsmiths and dagger makers of Sofia, Skopie and Plovdiv be sent to work in the arms workshops in Istanbul.[69] The manufacture of gunbarrels was normally a separate trade in Europe and in Ottoman lands. In a list of arms dated 1009/1600 from a vizier's *cebe-bane*, comprising 75 *tufeng*, were the following types: *Cezayiri* (from Algiers), *Firingi* (from Western Europe), *Rumi* (Ottoman), *Istanbuli* (from Istanbul), *Macari* (from Hungary), *Alaman* (from Germany), *Macari zenberekli*, and *kar-i Moton* (made in Modena or Modon?). The *Cezayiri* was a heavy musket (with shot of 25 *dirhems*), the *kar-i Moton* a lighter musket (with shot of 7 *dirhems*).[70] A major reason for the diversity of sources of these weapons is found in the heterogeneous nature of the Ottoman army. When the sultan ordered a campaign the *timar* system ensured that the *sipahis* collected under the command of the *subasis*, who in turn rallied to their *sanjak beyi* or provincial governor. These units then marched to join the *beylerbeyi*, who led them to the place appointed by the sultan who would then review the troops. As this happened across the Ottoman empire, the army consisted of troops raised from every province with very different

military traditions. Rycaut lists the units and their troop numbers which took part in the 1683 campaign. These included 'the forces of Mesopotamia – all on horseback, 13,000; the Basra contingent – 14,000; Asiatick Troops comprehending the Provinces of Sias, Amasia, Maras, Bussia, etc. – 30,000; Militia of Judea, Egypt, etc. – 18,000; Militia out of Caramania – 16,000; Turks out of the parts of Greece – 16,000; Militia out of Armenia, Capadocia – 24,000; the remaining Asiatick troops were from Georgia, and the conquered countries thereabouts – 28,000; Janissaries of Europe – 12,000; Tartars, ill armed and worse clothed – 14,000; last of all marched the most flourishing part of the Turkish army, consisting of sons and servants of pashas, also of the richest *spahees* and other young men all richly clothed and armed – 35,000; Pioneers, Gunners, Attendants of the waggons of ammunition and provisions, tents, baggage, etc.'. In total an army of 264,000.[71]

Many of these troops, particularly the *sipahis*, were not paid from the central treasury, so that by the autumn they would want to return home, particularly those from far distant provinces who would have weeks of travelling ahead of them on foot or on horses exhausted by the demands of the campaign. The Ottoman army campaigned from March to October when the troops dispersed. In this manner weapons came to the Ottoman provinces through conquest and trade in Eastern Europe – often smuggled. Eastern Europe absorbed Ottoman culture, even those areas which resisted the Ottoman onslaught. For example, documents of the period refer to the fact that at the end of the sixteenth century one could in practice only tell a Hungarian from a Turk by his hat[72] and there were considerable shifts in allegiance which inevitably involved transfers of firearms. In 1597 the Emperor asked Henry IV of France for aid against the Turks, and a French regiment of three thousand men under Baron de Bonparc was sent to Hungary. Two years later the survivors went over to the Ottoman side and fought against the Hungarians.[73]

Hungary was divided into several parts as a result of the Ottoman wars. The central plain became part of the Ottoman empire, while the northern and western regions were ruled by the Habsburg emperors and the Hungarian kings respectively. Transylvania was a vassal state of the Ottomans. The Hungarian gunmaker Gaspar Hartmann worked for King Gyorgy Rakoczi I in about 1634, but also made guns 'of Damascus steel, a costly and strong product' for the Habsburg Emperor Ferdinand III.[74] The

great gun-making centre for the Austro-Hungarian empire was Ferlach in Carinthia. The Ferlacher Genossenschaft was founded in 1577 and had a virtual monopoly of the trade until 1815.

The Turks were never very innovatory in naval matters, treating engagements at sea in the manner of land battles. Barbaro remarked that they had not a single naval term proper to their own language but borrowed from the Greeks and the Franks. Ottoman naval artillery was as good as that of the Christians, though the short Venetian cannon was regarded as the best available for sea service.[75] At the battle of Lepanto in 1571, the six Christian galleasses, equipped with forty or more cannon, used their heavy guns to fire forward with terrible effect. They were aided by the removal of their rams, allowing them to depress their cannon lower than those of the Turks, which were reported to be lighter, fewer and unable to reply effectively as the fleets closed. Lepanto resulted in a major change in the Ottoman use of handguns at sea. The Venetians had replaced the crossbow with the arquebus on their war galleys in 1518 by order of the Council of Ten. Other Mediterranean naval powers had followed this development, with the exception of the Turks, who maintained the use of the bow. The corsairs from the Maghrib had a better awareness of the merits of both weapons. Before the battle of Préveza in 1538, three thousand janissaries armed with arquebuses had been embarked on Barbarossa's fleet. A Spaniard who had been captured in 1561 and had served as a galley slave for the Pasha of Vélez in North Africa escaped to record that the Pasha's galiots were manned by sharpshooters 'each one of whom carries an arquebus (*escopeta*) and a bow'.[76] Nevertheless, at Lepanto the Turkish galleys still carried more bowmen than matchlockmen. A comparison between the troops on the vessels of the two opposing admirals reveals that Don John of Austria had four hundred arquebusiers from the Regiment of Sardinia aboard his flagship; whilst Ali Pasha, the Turkish kapudan pasha, had three hundred janissaries, one hundred crossbowmen and some arquebusiers. An impressive Turkish matchlock belonging to Don John of Austria, presumably captured at the battle of Lepanto in 1571, can be seen in the Real Armería, Madrid.[77] In a letter dated 10 June 1572, François de Noailles, Bishop of Dax and Charles IX's ambassador at the Porte, wrote informing his master that the Turks were eager that foreigners see their new fleet because they had built two hundred galleys in six months to replace those lost

at Lepanto and were going to put 20,000 arquebusiers aboard them, 'a thing which has never been seen in this Empire'.[78] The new kapudan pasha, Uluj-Ali, had taken part in the battle and been wounded by arquebus fire. He had already had novices fire arquebuses in his squadron during the battle and was encouraging the Turks to leave their bows behind for the forthcoming campaign.

Shortly after the battle of Lepanto a report from Venice dated 12 November 1571 stated that the shops on the bridge of the Rialto were adorned with Turkish rugs, banners, trophies, arms and turbans. The estimated expenditure by Venice on the fleet and the Arsenal[79] alone amounted to 25 to 30 per cent of revenue during peacetime, and this did not include expenditure for the army on land. In time of war the standard revenue was inadequate and loans and depreciation were the usual method of meeting military expenditure.[80] The burden of military expenditure on the economy of the Ottoman state was to have a progressively enervating effect, compounded when the Ottomans lost control of the sea in the seventeenth century and were no longer able to protect their own coastline and essential trade routes. Nevertheless, it was noted by Turkey's Christian enemies in the seventeenth century that whatever the losses there was always a fully equipped Ottoman army in the field the following campaigning season, though the cannon were increasingly inclined to be obsolete, having been taken from some fortification where they had languished.

OTTOMAN CONTROL AND DIFFUSION OF FIREARMS

The spread of matchlocks was inevitable, though the Ottomans made great efforts to restrict their usage and prevent them falling into undesirable hands both at home and abroad. Weapons were exported as a deliberate part of foreign policy, to Mamluk Egypt, for example, or to Muslim Abyssinia. Either by design or by accident, the countries of the Islamic East acquired their firearms and expertise very largely via the Ottomans. The Yemeni histories, for example, state that the *bunduq* (arquebus) first appeared in the Yemen in 922/1515 and that it first came to the Hadhramaut with the Turks (*al-Rum*). The guns were known as *banadiq*, the plural of *bunduq*.[81] The Turkish word for gunpowder is *barut*, a pronunciation similar to that used in the Hadhramaut and Oman, in contrast to the *barud* pronunciation of the rest of the Arab world, and providing evidence of the origin of the imported technology.

In peacetime weapons of all sorts were stored in special depots under the control of the *cebeci-basi*, who was also responsible for restoration of the arms. Rycaut describes this duty in the seventeenth century: 'they are in number six hundred and thirty distributed into sixty chambers, and have their Quarters near the Church of Santa Sophia in Constantinople; their office is to conserve the Arms of ancient times from rust, by cleaning and oyling them, so as to remain as Trophies for ever of the Turkish Conquests.'[82] Members of this unit were sent to those major cities and castles of the empire where there was an arsenal in which gunpowder and arms were stored and firearms made. It is believed that most of the firearms were made in Istanbul; this was probably true at a time when the Ottoman state was at the height of its power and control was exercised from the centre. Authority to distribute arms came from the sultan himself. Beside the principal arms depot, *cebe-hane*, in Istanbul at Top Hane and at Galata, local fortresses had their own depots. Without providing an exhaustive list, arms were certainly made in Egypt and Syria, Baghdad, Erzurum, Diyarbakir, Ankara, Belgrade as well as in Anatolian fortresses, while considerable quantities were made in the Balkans and the Caucasus.

Ordinary *re'aya* (peasants), Muslim and non-Muslim subjects, were not allowed to bear weapons of any kind. This prohibition was particularly important when the Qizilbash of eastern Turkey were in sympathy with the Safavids in the early sixteenth century. Searches for firearms by the Ottomans were frequent and if found the owner was mutilated or executed. The manufacture of firearms was a state monopoly and those who traded in them ran severe risks. By the 1560s and 1570s private ownership of the *tufeng* was widespread despite the restrictions, which disadvantaged law-abiding Turks when confronted with bandits and armed civil unrest. The situation encouraged the smuggling of *tufeng* from Western Europe, Ragusa and from Algeria, which according to Inalcik was a prominent producer at this date,[83] and also encouraged the construction of illicit firearms within Turkey.

Glimpses of the continual improvement in firearms can sometimes be seen. For example, the Druze of Ayn Dara in 973/1565 acquired a new type of musket capable of out-ranging those of the *sipahi* who accompanied the Ottoman official responsible for collecting tax.[84] The Ottoman government was obliged to take strong military action against the brigands, proclaiming them *celalis*, enemies of the state, and enlarging the janissary corps by relaxing its recruiting standards from its original elite standards. Though formerly the janissaries had been celibate, in a moment of government weakness they had won the right to marry and their sons now demanded the right to become janissaries. Barbaro wrote of this: 'Ben e vero che a questi tempi con corruttela et scandalo si va introducendo con favor figliuoli de Turki' (it is certainly true that at these times of corruption and scandal, the sons of Turks were being accepted by preference).

At the end of the sixteenth century the *celalis* numbered twenty thousand armed men defying authority and there was a collapse in the structure of Ottoman society, leading to the breakdown of the *sipahi* cavalry system and the rise of the *kapikulu* standing forces with the recruitment of *re'aya* into the army. The increase was accomplished through the recruitment of Anatolian Muslim peasants into the imperial forces and the raising of 'irregular' levies. The changing nature of warfare, and the localities in which the Ottoman armies found themselves engaged, required a greater reliance on infantry than had hitherto been the case. This was particularly evident in the fighting in the Caucasus in 986-98/1578-90 and also in the Danube campaign of 1593-1606. There were armed mutinies by the soldiers across the empire, in Egypt for example, in the last quarter of the sixteenth century and the first decade of the seventeenth. In 1009-10/1600-1 Arab and Turkish renegades seized the Yemen state armoury.

Ottoman merchants traded arms illegally across the Black Sea in the later sixteenth century with the Abaza, whose port was Sukhumi, in the north-west Caucasus, and the Mingrel. The Abaza were keen to buy handguns (*tufek*) daggers (*kurde*) and bows. The export of war materials from Turkey was prohibited and in 1572-3 the Porte forbade all trade with the Abaza in an effort to stop arms smuggling. This was ineffectual. In 1612 a vessel was wrecked on the Sea of Marmara and driven on shore. Five handguns were found (for which local authorities hoped to get between 120 and 1000 *akce* each) and many swords (worth less than 150 *akce* each). In the Aegean region a document sent to the local governors of Izmir and Foca described horses, lead, arms and gunpowder as prohibited trade goods.[85] In the seventeenth century, Evliya Chelebi visited Mingrelia to which 'ships of all countries bring powder, lead, muskets, arrows, bows, swords, shields, lances and other weapons'.[86] Chelebi records that firearms were being exported from Gemushane and the region of the River Coruh in north-eastern Anatolia to Mingrelia and the Caucasus. This appears to have been an unauthorised centre of production, the extent of which is not known, though it may well have originated from the armed rebellions of the previous century.

A consequence of the challenge to Ottoman authority was the stationing of janissaries in the provinces where they in due course formed a new upper class. Another was the authorisation of local governors to raise local auxilliary troops to deal with the situation. One of the earliest examples, recruited in Syria at the beginning of the seventeenth century, was the *sakban*, a word of Persian origin referring to the dog handler with a musket who accompanies the amir when hunting. Such recruits served as infantry, cavalry and as garrison troops. A provincial militia called the *sarija* was also formed and equipped with firearms. Nevertheless, the reputation of the Ottoman army was greatly diminished. While it would be simplistic to attribute these events solely to the diffusion of firearms both within and outside the Ottoman state, they were a major causal factor at the heart of the process of change.

With hindsight it is easy to see the weaknesses of the Ottoman state in the seventeenth century. The contemporary Christian perception was one of fear: at the beginning of the century, in Oxford, Richard Knolles wrote in his *History of the Turks* that they were 'the present terror of the world'. A reflection of the unstable state of affairs within the Ottoman state can be seen in the peace treaty signed between the Ottomans and the Austrians at Zitva Torok in 1606 after an inconclusive war. For the first time the Ottomans were obliged to accept that their armies were unable to dictate terms to the Habsburgs, who signed as equals with full imperial title. The Ottomans also lost control of the sea and even the ability to protect their own coastline. The Cossacks sailed down the Dneiper and raided the Black Sea coast at will, even attacking a suburb of Istanbul in 1625. In the Mediterranean

the activities of Tuscan and Maltese corsairs based in Crete were a perpetual irritation. In 1644, when Maltese corsairs captured a ship on which the former chief eunuch was travelling to Egypt, the Ottomans decided on war. There followed a lengthy campaign (1645-69) which they had difficulty in concluding. The efforts of the reforming Koprulu grand viziers (all of Albanian origin) brought victory in the twenty-four-year war and an end to many of the practices which had proved so debilitating to the Ottoman state. However, the century ended with ill-judged campaigns in Eastern Europe. These included the Ottoman defeat at the second siege of Vienna in 1683, though the narrowness of that defeat effectively disguised the decline of the Ottoman military threat to Europe. Under the auspices of the pope, a Holy League comprising Austria, Poland and Venice, subsequently joined by Russia, was formed against the Ottomans. The treaty of Carlowitz in 1699 ended this disastrous war for the Ottomans, with the Hungarian question resolved in favour of the Habsburgs and Austria at the gates of the Balkans, while the Russians had for the first time gained access to the Black Sea by capturing Azov.

THE OTTOMAN ADOPTION OF PISTOLS

Pistols were slowly adopted by the Ottomans and were known as *tabanca* or *tabancha*, with some Western writers transliterating the word as *tabanja*. The word as written in Arabic script remains the same. In Europe the word 'pistol' relating to a firearm first appears in 1544 in the *Memoires* of the Frenchman, Martin du Bellay, describing German allies armed with a new weapon.[87] The earliest German reference to its use by cavalry relates to the Ottoman attack on Stuhlweissenburg in Hungary in 1548. A German chronicler in 1555 states:

> Nothing was taken from our men other than their firelocks, which the German cavalry carried on their saddlebow as well as the long lances, in accordance with the new fashion, since these were deadly and effective weapons.

The Turks were greatly delighted with them because they were a novelty and most remarkable from the mechanical point of view for no match was necessary, but only a small wheel which had to be wound up. On this a fire-stone[88] pressed and gave fire when the wheel was let free. The powder was thereby ignited and the gun went off.[89]

Ogier Ghiselin de Busbecq, ambassador of the Emperor Ferdinand I at Istanbul from 1554-62, describes how 'the Turks are much afraid of our carbines and pistols such as are used on horseback' (by Christian forces). He records how an attempt was made to equip two hundred of the grand vizier's household servants with firearms for use in the Christian manner as dragoons, and to drill them:

> But they had not completed half the journey when their guns began to get out of order. Every day some essential part of their weapons was lost or broken and it was not often that armourers could be found capable of repairing them. So, a large part of the firearms having been rendered unserviceable, the men took a dislike to the weapon; and their prejudice was increased by the dirt which its use entailed, the Turks being a very clean people; for the Dragoons had their hands and clothes begrimed with gun powder, and moreover presented such sorry appearance with their ugly boxes and pouches hanging about them, that their comrades laughed at them, and called them apothecaries. So, since with this equipment they pleased neither themselves nor others, they gathered round Roostem and showing him their broken and useless firearms, asked what advantage he hoped to gain from them when they met the enemy and demanded that he should relieve them of them and give them their old arms again.[90]

The same author recounts how a group of elite Ottoman cavalry excused their defeat at the hands of Christian forces because the enemy had not fought in a manly fashion with traditional arms but had resorted to firearms, a mode of fighting which the Ottomans deplored. On 11 May 1590, Rudolph II, Holy Roman Emperor, ordered the Hoffkammer to supply Sinan Pasha with

helmet, breast plates and pistols.[91] An account of the entry of the Habsburg Archduke Maximilian (1558-1618) into Vác in 1596 shows how well equipped with firearms the Christian horsemen had become: 'Three hundred well equipped horsemen rode at the head of the column... The saddle of each horse was furnished with a gun, a broadsword encrusted with gold, and a pistol on either side.'[92]

It appears that others in the Near East were less reluctant than the Ottomans to adopt pistols. When Sir Thomas Roe visited the island of Socotra in 1516 on his journey to India, he noted that the sultan had twelve guards, 'some with Turkish bowes, some with pistols, some with musketts, all with good swords.'[93]

Nevertheless, the difficulties of the manufacture or even the maintenance of wheellock pistols was never satisfactorily resolved by the Ottomans. This is curious because of their enthusiasm for clocks and the presence in Istanbul of European clockmakers. Antoine Petremol, French Resident at Istanbul from 1561 to 1566 wrote that the Turks 'sont si amoureux d'horloges que c'est le plus grand present qu'on leur scauroit faire' (... are so fond of clocks that it is the best present one can give them).[94] A wheellock pistol with the St Irene arsenal mark is in the Askeri Museum (Env. 241). On the basis of the mark Turkish scholars claim that it was made in Istanbul but in every other respect this pistol appears to be a typical product of Nuremburg of about 1560, and the German city has the better claim. By the nature of its firing mechanism the matchlock pistol did not provide a viable substitute to the wheellock. A combination of lighted match, a loaded pistol thrust into a sash or holster, and a horse was unlikely to inspire confidence in any soldier. (A number of matchlock pistols were produced, particularly in India, but these do not appear to be horse pistols.)[95] For this reason, and despite the heavy casualties endured by the cavalry, the Ottoman armies did not adopt pistols until the snaphaunce lock became available, which could be safely carried loaded, and cocked when needed. Because of this, the Ottoman cavalry continued to rely on the bow. Thomas Dallam describes the 'janissaries' he saw near Aleppo in 1599. Since he confesses that neither he nor anyone else in his party were able to talk with them, it is possible that these were in fact sipahis: 'Most of them weare horsmen, and everie man had his Lance, and most of them his boye, or slave, to beare his Lance, and everie mane his bowe and quiver of arrowes, and semeterrie

by his sid. Not only there manner of shoutinge but ther bowes and arrowes be strainge.'[96]

The Ottoman cavalry began to arm themselves with firearms in the Hungarian wars of 1593-1606. Venetian sources record that the *sipahi di paga*, the sultan's household cavalry, were frequently equipped with the *terzaruolo*, a short-barrelled arquebus, but that the pistol was not used by them. Chelebi describes meeting a warrior with six pistols (*alti tabancasi*), a musket (*tufegi*) and on his back a shield from Aleppo. This is exceptional and Chelebi caustically describes him as looking like a walking arsenal.[97] It was not until the Cretan war of 1645-69 that it was recorded by Western observers that most of the Ottoman horsemen carried pistols. The siege of Candia from 1647 to 1669 saw a great deal of close-quarter fighting, often underground as mines and countermines were dug. There was an order for pistols with belt hooks as side-arms for the Venetian infantry and the flintlock was reported to be proving its worth in the bitter fighting. Candia was finally stormed by the Turks after a siege of twenty-two years during which there were technological advances in firearms design. However, even at this late stage firearms were not adopted with enthusiasm by many in the Ottoman forces.[98] Paul Rycaut, describing the situation which existed at the time of the first of the Koprulu viziers (1066-87/1656-76), stated that the *sipahi* cavalry still held firearms in low regard. His description of the *sipahis* reveals the conservative attitude of these troops:

These light horsemen are armed with the Scimetar and Lance, called by them Mizrak, and some carry in their hands a Gerit (Jarid), which is a weapon about two foot long, headed with iron, which I conceive to be the same as the Pila amongst the Romans, which by long exercise and custom they throw with a strange dexterity and violence, and sometimes darting it before them in the full career of their horse, without any stop recover it again from the ground: they also wear a straight sword named chaddare, with a broad blade fixed to the side of their saddle, which, or the Scimetar, they make use of when they arrive to hand-blows with the enemy; many of them are armed with Bows and Arrows; and with Pistols and Carbines; but esteem not much of Firearms, having an opinion that in the Field they make more noise than execution...'[99]

The modernising effect of the Cretan campaign on the Ottoman troops and the reforms of the Koprulu viziers can be seen elsewhere in the Ottoman empire. Manuel Godinho describes the arrival of some well-armed Turkish cavalry at the village house where he was lodging outside Basra in 1663: 'At about Angelus time, eighteen Turkish horsemen came into the same courtyard, well armed, with matchlocks in their right hands, scimitars and pistols in their belts and iron maces at the side, on the saddles, and all at the ready.'[100]

A comparison with the arms carried by Godinho's party, which was about to undertake the perilous journey across the desert from Basra to Damascus on horseback, reveals that the equipment scarcely differed between the two groups:

Illustration from *Stato Militare dell'Imperio Ottomano*, by Marsigli, published in 1732, showing the firearms used by the Ottoman troops at the end of the seventeenth century. These comprise a heavy matchlock, and a carbine and a pistol with a miquelet lock which Marsigli compares to Spanish firearms.

The four of us, two dressed in Turkish and two in Arabian fashion, mounted the horses and made our way through the city gate, all well armed with weapons and patience to bear the rigours of the sun and of the Deserta sands, which start just outside Basra's western gates. The shauter (Arab guide) had his lance; the Turkoman (that is the interpreter in Turkish and Arabic) carried two pistols and a carbine; the Portuguese, pistols and muskets; I, pistols and a carbine. We all carried scimitars besides, on one side of the saddle, under the leg, as well as an iron mace fastened on the other side.[101]

4. A Scandinavian flintlock sporting gun fitted with a Turkish 'damascus twist' barrel, c. 1700, viewed from above.

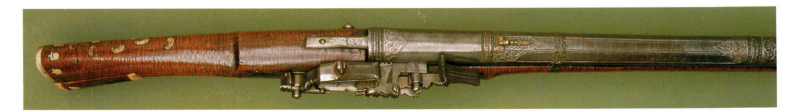

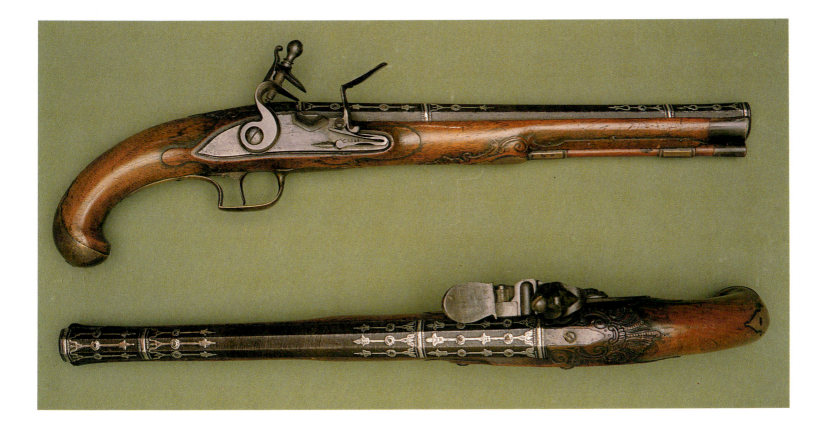

5. A pair of Austrian flintlock holster pistols, c. 1740, with Turkish 'damascus pattern' barrels.

Comparing these groups with the Arabs in the same region Godhinho says that 'The weapons of these Arabs are long spears, meant for hurling, which they never leave hold of, and there is nothing that catches their eye so much as a good staff for a spear. They use bows and arrows, scimitars and iron maces, which they carry under their legs while riding. They have no use for firearms.'[102] This attitude to firearms continued amongst some of the Bedouin until the early twentieth century.[103]

Marsigli confirms in 1732 that the Turks carried pistols like most cavaliers. They were known in both Arabic and Turkish as *tabanja*. The illustration of a pistol in Marsigli's book (see facing page) accurately shows the distinctive bulge in the wooden stock in front of the trigger which is a characteristic of early Ottoman

pistols, as can be seen in a group of examples in Topkapi Sarayi. Largely due to an innate conservatism, the Turks failed to keep pace with Western arms technology, so that Ottoman pistols of the eighteenth century resemble those of the seventeenth century until the Turkish gunsmiths in the middle of the century adopted the form of the early eighteenth-century Dutch pistol. Turkish examples in this style have a more slender butt than the Dutch pistols which they seek to copy and are of poorer quality, with a false ramrod. The Dutch were selling their pistols in the Levant and the local gunsmiths were obliged by popular demand to produce an identical product. Indeed, between the sixteenth and eighteenth centuries the design of Ottoman weapons remained largely the same, though the gunlocks changed and armour and shields gradually disappeared as the effectiveness of firearms made them redundant.

As early as 1596, a Muslim soldier from Bosnia was lamenting that the Imperial forces, using the most modern types of arquebus and cannon, had acquired in their warfare a marked

advantage over the Ottomans.[104] One major change was their abandonment of the pike and adoption of the plug bayonet. The Ottomans are thought to have first encountered this at the Imperial siege of Buda in 1686, though the flintlock with a bayonet had been distributed to some of the regiments serving the Emperor in 1684.

THE EVOLUTION OF OTTOMAN FIREARMS IN THE 17TH AND 18TH CENTURIES

The Ottomans experimented with combination weapons, using a firearm alongside a traditional weapon. The idea may well have derived from Europe where it was popular in the sixteenth and seventeenth centuries. An extremely early example of a wheellock can be found on a combined crossbow and gun in the Bayerisches Museum, Munich. From the monograms and coats-of-arms that it bears it can be dated to 1521-6. Three other wheellock crossbow guns are in the Armoury of the Doge's Palace, Venice.[105] In Topkapi Sarayi there are a number of these weapons, including a combination gun and war hammer [106] and a *yataghan* incorporating a flintlock pistol. Such Ottoman pieces are extremely unusual and in no way reflect the true, extremely conservative, evolution of Ottoman arms. The practice was particularly popular in India. The Turkish combination dagger and double-barrelled flintlock pistol (Catalogue no. 6) in the Tareq Rajab Museum is an example of a small group of sophisticated arms which clearly date from the nineteenth century. This example is in particularly good condition.

Turkish firearms may have one or more of a number of proof and arsenal marks on them. This practice appears to have begun the reign of Murad II (1421-51). The Ottomans claimed descent from the Kayi, regarded as the noblest of the Oghuz tribes. For this reason the Ottoman dynasty considered itself superior to other Turkoman dynasties and to the sons of Chingiz-Khan. Possibly to emphasize their right to rule, the Kayi tribal mark (known as a *tamgha*) was used as the official emblem of

the Ottomans, appearing on coins during the reign of Murad II. An Ottoman manuscript which survives from this reign sets out for the first time the genealogical proof of the Ottoman descent from the Kayi. The Kayi mark appears on the weapons of his successors though it is impossible to say if these were applied during their reigns or subsequently. It is better known to collectors and dealers as the St Irene arsenal mark, named after the church within the Topkapi Palace complex which the Ottomans used as a weapons store until the present century. The reigning sultan's *tughra*, his distinctive official signature, was used as an assay mark, often with a number to indicate purity.[107]

Ottoman muskets usually had longer barrels than the corresponding European weapons and clumsy full stocks. Their barrels, by contrast, were extremely fine and it is usually the barrel which is signed rather than the lock, as is more common in Western European firearms. Each part of the gun was made by a different *ustad* or master craftsman, who often signed his work, so differing names appear on the lock and barrel. The barrel, whether imported or made in Istanbul, received an official stamp or *tamgha* which indicated both state ownership and a form of quality control. Until the end of the eighteenth century Turkish barrels were marked *imtihan* or tested. This was replaced by the word *sahh*, meaning correct, a term commonly written on documents to signify the reader's approval. This mark was used on imported and locally made weapons and was in turn succeeded by a variety of words appearing on barrels: *sad, bala, vala, miknet, nusret*, referring to a variety of qualities. The last *tamgha* to be used was the letter *mim*, which administrators also used to mark documents that had been examined. Serial numbers appeared at a late date. The words *tufeng-hane-i amire* sometimes appear on barrels, signifying that the weapon was made in the imperial armoury in Istanbul.[108]

A good example of a late sixteenth-century Ottoman silver inlaid matchlock barrel, now mounted on an eighteenth-century Algerian miquelet gun is in the Tareq Rajab Museum (Catalogue no. 3). Another example, dated 1026/1617, in the Military Museum, Istanbul (No. 2307), belonged to Silahtar Mustapha Pasha. It is a matchlock with a particularly fine barrel, part octagonal changing to a rounded form with a boldly chiselled monster-head flared muzzle.[109] Since the matchlocks of ordinary Turkish troops were issued by the *cebecis* for a particular occasion and then collected afterwards and replaced in the arsenals, these weapons

are invariably without owners' names. Only men of rank had personal firearms with their names and titles on the barrel in gold or silver.

Also of great importance is the gun belonging to Sultan Suleyman III (1687-91) in the Hungarian National Museum, described by the arms historian Temesváry in 1982. Its stock is covered with plates of ivory, unusually large corals and sheet silver engraved with decorative motifs. The decoration of its richly gilded barrel follows well-known designs and motifs from Turkish fabrics.

Four Turkish guns were captured by the Danish Admiral Adler and placed in the Royal Danish Kunstkammer where they appear in the inventory for 1674. One of them is a wheellock, very rarely found on Turkish guns. The Turks moved from the matchlock to the miquelet lock of Spanish type[110] without much use of the wheellock which, when found on Ottoman firearms, is invariably of Western European manufacture. The miquelet lock soon became general throughout the Mediterranean and passed further east to the Caucasus and Kurdistan. Rycaut lists European guns amongst the diplomatic gifts given to Muhammad IV. In 1665 the German ambassador's gifts included 'four Guns with silver stocks and a "Cutlash" of silver'. Two years later the Polish ambassador gave 'a Gun which discharges twenty times'.[111] The transition from match to flint in Western military usage occurred in the 1660s. The Venetians ordered 'a thousand of the newly invented muskets with double locks, that is, one with a flint and the other using a match.' The Austrians adopted the same system in 1666, which is called the Montecuccoli lock after its inventor.[112]

6. A nineteenth-century Turkish double-barrelled flintlock pistol with concealed dagger. A similar weapon is in the Museum Narodowego, Cracow.

A gun of this type which bears an inscription stating that it was captured from a janissary in 1683, is in the Dresden Historisches Museum. A fine Ottoman example is in the Museum at San Marino. Raimondo Montecuccoli formulated the tactical use of concentrated firepower against the traditional Ottoman battle line, a development which resulted in a long series of victories for the Christian powers.[113] Volume as well as concentration of fire was crucial; although the Ottoman firearms were becoming less cumbersome, they were slower to load than the Christian weapons and could not compete with them.

In his *Stato Militare dell'Imperio Ottomano*, published in 1732, Marsigli wrote that the Turks relied on Christians for their firearms and that

> The firearm carried by the Turkish soldier is a much heavier musket than any other and takes a ball of 6, 9, 12, 15, 25 drams; and this is a matchlock. Another gun is very similar to the Spanish type but with a different mechanism. The third, which is the smallest that can be used with one hand is a pistol made like the (previous) gun, and takes bullets of 4, 6, 8, drams. [114]

He described how the Ottoman muskets were much too heavy to carry on campaign or to shoot without a rest, and how the musketeer was forced to step back to absorb the recoil. The tribesmen of southern Arabia, who had been taught the use of matchlocks by the Turks in the sixteenth century, often did the same up to the nineteenth century, according to contemporary accounts.[115]

The Royal Danish Kunstkammer guns are clumsy in comparison with a snaphaunce in the Historisches Museum, Dresden,[116] which has a damascus barrel damascened in gold with similar decoration on the lock. Engraved brass ribbon inlay decorates

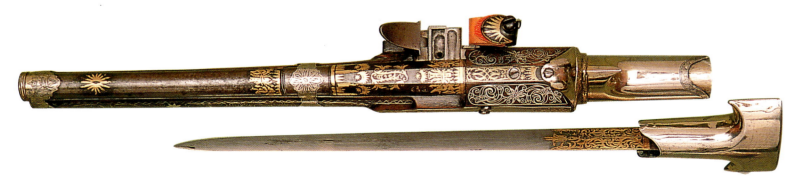

the striped wood stock, which has an ivory butt plate. Let into the barrel is a nielloed inscription 'Made in the well protected city [i.e., Istanbul] in the sixth year' – in this case the sixth regnal year of Ahmed III (1703-30).[117] The barrel also has a maker's mark. This gun provides proof of the confident adoption of the snaphaunce system in a gun that is manifestly Ottoman in style though clearly made for a wealthy patron rather than for ordinary military use. It may reasonably be assumed that this gun made in Istanbul represents the most up-to-date form available at that time. The form can also be found in many examples with more rustic decoration, clearly provincial work, attributable either to the Balkans or Turkey, with the greater production probably emanating from the Balkans. Comparison with Balkan folk art, particularly staghorn powder flasks,[118] reveals marked similarities between the decorative motifs on the flasks, many of which are Romanian, and the eighteenth- and nineteenth-century stock decoration of the miquelet lock long guns loosely described as 'Turkish'. They are clearly of provincial eastern Balkans construction, yet the word 'Turkish' is not inappropriate to this area, because large numbers of western Anatolian peasants settled in Thrace and the eastern Balkans in the fifteenth century, a practice which continued over a widening area as the Ottoman conquests moved the frontier north.[119] The precise spread of these guns, often referred to as *shishane*, is hard to determine and they are claimed by a number of modern Balkan states as typical of their own production. They are the equivalent of the jaeger rifle of central and northern Europe, with their short heavy barrels of about thirty inches, and existed virtually unchanged from about

7. A large, late seventeenth- or early eighteenth-century Turkish or eastern Balkan miquelet rifle.

8. A Turkish miquelet rifle, *c.*1780.

1665 until 1850. Like the jaeger rifle, these Balkan guns were usually rifled with seven grooves. Daskalov and Kovacheva suggest that the key-hole-shaped hinged receptacle in the base of the stock of some of these guns is characteristic of those produced in north Bulgaria.[120] In the mid-nineteenth century Gille wrote that one of the guns of this general type in Tsarskoe Selo is from Trebizond, but it is hard to know what credence this attribution should be given. Certainly it is true that in the hands of the later Mamluks and janissaries these guns were to be found as far afield as Egypt, and in time they may be more accurately attributed on the basis of decoration. For example, it would be consistent with the literary evidence to attribute many of those guns with an abundance of sheet ivory decoration or those stocked in ebony

to Egypt. An example from the Tareq Rajab Museum (Catalogue no. 7) is early eighteenth or possibly seventeenth century, the heavy lines in strong contrast to the more elegant later pieces.

Other examples of arms from the Ottoman court workshop from the eighteenth and early nineteenth centuries illustrated by Rogers[121] show a continuing delight in surface decoration. In particular, Ottoman taste favoured precious stones set on a raised flower-like setting and gold or silver wire arabesques standing proud of the stocks in which they were set, in a manner that was used to decorate court objects in the sixteenth century. The Ottoman historian Isi records the objects selected in 1746-7 as gifts for Nadir Shah, who it was feared might invade eastern Turkey. These richly decorated and bejewelled objects included six muskets and a brace of pistols. The most valuable, at 15,000 *akce*, was 'a flintlock, the barrel hexagonal, Istanbul work, the bands, slings, mounts, breech and powder pan set with 398 medium sized and small diamonds...'[122] The value undoubtedly lay in the diamonds rather than the gun itself, because another flintlock in this group, made by Mehmed, the head of the Guild of Flintlock Makers, but decorated with silver and coral, was valued at a mere 300 *akce*. (A gun from this period which matches this description, but signed Hajji Mustapha is in the Askeri Museum in Istanbul [Env.1373]). Of the six muskets, five are Istanbul work and all of these have hexagonal barrels. Three gunsmiths are named: Hajji Mehmed, who made two of the guns, Ali, and Mehmed, the head of the Guild. The other gun is Algerian work. The pistols were also Istanbul work but the maker is not recorded, even though they were covered in precious stones.[123] A jewelled pistol from this period can be seen in the Musée de l'Armée (No. M2349). The painting of Sultan Mahmud I on page 14 shows similar French pistols with blued and gilt barrels and diamond-decorated stocks. The variety of decorative materials used is remarkable, but in contrast to this artistic originality the Ottoman gunmakers made no major mechanical innovations and the locks employed by them are invariably versions of the Spanish or Italian snaphaunce or miquelet with minor variations. During the eighteenth century, these were replaced by the French-style flintlock. In the Turkish vocabulary the adoption of new words signalled the absorption of new firearms technology: *mushkat tufenkleri* meaning musket; *karabina* meaning carbine; and *chifte tabanjalis tufenk* meaning doubled barrel pistol.

THE EUROPEAN ARMS TRADE
WITH THE OTTOMANS

In the seventeenth and eighteenth centuries English and Dutch firearms found a good market in the Levant. The trade guns of Liège, which started to be made in appreciable quantities in the late seventeenth century and carried no identifying mark, were shipped down the River Meuse to Holland, Amsterdam and Rotterdam being major centres for re-exporting arms. From there the guns were carried to North Africa and the Levant, often via Marseilles, Leghorn or Trieste.[124] French Mediterranean trade had dwindled to the extent that in 1664 Colbert, the French minister, found only thirty trading vessels in all of Provence and the French export of guns had virtually ceased. Louis XIV ordered the reorganisation of the Manufacture Royale de St Etienne under a directive of Colbert, and the firearms produced began to be exported to Spain.[125] France led the fashion in gunmaking during the second half of the seventeenth century and the first half of the eighteenth, the beginning of this period coinciding with the 'Sun King's' dominance of Western European politics. A Swedish lieutenant, Augustin Ehrensvard, who in 1736-8 travelled to Denmark, Germany, the Netherlands, Belgium, France and Great Britain in order to further his education, related that the Dutch had at an earlier period ordered firearms of the most inferior kind in Liège for export to India. This trade, he stated, had ceased by the 1730s, though locks made in Liège were supplied to a Dutch East India Company factory in Amsterdam where guns were manufactured which, though simple, were nevertheless fit for export to the Dutch colonies and Portugal. Ehrensvard also stated that the French had overtaken the Dutch as purveyors of arms to Turkey.[126] This view of French supremacy in the export of firearms to the East is challenged by an anonymous Englishman resident in Holland, who wrote in 1743 that the Dutch 'divide the Levant trade with the English. By the Levant trade is understood that carried on in Italy, Greece, Asia Minor and Egypt.'[127] He goes on to describe how 'The Dutch are the most expert Founders in the World, and furnish most countries with Ordnance. The German, Spanish, Italian, African and Turkish troops have their arms principally from Amsterdam; as also their Cannon, Mortars, Powder and Lead.'[128] After describing the proof system, decoration and price of fowling pieces made at Utrecht, the writer speaks of British firearms:

> Our Gunsmiths and Founders have carried their respective Arts great lengths. The King of Portugal, in Gratitude for our sending a Fleet to defend him against the Spaniards, laid out great sums of Money for Arms. As we have a considerable advantage over the Dutch in our Mediterranean and Levant Passes, it were to be wished that our Taxes were reduced, or in the meantime that our Workmen would contrive to live lower, and work as cheap as the Dutch, in effect of which the whole Trade would fall into our Hands, and we should furnish the Armies of the Grand Seignior, the Algerines, Tripoli, the Emperor of Morocco, and the rest of the States on the African Coast, with Arms, Ordnance, Powder, and Lead, of our own Manufacture.[129]

9. A high-quality Turkish miquelet rifle, from the third quarter of the eighteenth century, with coral decoration (*cezayir isi*) and a Spanish-style barrel.

10/11. A pair of Turkish flintlock *kubur* pistols, c. 1770, the barrels signed Lazari Cominas.

The Swede Angerstein, who was in England in 1752-3, recorded in his diary that at Wednesbury and Bilston and other villages in the vicinity of Birmingham gunlocks were being made in large quantities, ranging from good quality to 'common trading locks'.[130] The cheap locks were mostly sent to the colonies and to America, and must have closely resembled those produced in Liège, because in Sweden in the eighteenth century, Birmingham firearms were always attributed to Liège manufacturers. Attempts in the eighteenth century to establish an arms factory at Norrtalje in Sweden to produce arms for export were not a success and only small quantities of gun barrels and guns were exported between 1754-64 to 'the Mediterranean'.[131] The Swedes had first methodically acquired examples of trade guns from Holland, Belgium, France and Britain and these are still preserved in their army museum, together with later trade guns. The trade gun was known in the Low Countries as a *bargolet* in the eighteenth century, and in a price list of 1789 the Liègeois barrel-makers indicate their export markets with names like 'Janissaires' and 'Barbarins'.[132] In particular, a crude but effective snaphaunce lock was exported

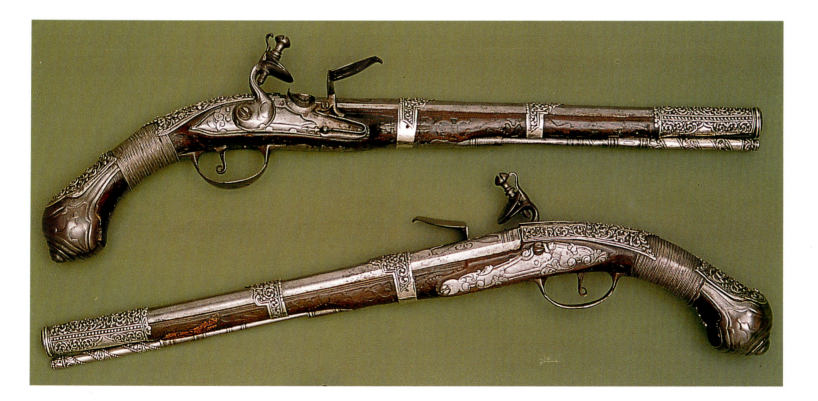

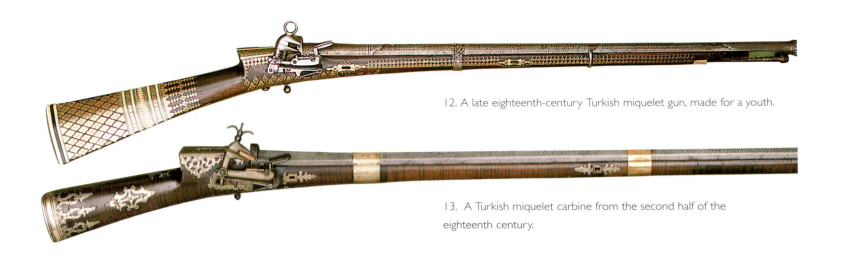

12. A late eighteenth-century Turkish miquelet gun, made for a youth.

13. A Turkish miquelet carbine from the second half of the eighteenth century.

in large quantities and was particularly sought after by the Muslims of North Africa. This form of lock continued to be faithfully copied by North African gunsmiths until this century.

Angerstein visited Lisbon in 1752 and recorded that large consignments of guns manufactured in Belgium were sent there for sale or re-export. During the eighteenth century and at least as late as 1935 a pattern of gun referred to as *lazarinos*, with copies of the Spanish-Portuguese snaplock, were manufactured in Liège for the Portuguese export trade. Serpa Pinto, the Portuguese explorer, reported in the 1870s that such arms were manufactured by a gunsmith named Lazaro in Braga in Portugal at the beginning of the nineteenth century and that clumsy imitations of his signature were made in Liège.[133] Alm draws attention to guns at the Musée d'Armes in Liège with the following inscriptions: Lazaro Lazarin Legitimo de Braga; Lazaro Lazarino Legitimo; Lazarino Legitimo; and the most commonly encountered, Lazaro Lazarino.[134] (See Catalogue no. 69.) There is clearly ample room here for confusion with the barrels originally produced in Brescia in the seventeenth century by Lazarino Cominazzo (born 1563). The same name was also inscribed by his nephew and cousin, and with variations by his descendants and other Brescian gunsmiths up until the nineteenth century. These barrels were much copied and sought after by the peoples of the Near East. The Arabs in particular considered el-Lazzary' to constitute the best barrels available, a judgement that held when the barrel was genuinely by the maker, which it rarely was.[135]

In 1673 and 1740 the French had signed new commercial treaties with the Ottomans, but by the end of the eighteenth century the abuse of these privileges and capitulations had brought the Ottoman empire to a point of economic and political subordination to Western Europe, so that the French ambassador Choiseul-Gouffier could in 1788 refer to it as 'une des plus riches colonies de la France'.

The arms manufactured at St Etienne in the late seventeenth and eighteenth centuries, particularly those intended for the North African market, were created during a period when standards of craftsmanship were high – though below that of Charleville and Tulle[136] – by Stephanoise gunsmiths such as Jean Blachon, armourer and merchant in 1690, whose son Joseph supplied a large marine market in 1725. Joseph Penel also produced naval pistols in 1742, as did Gabriel Bonnard who with his son Louis produced arms for the 'colonies' in 1730. Pierre Perret, who made guns in the 1740s, specialised in arms for export to the East. Pierre Girard, master armourer, assisted by his son Pierre François, entrepreneur of the Manufacture Royale, made luxury arms for 'distant markets', was merchant and arquebusier 'du Regent' in 1717 and was still operating as a business in 1748. Five trade guns manufactured at St Etienne in the mid-eighteenth century are preserved in the Army Museum in Sweden, and are described by Alm in detail.[137] These are clearly the type of gun the French were exporting to Turkey and the Levant. In 1770 De Warnery noted how old-fashioned the janissary guns were, though clearly European in form: 'les armes des janissaires consistent dans un

fusil long et pesante à crosse courte, comme ceux, que les Croates avoient les guerres precedentes' (...the janissaries' arms consist of a long and heavy gun with a short butt, like those the Croats had in earlier wars).[138] These long trade guns are what the Arabs in Syria called *barud tawil*, literally 'long gun', a name which came into common use in the second half of the eighteenth century.

Many of the French pistols intended for the Ottoman market were shipped through Marseilles and some are signed by Marseilles makers or embellishers. Many of the weapons assumed to be made up of French locks and barrels mounted in the Orient are entirely French. Beaujour, the former French consul in Greece, writing at the time of France's Revolutionary Wars at the end of the eighteenth century, makes plain the importance of Marseilles in Ottoman trade:[139] 'Whatever may be the fate reserved by the present war for the Othoman empire, the commerce of Greece belongs to Marseilles and the force of things will bring it back to that place. But there is great reason to apprehend that France will be deprived of that fine market of the Mediterranean, if the English chance to deprive it of the commerce of the Levant.'[140]

By the eighteenth century it was apparent that the Ottoman gunsmiths had failed to provide essential military firearms equal to those of Turkey's enemies and that it was necessary to acquire expertise from Europe. The janissaries were more tolerant of modern European equipment than they were of the Westernisation of the army itself. With the ending of the *devshirne* system of recruitment, the janissaries were now generally Muslim by birth. With pay usually many months in arrears they entered into trade and crafts and became important in the guilds. Now

Regular Ottoman soldiers in their new European uniforms. Watercolours commissioned by the Prussian Ambassador at Pera and sent to the King of Prussia, 1826. Courtesy of the Director, National Army Museum, London.

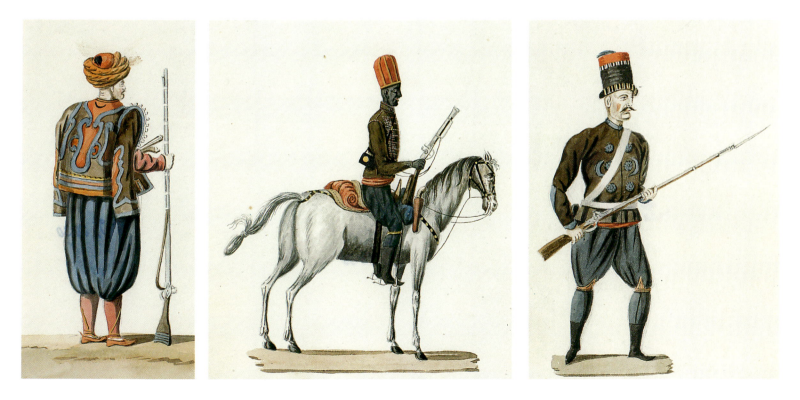

usually married, financially independent, closely tied to the *ulema*, they were reluctant to leave home and fight in distant parts of the empire and used their military strength to maintain their privileges. Efforts to remove this perceived cancer by posting janissary detachments to the provinces had merely served to spread the disease. Early in the century an attempt was made to reform the Ottoman army by the Comte de Bonneval, who became a Muslim in Ottoman service from 1729 to 1747. Since it was impossible to change the practices of the *sipahi* and the janissaries he revived the mortar regiment (*bumbaraci*) and turned it into an effective field unit, whilst creating the schools and production facilities necessary to support the enterprise. He constructed cannon, musket and gunpowder factories. His reforms led to some military successes but scarcely survived him, the janissaries preferring their traditional ways. De Warnery wrote that 'les Turcs ne changent rien à leurs anciens usages, quand même ils en connoissent les

defauts' (the Turks change nothing of their old methods, even though they know of their defects).[141] De Warnery illustrates this point repeatedly in his book, as in this example of the janissaries on the battlefield:

...in flat country they rush in large groups on the foe, with the *enfans perdus* at their head: and, since they keep no order, only the foremost amongst them can use their firearms. They hold a sabre or a knife in the right hand, with their musket in their left, before the head, in order to ward off the bayonet and sword thrusts delivered against them. The rearmost of them as a rule carry their musket slung over the shoulder. Some of them also take up in their teeth the hem of their jacket and breeches, which are very ample, and fall like bulls, head down, on the enemy, crying with all their might, Allah, Allah: God, God...[142]

14/15. A pair of Turkish flintlock *kubur* pistols, *c.* 1800.

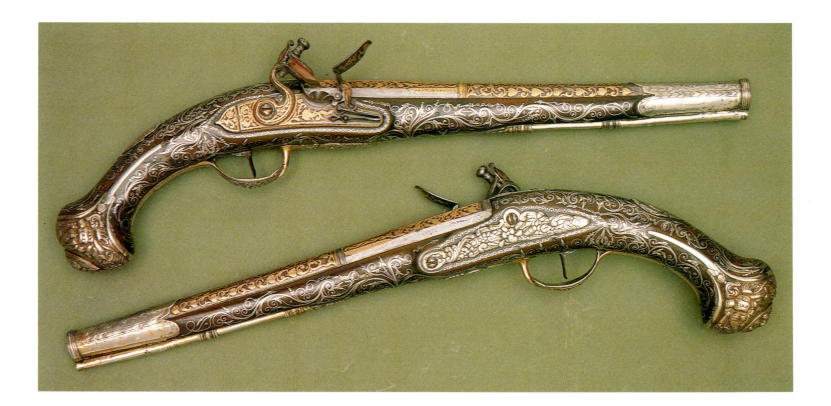

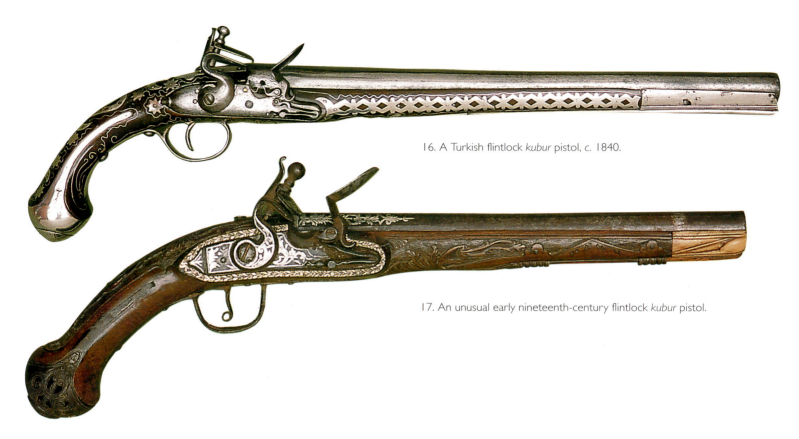

16. A Turkish flintlock *kubur* pistol, *c.* 1840.

17. An unusual early nineteenth-century flintlock *kubur* pistol.

Another reformer later in the eighteenth century was the Frenchman Baron de Tott who arrived in Istanbul in 1755 and whose work lasted longer.[143] The Vizier Halil Hamid (1781-5) was executed when his reforms proved politically unacceptable. Under Selim III (1789-1807) reform in emulation of European models was attempted, including the creation of a new corps of disciplined infantry and the standardisation of calibres. French military advisers came to instruct the Ottoman army in 1796 and the previous year a young officer named Bonaparte had offered to reorganise the Ottoman artillery. However, the French invasion of Egypt in 1798 and their naval defeat by Nelson at the battle of the Nile destroyed French influence in Istanbul. An Anglo-Ottoman treaty in 1799 committed the British to the defence of Ottoman territory against the French and to the supply of military materials.

The rejection of the reforms of Mahmud II (1808-39) led to the massacre in Istanbul in 1826 of the janissaries who had opposed them and opened wide the door to the modernising period of the Tanzimat. One major reform was the separation of domestic administration from the military. The Sultan lost no

time in commencing the Westernisation of his army. The Ambassador to the King of Prussia wrote from Constantinople on 11 December 1826; 'Le Sultan continue à vouer sa sillicitude à l'organisation successive des nouvelles troupes et à opérer graduellement les reformes que les Corpes de toutes les armes sont destinés à subir. La docilité et le zèle perseverant des nouvelles levées sont l'objet de notre surprise autant que notre admiration...'[144]

With this despatch the Ambassador sent watercolour paintings of the troops in their new uniforms. Ottoman firearms lost their rich and solid individualism and set out to copy Western arms, which had already absorbed the best of Islamic arms technology, such as damascus gunbarrels and swords. Many of the late eighteenth- and nineteenth-century Ottoman firearms were imported weapons from Europe, commonly from Liège or St Etienne, mostly in French style, or inferior locally made copies in a rather florid French style, often using European locks. French gunsmiths were unaffected by the decorative style of the third quarter of the eighteenth century, known as Louis Seize, and continued to make pistols with rococo decoration. When, in due course, the French Revolution swept away the decorative exuberance

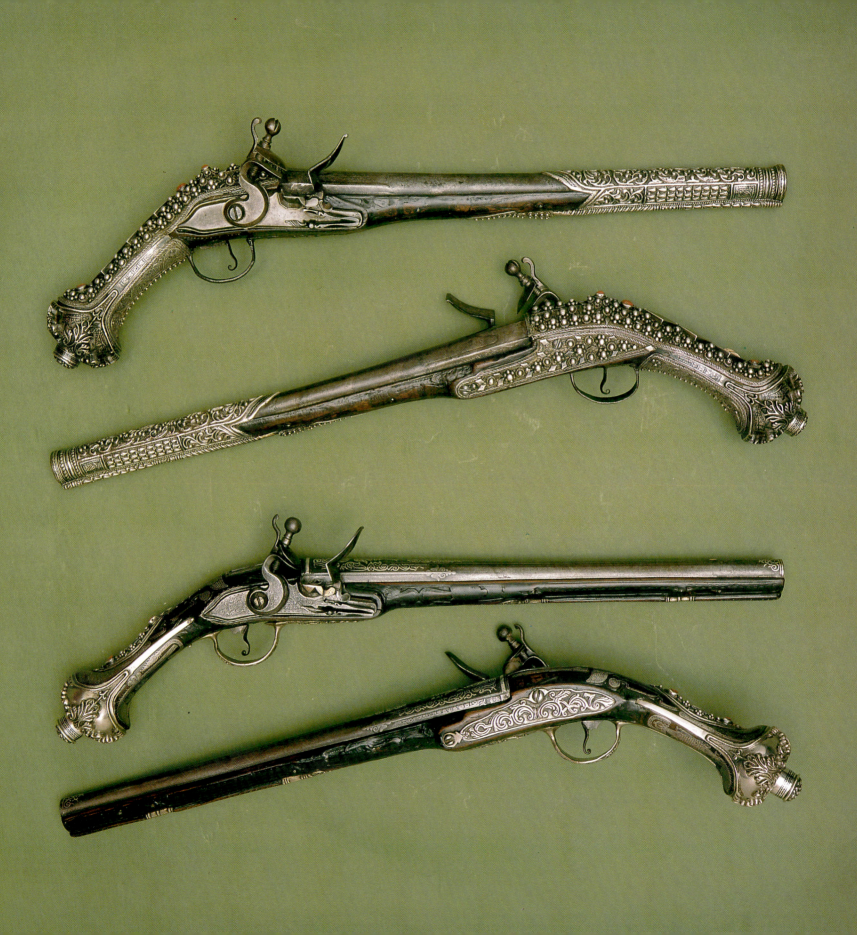

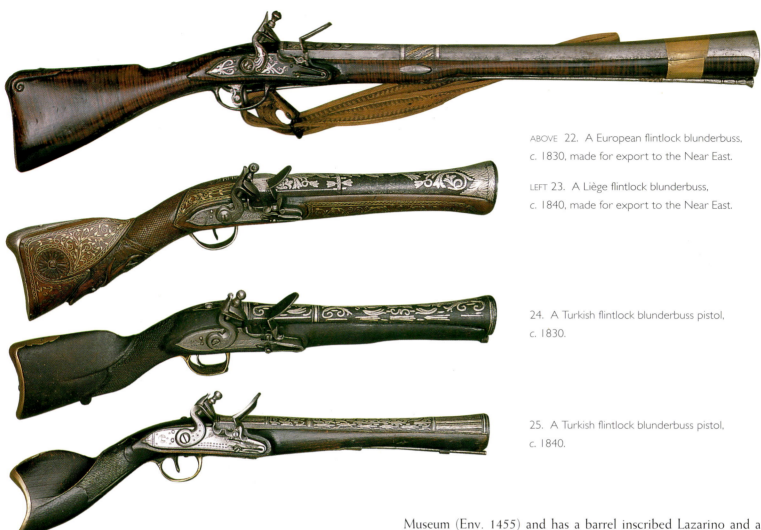

ABOVE 22. A European flintlock blunderbuss, c. 1830, made for export to the Near East.

LEFT 23. A Liège flintlock blunderbuss, c. 1840, made for export to the Near East.

24. A Turkish flintlock blunderbuss pistol, c. 1830.

25. A Turkish flintlock blunderbuss pistol, c. 1840.

OPPOSITE 18/19. A pair of Turkish flintlock *kubur* pistols, c. 1800.
20/21. A pair of Turkish flintlock *kubur* pistols, c.1800.

associated with the Bourbons, the Turks continued to import pistols in the rococo style and these French or French-style large flintlocks or percussion pistols are called *kubur*, or horse pistols, in both Turkey and the Balkans. The holsters in which they are carried in front of the saddle are known as *kuburluk*.[145] Pistol No. 16 in the Tareq Rajab Museum is struck with the *tughra* of Abdulmecid and dates from about 1840; it also bears the *sahh* arsenal mark. A very similar pistol from the same workshop is in the Askeri

Museum (Env. 1455) and has a barrel inscribed Lazarino and a lock dated 1220 AH (AD 1805). These pistols resemble the Spanish Ripoll *pedrenal* of the second quarter of the seventeenth century, in the elongated barrel and the perforated silver sheet decoration, particularly under the barrel on the wooden fullstock. The long jaws to the cock may well reflect miquelet tradition, which was overtaken in Spain by the popularity of the French flintlock in the early nineteenth century.

The relationship between Liège and the French arms producing centres was close. Liègeois gunmakers were employed in the French royal arms factory at Tulle in the seventeenth century and later at St Etienne and Charleville. The French and Belgian weapons are often difficult to distinguish unless bearing visible makers' marks or signatures. The same applies to the firearms exported from northern Italy to the Ottoman empire. Beginning

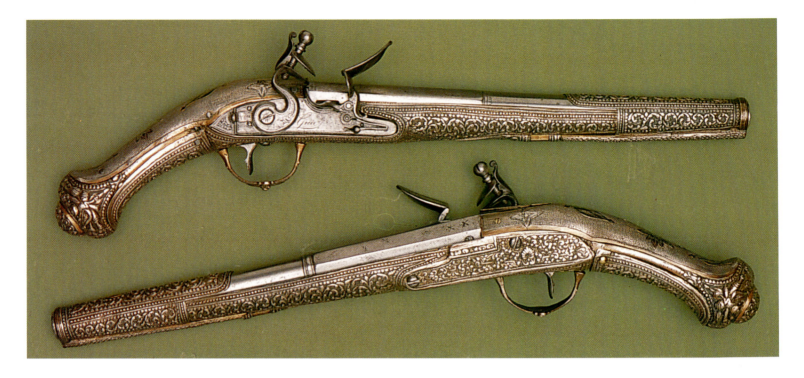

26/27. A pair of Turkish flintlock *kubur* pistols, with English locks, *c*.1790.

in the seventeenth century, Liège produced pistols and blunder-busses for the Eastern market until about 1860. Cavalry regiments armed with blunderbuss pistols with a vestigial butt were to be found in the Ottoman empire and further east, while in Egypt the Khedive's bodyguard was armed in this manner.[146] These blunderbuss pistols, which were very popular in the Ottoman empire, probably derived from Ripoll blunderbuss pistols of the early eighteenth century. Liège export guns have false damascus barrels and are sometimes decorated with cheap Crahay (a suburb of Liège) damascening. The Belgian blunder-busses frequently have a carved animal head and distinctive che-quering on the stock. Others were plain, to be embellished and mounted by local craftsmen. (See Catalogue nos 22, 23, 24 and 25.) Barrels referred to as 'Damascus' were made by the Liègeois from 1700[147] and barrels made using the damascus technique were popular and became common in France in the second half of the eighteenth century. By 1830 false damascus or painted damascus was a standard part of the Liège barrel maker's repertoire and was

used, particularly for export arms, well into the present century. By the end of the nineteenth century almost thirty different types of true damascus-pattern barrel were available in Liège. According to a petition presented at St Etienne in 1780, Liège was then exporting to France ten time more arms than St Etienne itself was producing.[148] However, this situation was reversed during the period of the French Revolution and Empire, 1789-1814, when the Liège arms industry was in great difficulties and the principality was annexed to the French Republic as part of the Ourthe Département. Many Liègeois went to St Etienne, Charleville, Maubeuge and other arms-producing centres in France. 'Locks stamped with the mark "Marseilles" were manufac-tured, in the Département of the Ourthe amongst others, for Arab customers who were in the habit of making up their own guns from components which they purchased in the belief that they had been made in the great seaport of southern France.'[149]

In the eighteenth and nineteenth centuries the pistols signed by makers of Marseilles were almost entirely made in St

Etienne by Stephanoise or Liègeois craftsmen, or in Liège, rather in the manner that the London gun trade embellished and put their names on the excellent products of Birmingham. Ornate examples of these European pistols and the oriental copies they inspired in the decorative style of Louis XIV, XV and XVI are well represented in the Wallace Collection, London. Both St Etienne and Liège supplied apprentices to Nicolas Noël Boutet, Director of the French state arms factory at Versailles at the end of the eighteenth century. In 1793 Boutet was authorised to recruit master gunsmiths from Liège for the Manufacture de Versailles. Boutet manufactured superlative arms, many intended as diplomatic *douceurs*. For example, in 1803, at a cost of 7,500 francs, he made a suite of arms comprising a carbine and a pair of pistols which was sent to Dzejar, Pasha of Saint-Jean-d'Acre. During the Napoleonic wars Boutet signed his work with his name and the title Directeur Artiste. He also made other arms for Eastern potentates.[150] A fine pair of flintlock pistols made for the Eastern market were sold at Sotheby's,[151] signed Rundell Bridge and Rundell with London hallmark and date letter for 1809-10. These are illustrated by Blair (no. 289), who quotes the firm's trade card: 'All sorts of Turkish Ornaments in the newest taste, after the most approved drawings and models from their Agents in Constantinople, rich Diamond and enamelled Sabres, Daggers, Snuff boxes, Watches, Pistols, Coffee Cups, Telescopes etc. etc.'

Because of the Napoleonic Wars, the British naval blockade of Europe forced the Liège merchants to abandon their customary trade routes by sea to the Levant and North Africa. Arms went overland from Liège to Trieste, via Cologne.[152] In spite of the blockade, the Stephanoise gunmaking family of Lamotte, now under the direction of Marie-Anne Lamotte, maintained sales in luxury arms in 1800 through nine trading outlets across the world, including Morocco, Egypt, Turkey and America. In 1810 she created an arms depot at Smyrna on the western coast of Turkey, an enterprise which continued until 1819.[153] St Etienne

and Liège, the latter closely linked with France even after 1830, continued to supply the mass market in the East in the nineteenth century.

However, British goods were also in strong demand, as a letter sent by the British Levant Company to one of its agents in 1814 demonstrates:

> The desire for British manufactured goods which has been manifested by the subjects of the Porte of every description opens a door to an extention of our trade of the highest importance to this nation. The quantities of these articles consumed in Turkey even under the difficulties opposed to them have far exceeded our calculation, and we have every reason to believe if those obstructions are removed, the demand will be prodigious.[154]

In addition, the weapons manufactured at Gardone in northern Italy entered the arsenals of the Turks in large quantities. Beaujour records the sale of arms from Brescia in his *Tableau du Commerce de la Grèce* at the end of the eighteenth century:[155]

> The manufacturers of Brescia send into the Greek markets thirty cases of firearms. Among these cases are twelve firelocks and eighteen pistols. The usual price of a firelock is from six to eight piasters, and that of a pair of pistols from ten to twelve. The Turks prefer barrels of polished iron; they also prefer the Venetian arms to ours, because ours are bronzed. This taste of theirs is capricious, but it is well founded. Their armourers know not how to clean a gun without polishing the barrel with a file or with pumice stone, which disfigures it, and rubs off the bronze. Another proof of the caprice of their taste is, that they prefer plates [to which the locks are fixed] which are hard, to those which are soft and ductile. The barrels which sell

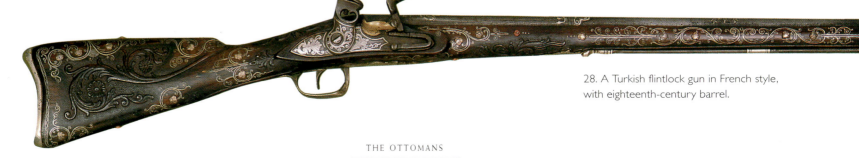

28. A Turkish flintlock gun in French style, with eighteenth-century barrel.

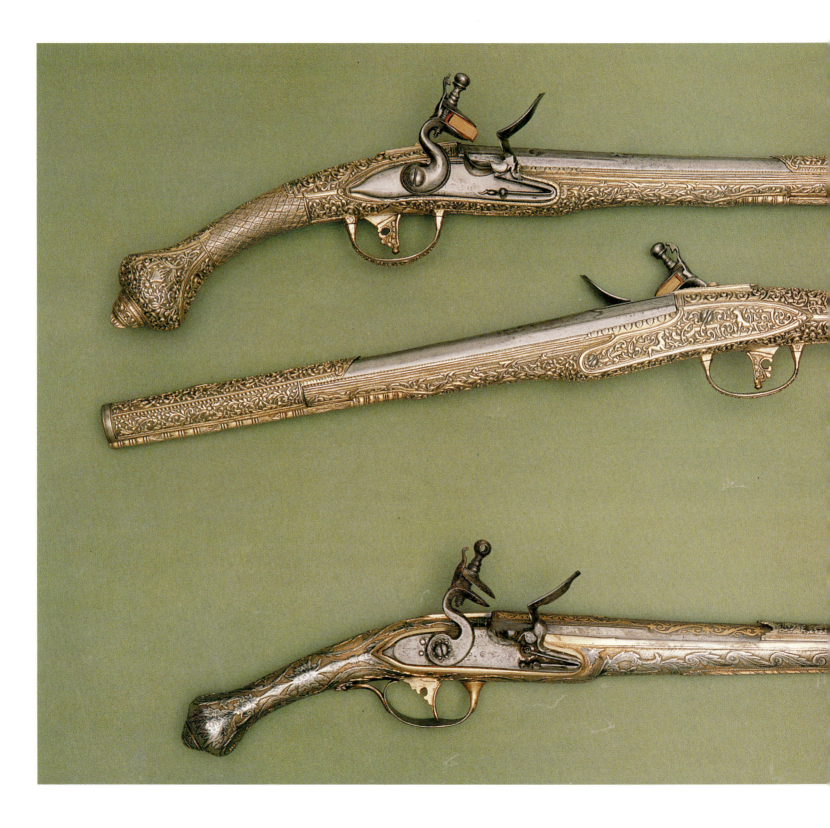

29/30. An early nineteenth-century pair of silver-gilt stocked Turkish or Greek flintlock *kubur* pistols.

31. A Turkish or Greek flintlock *kubur* pistol, c.1830.

best are those that are ornamented towards the breach with sculptures, and which are inlaid with gold and silver. The stocks that are adorned with gold and silver, inlaid or carved, are also in very great request.[156]

Marco Cominassi wrote that annual production at Gardone prior to 1803 was about 30,000 barrels, of which no fewer than 29,500 were exported to the Near East, Spain and Piedmont. 'Great quantities of arms were also sent to foreign lands through the ports of Venice, Trieste, Livorno and Genoa, especially to the Levant, to Spain and to Africa.'[157] It is recorded that 'in the years 1819, 1820 and 1821 thousands of barrels that we commonly call greghetti, gregoni, danziche, canne quadre, lazzarine and schioppettini were sent to Greece, Turkey and Algiers.'[158]

In 1821 a law was promulgated which forbade the export of military firearms from the state, but exceptions were made for sales to friendly nations and little seemed to change in the East. Fifty years later Beretta were still selling well in their old established markets in the Levant and Africa. 'In Greece, Turkey, Egypt and Tunisia, Beretta guns were solidly entrenched and sales were in constant expansion.' Giuseppe Beretta explained the reason for the success in the Italian newspaper *La Borsa* in 1878:

> In Gardone the medal-winning Arms Factory Pietro Beretta... sends out finished guns, which are sold not only in Italy but also abroad, especially in the Regions of the East, where they enjoy fame and are much sought after for their quality and safety, it being well known that no weapons leave this factory until the barrels have been proved and found perfect.[159]

The Liègeois must also have been gratified by the demand for their arms, for between 1830 and 1860 Liège was the biggest arsenal in the world. Large numbers of their guns were bought by the peoples of the Ottoman empire. Typical was the Liège firm of Maison Hanquet which produced large quantities of flintlock and percussion guns with flamboyantly carved and decorated stocks, a common characteristic being the use of silver nail heads to embellish the chequering. These exuberant objects bore no relation to indigenous Ottoman or Arab culture, but the numbers which have survived indicate plainly enough their popularity.

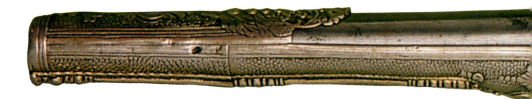

32/33. A pair of silver-gilt stocked Turkish or Greek flintlock *kubur* pistols, *c.* 1750, with earlier Italian locks and barrels.

After the Convention of Balta Liman of 1254/1838 the Ottoman empire became an entirely open market for Western products, just when European industrialists were looking for outlets for the products of the Industrial Revolution. The consequence of this was the collapse of local industry in the Near East. Liège failed to industrialise in the 1860s when other European manufacturing centres were doing so and the manufacture of military firearms passed elsewhere.

The extent to which the Ottoman army remained equipped with out-dated firearms despite the military reforms can be seen in the mid-nineteenth century. The war correspondent William

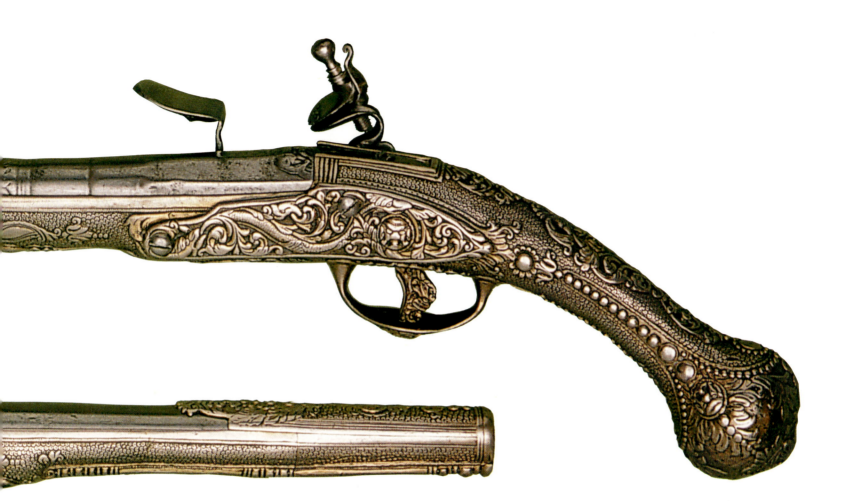

Russell described the arrival of 15,000 Turkish reinforcements in the Crimean War in 1855: 'finer young fellows than some of the soldiers of the crack regiments I never saw', who were armed for the most part with 'flint firelocks', 'but they were very clean and bright'. Russell describes their musket barrels as polished, continuing the Ottoman tradition of brightly burnished arms. 'One of the Regiments had Minié rifles of English make.'[160]

The Ottoman government ordered 20,000 muzzle-loading short Enfield rifles from the Birmingham Small Arms Co. Ltd. which were delivered in 1863. In the war against Russia, 1877-8, the Ottoman troops had largely replaced their British Snider rifles with American Martini-Peabody rifles and cartridges with solid brass cases, which completely out-performed the Russian Krnk rifle. In 1883 a German military mission arrived in Istanbul under Colonel von der Goltz. For the next thirteen years Goltz worked indefatigably to modernise the Ottoman army, placing orders for arms and ammunition with German companies, particularly Mauser, all the while secretly opposed by Sultan Abdulhamid, who feared the threat of military revolt posed by a strong modern army.

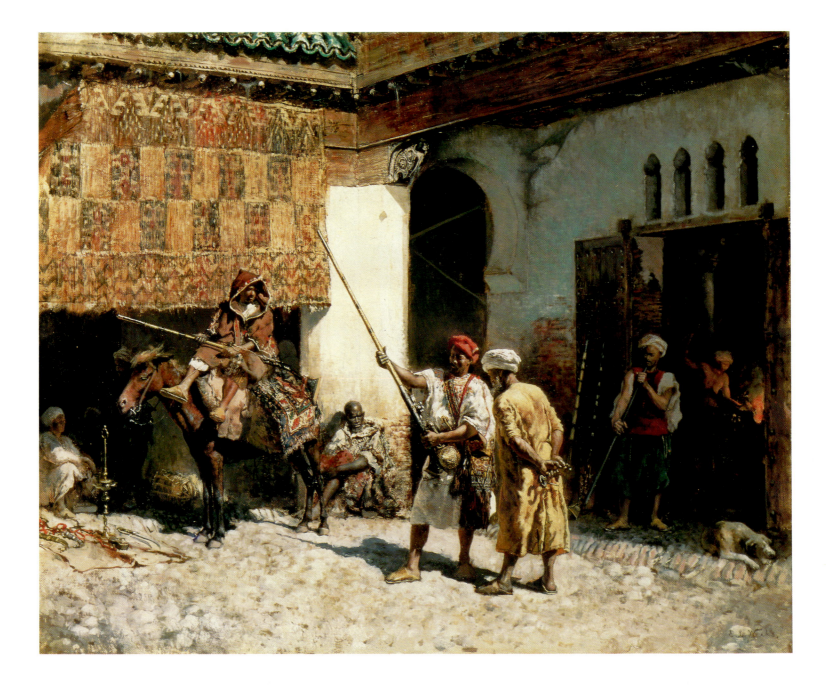

THE MAGHRIB: MOROCCO, ALGERIA AND TUNISIA

T HE NORTH AFRICAN coastal states were known to the Arabs as the Maghrib, by which was meant Tripolitania, Tunisia, Algeria and Morocco. These Muslim countries had long and close ties with Western Europe. The Almohad dynasty (1130-1269) began in Morocco and overran Muslim Spain, moving its capital to Seville, and conquered as far as Tunis and Tripoli. It invited Christian merchants to settle in North Africa in the twelfth century and the last of the dynasty recruited Christian mercenaries, especially Spaniards, in the thirteenth. By the end of the century, mercenaries, merchants and missionaries from Europe were widespread. The effect of the missionaries was very limited and the mercenaries had only a transient impact, but the merchants came to dominate trade to the point where the maritime commerce of the Maghrib and the impetus of the trans-Saharan trade was principally in the hands of Italians and Catalans, together with the Portuguese and the merchants of Provence. There was an ever-present threat of invasion from Christians and several European powers sent military expeditions to seize coastal towns: these all failed, until the Portuguese captured Ceuta in 818/1415. In 1445 the first of the overseas castles intended to protect Portuguese trade was constructed at Arguim on the Moroccan coast.[1] These became a symbol of Portuguese expansion, a practice followed by the English, French and Dutch. By the beginning of the sixteenth century, the Atlantic coast of Morocco was occupied by a chain of Portuguese factories (*feitoria*) from Tangier to Agadir, while the Spanish settled at Melilla in 902/1497. To these trading bases the Europeans took the most modern firearms available. Although divided into three politically unstable parts which were frequently at war with each other and

'The Arms Merchant' by Edwin Lord Weeks (1849-1903). Oil on canvas. The setting is North Africa. Whitford & Hughes, London/ Bridgeman Art Library, London.

with a hinterland inhabited by tribes which were difficult to control, the region was commercially and geographically drawn to the world of the western Mediterranean.

The Maghariba had a long tradition as corsairs and mercenaries serving the Ottoman empire. The duty to protect and extend Islam by means of the *ghaza* or holy war was an obligation taken very seriously by the Ottoman state and stimulated great endeavours and individual *ghazis*. The *Qur'an* states unambiguously that 'Allah loves those who fight for His cause in ranks as firm as a mighty edifice.'[2] Morocco, Algeria and Tunisia were regarded as frontier areas in the fight against Spain, which had deprived the Spanish Muslims of their lands. A large proportion of the Moroccan corsairs were Moriscos, driven out of Spain in 1609 and known as *al Andalus*. These had a high reputation as matchlock men. In the eighteenth century, Maghribi soldiers

An unidentified Shawia with a long-barrelled flintlock musket. The barrel is inlaid with silver, the stock encrusted with ivory, coral and mother-of-pearl. Such muskets were generally unmarked and unauthorised by the French Government. Photograph by Hilton-Simpson, Algeria, 1914. Royal Anthropological Institute Photographic Collection.

Shawia male chipping flints for the flintlock muskets and pistols used in the Aures Mountains. Photograph by Hilton-Simpson, Algeria, 1914. Royal Anthropological Institute Photographic Collection.

were recruited in southern Syria and amongst other duties guarded the pilgrim route from Damascus to Mecca. Many of these troops were Algerian because the sons of Algerian soldiers were not permitted to serve in the army and were therefore obliged to seek military service overseas. The occupation of Algiers by the French in 1830 led first to the conquest of Algeria and then to that of the whole of the Maghrib.

The Maghrib has long been famous for its firearms. The origin of this reputation predates the historic rivalry between Habsburg and Bourbon when the French, with their usual prag-

matism, saw an advantage in supplying the Arabs with cannon and handguns in the sixteenth century. It also predates the exodus from Granada of the non-Christians, some of whom were skilled metalworkers, in response to the attempt to enforce conversion to Christianity. Certainly, close proximity to Spain had resulted in two very closely linked societies.[3] Many of the firearms from the Maghrib are described rather vaguely as Berber. The Berbers were the original occupants of the region, and were driven from the fertile lowlands into the mountain valleys and deserts by the Arab conquests of the seventh and eighth centuries. They live to this day in scattered groups stretching from the Libyan-Egyptian border to the High Atlas mountains of Morocco, two thousand miles to the west. The Kabyle, for example, are Berbers who inhabit a mountainous region of northern Algeria and have a form of musket that they call *moukalla*, though they are better known for their distinctive sabres called *flissa*.

The indigenous firearms of the Maghrib have been influenced by those produced in Europe, including Portugal, Spain, Italy, France, England and Holland. The long list of European countries reflects the changing political or trade dominance over a period of four hundred years. Not only are the lock forms borrowed from Europe, though the wheellock is never used, but the stocks too appear to be copied. For example, the Taouzilt snaphaunce long gun from Sous in the Tareq Rajab Museum, No. 39, a typical gun of the region, has a stock which closely resembles that used on Spanish miquelet muskets of the second quarter of the seventeenth century,[4] while the *afedali* long gun from the region of Taroudant and the valley of the Oued Sous (Catalogue no. 36) has a fish-tail stock which closely resembles the Dutch matchlock musket of about 1680.[5] The influence of Spain on North African firearms can be seen in the Civico Museo Correr, Venice, where a pair of North African miquelet pistols made in the Spanish style of the early seventeenth century can be found. These are described by Lavin as late seventeenth- or early eighteenth-century.[6] Local aesthetics were allowed relative freedom in the decoration of the gunstock or pistol grip, but European forms determined the shape and the ignition. Hoff suggests that the lock plate on North African-made snaphaunce locks was thicker than those imported from Holland.[7] So conservative was the Maghribi attitude to gun locks that local variations on the Anglo-Dutch snaphaunce lock of the 1600s were still in produc-

tion in the nineteenth century, while the disc that forms the fence on the side of the pan on late sixteenth-century northern European firearms continued to feature on the locks of many of the indigenous Maghribi guns until they became redundant in this century with the introduction of modern breechloaders.

MOROCCO

Al-Hasan b. Muhammad al-Wezzan al-Fasi was born in Granada and spent seven years in North Africa as a diplomat and traveller. He left Morocco in 1516, but records that the army of the Banu Wattas was equipped with cannon, and arquebuses carried by horsemen.[8] It is not clear where these firearms had come from, although the English had begun trading there in 1511. Under the Sa'dids (1553-1654) guns came into general use and the manufacture and import of firearms was greatly increased as the Sharifs modelled their army on that of Ottoman Turkey. They recruited a corps of Turkish and Andalusian (Morisco) arquebusiers (*rumat*), based closely on the janissaries, while renegade Europeans taught them the art of casting cannon. The army of the Sultan possessed more than one hundred and fifty cannon in 1575, one of which is in the Musée de l'Armée in Paris and is notable for having nine barrels.[9] The firearms of Morocco were already well known to the Christians when Balbi, himself a professional arquebusier, described them in 1562 at the siege of Malta. He said that the Muslims were 'armed with the fine muskets of Fez'.[10] In 1578 the Moroccan army went into battle at Wadi'l-Makhazin with 34 cannon, 3,000 Andalusian arquebusiers on foot and 1,000 arquebusiers on horseback, and crushingly defeated a Portuguese army.[11] A large part of the Portuguese nobility were taken prisoner, together with considerable booty, and Portugal was never again a danger to the Moroccan state. The English, French and Spanish were impressed by this victory and hastened to establish good relations with the Moroccan sultan, al-Mansur.[12]

In the late sixteenth and seventeenth centuries there was considerable trade between the North African coast and northern Europe and as a result a stock form and lock based on the northern European snaphaunce was adopted by local Arab gunmakers. Lenk describes the sweeping curves of the butt on muskets from

the Netherlands 'during the decades around 1600' and continues: 'This type of butt with increasingly rounded forms still survives on muskets throughout the whole of the earlier half of the seventeenth century. Their last offshoots are to be found on the Moroccan guns with Netherlands snaphances.'[13] Hayward expressed the opinion that 'there is at present no means of distinguishing between Dutch and English firearms equipped with snaphance ignition'.[14] The English dog-lock, which was popular in Morocco, was not always fitted with the catch from which the name derived, and the snaphaunce lock, with or without the dog-catch (see drawing below) came into general use in the early seventeenth century.[15] A particularly fine lock with a dog-catch made by an Arab craftsman in Algeria and dated 1157 (1744-5) is in the Museo Poldi Pezzoli in Milan.[16] The importance to trade of maintaining good relations with Morocco can be seen in the periodic gifts to the sultan from the English and Dutch. Dutch snaphaunce guns were delivered to the sultan of Morocco in 1612.[17]

In 1638 the English Privy Council examined 'the petition of gunmakers for the continuance of the vent of slight guns into Barbary'. Shortage of saltpetre in England in 1640 provoked the suggestion to the King that 'birding pieces' from London might be exchanged with the sultan for saltpetre. London gunsmiths

trading with Morocco in the mid-seventeenth century included Edward Burrows, who applied in 1649 and again in 1653 when he requested to ship 3,000 birding pieces. William Graves applied to ship 1,500 birding pieces in 1652 and again in 1655 sought permission to export 3,000 birding pieces and 1,000 locks for birding pieces. Thomas Davis and William Bolton in 1656 sought to send 4,000 birding pieces to the same destination.[18]

In 1680 Charles II sent the sultan gifts which included twenty long guns and twelve pairs of pistols, all with carved and inlaid barrels.[19] In 1704 Queen Anne sent a variety of objects, including 'halberts with firelocks to open in severall Angles' and 'six long guns with Barbary Cocks finely wrought', made by George Trulock for £22 10s 0d. These guns, and an 'Arabian Simiter' made by Samuel Nash, were given Arabic inscriptions by the goldsmith Richard Rutacht.[20] Arne Hoff cites a letter from the sultan of Morocco to Louis XIV in 1684 which mentions the arrival of 1000 gun locks from Europe.[21]

Interior and exterior view of a typical North African snaphaunce lock; the Arabic names of parts are after A. Joly, *Archives Marocaines* and are those that were in use at the beginning of the twentieth century.

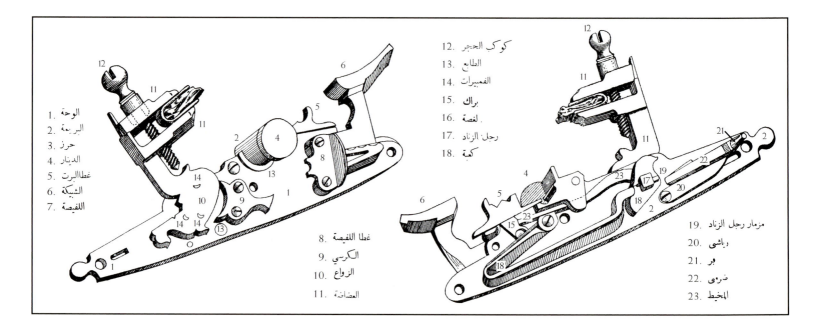

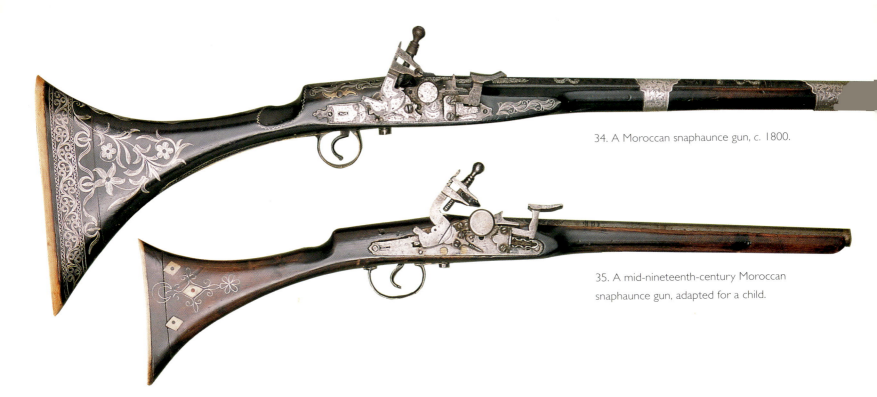

34. A Moroccan snaphaunce gun, c. 1800.

35. A mid-nineteenth-century Moroccan snaphaunce gun, adapted for a child.

According to St Olon, ambassador to Morocco in the late seventeenth century, Holland was supplying Morocco with arms and munitions; and large quantities of gunpowder were imported from Italy.[22] St Olon described the Moroccan army at this time, saying that it was obliged to; 'mount, arm, equip, and maintain themselves at their own cost during all the campaign; and, as for the most part they have neither firearms nor powder, they march only with swords, lances or staves.'[23]

The king was reported to have 10,000 muskets in his armoury together with 150 brass cannon, most of which he took from a Spanish ship, though some came from captured towns. St Olon gave the king arms as a diplomatic gift.[24] Bronze cannon were also cast in the Sa'di workshops at Fez, Marrakesh and Taroudant, and ordered from Holland. These were usually engraved with the *tughra* of the reigning sultan.

In contrast to the usual production from Liège for the Eastern market are a pair of snaphaunce guns and a pair of flint-lock holster pistols in the Musée de l'Armée, Paris, made by the Tomson family of Liège and signed on the locks 'I. Tomson & Zoonen Rotterdam.' They are known to have been ordered by the Emperor Napoleon as a gift for the sultan of Morocco and

they are made in North African taste, the pistols being inlaid with gold and semi-precious stones. The flat locks of these pistols have extravagant swan-neck cocks reinforced with scrolls. The style is of Arab export Liège pieces, but the quality is extremely high.[25] There is also a snaphaunce gun in the Legermuseum, Leiden, made for this same market in about 1805, which is signed 'I Tomson & Zoon Rotterdam' on the lock.[26] The signature of Tomson and Son (*Zoon*) indicates a date of manufacture between 1804 and 1807. Hoff dates the successful growth of the firm to the early 1790s: in 1792 Nicolaas Tomson contracted to deliver eight hundred trade guns of various kinds for export to the Orient.[27]

Due north of Fez, in the plain below the Atlas mountains, is the town of Tetuan. Many of the half million Moriscos expelled from Spain by Philip III in the final edict of 1609 settled in Tetuan where they prospered. The town produced guns and edged weapons for several centuries, through to the 1920s, though by then the edged weapons industry had all but disappeared. Muskets were also made at Targist. Each time a barrel maker died he was not replaced, and the number of skilled workers was diminishing day by day in the early twentieth century.

The manufacture of firearms was divided into three trades: barrel making (dja'ibi, pl. dja'ibiya), lock making (znaidi, pl. znaidiya) and stock making (srairi, pl. srairiya). The barrel makers inhabited the Suq al-Zara, Trankat and al-Gharsa al-Kabira. Raw materials were purchased from Muslims and Jews who imported mild steel (hadid artob) from Europe. The work of the barrel makers was ill paid and arduous. The barrels were made by the processes of forging, boring, filing and polishing, and assembling. Their length varied from just over 1 metre to 1.80 metres. In addition to this, short barrels of 80 cm were also made for percussion lock pistols known as chkoupita, from the Spanish escopeta. Some barrels were fluted or engraved by specialists using burins and hammers. Others were enhanced with rings and decorative ironwork which acted as reinforcements and were known as hazem. The same word, in south Morocco, is used for that part of the lock known in Tetuan as birz. As soon as the barrels were finished, they were sold to the mounters and stock makers.

The lock makers (znaidiya) were established at Suq al-Zara Zanqat Bab al-Tut, at Feddan and at Trankat. A good worker could make one lock a day. With the help of an assistant or an apprentice, he could make three every two days. The value of the lock was in the quality of the work, the raw materials costing very little. The znaidiya made dog-locks, flintlocks (zned) and

screws to assemble them. It should be noted that some of the locks were said to be extremely beautiful, with Prussian blue or violet springs, some bronzed in colours ranging from brown to gold, decorated with filigree, damascening in silver, and so on. In some locks the screws are 'lost head', known as loualeb medqouqin. Typical of the arms produced in Tetuan are Catalogue nos 34 and 35.

The Tetuan manufacturers faced competition from mountain workmen as skilful as themselves but much more cunning and dishonest. These artisans usually worked to orders set in motion by a small gift of money and goods. The workmen would begin the order, working as slowly as possible. When the client came to take delivery, he would invariably be told that his order was not ready and would take four or five days more. This would happen several times, until out of exhaustion and frustration the client would stay with the workman and not leave until his order was completed. However, he would have had to bring presents at

Exterior view of a common North African gun; the Arabic names of parts are after A. Joly, Archives Marocaines and were in use at the beginning of the twentieth century.

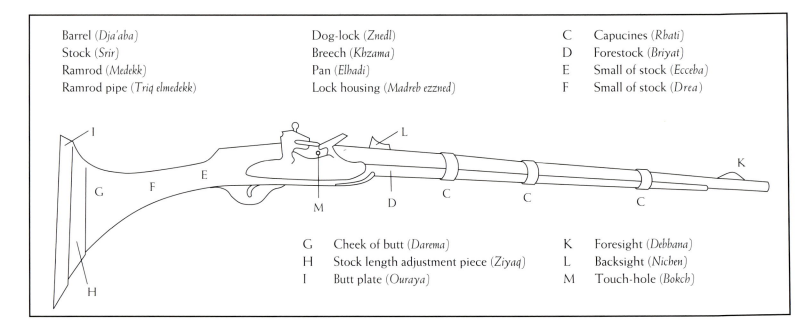

Barrel (Dja'aba)	Dog-lock (Znedl)	C	Capucines (Rbati)
Stock (Srir)	Breech (Khzama)	D	Forestock (Briyat)
Ramrod (Medekk)	Pan (Elhadi)	E	Small of stock (Ecceba)
Ramrod pipe (Triq elmedekk)	Lock housing (Madreb ezzned)	F	Small of stock (Drea)

G	Cheek of butt (Darema)	K	Foresight (Debbana)
H	Stock length adjustment piece (Ziyaq)	L	Backsight (Nichen)
I	Butt plate (Ouraya)	M	Touch-hole (Bokch)

each visit: eggs, butter, cheese, fruit, vegetables, and in the meantime the workmen would sell all the other items they had made during the delay, without having to work unduly hard.

The black wood stock of the typical Tetuan long gun was splendidly decorated with inlaid gold and silver wire. This was bought from the Jewish jewellers of Tetuan, and before being set in the stock was hammered flat. Niello and gold and silver damascening were also popular.

A distinctive pistol with a curious egg-shaped butt also comes from Tetuan. An example can be seen in the Victoria & Albert Museum, London,[28] which has a snaphaunce lock of early seventeenth-century English form. This pistol was probably made in the late eighteenth or early nineteenth century. This butt form may be descended from the Brescian and Spanish pistol butt form of the second half of the seventeenth century which it so closely resembles, both in shape and in its applied pierced metal buttcap.

Captain Delhomme, stationed in Agadir in the early years of this century, gave the following detailed description of the most widely seen gun types at that time. Most common was the flintlock which he called 'Bou Chfer'. This is the *bu-shfer* or 'fired by flint'. Three types can be identified, based on the shapes of the butt. *Afedali* comes from the Taroudant region and the Oued Sous valley (Catalogue no. 36). It resembles other guns common to the Maghrib, only the decoration differing. *Altit* comes from the Little Atlas Mountains and has an almost cylindrical butt, at the end of which a plate decorated with strips of bone or ivory reinforces the metal framework (Catalogue no. 37 and 38). *Taouzilt* comes from Ras el Oued, in the high valley of the Sous (Catalogue no. 39). The percussion lock gun, called by Delhomme 'Bou Haba' (*bu-habba*) was preferred to the 'Bou Chfer' but was rarely used as the caps were quite expensive. It came in the same shapes as 'Bou Chfer' but in larger calibres. The best-known makers were Mohammed Ould Douahim of El Aouina and Bihi ben Hammou of Tiznit.

Barrels in two forms, *abouri* and *tarouhalt* were manufactured by the Boudrara, a mountain tribe of the Small Atlas. They used imported metal that was brought in from Mogador, putting together two or three pieces carelessly and then boring through them. The wood used was always walnut from Goundafa and all silver decoration came from coins, usually the Spanish coin

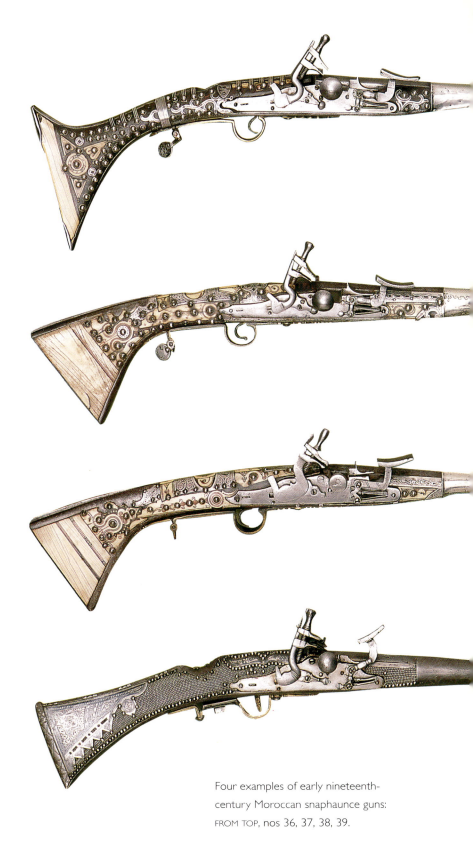

Four examples of early nineteenth-century Moroccan snaphaunce guns: FROM TOP, nos 36, 37, 38, 39.

called *zabil*. Simpler guns were decorated with camel bone, but ivory was used for the finer pieces. This came from Sudan and was available in all market-places. All artisans had their own particular type of decoration which was easily recognisable by those who know them. The most famous butt maker was Ali ou Rekkes el Resmouki of Tiznit.

In Morocco the European breechloading military longarm is called a *klata*, from the Spanish *culata*.[29] The multi-shot weapons most commonly in use were: *Bou Hafra* or *Tanjaoui*, a Martini-Henry of 11 mm.; *Menebbi*, a Martini-Henry of 11.5 mm; *Settachia* (six shots), a Winchester 1873 of 12 mm; *Sassepot* for *Chassepot*; a Gras 1874 of 11 mm; *Tsaia* (9 shots), a Lebel 1886 or 1886/93; *Rbaia*: (4 shots), a Lebel 1892. These guns were sometimes decorated in the local style. Pistols, very coarse examples of which were manufactured locally, were used by merchants and caravan leaders. Imported revolvers of mediocre quality came from the coastal towns and Marrakesh.

Gunpowder could be obtained as contraband or from caravans from Rio de Oro. It was also quite easy to produce locally. The method was the same in all regions and any differences were due to the skills of the various manufacturers. The recipe was two ounces of sulphur and two-and-a-half of carbon for each pound of saltpetre. These were mixed together in a hollow olive tree trunk for a few hours and a little water was added to fix the carbon powder. The paste was then dried in the sun for a couple of hours, and ground with a grindstone. A little water was then added, and after further pounding the gunpowder was allowed to dry and was then ready for use. One maker, with two helpers, made about six pounds of powder in a day. Certain makers in Tiznit, Mira and Tiourgan were known at this time for the strength and fine quality of their powder and these men also made cartridges. Second-grade powder was used for flintlocks and percussion lock guns. The manufacturing of caps was particularly important as they made it possible to re-use the cases of the old cartridges. This delicate operation was performed only by the most skilful makers. The detonating material – taken from match-heads – was mixed with petrol and the covering of the caps was made of a thin coating of lead. These men also made the cartridge cases out of copper from old plates and other pieces made out of the metal.

ALGERIA

Algeria was famous in the Christian world for producing fine guns and for the daring of its corsairs, who threatened the sea routes of the western Mediterranean and even raided out into the Atlantic as far as the British Isles. At the end of the fifteenth century the principal dynasties had lost control and the area fragmented into small autonomous states. The ports had become bases for corsairs who raided merchant ships and carried on war against the infidel. Khayr al-Din, better known as Barbarossa, rebuilt the city of Algiers and organised it as a corsair state, financed by ransom and plunder. In 1533 he was summoned to Istanbul and made Admiral of the Fleet, to counter the successes of the Christian admiral, Andrea Doria. The privateers gained fresh recruits when the Moors were driven out of Spain. The Spanish attempted to emulate the Portuguese in Morocco and establish *presidios* or garrisons in the main coastal towns under the pretext of the crusade against Islam, but they encountered the simultaneous opposition of the corsairs and the Ottoman state. Nevertheless, in the short term the Spanish succeeded in making themselves masters of the Algerian coast. However, Philip II of Spain was unable to act decisively in North Africa due to pressing problems in Europe, and in 989/1581 was forced to conclude a truce with the Ottoman sultan which left Algeria, Tunisia and Tripolitania as Ottoman provinces, while Morocco maintained its independence.

The Spanish retained Oran, Melilla and Mers el-Kebir. A struggle for power developed between the janissaries, mainly Turks recruited in Anatolia, and the corsair-captains, mainly renegade Christians from Sicily, Calabria, Corsica and elsewhere, many of whom, having been captured, had seen no future in remaining slaves and had converted to Islam.[30] Others came freely. The Dutch had sailed very infrequently to the Mediterranean and Levant until the last decade of the sixteenth century when a series of bad European harvests made trade in grain profitable despite the longer voyage. Dutch trade with the region then increased rapidly. The Dutch also began trading on the Gold Coast in 1591-2, selling guns from 1594; the following year they sold twenty-five 'musketten ende roers'.[31] At about this time the Dutch developed a more efficient cargo ship, the *fluit*,[32] which was manned by relatively few hands and was built in large

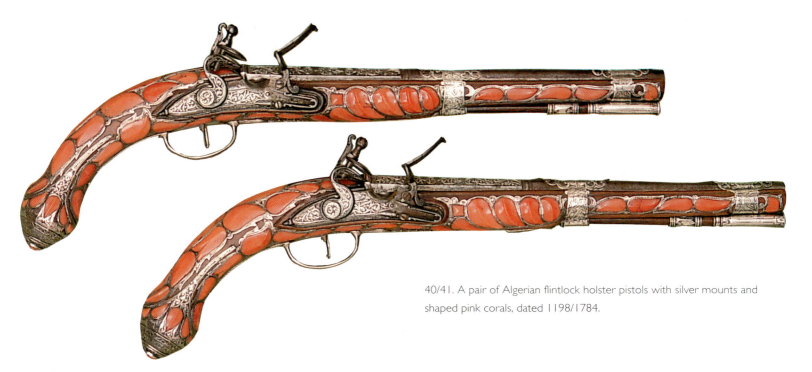

40/41. A pair of Algerian flintlock holster pistols with silver mounts and shaped pink corals, dated 1198/1784.

numbers. A result of this was that many Dutch sailors were thrown out of work, and some joined the Barbary corsairs, with important consequences for the development of North African firearms. The firearms of the Maghrib were already famous but were greatly improved by the addition of the northern European gunlock.

The diversity of nationalities and familiarity with distant waters contributed to the preference of the corsairs to raid far and wide. In one short period between 1609 and 1616, 466 English vessels were captured and their crews enslaved. Since the English ships were armed, the sheer number of weapons passing into corsair hands can be imagined, particularly since the English were not the only maritime nation suffering these depredations. In 1627 Algerian corsairs raided Iceland and seized several hundred captives. Raids in strength on the Atlantic coast of France and the British Isles are also recorded, with Cornwall, Devon and Dorset hit badly. Frequent efforts to control the corsairs led to diplomatic missions[33] and to bombardment of the Algerian ports, which resulted in booty, including weapons, being brought home. Those weapons which can be reliably identified provide valuable evidence today. When the British government tried to ransom British captives held by Barbary pirates in 1701, they were obliged to purchase their freedom by a payment of one hundred locks per man.[34]

At the beginning of the eighteenth century the Ottoman sultan's representative was driven out and the sultan was forced to acknowledge the authority of the tenth dey (dayi) who remained in allegiance to Istanbul. The rulers of Algiers concentrated all their efforts in privateering, leading to hostilities with Holland, England and France, but never simultaneously. The British bombarded Algiers in 1622, 1655 and 1672; the French in 1661, 1665, 1682 and 1683. In 1689 a treaty was signed between France and Algiers establishing commercial relations. Some Dutch, British and French merchants established themselves in Algiers but intermittent hostilities hindered commerce, much of which was conducted between the Jews of Algiers and Leghorn, the port to which a considerable quantity of firearms was supplied by European producers. Arms were also shipped from Marseilles, which had a long history of trade relations with Algiers.

The important stronghold of Oran was recaptured by the Spanish during the reign of Philip V from the renegade Spaniard Bey Mustapha, who had seized it in 1708. Some of the weapons obtained by the Spanish are now in the Real Armería, Madrid. A locally made musket with Spanish-style flintlock bears the Arabic inscription 'Work of Muhammad. Year 1110[1698]'. Another bears the same name and is dated 1123/1710, whilst a similar example is signed 'Work of Ahmed'. All these guns show the strong influence of Spain in the construction of the lock mechanism.[35]

At the request of Louis XV, the great Stephanoise gunsmith Jean Bouillet made a gun which fired three shots for presentation to the dey of Algiers in 1752. His eldest son Claude Bouillet left St Etienne in 1755 for Algiers, where he set up a gun shop and atelier. He became arquebusier to the dey but was murdered in Algiers in 1758.[36] An Algerian musket was presented to King Charles III of Spain in 1787 by the dey of Algiers.[37] A period of political instability caused by the indiscipline of the janissaries in Algeria coincided with increased privateering activity during the time of the Napoleonic wars, though privateering virtually ceased after 1815.

Arguably the most famous guns from Algiers are those decorated with coral, which was very much a hallmark of the area.[38] The Tareq Rajab Museum has particularly good examples, including a very fine pair of pistols (Catalogue nos 40 and 41) and a magnificent miquelet long gun (Catalogue no. 42). There are comparable pistols at Windsor Castle.[39] Two pairs are described in the catalogue of Carlton House, London, as 'Presented by the Algerian Ambassador from dey of Algiers, 25th February 1811'. Another of the pairs came from the same source on 30 May 1819. With each gift came a coral-mounted long gun. Guns decorated in this manner were made over a long period of time. Peter I of Russia (1682-1725) was presented with a fine long gun by the Tatars, which he in turn gave to Friedrich August I of Saxony on the occasion of his coronation as August II, King of Poland, in 1697. This gun is in the Dresden Historisches Museum and was wrongly catalogued by Schobel, who attributed the gift to Catherine the Great.[40] Schobel refers to the gun as Turkish, which is possible, as Algerian work was popular in Istanbul and guns decorated in the Algerian manner were made there. As we have seen, the head of the Gunsmith's Guild in Istanbul made a flintlock decorated in coral and silver in 1746. The barrel on the Dresden gun is signed 'Amal Mehmed' and the lock is referred to in the 1683 inventory as Spanish ('mit einen Spanischen Flinten Schlosse'), though it is typically North African in form and of high quality.[41] This much travelled gun was almost certainly made in Algiers.

The Tareq Rajab Museum is particularly strong in good Ottoman miquelet musquets of the eighteenth and early nineteenth centuries. Catalogue number 45 in the collection is similar to an unsigned gun with a distinctive coral ornamented lock,

obviously from the same workshop, in the Wallace Collection, London (no. 2157), and there are others known in this group. The origin of this style of decoration is not certain but the use of coral, which had always been an important import in the East,[42] became fashionable in the Ottoman court in the eighteenth century. Coral was used extensively to decorate weapons and horse trappings in Turkey and this was referred to by the Ottomans as Algerian work (*Cezayir isi*). Pistols with coral decoration in Algerian and Turkish style were also made in France for export, (see Catalogue no. 46).

Gille, writing in the mid-nineteenth century, states that the locks on the Kabyle guns look European and are made specially for them in Italy.[43] In fact the wing nut which forms the head of the top jaw screw on Kabyle guns is also found on Spanish firearms from Ripoll; it may have its origin in sixteenth-century German firearms imported into Spain at that time, which have the same characteristic.

TUNISIA

Leo Africanus, writing of the early years of the sixteenth century, states that the king of Tunis had a bodyguard of Turks armed with blunderbusses. When Tunisia became an Ottoman province it was ruled by a *beylerbeyi* and 3-4,000 janissaries under an *agha*, with replacements regularly sent from Anatolia. In 1594 the janissary officers seized power, formed a divan and elected one of their number as *dey*, relegating the *beylerbeyi-pasha* to a representative role. The army included Levantines and non-Turkish elements including European renegades, some of whom rose to be dey, but was dominated by Anatolian troops. Discipline remained firm in the army and administration and commerce flourished, particularly after 1609 when many Moors driven out of Spain settled there. There was considerable privateering in Tunisia, though not as much as in Algeria. Amongst the European renegades was an Englishman by the name of Ward who was responsible for the renewal of the Tunisian navy at the beginning of the seventeenth century.[44]

The Spanish were particularly interested in the control of Tunis because its position gave control of the Sicilian channel and cut communication between Algiers and Istanbul. In 1630, a

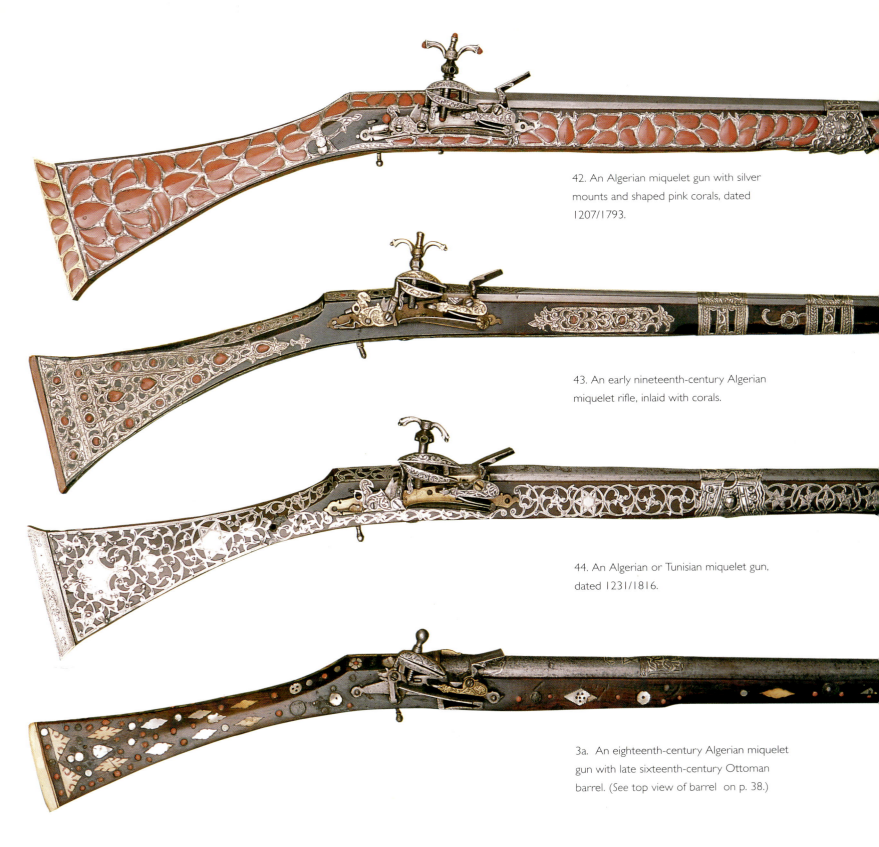

42. An Algerian miquelet gun with silver mounts and shaped pink corals, dated 1207/1793.

43. An early nineteenth-century Algerian miquelet rifle, inlaid with corals.

44. An Algerian or Tunisian miquelet gun, dated 1231/1816.

3a. An eighteenth-century Algerian miquelet gun with late sixteenth-century Ottoman barrel. (See top view of barrel on p. 38.)

Morisco who had fled to Tunisia wrote a manual in Spanish on artillery based on German practices. German gunners are frequently recorded in the accounts of travellers and had a high reputation in their profession. While in the Venetian colony of Modon in 1497, Arnold von Harff encountered a German master gunner, Peter Bombadere, who had 'many fine cannon, great carthouns and slings' and at Candia, another Venetian colony, was befriended by another German master gunner, Peter of Ulm. Harff wrote that 'they make things necessary for crossbows, guns and other weapons. The Lordship of Venice has a fine array of ordinance in this town.'[45] The people of the Maghrib had a reputation as great travellers, in contrast to the Egyptians, and would have been well aware of the military arrangements of the Christian powers in the eastern Mediterranean. The manual on artillery was translated into Arabic with the intention that it should be presented to the Ottoman sultan and other Muslim rulers. This work states that *midfa* meant cannon in Tunis but

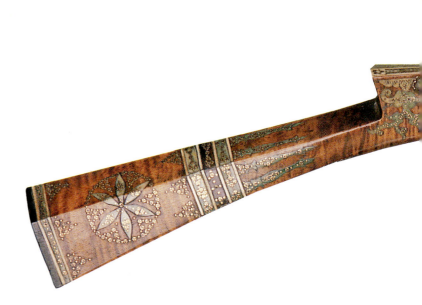

45. An eighteenth-century Turkish miquelet rifle.

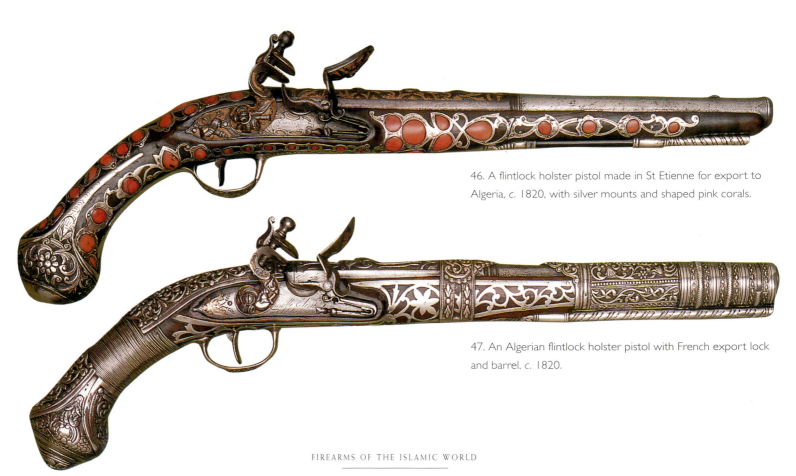

46. A flintlock holster pistol made in St Etienne for export to Algeria, *c.* 1820, with silver mounts and shaped pink corals.

47. An Algerian flintlock holster pistol with French export lock and barrel, *c.* 1820.

FIREARMS OF THE ISLAMIC WORLD

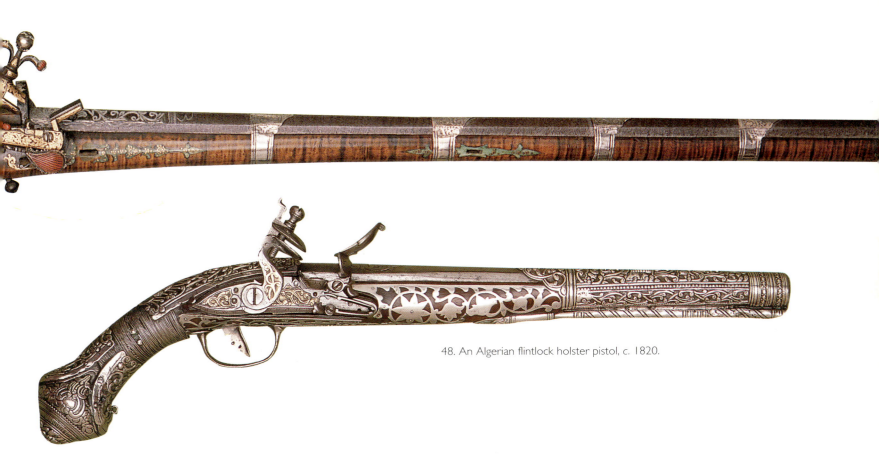

48. An Algerian flintlock holster pistol, c. 1820.

musket in Morocco; while *anfat* meant cannon in Morocco and fireworks in Tunis.[46] The smiths of Timbuktu used the word *madafi* for guns instead of the more usual *banadiq*, which may indicate the origin of the earliest guns to reach that town.[47]

Tunis was a cosmopolitan port which in the seventeenth century was settled by many foreign merchants – English, Dutch and French – particularly the Marseillais, who strove to control the coral trade. In 1743 and 1744 Ali Pasha sent to Toulon for a founder who repaired several cannon in a temporary workshop. Under Hammuda Pasha a regular foundry was established under the charge of some Frenchmen in a wing of the Hafsiya Palace.

Stone cites an unknown, but apparently early, Arab source[48] as evidence of large-scale gun production in the interior behind Sousse in Tunisia. Clearly Dutch, English and French firearms would also have reached Tunisia in large quantities. H. W. Mortimer, who was appointed gunmaker to George III and supplied the (British) East India Company,[49] specialised in repeating pistols and gold-mounted guns for the Eastern market. In 1801-2

he made gold-mounted firearms set with diamonds for the United States Government to present to the Dey of Tunis as part of the American diplomatic efforts to rescue enslaved American sailors.[50] Zygulski writes that barrels and locks were brought to Tunisia from Europe 'chiefly from the region of Brescia in Italy'.[51] In the late nineteenth century, Beretta was making considerable sales of guns to Tunisia.[52]

Attempts at reform in Tunisia in the nineteenth century were greatly influenced by the example of Muhammad Ali in Egypt. As in Egypt, reform started in the army, where the beys tried to create a European-style force. Beginning in 1830 and spurred on by the French occupation of Algeria, a large expenditure, which rose to take two thirds of the annual budget, produced an army of ten thousand men, with a military school at Bardo, a textile mill, a gunpowder mill and a foundry, all of modest value. The economic decline that affected Tunisia as the century progressed led directly to Tunisia becoming a French protectorate in 1881.

THE SUDAN

I N THE SUDANIC STATES, firearms were adopted very slowly, especially when compared with the forest kingdoms to the south and the Arab states which bordered the Mediterranean, both of which areas had the advantage of direct trade links with Europe and controlled the supply of guns to their less accessible neighbours on the trans-Saharan trade routes. The technical problems of maintaining those guns which did reach the Sudanic states, their consequent unreliability, and the style of warfare in the open country which favoured cavalry against ill-trained musket men, meant that firearms were neither freely available nor entirely favourably regarded. They were nevertheless much in demand, which allowed the region to be dominated by neighbouring states. For example, Egypt controlled the supply of

firearms to Darfur and eastern Sudan, so that although firearms and ammunition were available and in use, local wars continued to be fought with the weapons and in the manner of medieval Islam until the early twentieth century.[1] Mail and quilted armour, the sword, spear, lance and bow retained their place within the armies of the region. Indeed, some societies regarded firearms as un-Islamic, unmanly, unsuitable for a man of rank and undesirable. In the context of their own values, no doubt they were right, and in addition the available firearms were unreliable. The disciplined steadiness of Napoleon's infantry veterans in the Egyptian campaign, who could face a charge by the Mamluk cavalry and fire volleys confident of slaughtering their enemy, had no infantry equivalent in the armies of the Sudanic states.

The earliest reliable mention of firearms in central Sudan occurs in the late sixteenth century at the time of Idris Alawma, ruler of Bornu.[2] A historian of the reign, Ahmed ibn Fartuwa wrote: 'Among the benefits which God (Most High) of His bounty, beneficience, generosity, and constancy conferred upon the sultan was the acquisition of Turkish musketeers and numerous household slaves who became skilled in firing muskets.'[3]

Shuwa Arab cavalry, Kanembu spearmen and musketeers from the Sheikh of Bornu's army attack a Fulani settlement. Engraving after the sketch by Major Denham from D. Denham and H. Clapperton, *Narrative of Travels and Discoveries in Northern and Central Africa in the years 1822, 1823 and 1824*, London, 1826.

There is some doubt as to how these Turks and their guns came to be in Bornu. It has been suggested that Alawma went on the *hajj* and saw the benefits of firearms. Another theory is that the Moroccan column that marched against Songhay in 1590 was defeated and that some of the matchlockmen survived and were persuaded to serve the ruler. Alternatively, the Sultan may merely have recruited matchlockmen in the usual fashion and acquired arms and men through diplomatic relations with Tripoli.[4] The Ottomans arrived in 1551 and 'guns and fine horses' were given as diplomatic gifts in 1577-8. However, it appears that the ruler of Bornu could not obtain enough of these weapons from Tripoli because he subsequently applied to Morocco for soldiers and guns. In the seventeenth century there are periodic references to Bornu's quest for more firearms and skilled troops to use them, including Christians. However, the extent to which the introduction of firearms changed the local balance of power is debatable,[5] since local warfare was fluid and fast moving and the problems of the maintenance of the firearms remained.

Guns reached Darfur much later, from Egypt. The first ruler known to have possessed them was Ahmed Bukr in 1682, who apparently spent two years training and equipping his army with guns obtained from Egypt before using it to defeat Wadai. He killed one of his sons by knocking in his skull with a musket butt.[6] The traveller Gustav Nachtigal found in the late nineteenth century that there was a royal official, the *bandaging sagel*, or supervisor of the royal muskets, who still guarded the first firearm that had come into the country and was himself descended from the European who had brought the weapon to Darfur.[7]

Wadai itself obtained guns in the early nineteenth century from North African traders, who also instructed the locals in their usage. It is clear that from the sixteenth century onwards, the trans-Saharan trade routes played a key role in the sequence in which societies obtained firearms; but the effective military and political use of them was usually linked to the arrival, for various reasons, of foreigners capable of acting as advisors – Turks, renegade Christians and Arabs. The desire of the northern Arab coastal states to dominate the regions to their south was motivated by the needs of security for themselves and the trade routes which provided them with slaves and ivory. Niebuhr describes meeting a caravan at Alexandria in 1762 that had come up from Sennar with slaves and expected to return with a variety of wares,

including sabres and guns. In the nineteenth century the recorded incidence of the existence of firearms increases dramatically, but they remained comparatively rare until the last quarter of the century and the supply of ammunition was also a problem. Nachtigal found polished stones being used as ball ammunition in central Sudan.[8]

Considerable quantities of guns also entered the Sudan from the south in the second half of the nineteenth century.[9] The origin of the guns recorded is of great interest. Virtually none were made locally, although there was considerable repair work to existing firearms. According to Burckhardt, the Bey of Tripoli gave a few firearms to the ruler of Wadai. The Khedives actively tried to prevent the trade in guns from Egypt to the Sudan and the slave traders of Khartoum restricted their firearms sales. Sultan Muhammad Husayn al-Mahdi of Darfur ordered his guns from Istanbul when he decided to equip a force of black slaves. The Hausas bought Birmingham muzzle-loaders with long barrels of modern manufacture, which they called 'Dane' guns. After 1750 the Danish export musket, which was known as a Dane gun or 'long Dane', became the principal firearm exported to West Africa[10] and it remained the most popular of all guns until the nineteenth century.[11] The Danish factor Romer stated that the Danish flintlock, which was one and a half hands longer than the English flintlock, sold better, so the English, and later the French, copied the Danish gun. It is not always clear where the Dane gun was made. Romer states that it came originally from Celle in Hanover. Others suggested that the guns were made in Holland. In the 1780s the Danes obtained their trade guns from Suhl but in the early nineteenth century the weapons came from near Hamburg.[12] The Birmingham gun-maker Edward Brookes who exhibited at the Great Exhibition of 1851 published a list of his manufactures, including 'Dane guns, black and red stocks, brass and iron mounted.'[13] Howard Blackmore remarks that he has seen a German catalogue of 1911 still advertising the 'Long Deane (sic) trade flintlock gun'.

Birmingham and St Etienne produced trade guns in large quantities, but were ultimately undercut by Liège whose gun names reflect the popular products of the nations that they replaced. William Baikie, the British Consul at Lokoja, writing to the Foreign Office in 1864 on behalf of the Emir Masaba of Nupe, requested a shipment of Enfield Rifles, and muskets, the

former for fire power and the latter 'for noise, a very important element in warfare here'.[14] Indeed, there are a number of accounts of the enemy cavalry being driven off by the sheer noise of musketry. In the Mahdi's army firearms were forbidden initially as being alien to the *Sunna* of the Prophet. However, it was not long before Remington rifles, captured from the army of the Khedive, were freely used. The Jallaba merchants traded cheap Belgium guns bought in Cairo[15] for slaves in western Darfur and Wadai, and in the early twentieth century the Sanusi in Cyrenaica regularly used guns as a means of exchange. According to French records in 1907, the rate was 'still' one slave for one Fusil Modèle 74 in good condition and forty cartridges.[16] In 1873 Sultan Ali of Wadai preferred the flintlocks that the Arab traders brought him from Tripoli to the bad quality percussion guns which the Nile traders could supply. The term trade gun became unacceptable in Europe with the abolition of slavery and the name changed to export gun. In time this became muzzle gun and ramrod gun, denoting their obsolete construction. The rapid advances in firearms design and the need of the European armies to modernise after 1867 were instrumental in speeding the adoption of more sophisticated weapons in Africa and Arabia, which provided an insatiable market for the obsolete firearms of Europe. The Sanusi acquired contraband arms from European ships through the North African port of Tobruk and supplied the Muslims in Sudan with arms and ammunition and propaganda for use against the French. In the 1890s and the first decade of the twentieth century the French made substantial gifts to local potentates whose support they courted; while large quantities of illicit weapons flowed into the region. Frequently the relationship changed so that a former French ally became an implacable and well-armed enemy, as in the case of Muhammad al-Sanusi. As one observer wrote of Cyrenaica: 'quantities of modern arms have been and still are imported ... in spite of Turkish vigilance and the representations of many Consuls. European guns and rifles of every pattern and origin, from the old blunderbuss to the latest Mauser pistol, can be found in most towns along the North African coast, and will be supplied by unscrupulous agents of respectable firms as long as there is a profit.'[17]

CHAPTER SIX

ARABIA

FIREARMS arrived in the Arabian peninsula[1] as a result of the Mamluk and Ottoman response to the arrival of the Portuguese in the Indian Ocean at the beginning of the sixteenth century. A contemporary history of the Yemen describes the arrival of the matchlock in the hands of the Turks:

> The soldiers of the Lord of the Room [*Rum*] were armed with musket-bows with which they took aim. It is a most wonderful weapon, and whoever confronts it must be overcome. It is something like a cannon only it is longer and thinner. It is hollow, and in this hollow is inserted a piece of lead as large as a lote berry, and it is filled with powder, and then discharged by means of a match at the bottom of the musket, and if it strikes any one he must perish, for it goes in at one side of him and comes out the other.[2]

Other contemporary writers of histories state that the *bunduq* first appeared in the Yemen in 922/1515. Local rulers used the rivalry between Ottomans and Portuguese in the Indian Ocean to extend their power with the use of the new weapons. Badr Ba Tuwarik used Portuguese matchlock men to dominate the western Hadhramaut in 945/1538-9, while at other times siding with the Ottomans. In the Arabian Gulf the Ottomans were further from their bases and less successful in confronting the Portuguese, who assisted the Persian Shah Tahmasp with arms technology. In their conflict with the Portuguese in the Indian ocean the English and Dutch supplied gunners, cannon and ammunition to the Omanis, who successfully evicted the Portuguese in 1650. Omani ships were influenced by those of the English and Dutch and emulated the size and weight of their armaments in the seventeenth and eighteenth centuries, making them a formidable naval power in the Indian Ocean and providing the basis of the

An Arab guide leading travellers through the desert. Note the Arab's matchlock and the European guns of his employers. Emile-Jean-Horace Vernet, exhibited 1844. Reproduced by permission of the Trustees of the Wallace Collection.

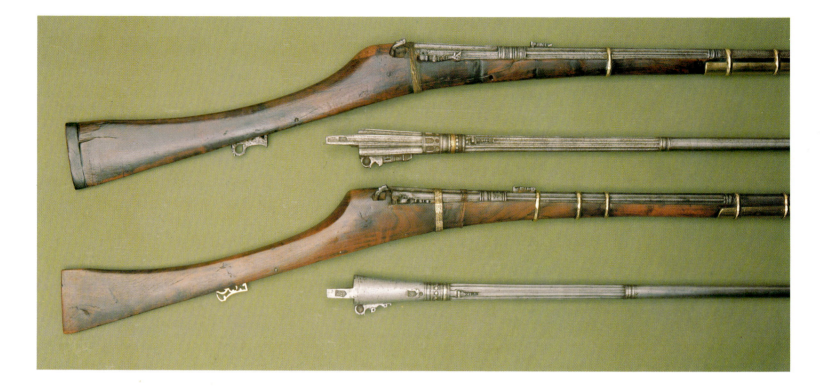

Omani maritime empire. Mocha, one of the principal ports in the Red Sea for international trade, was visited by the Danish explorer Niebuhr and his companions in 1763. He noted in his diary that the Arabs were interested in trading for iron, steel and gun barrels, 'which they prefer to be not round but thick and pentagonal.'[3] This is not a description of a European barrel but probably refers to an Iranian one of the type exported by sea to the ports on the Arabian littoral.

The matchlock spread very slowly amongst the tribes of Arabia and the bow remained in use well into the eighteenth century. The numbers of firearms owned by the various tribes was a matter of some interest to the British, not because they harboured ambitions to occupy any part of the peninsula, but rather because Arabia lay upon the overland and sea route to India, of great strategic and commercial importance to them. British travellers and officials reported on such matters to London and as a consequence information about numbers of firearms is available. Unfortunately, any other details, such as the origin of the matchlocks or their proportions, are almost entirely lacking. For example, the British traveller Wellstead in 1835 esti-

49. An Omani *abu fitila* or matchlock gun, *c*. 1700.
50. A seventeenth-century Omani matchlock gun barrel.
51. An Omani *abu fitila* or matchlock gun.
52. An eighteenth-century Omani matchlock gun barrel.

mated the Bani Abu Hasan Bedouin at 1,200 men 'but they cannot muster more than seven hundred matchlocks'.[4] John Lewis Burckhardt was still able to write that the Bedouin preferred to convert any flintlocks that they obtained to matchlock because they were less likely to misfire. Many of the barrels in use in Arabia were imports. The Omani barrels often came from India and Persia. Burckhardt saw many 'fine Persian barrels' in the Hijaz, and also observed that the Syrian Bedouin preferred the lance to the matchlock: 'Matchlocks are scarce among the Syrian Bedouin, and in general amongst all of them northwards of the Akabas [Aqaba]. Every Bedouin in the Nejd country, in Hedjaz and Yemen, is armed with a matchlock. The Wahabys' principal

force consists in this infantry. Their matchlocks are of very coarse workmanship: They procure them from the towns in their neighbourhood.'[5] The attitude of the Syrian Bedouins to firearms is well illustrated by the response of Faris, Shaikh of the Northern Shammar, who had enjoyed shooting with some guns owned by the Blunts and was offered them as a gift: 'No,' he said. 'I am better as my fathers were, without firearms...'[6]

Forty years later, in 1911, Gertrude Bell encountered the same Northern Shammar still 'carrying the long spears that are planted before the tent door.'[7]

Pistols were very much associated with Europe and, as has been discussed, were adopted comparatively late in the Ottoman empire. Locally made pistols were recognised as inferior to their Frankish counterparts. The English traveller Pococke in the Levant in about 1740 was armed with a pair of pistols which attracted the covetous eye of the local shaikh:

The Sheikh happened to caste his eye on a pair of my pistols which he liked and immediately ordered his man to propose an exchange for his, which I refused.

When I returned from seeing the town of Efbele known to the Franks as Gibele... I was informed that the Sheikh intended to take my pistols by force, if I would not agree to his proposals. The Sheikh himself came soon afterwards, took my pistols out of the holsters, and would have put his own in their place, which I would not permit: he then put his pistols into the hands of one of my men, whom I ordered to lay them down on the ground; they offered to give me some money also in exchange; but I intimated that if they did not return them, I would complain to the Pasha of Tripoli. I departed, and they sent a man after me to offer ten dollars: two or three messages passed, and when they were about a mile from the town they sent the pistols to me; for, as they knew the character of the Pasha, it is probable that they apprehended he would be glad of such a pretence to come and raise money on them.[8]

Few of the shaikhs had pistols, even the old European flintlock holster pistol known as 'el Engleysey' was rare even at the end of the nineteenth century. The town dwellers liked them because they came from Cairo or Istanbul and provided a degree of sophistication. Sir Richard Burton said in 1855 that pistols were newly introduced into the Hijaz. He recommended Turkish barrels with European locks, a conventional view at that time, and while noting that percussion caps were for sale in the *suqs* of Mecca and Medina, decided that a Colt sixshooter might attract too much attention.

Doughty saw newer Spanish, Egyptian and Barbary guns in Arabia. The best firearms were always considered to be '*el-Lazzary*', the barrel bearing a version of the famous Lazzarino Cominazzi name which had become a symbol of quality. These were copied all over the Balkans and even in Liège which produced a gun called 'the Lazarino'. Other guns made for the Eastern market included the 'Algerien', the 'Mahomet', the 'Janissaire', the 'Bedouin', and the 'Egyptien'. In addition, those who wished to appear modern and progressive might purchase copies of famous English makes such as the 'Brown Bess', the 'Ketland' and the 'Wilson'. After '*el-Lazzary*' in estimation came '*el Majar*', but what it was is not clear; it was in turn followed by '*el-Englesey*'.

One reason why the guns of the Balkans were considered so superior was the fact that they were very shiny. Highly polished arms were the mark of a man of standing in the East, though an exception might be made for a watered barrel. Burton told how 'All weapons must shine like silver if you wish to be respected; for the knightly care of arms is here a sign of manliness'.[9] Kinglake made the same point, referring to arms that 'were inlaid with silver, highly burnished, and they shone all the more lustrously for being worn with garments decayed and even tattered (this carefulness of his arms is a point of honour with the Osmanlee; he never allows his bright yataghan to suffer from his own adversity)'.[10] The quality of the metal of the barrel was judged by Arabian smiths and was considered decisive for the gun's good delivery of the ball. It was widely supposed that good metal should show clean and neat and shining 'like the mouth of a coffee cup' and that a barrel made of inferior metal would foul sooner and produce 'dull' shots. The older the weapon the more it was esteemed by the Arabs. Guns were passed down from father to son and acquired special names and were never parted with save in extreme necessity. Burton observed that a Bedouin particularly valued a good barrel seven spans long and would rather keep it than his coat.

Like the Persians, 'they esteem the barrels in proportion to their size and weight: the heavier and larger being the most valued'. It is very noticeable that in the Arabian peninsula the accounts speak of Persian gun barrels being imported rather than Turkish. The reason is probably that the Porte maintained control of firearms as far as it was able and prohibited the sale of war material to enemies of the state. As late as the nineteenth century Muhammad Ali's son had to relinquish his governorship of Syria because of the unpopularity he had incurred by his policies, including an attempt to confiscate firearms from the population. The Persians, by contrast, were perfectly content to see arms sold to anyone who might oppose the Ottomans, though the weakness of central government in Iran was such that any sales must be regarded as private mercantile initiatives.

Arab horsemen on exercise, drawn from life. English print, 1821. Courtesy of the Director, National Army Museum, London.

Opinion varied as to whether the Arabs were good shots. Burckhardt thought they were:

A European would think it almost impossible to take a sure aim with an instrument so rude as the Arab matchlock, which is often not worth more than one dollar. Yet by means of such guns, loaded with balls, I have seen crows, and even partridges killed. In numerous encounters between the Turks under Mohammed Aly Pasha, and the Bedouins, the latter invariably defeated the enemy whenever they fought in rocky districts, by the mere fire of their muskets, but were constantly defeated wherever the Turkish cavalry had room to act.[11]

This was all the more surprising in view of the quality of the powder and shot used and the Arab penchant for removing the sights, which they did not understand. Doughty saw Indian army rifles with 'Tower' locks in Ha'il which had been treated in this manner. Other travellers report the same occurrence in the Asir in 1913. Manuel Godinho in 1663 described the Arabs as 'crack shots with the matchlock, which they load with a single ball but insert with such force that it is bar shot when ejected'.[12] Many of the matchlocks had a tapering breech which gripped the ball when rammed down hard, as wadding was in short supply.

Wyman Bury, a political officer in southern Yemen before the First World War, tried firing a tribal matchlock, which he said 'after a display of pyrotechnics from the priming-pan, let go with a kick like a transport mule, knocking me backwards and making my nose bleed'.[13]

The arrival of modern cartridge rifles in the hands of the Turkish garrison in Arabia led Wilfred Blunt to note that the power of the Bedouin tribes had been curtailed, though they initially regarded the modern weapon with contempt because of the wretched shooting of the Turkish conscripts. However, from 1883 the arms trade began selling large quantities of modern rifles in the Gulf, initially from Bushire in Persia. Huge quantities of rifles were sold, particularly Martinis, the principal sellers in 1907 being Belgium, Britain, Germany, France and Romania. Nevertheless the traditional weapons of Arabia remained in use and the battle of Sibila in 1929 was fought with sword and spear between rival Arabs in a manner that was recognisably the same as before the time of the Prophet.

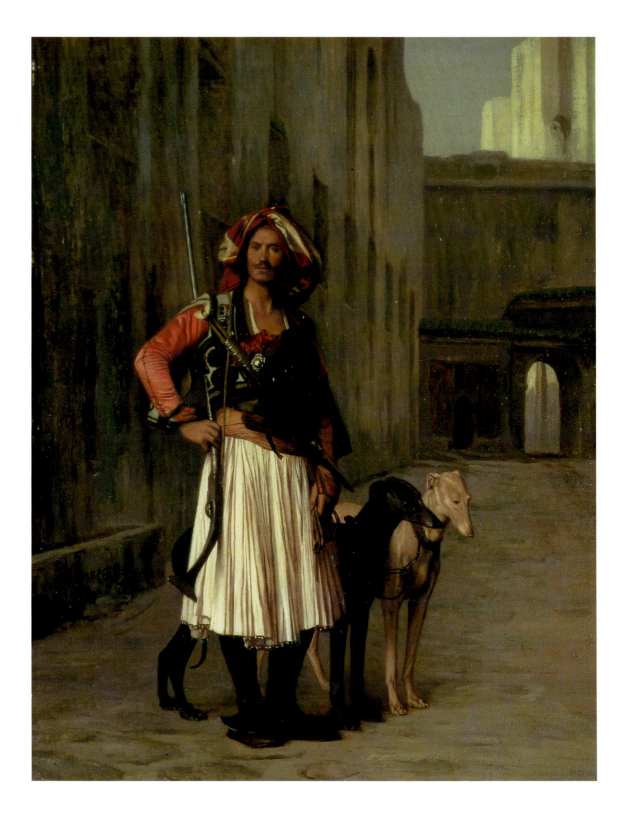

THE BALKANS IN THE 18TH AND 19TH CENTURIES

THE BALKANS has, since the invention of firearms, been a centre for the manufacture and assembly of handguns. The history of the area has been closely identified with the Turks since the fifteenth century and is discussed as part of the Ottoman acquisition of firearms in Chapter Three. The influence of Italy, particularly Venice and its great arms-producing centre at Gardone, has been prodigious. The Venetians dominated the Adriatic coast of the Balkans and the markets inland, so that Italian barrels and locks were highly regarded from the fifteenth to the nineteenth centuries. Most of the professional fighting men on the Venetian galleys were lightly armed Dalmatians or Greeks and Albanian *stradiots*, mercenaries[1] from the Venetian empire who fought in the Italian wars, as well as against the Turks. There are some fine sixteenth-century *stradiot* swords in Madrid, evidence of high-quality arms in the possession of these mercenaries; and in the State Archive in Venice from 1606 onwards there is correspondence concerning orders for wheellock arquebuses from Germany for the Albanian and Croatian troops.[2] To the north of the Balkans, the arms manufacturers of Germany and Hungary exerted their influence, particularly on the development of firearms which were transmitted to the Turks through the Balkans.

The huge demands of the Ottoman forces could not be met without drawing on the metal-working skills of the inhabitants of the Balkans. Whole towns and villages were committed to the

Arnaut of Cairo, 1871 by Jean-Léon Gérôme (1824-1904). Oil on canvas. The Fine Art Society, London/ Bridgeman Art Library, London.

53. An eighteenth-century Turkish rifle without its lock.

production of war materials of one kind or another. Lead, iron, charcoal and fighting men were major resources that the Ottoman army took from the area. The Bulgarian town of Nikopol was referred to by Chelebi in the mid-seventeenth century as a centre for the best Ottoman weaponry. The very name of the town of Sliven also became synonymous with any sumptuous weapon. It produced six to seven thousand barrels per year to meet state orders in the early nineteenth century, with the state itself providing the raw iron, eight kilos per barrel. The Ottomans obtained iron from the mines at Samokov in Bulgaria. Gun locks and mounts were also made. The quality of work was high and Sliven guns were exported in large quantities to Iran, Kurdistan, the Caucasus and Asia Minor. [3]

Gabrovo was another town full of Bulgarian ironsmiths. The Russian General Liprandi wrote that 'In Gabrovo one can find the famous stuzers called "shishane" with which the inhabitants of the Deli Orman [north-eastern Bulgaria] are armed without exception.'[4] The word *shishane* means six in Persian and refers either to the number of flat planes on a rifle barrel or to the number of grooves cut for rifling. The most common number of rifle grooves is seven, and examples with six are lacking. Zygulski argues that the name is 'an allusion to the beam-like angular shape of the butt; in Turkish *sis khane* means divided into six parts (hence the name for gunsmith *sis khanedshi* synonymous with *tufendshi*).'[5] This seems unlikely, as the butt of the *shishane* is five-sided unless one regards the apex of the triangle forming the top of the butt as the sixth side, which it scarcely justifies. Dalskalov and Kovacheva write that 'the term "shishene" is of Persian origin and means a hexagonal gun' – which does not advance the debate. Steingass's *Persian-English Dictionary*[6] gives *shash* meaning six. Names in the Islamic world are very often descriptive, such as

shash-par, a mace, originally six-flanged. *Shash-khana* means any rifled firearm; *shash-khana tufang* means an arquebus or rifle; *shash-khana top* means a rifled cannon. The dictionary description strongly supports the belief that the six in the name refers to rifling. This is further supported by the Iranian word for a sharp shooter, *shashkhanaji*, since a rifled gun may be supposed to give greater accuracy. In eastern Tunisia and Libya, according to Colin, the rifled carbine is known as *sheshkhan* which he describes as 'from Persia, "with a sexangular barrel", received through Turkish'.[7] The name *shishane* was adopted in Bulgaria, a clear indication of the principal market for these guns. They were also frequently found amongst the Arabs of Arabia and Syria who knew them by that name, as did the Iranians. It was said that the low price of the gun undercut the sales of French firearms in the region.[8]

Gabrovo had forty workshops involved in making guns and pistols in the eighteenth century and there were gunsmiths' quarters in Nikopol, Vidin, Tetovo, Prizren, Nevrokop and Sofia. In the late eighteenth century these towns began to imitate the French flintlock mechanism.[9] A local form of the miquelet lock from this region was known as a *boyliya* (a name also applied to the rifle itself), though it is not clear over what area it was manufactured. It is recognisable by the solid semi-circular back to the cock, which is always surmounted by a wing-nut-headed screw securing the top jaw and passing through the lower jaw in the usual manner. The exterior plate or fastening bridge which links the base of the cock to the base of the frizzen varies in form but is usually curved, in contradistinction to the usual Mediterranean miquelet lock. Lock and bridge are frequently covered with silver foil with shallow engraving. The lockplate invariably terminates as a triangle pointing towards the butt, while the other end of the

Four examples of Balkan *boyliya* miquelet guns, *c.* 1800.
These guns share a lock form and profile which indicates a common
origin, but the diversity of decoration suggests that the ethnic group
that owned them served all over the Ottoman empire.
(FROM TOP) NOS 54, 55, 56, 57.

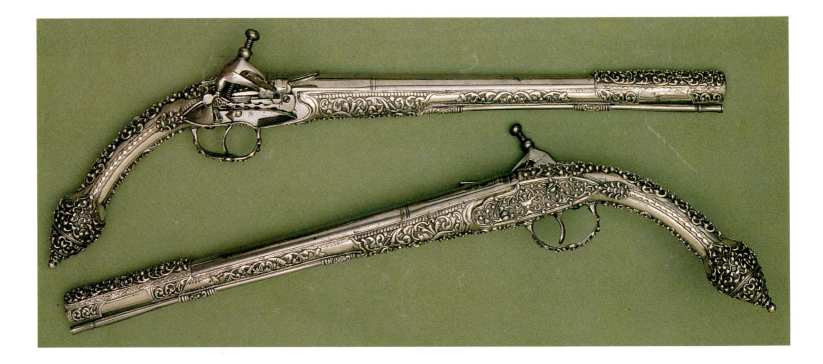

ABOVE 58/59. A pair of Albanian or northern Greek miquelet *kubur* pistols, c.1800.

RIGHT

60. An Albanian miquelet gun, c. 1820.

61. An Albanian miquelet gun bearing the date 1852.

62. An Albanian miquelet gun, c. 1800.

63. An Albanian miquelet gun, c. 1820, with later English trigger guard.

lock plate is usually round. These locks consistently appear on long guns catalogued as Turkish which have a part velvet-covered stock and lozenge-shaped mother-of-pearl plaques covering the stock adjacent to the chamber, though silver and silver-gilt embossed sheet metal also occur. (See Catalogue nos 54, 55, 56 and 57.) In all particulars they differ from the usual metropolitan Turkish gun and are from the Balkans.

In the early nineteenth century the Russians were well aware of the excellence of Bulgarian gunsmithing and were eager to persuade craftsmen to move to Russian arms production centres. Weapons production, which in Bulgaria had always been based on individual craftsmanship, declined during the mid-nineteenth century due to the increasing industrialisation and mass production amongst the more advanced nations and virtually disappeared within a very few decades. The process began with the import of mass-produced Liège percussion guns between 1830 and 1860 and culminated in the 1870s with large orders for Winchesters and Martini-Peabody guns for the army.

Many of the people of the Balkans were non-Muslim Ottoman subjects, *re'aya* of questionable allegiance, and the Ottomans intermittently initiated searches for prohibited arms as they did elsewhere in the empire. In 1709 and 1711 there were searches in the region of Silistra and in 1826 a report from the same region lists the confiscation of 3,905 guns, 311 pistols, 45 swords and 220 daggers.[10] Other peoples of the Balkans, particularly from the impoverished mountain regions such as Albania and Montenegro, had a traditional occupation as mercenaries or *bashi bazouks* in the Ottoman army and it would have been difficult or impractical to attempt to disarm them. Ottoman rule never really extended over the remote and inaccessible mountain areas, where cavalry could not be used. Greece, Albania and

Montenegro were never completely subjugated and in return for military service or payment of a nominal tribute were allowed considerable autonomy. Indeed, for the Ottomans to have forced their rule on these mountain peoples would have been as expensive as it would have been pointless. Albanian guards served high Ottoman officials throughout the Balkans.

In Greece the so-called *klephts*, or bandits, in the mountain villages (*klephtochoria*) robbed lowland Greek and Turk with indiscriminate enthusiasm, needing little encouragement from the Venetians who held the Ionian Islands, from which they supplied money and arms for use against their Ottoman enemies. The mercenary's calling took them, and their region's arms, to all cor-

ners of the Ottoman empire. There also appears to have been a considerable interchange of arms between the various regions within the Balkans, so that the distinctive arms of one area may appear in a totally different one. It may be said that the Balkans produced more warriors and arms than could be absorbed locally. The description of mercenaries as Albanian often covered levies from a considerably wider area; Albanians had a high reputation as skirmishers in the seventeenth and eighteenth centuries:

> ...the Albanians are a militia from Bosnia, Albania and Macedonia, most of them on foot; they are counted amongst the volunteers. They serve by contract...they

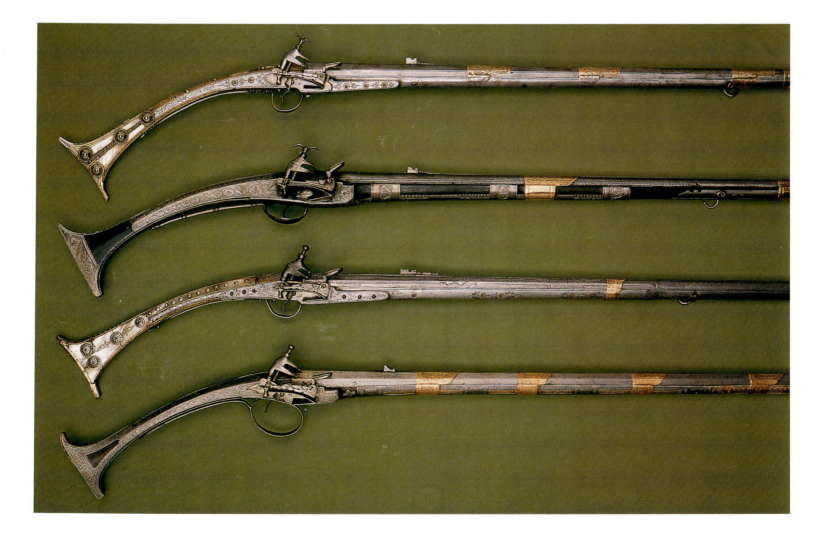

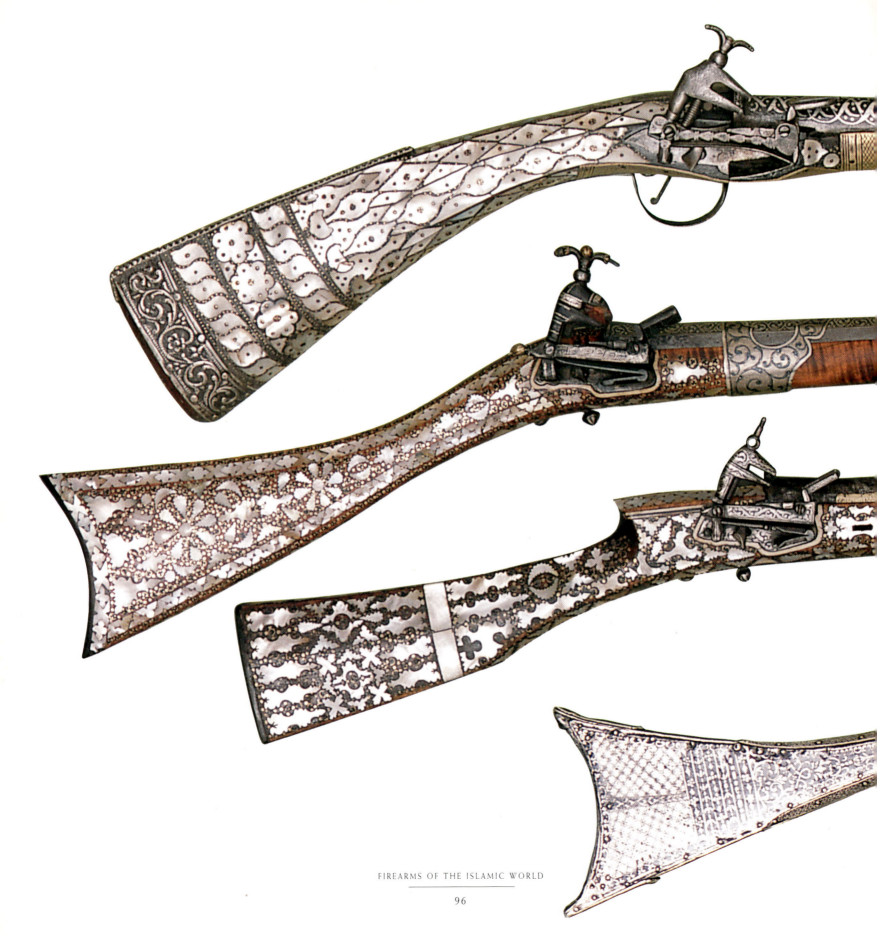

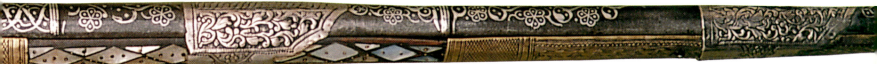

64. A nineteenth-century western Balkans (Herzegovina or Montenegro) miquelet *dzeferdar* with a late seventeenth-century barrel.

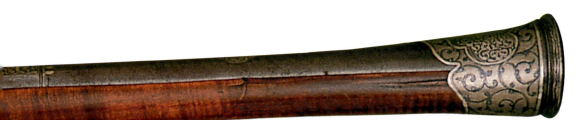

65. A nineteenth-century Balkan miquelet blunderbuss.

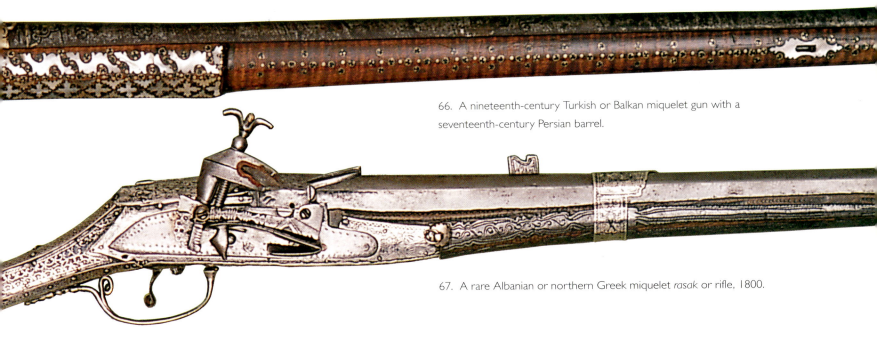

66. A nineteenth-century Turkish or Balkan miquelet gun with a seventeenth-century Persian barrel.

67. A rare Albanian or northern Greek miquelet *rasak* or rifle, 1800.

are recruited in this fashion: a Turkish officer proposes to raise a corps of eight to ten thousand men, whom he will arm and maintain in consideration of ten crowns [ecus] per month for each man; and this contract is normally for one campaign or five months. If there is further need of these troops, the contract is renewed...'[11]

Firearms from the Balkans are extremely varied in form and frequently employ imported barrels and locks. Pistols were extremely popular and very widely owned – usually embellished, with embossed silver sheet covering all but a part of the barrel. According to Temesváry, beginning in the eighteenth century 'Balkan pistols began to pour in, in ever greater quantities' to Hungary,[12] which had liberated itself from Ottoman control at the end of the seventeenth century. In the western Balkans: 'The poorer people carry only one pistol in their belts, but it is their constant companion; and when they afford to have the long peaked handle of it worked in rough silver, they are not a little proud of their weapon. They are not so particular about the barrel or the lock; for most of these pistols, when fired, if they do not burst, lacerate the hand very badly.'[13]

Weapons were an integral part of the national costume of a Montenegrin man, due to the continuous fighting that took place between the indigenous peoples and against the Turks.[14] Weapons became a necessity and a mark of status and freedom and were ornamented extensively to reflect their importance and that of their owner. It was usual to wear a brace of silver pistols, called *ledenica* [pl. *ledenice*] or *kubura*; and a *yataghan*[15] and to carry a long rifle, either the type called a *dzeferdar* (a word of Turkish origin) or an *arnautka*, the latter referring to the name 'Arnaut' by which these men were known as mercenaries throughout the Ottoman East. The Montenegrins were particularly noted for their ability in hand-to-hand conflict with the *yataghan*.

Montenegrin weapons were made in the workshops in the Bay of Boka Katorska, at Kotor, Skadar, Prizren and elsewhere. Kotor was one of the earliest towns to use cannon in the Balkans in 1378 when it employed three bombards against the warships of Venice.[16] The pistols are decorated overall with silver sheet, to which is applied plaques of niello, or coral in settings. The bulbous butts are cast with baroque decorative detailing, and silver filigree and granulation is usually employed. These pistols are made with vestigial ramrods since it was the practice to carry a separate and ornate ramrod on a cord for actual use.

The *dzeferdar* rifles are decorated with mother-of-pearl plaques over the wooden stock. Locally produced barrels are decorated with a zigzag line engraved on the barrel. These represent lightning or snakes, in either case adding to the potency of the weapon while also serving to ward off the evil eye. The *arnautka* rifles are sometimes entirely sheathed in silver metal and end in the characteristic T-shaped butt. The ramrod is called *arbija*. In the 1890s Liège produced a large revolver copied from the Austrian Gasser, known in the gun trade as the 'Montenegrin'.

In the Tareq Rajab Museum the firearms of this area are well represented. From Albania or Montenegro come Catalogue numbers 60, 61, 62 and 63, with their fish-tail stocks. Catalogue number 67 is also from Albania, and is similar in type to the so-called musket (Greek *doufeki* or *toufeki*) of Ali Pasha in the Benaki Museum, Athens, which was very probably a gift from Lord Byron. Ali Pasha ruled for thirty-three years from his capital Jannina, an area of north-western Greece and Albania.[17] This flintlock rifle is entirely sheathed in embossed, lightly-gilded silver sheet, typical of the work of the region. Bartlett Wells pithily describes the type: 'The elements are floral, the spirit is bold and splashy; and the mechanical fitting is rather slipshod.' Ali Pasha had no compunction in declaring that a gun was a gift from a ruler and, when the gift was insufficiently grand for his exalted state, in embellishing it, as he did with some rather plain guns which Napoleon had sent him. A similar flintlock long gun is in the Metropolitan Museum, New York,[18] which suggests that the lock and barrel are French. It is decorated with sapphires, diamonds and thousands of seed pearls. Clearly this was the parade weapon of a person of importance. Another miquelet lock gun of a different form is also in the Metropolitan Museum,[19] dated 1814/15 and formerly owned by Ali Pasha of Jannina.

Ali Pasha of Jannina, north-western Greece, 'after a sketch by L. Dupré, taken from life at Bucintre, March 9th, 1819'. Engraved by Robert Havell & Son, Published by Messrs Colnaghi & Co., London. Most of the contemporary sketches of Ali Pasha show him armed with typical rat-tail pistols and with other Balkan arms hanging haphazardly on the wall of his palace. British Museum.

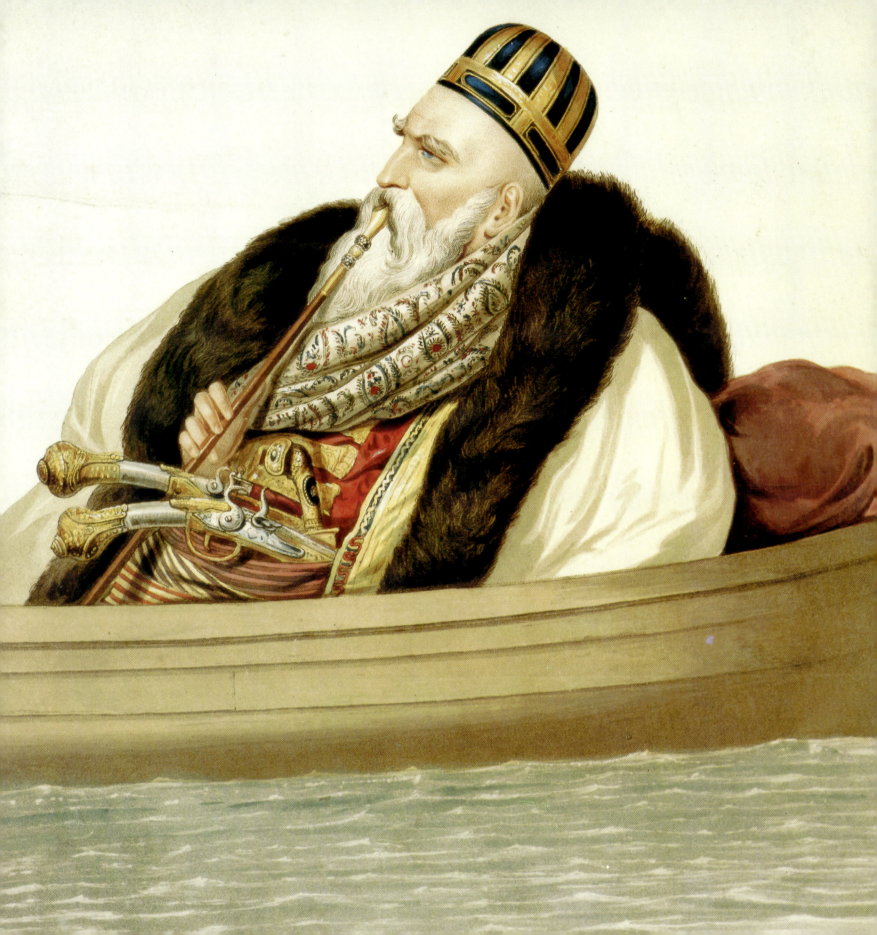

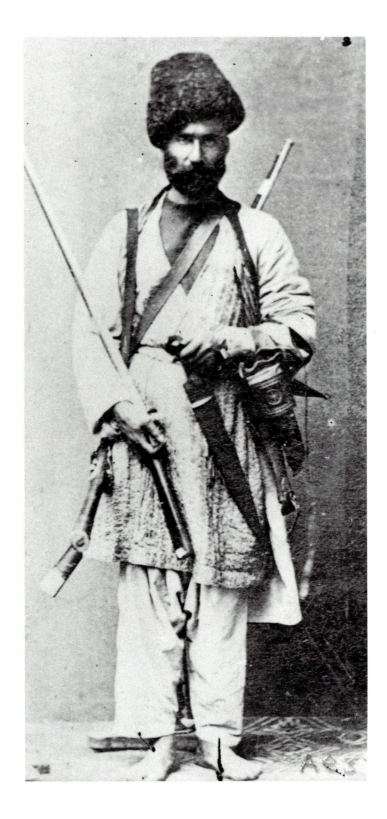

THE CAUCASUS AND DAGHESTAN

THE PRODUCTION of fine weapons has a long tradition in the Caucasus. The metal-working tradition is similar to that of Persia, but the firearms are quite distinctive, with some common elements. For example, the wood used for stocks in the Caucasus and western Persia is very frequently burr elm.[1] The main centre of production was Kubachi in Daghestan,[2] which was famous for niello work and heavy gold floral decoration contrasted with steel, but Kumukh and Kazanistehi were also important centres for firearms.[3] That the Caucasus enjoyed such a high reputation for niello should not disguise the fact that the towns of eastern Anatolia such as Trabzon, Erzurum and Van were also notable exponents of the technique. The Russians fought for many years to subdue Muslim resistance and incorporate the region into their empire.[4] They were hindered by the local convention that to be disarmed was to be dishonoured. Arms were the most cherished possessions of any family, handed down from father to son. The arms of the Caucasus were so famous that in 1831 men were sent from the Russian government works at Zlato-oust to Tiflis to learn the art of steel-making from a certain Eliazaroff.[5] The Circassians were visited in 1834 by the Scot, David Urquart, who sought to persuade the British government to support resistance against the Russians. Unsuccessful in this, he nevertheless managed to supply them with arms purchased in Britain by private subscription. For the study of firearms the area divides into north-west Caucasus and Daghestan.[6]

NORTH-WEST CAUCASUS

As has already been mentioned, there was considerable trade in the sixteenth century between the Turkish coast and the port of Sukhumi. Ottoman merchants traded in weapons of all kinds, particularly guns. However, demand far outstripped supply and it was not until the eighteenth century that firearms could be said to be widespread. Guns were made locally in small quantities and

A weapons seller; Tiflis, c. 1865-70. Pitt Rivers Museum , Oxford.

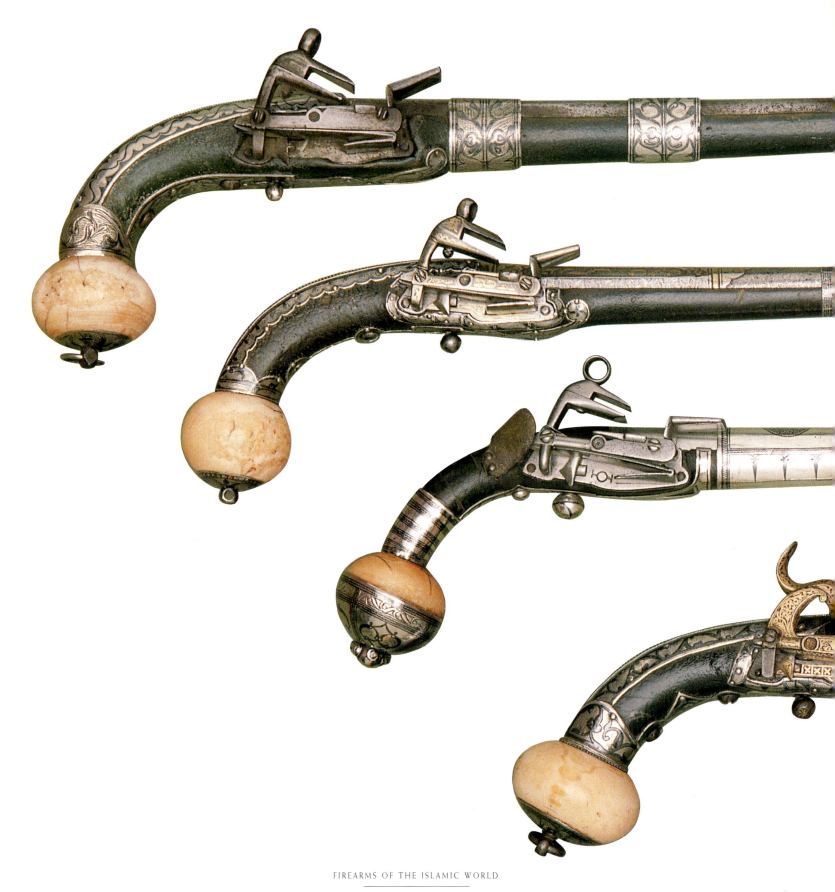

68. A Caucasian miquelet ball-butted holster pistol,
c. 1780, with a barrel inscribed Lazarino.

69. A Caucasian miquelet ball-butted holster pistol,
c. 1800.

70. A Caucasian miquelet ball-butted holster pistol,
c. 1800.

71. An unusual Caucasian miquelet percussion
lock, ball-butted holster pistol, dated 1850.

bought from the Crimea and from Kubachi in Daghestan, which was famous for its arms throughout the Near and Middle East and Russia and supplied a large market. It has been argued that guns with faceted barrels and the Turkish inscription 'tested', dating from the late eighteenth or nineteenth centuries, are probably from the Crimea.[7] As has been shown earlier, this mark appears on Turkish guns until the end of the eighteenth century, though it is possible that it was copied elsewhere in the region. These guns have long, narrow, leather-covered stocks and are almost without decoration. Guns made by the local gunsmiths in the north-west Caucasus have heavier barrels and silver capucines,[8] and applied silver plates, decorated with a local design. The production level of firearms was particularly high in the 1840s and 1850s, reflecting the conflicts in the area at that time. Examples in the Tareq Rajab Museum include Catalogue numbers 68, 69, 70 and 71, which are distinguished by ivory ball butts and their black, leather-covered stocks, silver niello – particularly the distinctive capucines which hold the excellent barrels in place – and the rather flat miquelet locks.

DAGHESTAN

The manufacture of firearms in Daghestan probably began in the second half of the seventeenth century. They were made in a number of villages, the most important being Kharbuk and Kubachi. Kharbuk specialised in making barrels, and the work was divided between three armourers, one of whom did the rough forging, after which the barrel was rifled and finished by filing. The barrel was then sent to Kubachi where the gold damascening was applied. The barrels manufactured at Kharbuk are decorated with an arch shape embellished with gold inlay, such as Catalogue no. 69 in the Tareq Rajab Museum.

The Kubachi craftsmen also made the lock, all the silver decorative parts and the stock, and assembled the weapon. Pistols made in Kubachi in the first half of the nineteenth century have a wooden stock with a pear-shaped grip. The stock is sometimes decorated with silver plaques. Later examples made use of ivory and the stocks tended to be more closely covered with nielloed silver plate. Towards the end of the nineteenth century in Kubachi, deep engraving or chasing came into fashion. The craftsmen argued that this gave a better grip, ensuring that the pistol did not slip in the hand. The Kubachi decorative repertoire consisted of stems, twigs and leaves centred round a flower head in a very symetrical pattern. This distinctive style soon spread to other parts of the Caucasus. Two of the most popular designs in Daghestan were the 'thicket' (*markharai*) and 'branch' (*tutta*). Particularly exuberant decoration was often the work of Lak armourers from the district of the same name, who travelled in search of work and tended to produce cruder weapons than Kubachi craftsmen. A good example is illustrated by Blair.[9]

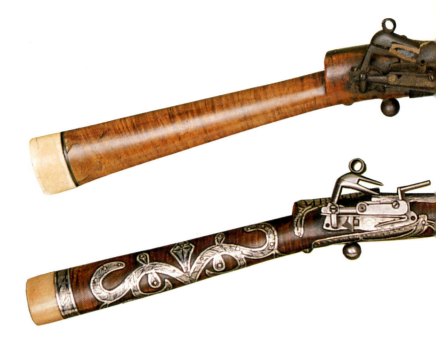

At the end of the nineteenth century this decoration became finer and even more intricate, with a stricter control of the composition, whilst new materials such as enamel began to be employed. Particularly fine silver-work was done in the Kazi-Kumukh district in Daghestan from the 1860s. Because of the small local market, the craftsmen emigrated to other areas of the Caucasus and southern Russia. These pistols had a good reputation in Russia for accuracy and were bought by Russian officers. (See pistol Catalogue no. 71). A pistol of this type from Daghestan in the Victoria & Albert Museum, London, is dated 1786, indicating that the design scarcely changed over the next

69a. A Caucasian miquelet ball-butted holster pistol, *c.* 1800, viewed from above (see also p.103).

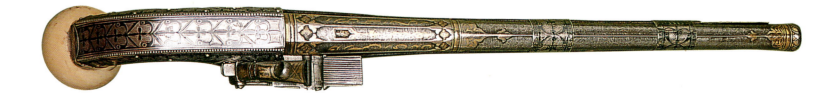

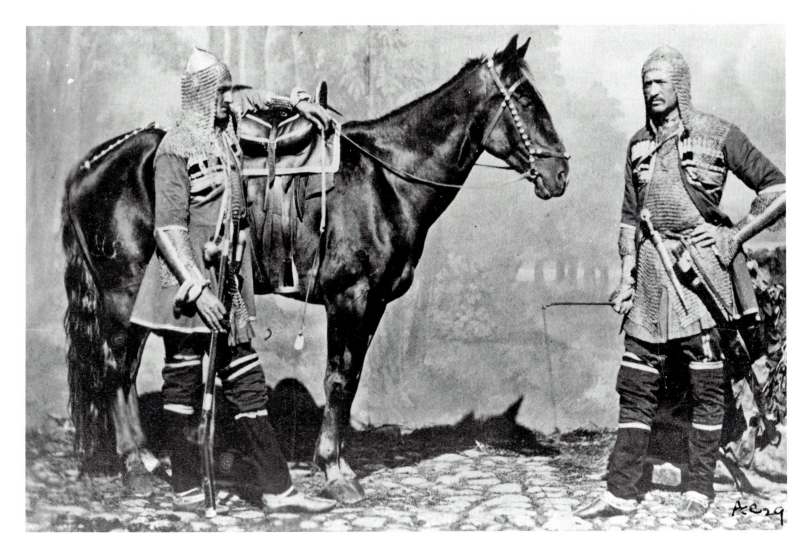

72. A miquelet rifle, *c.* 1800, from Daghestan.

73. An early nineteenth-century miquelet rifle from Daghestan.

Khevsur tribal warriors. Caucasus, *c.* 1870. Pitt Rivers Museum, Oxford.

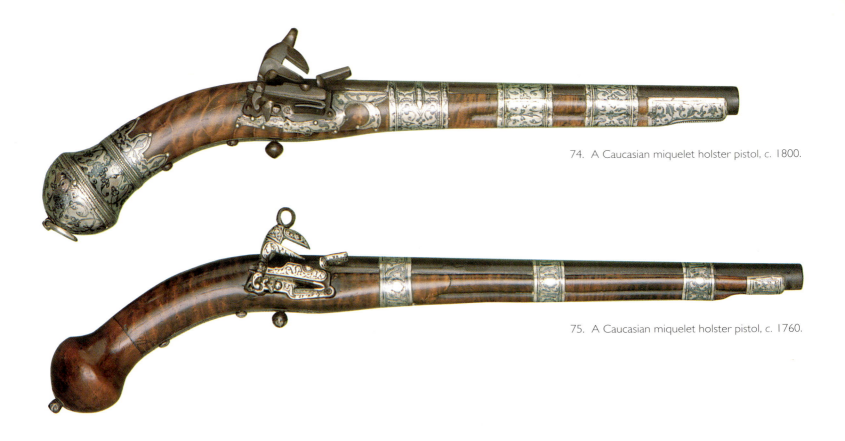

74. A Caucasian miquelet holster pistol, c. 1800.

75. A Caucasian miquelet holster pistol, c. 1760.

hundred years.[10] Many of these guns are of later date than appearances suggest. Hundreds of Kubachi guns were traded in the villages of Daghestan in the 1880s and the flintlock remained in use at this very late period because the sale of modern cartridge weapons was prohibited in the area (as was the case in the Central Asian Khanates after their occupation by the Russians), though the manufacture of the flintlock mechanism declined. Chirkov states that flintlock production stopped in the mid-nineteenth century.

The arms produced in the Caucasus were exported widely. Egerton wrote that the Durrani chiefs from Herat and Kabul prized pistols from Daghestan above all others, but they were so perfectly copied in Kashmir as to be indistinguishable.[11] Grancsay describes a fine Caucasian rifle which he dates to about 1825. This bears an inscription which states that the rifle belonged to Bab Muslim Khan and was made in Shamkhal in Daghestan.[12]

Palgrave describes the appearance of the Georgian soldiers in the second half of the nineteenth century: 'In the girdle are invariably stuck a long double-edged knife or dagger, and one or two silver adorned pistols. In the hand or over the shoulder is a single barrelled gun, long, bright, brass-mounted with a flintlock; this the Georgian never fails to carry with him.'[13] He also paid tribute to the quality of their craftsmanship: 'What most distinguishes them is their skill in handicraft. Guns, pistols, swords, daggers, embroidery, silver work, the staple articles of manufacture among a semi-barbarous people – for all these the Georgian holds the first rank in the Anatolian market: and the primitive simplicity of the tools employed enhances the cunning of the worker's hand.'[14]

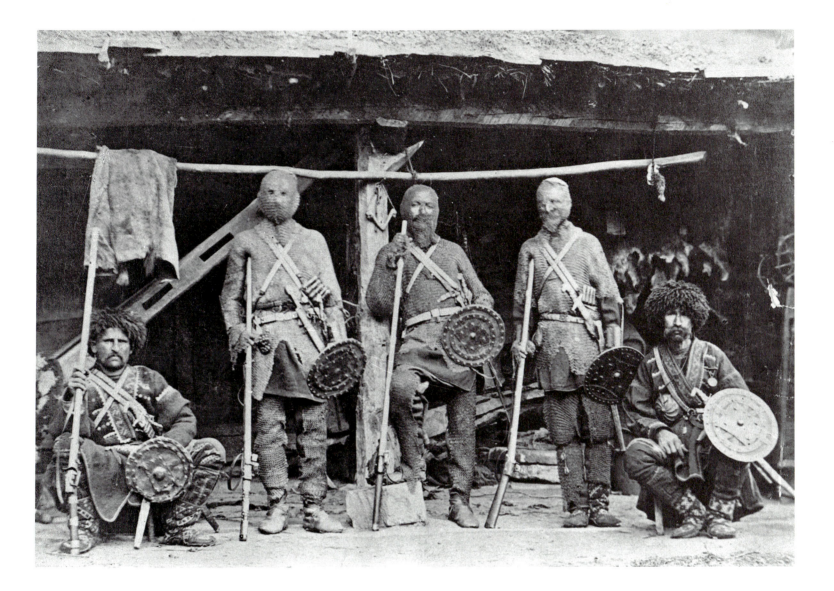

A posed group of Khevsur tribal warriors. Caucasus, c. 1870.
Pitt Rivers Museum, Oxford.

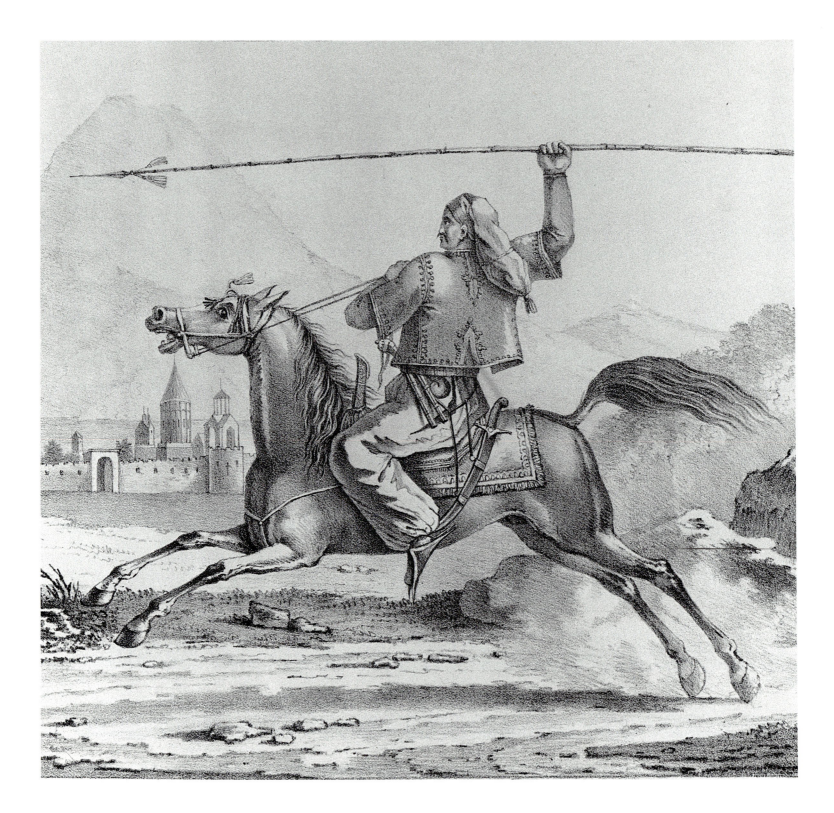

NORTHERN SYRIA AND IRAQ

THE TYPE OF ARMS used by the Mamluks in Egypt in their war with the French at the end of the eighteenth century was also in vogue in northern Syria and Iraq, where the style was more Iranian. In May 1810, Burckhardt visited the Ryhanlu Turcomans who inhabited a region 'seven hours distance from Aleppo to the north-westward'.

> A Turkman never leaves his tent to take a ride in the neighbourhood without being armed with his gun, pistols, and sabre. I was astonished to see that they do not take the smallest care of their firearms: a great number were shewn to me, to know whether they were of English manufacture; I found them covered with rust, and they complained of their often missing fire. They have no gunsmiths amongst them; nor any artizans at all, except some farriers, and a few makers of bridles and of horse accoutrements.[1]

Ker Porter inspected a Kurdish warrior in full fighting harness in 1818 which included armour, a sabre and guns, replacing the bow:[2]

> ...a short carbine slung across the left shoulder by a rich belt of leather or velvet embossed with silver and gold, and hanging pretty low down upon the right hip. A small silver powderhorn is attached to the same side, usually ornamented with pendent pieces of money; also an iron ramrod, suspended by a silk cord from the same shoulder, together with an embroidered cartouche-case for charges. On the appropriate side appears a similar little appendage, to contain a page of the Koran, charms, etc. A couple of long pistols are stuck in a crimson velvet belt, fastened before by a pair of large clasps of embossed metal.

Kurdish cavalryman armed with Caucasian pistols. French print, c. 1830. Courtesy of the Director, National Army Museum, London.

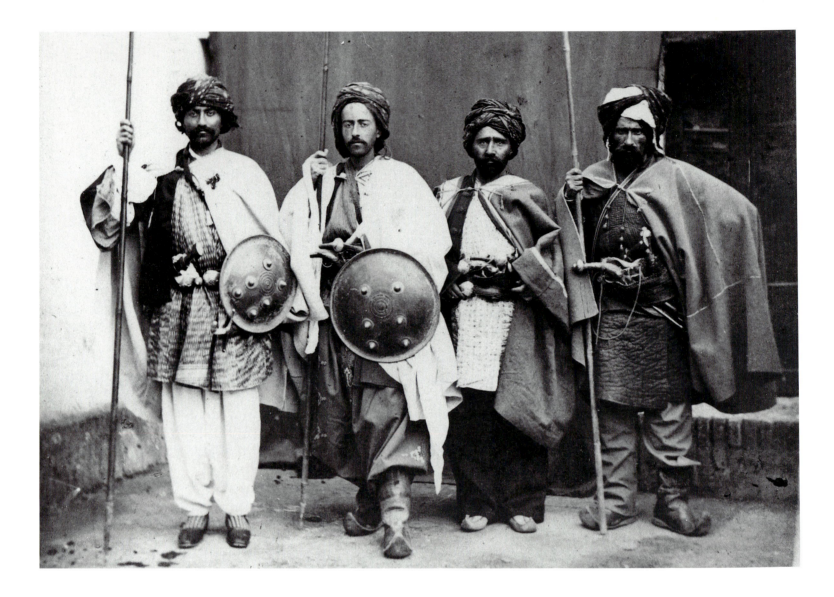

Heavily armed Kurds wearing Caucasian pistols pose in a makeshift studio in Tehran, 1867. Sykes Collection, Middle East Centre, St Antony's College, Oxford.

Despite the presence of these firearms, the Kurd's costume was extremely conservative, reflecting a style of warfare unchanged for centuries and remarkably unaffected by the improvements in firearms.

His shirt of mail was bright, and closely rivetted, and ornamented in various parts with small roses embossed in silver. The helmet consisted of a skull cap of damasked steel. It had a gilt nasal-defence, capable of being lowered

or elevated by means of a screw. A spike projected from the crown; and two small tubes started from just over the forehead, for carrying heron's or peacock's feathers. This plumage is not merely ornamental; it distinguishes the martial character of the wearer, a new feather being added to the crest for every fresh enemy who has fallen by his sword. Hence comes a saying in Courdistan [Kurdistan], 'Ah! Your courage has not given your helmet wherewithal to keep your helmet from the burning sun!' We have something like the idea, when we talk of any enterprise being a feather in a man's cap.[3]

In addition to his mail shirt and helmet the warrior had further defensive arms. The description of the single armguard or *bazuband* negates the commonly held belief that sets of shield, helmet and single armguard were invariably produced only to mount for display in European smoking rooms in the nineteenth century.

Part of the left arm is covered with a length of steel, which, united with the gauntlet, defends that member as high as the elbow. The right arm has no defence, its clothing being nothing more than the sleeve of the undervest. The shield, round and very small slung across the right shoulder and when the warrior is mounted, hangs behind the right leg... The sword is disposed in a similar manner to that of the Turks and Arabs.

Burckhardt describes how the great Turcoman tribes were often at war with one another and with the Kurds, though these wars seldom led to many fatalities. He gives as an example one five- or six-month 'war' in which six Kurds and four Turcomans were slain. In their mountain raids the Turcomans were accompanied by tribesmen on foot, armed with muskets, these being men who could not afford a horse. 'Neither the lance, nor the bow is used among them. Some tribes of Kurds, on the contrary, have never abandoned the use of the bow.'[4]

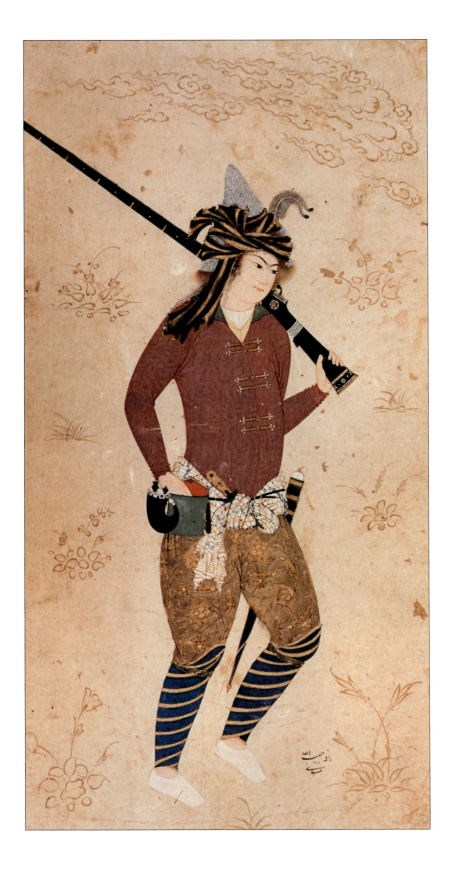

CHAPTER TEN

IRAN, AFGHANISTAN AND THE KHANATES

T HE HISTORIAN Rashid al-Din in his *Jami' al-tawarikh* written at the beginning of the fourteenth century, does not discuss firearms or cannon, though the manuscript does have illustrations of catapults (*manjaniq*) operated by Arabs attacking walled cities. These hurled a ball that was often wrapped in cloth soaked in oil and ignited. There is no sign in the miniatures of any transmission of Chinese firearms technology to the Islamic world. Firearms are said by Bausani to have first appeared in Iran in 1387 when they were known as *ra'd-andaz*, meaning 'thunder thrower', and at the end of the fifteenth century a few very primitive cannon were being produced in Herat.[1] Whether *ra'd-andaz* constitutes a firearm is dubious, but the more usual translation is 'explosive grenade'.[2] Timur encountered *ra'd-andaz* when he fought against Sultan Mahmud at Delhi in 800/1398. The *howdahs* on the sultan's elephants on that occasion had *ra'd-andaz* or hand-grenade throwers within them. As late as 1832, Mrs Meer Hassan Ali, reflecting the Persian culture of northern India, described matchlock men as *burkhandhars*, from *barq-andaz* meaning lightning-thrower.[3] Belenitsky, too, appears to believe that implements accorded to the descriptions 'thunder' or 'fire', 'must have been firearms'. It seems more likely that these words are transferred from one invention to their more modern replacement. Clavijo, the Spanish Ambassador sent to Timur's court at Samarkand, records the defeat of the Ottomans at the battle of Ankara in 1402 and

A young Persian carrying a matchlock, painted by Habibullah of Mashhad, c. 1600. Opaque colours and gold. Staatliche Museen Preussischer Kulturbesitz: Islamische Kunst.

describes the captive craftsmen from Syria and Anatolia, including makers of siege catapults, being herded back to embellish the victor's court: '...he [Timur] had gathered to settle here in Samarkand artillery men, both engineers and bombadiers, besides those who make the ropes by which these engines work.' Clavijo suggests that these machines were new in Samarkand by his remark: 'Lastly hemp and flax had been sown and grown for the purpose in the Samarkand lands, where never before this crop had been cultivated.'[4] There are a number of references to *tup*, the word later used to mean cannon, in the fourteenth-century texts, but it is not always clear whether siege engines such as mangonels or actual firearms are being referred to. Woods quotes *tup-i giran*, a heavy engine used for shattering walls; and also 'when once, following the custom, a tup projected fire' at the castle.

The history of firearms in western Iran and Iraq really begins during the rule of the Aq Qoyunlu leader Uzun Hasan or Long Hasan. The Aq Qoyunlu or 'White sheep' were a confederation of Sunni Turcomans centred on Diyarbakir and related by marriage to the dynasty of the Trebizond emperors. Uzun Hasan overthrew his Turcoman rivals the Shi'ite Qara Qoyunlu, or Black Sheep Turcomans, conquered Baghdad in 1469 and ruled over most of Iran except Khurasan in the east. The Christian countries of Europe saw him as an enemy of the Ottomans and therefore as a potential ally, and beginning in 1463, envoys were sent to his court from Venice, Naples, Hungary and Poland. Uzun Hasan's army was not equipped with firearms, so the Venetians decided to make good this deficiency: 'In 1471 the Signoria of Venice sent him six bombards, 600 culverin, matchlocks [*schiopetti*] etc. Owing to the complications at Cyprus the consignment did not reach Tabriz but it can be confidently assumed that the "sulpheric arts' had no secrets for the Aq Qoyunlu."[5]

Elsewhere the Venetian arms are given as '52 mortars, six of them large ones, 500 arquebuses, and 200 musketeers in order to instruct his army in their use'. It is agreed that the arms failed to arrive before the Aq Qoyunlu were attacked by an Ottoman army using firearms. In the first engagement the Turks under Mehmed Fatih suffered 12,000 casualties, but in a subsequent engagement at Terjan the Aq Qoyunlu were driven from the field by the Turkish guns. The main body of Uzun Hasan's forces escaped unscathed and no alteration to the frontier between the two powers resulted.[6] The '100 artillerymen of experience and capacity', sent by Venice under the command of Tommaso di Imola to Uzun Hasan in the 1470s, were sent on to Iran[7] and no more was heard of them. A document has survived that describes a great review of the Turcoman forces at Fars in 881/1476, listing the numbers of troops and their function. Many were armoured foot soldiers but the greater part were archers. Despite the large numbers and the presence of many important Turcoman leaders, there is no mention of the presence of firearms.[8] Uzun Hasan was not present at the review and died in 1478. There is evidence of a cannon cast of bronze at Mardin by order of Ya'kub Sultan Aq Qoyunlu, the son of Uzun Hasan (d. 896/1490)[9] An Iranian miniature painting of about 1500 (see facing page) shows a cannon, but the artist has apparently only heard of this remarkable weapon and has failed to understand the manner in which it functions since it is depicted shooting arrows like a machine gun.[10] It seems very likely that the artist has been influenced by Chinese depictions of cannon, possibly Chinese fire-arrows, which were used by the Mongols in their campaigns across Persia, or else by the Timurids whose links to China along the Silk Route were well established.

An anonymous Venetian merchant who travelled across the Shah's lands in 1507 reported the use of cannon at the siege of Arantelia. The merchant met personally the master gunner whose name he reported as 'Kamusabec' (Hamzabeg?) of Trebizond. In 1508 a Venetian Ambassador was asked to supply artillery. The period of domination by the Aq Qoyunlu Turcomans was of great importance for the history of Iran and in many respects the early Safavids merely continued the practices of their predecessors, not least by demonstrating a fair disinterest in the military possibilities of firearms.

The Safavids rose from dervish origins by a long campaign of propaganda amongst the heterodox Turcomans of eastern

Assault on a castle. From a lost manuscript, ascribed to Bihzad. Persia, c. 1500. Opaque watercolour and gold on paper. This picture shows a vase-shaped cannon in use. The artist has little familiarity with cannon and believes that they shoot arrows in a continuous stream. Harvard University Art Museums, Cambridge, Massachusetts.

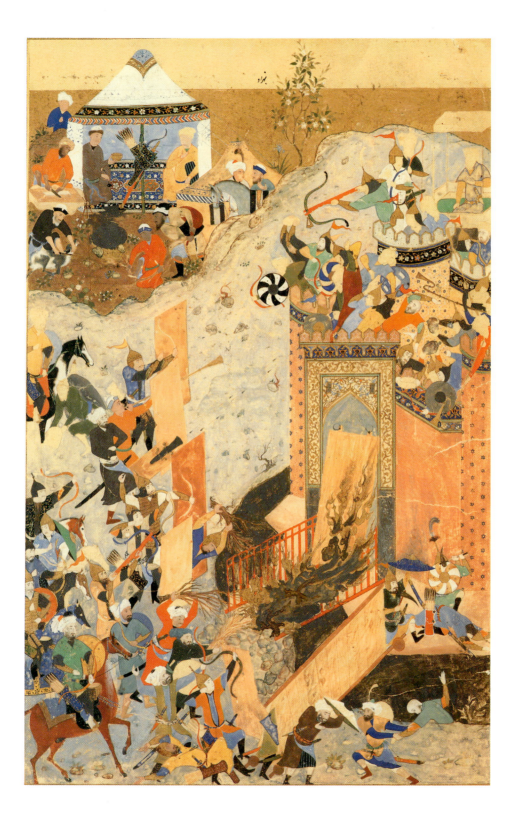

Anatolia. Shah Isma'il and his successors professed Alid origins and claimed a semi-divine status as the reincarnations of the Shi'i Imams. The Turkish tribesmen who supported them were known as Qizilbash from the red caps symbolising their spiritual and political allegiance. Isma'il seized Azerbaijan from the Aq Qoyunlu in 1501 and over the next ten years brought the whole of Iran under Safavid control. The Safavid movement had to confront the Sunni Ottomans, who were intent on expanding eastwards in Anatolia, and the Uzbeks, also Sunni, in the north-east. The Ottoman sultan Selim 'the Grim' led an army east and defeated the Safavid forces at Chaldiran, subsequently occupying Tabriz, the Safavid capital, before returning to Istanbul, taking with him Iranian craftsmen, including armourers.

The Ottomans won at Chaldiran because of their artillery and arquebuses which were anathema to the Safavids.[11] Nevertheless, casualties in the Ottoman army were very high. The janissaries who as Bektashi dervishes were highly susceptible to the Sufi[12] mysticism of the Safavids were not keen to fight a foe for whom they had religious sympathy, while the fanaticism of the Qizilbash made them formidable opponents. According to the Venetian Ambassador Contarini, writing in Italian in 1519, the Turks esteemed the Iranians as better fighters than any other nation, even the Hungarians: 'the Turks have a great fear of the Persians, saying that they fight fearlessly and are well armed with good arms; and until they are wounded, and have fallen to the ground, they fight with all their strength; so that, all in all, the Turks hesitated to fight them. They regard them as superior to the Hungarians or any other nation that they have fought.'

Shah Isma'il knew that he could not afford another defeat of the magnitude of Chaldiran, nor could he hope to win unless he could match the firepower of the Ottomans. He therefore set out to create artillery and arquebus units of his own to re-establish his military credibility, in the face of opposition from his Qizilbash supporters. The story is told by the historian, Bacqué-Grammont, largely on the evidence of an Ottoman spy whose reports survive in the Ottoman archives.[13]

It seems that after a time Isma'il recognised that his efforts at creating a firearms unit to match the size and efficiency of that of the Ottomans were not likely to be successful and that he quite deliberately organised a propaganda campaign to impress upon everyone the strength of his new weapons to compensate for this weakness. One of the earliest references to firearms in the shah's army occurs a little after the battle of Eski Koc Hissar in 1516. While crossing the Araxe River in their retreat from Tabriz the Ottomans had lost one or more cannon which the Iranians retrieved. The shah had fifty copies cast. These he fired to celebrate the Iranian New Year in an ostentatious display. Twenty janissaries deserted to the shah's camp and became instructors and two thousand arquebuses were made, which were frequently paraded. Historians have previously questioned the existence of these firearms on the grounds that one never sees the Safavid chronicles indicate the presence of firearms in any combat. However, Bacqué-Grammont states that they are repeatedly mentioned in the Ottoman and Venetian sources.[14] The arquebuses and artillery were served by deserters from the Ottoman army and also from the Portuguese. In 1515 the shah refused a formal Portuguese offer of firearms from Fernao Gomez. By the end of 1517, three to four thousand arquebuses in the hands of the Safavid army are mentioned regularly in the Ottoman spy's reports, a plausible number to produce as the result of three years' work. That Shah Isma'il failed to construct a firearms unit which was capable of confronting the janissaries is clear. Antipathy amongst the Qizilbash to guns remained until the end of the century. The shah was forced to recruit from Shirvan, the Caspian principalities and Georgia in order to escape the restrictions imposed by the semi-autonomous Qizilbash begs who had the right to raise their own troops and establish arsenals and forts. Nevertheless, the effective screen of Safavid propaganda about the strength of the Safavid army in firearms may have been responsible for Selim I's decision in 1518 not to proceed with a fresh invasion of Iran.

In Safavid Iran firearms were of two categories. *Tup*, meaning all types of cannon, and *tufang*, meaning all types of handguns. In 930/1523-4 it is recorded that the garrison at Herat included *piyadagan-i tufang-andaz* or infantry with handguns. In 1527 Kapaksultan Ustajlu was killed by an arquebus at the battle of Arpa Cay. In 1528/9 Shah Tahmasp's army in Khurasan included a unit of *Rumlu tufangcis* (Turkish arquebus men).[15] A report of Shah Tahmasp's victory over the Uzbeks with the aid of *tufak u araba* (*Rumi* fashion with matchlock and cart) occurs in the *Babur-Nama*.[16]

In 955/1548 the Portuguese supplied Shah Tahmasp with 20 cannon and 10,000 men to meet the Ottoman invasion.[17]

These may have been used at the siege of Kish in 1551 where it is recorded that the Iranians used 'Frankish cannon' (tup-i farangi).[18] The Ottoman Prince Bayazid, who sought refuge with Shah Tahmasp in 966/1559, is reported to have brought 30 pieces of artillery to Iran with him.[19]

The Russian annexation of the Astrakhan Khanate in 1556 by Ivan the Terrible gave the expanding Muscovite state an important outlet to the Caspian Sea and access to the northern end of the well-established Asian trade routes which stretched across Iran and Turan to northern India. Together with the northern port of Archangel which linked Russia with northern Europe, Astrakhan was Russia's most important link with the outside world for the next hundred and fifty years.[20] It was also of great importance to Iran, particularly because of the periodic economic blockades enforced against them by the Ottomans, which were intended to deny the Iranians the military materials and the finances to wage war. A letter written by the English merchant Arthur Edwards in Astrakan dated 16 June 1567, on his return from his first journey to Iran, describes amongst the items that the shah had requested 'three or four complete harnesses that will abide the shot of a handgun'. He also asked for 'twenty handguns, being good...' and 'also six good dags[21] with lockes travell withall'.[22]

A few years later a traveller recorded that the shah of Iran had no 'great ordinance, or guns or harquebusses'.[23] This view must be considered mistaken, as evidenced by the miniatures depicting the Safavid court in the first half of the century, but gives a fair indication of the antipathy to firearms which were clearly not openly displayed at that time.[24] This view is reinforced by Abel Pinçon, a gentleman in Sir Anthony Sherley's party who commented at the end of the century that 'infantry are held in poor esteem' and that 'quite recently they have acquired some arquebuses'.[25] It is also worth noting that in Persian miniatures the person armed with a matchlock usually occupies a subordinate position towards the margin of the painting until the end of the sixteenth century. The date at which portraits of an Islamic ruler begin to show him holding a firearm instead of the traditional weapons of sword, spear or bow is a good indication of when firearms became acceptable throughout society. A possible indication of the attitude of the Iranian court is provided by the inclusion of forty muskets amongst the diplomatic gifts presented to the Mughal Emperor Jahangir in 1616 by the Persian Ambassador

Muhammad Reza Beg.[26] There is a record of the preparation of a gift of arms from the Spanish monarch Philip IV to the 'king of Persia' in 1614, the supervision being the responsibility of Felipe Marquart in the Real Armería.[27] It is a pity that Roe was not more specific about the forty muskets as the two events may be related. He does remark that the Iranian embassy pretended to have as their business, the well-being of the Shi'ite Deccani rulers, but that their real purpose was to win the Mughal's alliance against the Ottomans.

The Iranians, like the Mamluks, disliked artillery. Extreme importance was given to mobility in Iranian warfare which the presence of artillery hindered, so that it appeared principally at sieges. Artillery was not likely to appeal to nomads whose whole ethos was based on mobility and the skills associated with horsemanship and the bow. It has been claimed that the Sherley brothers who entered Iran in 1598 introduced cannon into the country. It is true that they had a cannon-founder in their party, but it is clear that the Safavids had had cannon from 1516 and possibly earlier. Indeed, the Ottoman cannon that Shah Isma'il had recovered from the River Araxe in 1516 had passed into folk memory. Abel Pinçon wrote at the end of the century that the Persians 'have no artillery at all... although there are some who have written that Selim in his war with the Sophi left there all the artillery which he had transported over the Euphrates...'[28]

Such was the dislike of artillery that Abbas II (d. 1077/1666) took the extraordinary step of abolishing the corps of artillery and it does not appear again until the reign of Shah Sultan Husayn (1105-35/1694-1722). In 1722, at the battle of Gulnabad against the Afghans, the Iranians had twenty-four cannon under the command of the tupci bashi Ahmad Khan with a French advisor and master gunner, Philippe Colombe. Both lost their lives due to the incompetence of the tupci bashi.[29] Encouragement of the Iranian belief in the uselessness of cannon may have been fostered in 1094/1683 when captured cannon from Hormuz, much of it Portuguese, was displayed in the Maidan in front of the palace in Isfahan. As a result the Maidan acquired the name of 'Cannon Square'. N. Sanson, who saw these guns, described them as almost entirely decayed and useless.[30]

Allahvardi Khan, a Georgian, was made commander of the Iranian forces by Abbas I in 1007/1598, entrusted with the reorganisation of the army along lines supposedly indicated by Sir

76. A late seventeenth-century Persian three-stage gun barrel of 'twist steel' construction.

77. An eighteenth-century Turkish octagonal rifle barrel with 'damascus twist' pattern.

Robert Sherley, who had just arrived bringing a pair of pistols as a gift for the shah, and was in due course given the title of 'Master General against the Turks'. Sir Anthony Sherley has been given the credit for advising Abbas I to form a corps of musketeers on the evidence of a letter dated 22 April 1619, written by the traveller Pietro della Valle. However, this idea is certainly incorrect. Sherley himself describes Abbas I's defeat of the Uzbeks in Khurasan in 1007/1598 with an Iranian army of 30,000 men, including '12000 Harquebusiers which bare long pieces, halfe a foot longer than our musquets, sleightly made ...which they use well and certainly'.[31] It is necessary to distinguish between the existence of firearms and their use in a military unit of arquebusiers. The English traveller Herbert who was in the suite of the British ambassador to Iran, Sir Dodmore Cotton, in 1627 wrote that the Iranians had used arquebuses 'since the Portugals assisted King Tahamas [Shah Tahmasp] with some Christian auxiliaries against the Turk [probably the occasion in 1548 already referred to] so as now they are become very good shots'.[32] Herbert's explanation seems very plausible.

At about this time Shah Abbas established a standing army. Amongst the new regiments raised were 12,000 musketmen recruited from the peasantry or lowest class and a regiment of artillery with 12,000 men and about 500 guns.[33] It would appear that this was a conscious effort to create the Iranian equivalent of

the janissaries, troops without loyalties divided due to tribal membership, under the direct control of the shah himself. For this reason some of the new troops were recruited from the Circassian and Georgian peoples of the Caucasus.

The availability of Russian firearms, which developed through her European contacts, had an effect on her neighbours, particularly in the Caucasus and Iran. Armour and weapons figure often on the lists of gifts sent by the Tsars to the rulers of Persia, the Crimea, the Central Asian khanates and the Nogay Horde.[34] The Russian army during the reign of Ivan the Terrible (1547-88) had some regiments of *strelski* (fusiliers) equipped with matchlocks. Under Tsar Boris Godunov (1595-1605) an armoury was established at Tula in 1595 which initially appears to have concentrated on the production of cannon, some of which were sent to Iran. In 1602 the Grand Duke of Russia sent some artillery to assist Shah Abbas I in the siege of Darband. However, in action against the Uzbeks near Balkh in 1011/1602 the Safavid army abandoned three hundred of their new guns without having fired them. The Iranians also obtained many of their coats of mail from Muscovy, as a number of travellers record.[35] However, the export of Russian armour and weapons to the Islamic world was of political rather than economic importance and even the small quantities which were transported required the authorisation of the Tsar.

A dislike of firearms of all kinds remained a strong Iranian characteristic. Herbert described the Iranians as having little curiosity concerning 'exotic news, seldom exceeding this demand: if such and such a country have good wine, fair women, serviceable houses, and well tempered swords?'[36]

D'Alessandri, writing in 1571, says that Iranian arms are superior and better tempered than those of any other nation and that the barrels of the arquebuses are generally six spans long. Firearms did not come into general use until very late in comparison with neighbouring states, though they can be seen in miniatures from the sixteenth century. The Iranian reputation as superlative craftsmen was indicated by the manufacture of superb gun barrels. Mannering, who accompanied Sir Anthony Sherley to Iran, wrote that 'I did never see better barrels of musquets than I did see there',[37] but the popularity of the bow remained and Pinçon noted in Qazvin the 'masters who make gilded and coloured bows with arrows to match'.[38] Godinho, in the mid-seventeenth century, was amazed by the length of the barrels: 'Their weapons are chiefly bows and arrows, at which they pride themselves as being as adept as the ancient Parthians, their ancestors, and cimitars, maces and some rifles of such great length that I saw a Persian with one fifteen spans long.'[39]

Evliya Chelebi casually provides an indication that the Iranian matchlocks were longer than those to which the Turks were accustomed. Writing of the campaign of 1634, he mentions that 'the river Zenghi was crossed in spite of the long guns of the Persians, with which they endeavoured to annoy the Ottoman army'.[40]

The trade in gun barrels and the extent to which Iranian craftsmen travelled to neighbouring countries was such that it is extremely difficult to determine the country of origin of high-quality Middle Eastern gun barrels. Their attribution, then or now, is often a matter of opinion rather than of established fact. The ubiquitous Iranian craftsmen were in demand from India to Turkey and Egypt, dominating the field particularly in the seventeenth, eighteenth and nineteenth centuries. Indeed, it becomes questionable to what extent the famous 'Turkish gun barrels' were in fact produced by Iranians. A group of Iranian barrels captured in the Ottoman wars with Europe are in the Residenzbüchsenkammer, Munich, and were dated by Stöcklein on the basis of the signed and dated German stocks on which they are mounted. A similar analysis of eighty seventeenth-century Ottoman barrels mounted on Saxon stocks is yet to be undertaken in Dresden, where the survival of dated inventories is of great assistance. Large quantities of military stores were captured from the Turks in 1683. Rycaut describes how these were placed in the Vienna Arsenal including '560 barrels of Guns for use of the janissaries.'[41] There are still considerable difficulties in determining whether a

barrel is Ottoman or Persian as both countries exported their products and the craftsmen of each worked at home and abroad; but contemporary travellers in the Levant consistently speak of the Persian barrel and there are relatively few references to Ottoman export barrels. However, the number of Turkish barrels in Eastern Europe as a result of the Turkish wars, many on date-able European guns, suggests that this was more a matter of culture and trade flow than the great superiority of one over another.

Chardin gives a clear description of Iranian gun-making in the early seventeenth century.

> The Persians make also very well the Barrels of Fire-arms, and Damask them as they do the Blades, but they make them very heavy, and cannot avoid it.[42] They bore and scower them with a Wheel, as we do, and forge and bore them so even that they almost never burst. They make them alike strong and thick all along, saying, that the Mouth of the Gun being weak, the Report shakes it, and communicates the wavering Motion to the Bullet. That's the reason, that if their Guns be thicker, they therefore carry the Shot further and straighter. They Soder the Breech of the Barrel with the heat of the Fire, and reject Screws, saying, that a Screw Breach going in without Stress, may be thrust out by the Violence of the Powder, and is not to be rely'd on. They do not understand very well how to make Locks or Springs; those they put to their Fire-Arms, are very unlike ours; for they have no Steel, the Pan is very fast, being all of a Piece with the Barrel, the [missing word] which moves along a small rough Iron Branch, that comes out of the Inside of the Gun, and moves backward, that is toward the But-End, on the Pan, but quite contrary to it; the Pan is usually no bigger that the little Finger Nail, without Snap-haunce; and most Pans are rough within, like a File, that the Prime may stick the better to it. They do not understand how to Mount Fire-Arms, and do not observe the Rules of Staticks, but make the But-End small and light, which is the Reason that their Guns are light at the Breech, and heavy at the Muzzle.[43]

Burckhardt wrote that he saw many 'fine Persian barrels' in the Hijaz, and that 'They esteem the barrels in proportion to their size and weight: the heavier and larger being the most valued.'[44]

Two Iranian gun-makers from Isfahan are named by Benjamin as being particularly able though he gives no dates for

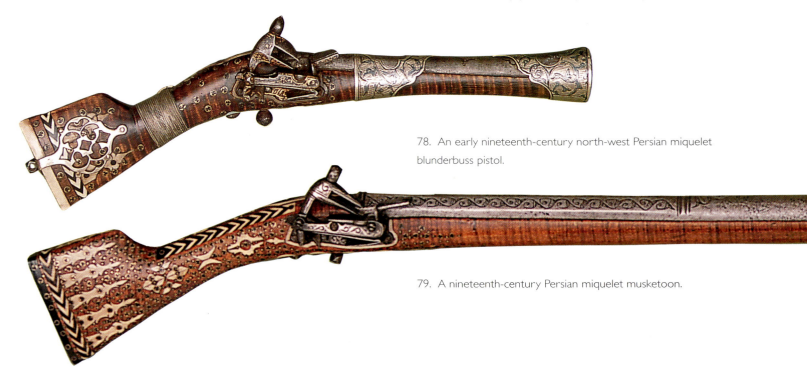

78. An early nineteenth-century north-west Persian miquelet blunderbuss pistol.

79. A nineteenth-century Persian miquelet musketoon.

their work: Hasan, whose work was more elaborate than that of Hajji Mehmet, whose work was superior 'in texture'.[45]

In the eighteenth century a corps of *jazayirjis* served in Nadir Shah's forces with success. The *jazayir* or *jaza'il*, or *jezail* as it is more widely known in English, is described by Steingass as a large musket, wall-piece, swivel, a rifle used with a prong or rest. Egerton refers to *jezails* in the Codrington Collection seven or eight feet long. Irvine comments that this would appear to be the usual length, and certainly it is consistent with the Iranian preference for long barrels. Colonel Yule refers in *Hobson-Jobson* to Chinese *gingals* or *jingals* 'six to fourteen feet in length'. There has been some speculation amongst oriental arms historians as to whether or not the word *gingall* or *jinjal* is derived from *jezail*. The weapons are certainly very similar. The Arabic *jaza'il* is corrupted in Hindi to *janjal* from which comes *gingall* or *jinjall*.[46] Elphinstone wrote in 1818 that 'there is but one gun in the fort, but there is much and good sniping from matchlocks and gingals...'[47] Brigadier Wheeler described a swivel gun, which he called a *jinjal*, that he found in a fort at Kangra in 1846, which fired a shot of 12 ounces. These weapons are found in Iran, Afghanistan, Hindustan and Central Asia. The modern state of Afghanistan is historically composed of the former Mughal province of Kabul and the Iranian provinces of Kandahar and Herat and its weapon types reflect that history. Its present form owes much to British desires for a buffer state between Russia and India in the nineteenth century and to the sturdy determination of its population to resist all foreign domination. Elphinstone describing the Durranis of Kandahar and Herat in the early nineteenth century, wrote that they were armed with a Persian sword and a matchlock and that few of them had firelocks. Sita Ram, a *havildar* in the Bengal army,

who took part in the invasion of Afghanistan in 1839, describes 'the long jezails' of the hill men 'that throw a ball three times the size of a musket-ball with accuracy at four hundred yards...'[48] Egerton credits the Afghan matchlock with a range of eight hundred yards and comments that it was 'much superior to our old 'brown bess''. John Gray, physician at the amir's court, describes the guns in the Kabul bazaar at the end of the nineteenth century:

> the native jezail with a curved stock ornamented with ivory, and with a very long barrel fastened on with many bands. The Afghan hillmen and the Hazaras make these, and they are good shots with them. They make their own powder also. There are old fashioned English rifles, flint-locks and hammer locks; some very heavy, with a two-pronged support hinged on the barrel... native pistols and old English pistols of various kinds...[49]

Moorcroft refers to the curved stock of the Afghan matchlock using the word *limak*. The North-West Frontier Province of India was garrisoned by British troops who fought continuous small wars against the Afghan frontier tribes armed with the *jezail*, as Kipling describes:

> A scrimmage in a Border Station –
> A canter down some dark defile –
> Two thousand pounds of education
> Drops to a ten-rupee jezail!
> The Crammer's boast, the Squadron's pride,
> Shot like a rabbit in a ride.[50]

In 1812 William Ouseley reported that amongst the Russian exports to Iran were gunpowder, iron, steel and locks.

In 1824 a British diplomat, James Morier, published a novel set in Iran, where he was stationed, entitled *Hajji Baba of Ispahan*. So accurate was the portrayal that many Iranians refused to believe that the author was not an Iranian. At one point in the novel, three travellers compare and boast of their weapons: 'The Mirakhor drew from his girdle a long pistol, mounted in silver, which was shown around to all the Company as a real English pistol. Another man exhibited his scimitar which was assumed to be a black Khorassani blade of the first water...'

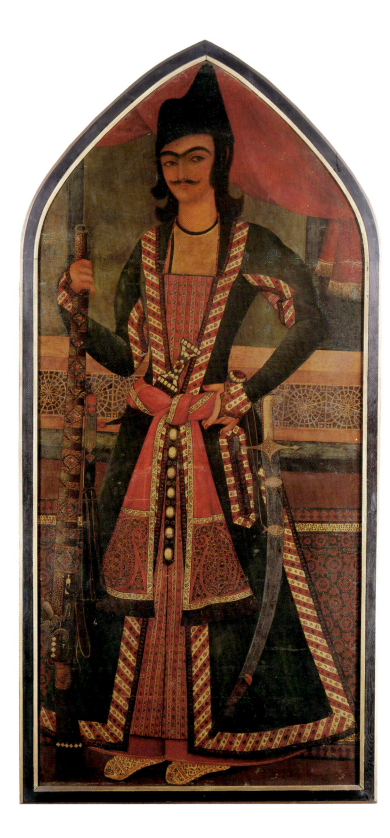

Portrait of a Qajar prince holding a flintlock, signed *Raqam-i-kamtarin Muhammad Hasan*. Period of Fath Ali Shah (1797-1834). Negaristan Museum, Tehran. Photo by permission of Sotheby's, London.

80. A Persian flintlock rifle with English export lock, c.1835.

Clearly the Iranians had a high regard for English pistols but still regarded their locally produced swords as better than Western imports. Also popular was a type of blunderbuss known by the Persian word *tamancha*[51] which was also found in Ottoman Turkey, the Caucasus, and India. The Indians called it *sherbacha* – literally 'tiger cub'. Irvine suggested that it entered India with Nadir Shah when the Iranians invaded in 1739 and sacked Delhi. If so, no examples of that date have survived, and a later date seems likely. In Lahore a regiment was equipped with the *sherbacha* in the last quarter of the eighteenth century. The name was also applied to pistols from Kabul used by Ahmad Shah Abdali's troops in 1760, but it is not clear if these were of the blunderbuss type. There are examples bearing East India Company locks (for example, in Egerton, No. 410). It seems likely that the word *sherbacha* was applied loosely both to blunderbuss pistols and to short musketoons with a vestigial stock. In the Tareq Rajab Museum there is a musquetoon (Catalogue no. 79), probably from north-west Iran. The bone inlay on the stock is particularly characteristic of Iranian tribal taste.

A remarkable example of the fusion of European and Iranian craftsmanship in a firearm can be found amongst the Iranian crown jewels.[52] The piece is a short flintlock carbine, the lock signed by the Parisian maker Fatou and dating from about 1800. This lock and the rococo mounts may well have come to Iran with the French military mission under General Gardane which arrived in December 1807. The mission came under the Treaty of Finkenstein of May 1807, only to find that it had already been rendered null and void by the Treaty of Tilsit of July 1807. The French mission withdrew. The forestock is made of Circassian walnut secured to the barrel with sheet gold capucines. The butt is ornamented with a profusion of precious cabochon stones, typical of Iranian style at that time, as is the trigger guard, which is possibly of Iranian creation though its rococo form is European.

The decoration in gold, enamels and gems is the work of Hajji Muhammad Haft Khan. The short carbine was particularly popular in Iran though its usual form was rather more utilitarian.

Many Iranian guns have Tower or E.I.C. (East India Company) flintlock mechanisms mounted on Iranian stocks with Iranian barrels – the result of a succession of British military missions, beginning in 1810, which were intended to 'Europeanise' the Iranian army. Since the Iranians believed in the efficacy of long barrels they would not have been impressed by the British India pattern musket with its thirty-nine inch barrel. When Sir John Malcolm arrived in 1810 on his third mission he brought with him ten cannon specially cast in India and decorated with the shah's name and arms. In the few months before he left it was agreed that an arsenal would be established under the management of British officers in the Arg at Tabriz where the crown prince, Abbas Mirza, who commanded the army, had his headquarters. Ouseley, the new British ambassador, brought with him the promise of a subsidy for Persian military expenditure; news of the sending of British officers, artillerymen, artisans and manufacturers; news that the East India Company had issued orders for the supply of 16,000 East India Company muskets and twenty pieces of horse artillery, and that a further 4,000 muskets would be supplied later from Europe and India.[53] A foundry was established at Tabriz under Robert Armstrong, which the crown prince planned to make 'the Woolwich of Azarbayjan'. Fath Ali Shah (1212-50/1797-1834) realised that if Iran was to resist the Russian advance through Georgia she must have modern weapons and adopt modern military methods. However, he failed to understand that modernisation required fundamental change in the finance and administration of the country.

It has been suggested that the character depicted in an early nineteenth-century Persian portrait of a prince is Abbas Mirza. The prince is proudly holding a superb gun. The lock is European,

81. An unusual flintlock musketoon,
c. 1820, with an East India Company lock.

possibly from the British East India Company though the mark behind the cock is unclear. The barrel is watered, resembling those of the amirs of Sind (the best of which were reported to come from Istanbul), damascened with gold arabesques at the muzzle and breech. However, the large size of the bore does not match the description of the Istanbul barrels seen at Sind with small bores, and there seems no reason not to assume that the barrel is Iranian. The capucines are enamelled gold with designs of pink flowers and green leaves. The stock is typically Iranian with modest bone or ivory inlay and does not differ from the common matchlock which was used in the eighteenth, nineteenth and early twentieth centuries. The wire wound round the butt is a relic of the match which used to be wound at that point for convenience and became a part of the expected aesthetics of a gun. The wire also serves to strengthen the butt and counterbalance the weight of the long barrel.

It was customary for the shahs to rely largely on provincial tribal troop contingents – Bakhtiyaris, Kurds, Afshars, Qaragozlus, Arabs, Qashqa'i, Baluch, Turcoman and others, raised when required with a small body of regular household troops who served as the core of the Iranian army. The royal body-guard contained 3,000 *ghulams*, according to Morier, and was formed from Georgian slaves and the sons of the Iranian nobles. Malcolm puts the figure higher and states that they were

well-armed and mounted. The standing army in 1809 was composed of some 12,000 men, levied from town and tribe.[54]

According to Fraser, the best *toffunchees* or matchlock men came from Astarabad. Malcolm states that Kirman manufactured matchlocks in the nineteenth century[55] and this is confirmed by Macdonald Kinneir,[56] who says that they were exported to Khurasan and the northern provinces. Writing elsewhere, Malcolm mentions Isfahan as a producer of swords and other arms; and Shiraz for 'guns, pistols, swords and other military arms'. Polak, whose book appeared in 1865, wrote that 'In the Arsenals of Isfahan, Shiraz and Tehran, firearms, especially rifles and pistols, are made on European models and are very close to the originals, including even the factory trademarks.'[57] It is extremely difficult to determine where a gun was made and where its decoration was added or the gun 'finished' during this period. Iranian craftsmen frequently worked outside Persia and within Iran Caucasian firearms were widely used.

The influence of Russia on Iran grew steadily as the former advanced its frontier in the Caucasus and Central Asia in the nineteenth century. When the Russians renewed their attack in the Caucasus in 1812, four officers and twelve sergeants from the British military mission accompanied the Persian soldiers into battle. In 1813, following intermittent war, Iran ceded to Russia the provinces of Georgia, Derbend, Baku, Shirvan, Shaki, Ganja, Qarabagh, Mughan and part of Talish. Under the Anglo-Persian Treaty of 1814, the British government continued to supply officers for drill and discipline, arms and munitions, but most of the officers were withdrawn in 1815 because of a dispute over a subsidy to be paid under the Treaty. Various freelance officers, French, Russian, Italian and others, came east after Napoleon's defeat and served in Iran in the Qajar armies from about 1814.

For much of the reign the army was neglected. Though militarily defeated the Iranians were not yet convinced of the inevitability of Russian victory. Neither side intended the Treaty of Gulistan to be final and war resumed in 1826. After initial Iranian success Russian reinforcements inflicted a series of severe defeats and Tabriz fell. Peace was finally made at Turkomanchay in 1828 in which Erivan and Nakhchivan were ceded to Russia and the territory lost by the Treaty of Gulistan in 1813 confirmed. Rebellions broke out in various parts of the country. Efforts to reassert Iranian authority led to an attack on Herat in 1832. This alarmed the Indian government and a military mission was sent from India in 1833, together with a supply of firearms, in the hope of regaining influence at the Iranian court. A gun that may very probably have been part of this diplomatic effort is in a private collection in Iran. It is a fine English over-and-under percussion pistol signed 'Joseph Brazier, Maker, Wolverhampton' and was made in the 1830s.[58] Joseph Brazier signed his work in this manner from 1827 until 1849 when his firm became Brazier and Son.[59] Most of the Wolverhampton makers supplied locks to Birmingham but the Braziers were big enough to sell their products direct to the British government and the export market. The gun has a belt hook and is the type of pistol that was gradually replacing the flintlock pistols owned by upper-class Iranians. The barrels are 'twist forged' and browned, eight and a half inches long and of 0.50 calibre. The top of the barrel bears the inscription 'His Royal Highness Prince Nayebul Ayadah Farhad Mirza'. Prince Farhad Mirza was born in 1813, the son of Abbas Mirza, the commander-in-chief of the Iranian army in the Russo-Iranian wars, and the grandson of Fath Ali Shah Qajar. The phrase *Nayeb-ul-ayadah* means Deputy Governor. In 1846 the prince became governor of Fars, so the pistol clearly predates that appointment. An alternative donor of the gift is Captain B. Shee of the Madras Regiment who joined the military mission in 1826. In 1835-6 he commanded Persian troops in Fars.

The British effort to reform the Iranian army was a failure and the officers were withdrawn in 1839 as a result of the Herat incident. French officers replaced them, to be replaced in turn by a succession of European missions. A London firm, Mills and Co., secured an order for 100,000 guns in 1848. An English trader, Alexander Hector, based in Baghdad, also managed to sell a quantity of guns to the Persian government.[60]

Foiled in her plans in the Near East by the Crimean war, Russia looked to Central Asia for expansion. In 1863 the Kirghiz steppe was subjugated. Tashkent fell in 1865, Khojand in 1866 and Bukhara soon after. Russia set her sights once more on Iran and Afghanistan. Of the Great Powers, only Britain was sufficiently interested actively to oppose the Russian encroachment in Central Asia. The Iranian army was in total disarray, the muster rolls falsified and many of the nominal troops engaged in other occupations.

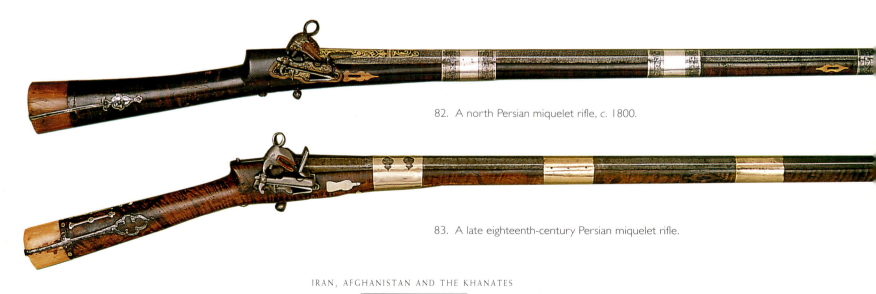

82. A north Persian miquelet rifle, c. 1800.

83. A late eighteenth-century Persian miquelet rifle.

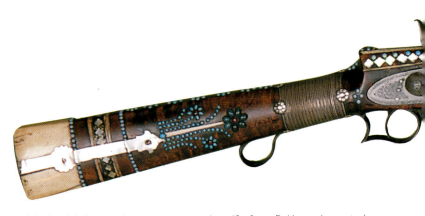

So prevalent is the employment of soldiers in all trades and professions that, when at Tehran reviews are ordered, it is not uncommon to see workmen, not suspected of being soldiers, drop their tools, don their uniforms, and take their places in the ranks. The duty completed, they return their clothing and muskets to the depot and again resume work.[61]

In 1878 Nasir al-Din Shah made his second visit to Europe and, as a consequence, a Russian and an Austrian mission came to reorganise the cavalry. The Russian officers remained and raised a force which came to be known as the Cossack Brigade. The first regiment was formed in 1879 and the second in 1880. Both were officered by Russians and the arms and munition were supplied by the Russian government, while the commander of the force was responsible to the Russian War Office. The Cossack Brigade became the most efficient military unit in Iran and greatly increased Russian influence in the country. The Austrians left in 1881, but their visit had been fruitful. The Iranian Minister of War, Na'ib al-Saltana, imported large numbers of the Austrian-made Werndl rifle which he sold to the tribesmen of northern Iran for a good profit. The rifles delivered cost slightly more than their equivalent price in Vienna, at that time fifteen shillings, and the tribesmen paid eight pounds for each.[62] In the south of Iran the tribesmen were buying large numbers of Lee Metfords and Martini-Henry rifles, imported through Bushire from Muscat.[63] Britain, France, Belgium, Germany and Romania all contributed to this trade. The Iranian authorities lost control of large parts of the country and it was said that 'Martini Khan' was shah. As late as 1890, Lord Curzon described the Iranian army as containing for the most part irregular units while the payment, provisioning and equipment of the regular army was never satisfactorily managed. Some irregular units were still equipped with the matchlock at the time of the First World War.

THE KHANATES

North of Iran but within the sphere of her cultural influence were the Central Asian Khanates of Bukhara, Khiva and Samarkand. The Russian Nikolay Murav'yov visited Khiva in 1819-20 and

84. A mid-nineteenth-century percussion rifle from Bukhara decorated with turquoises, with an English lock and trigger guard.

was granted an audience with the ruler Muhammad Rahim Khan, returning with gifts and messages of goodwill. He states that the feeling of hatred that existed between Khivans and Iranians made their mutual trade a matter of very trifling importance. Khivan firearms were described by Murav'yov:

They have but few muskets, and those they have are very long and heavy, with a small bore. If loaded with good powder, they carry fairly, but are very unwieldy. They cannot be used from horseback, as they must be fired from a rest,[64] so they are only employed in sieges. The barrels are often inlaid with silver, and some, but very few, have locks like the Persian muskets. The Khivans are good shots at a fixed mark, but their preliminary arrangements are so multifarious and slow, that their fire-arms are hardly worth the trouble they give. The marksman has to lie flat on his stomach and take a long aim, in the course of which he often lets his match go out, and when all goes well he cannot be sure of hitting anything at a greater distance than 60 or 80 paces. This description applies more or less to all Asiatic nations, and yet we hear travellers loud in their praises of Asiatic marksmen... Pistols are hardly known in Khiva, owing probably to the difficulty of getting locks.[65]

Later in the nineteenth century the horse pistol became common in the Khanates and was known as *topancha*, clearly a corruption of the Farsi *tamancha*, but this differed from the blunderbuss pistol of the same name as it was a conventional pistol.

85. A north-west Persian miquelet rifle, dated 1220/1805.

Those Khivans who did not possess firearms continued to use bows, though by the nineteenth century these were small and not very effective, with little spring in them and inferior strings. Gunpowder was manufactured by the Sarts in the Khanate, the ingredients being available locally. It was very cheap but weak, due to a lack of expertise as to the correct proportions needed. Murav'yov writes that the efforts of the Khan to produce cannon were a failure until a gun-founder was obtained from Constantinople. The artillery was served by Russian slaves but eye-witnesses declared that the Khivan artillery was useless.

Throughout the Central Asian Khanates the firearms situation was much as described in Khiva. There is a note of frustration and hopelessness in a remark by the orientalist and traveller Arminius Vambery, who described in the mid-nineteenth century how

Nothing can find its way here from Europe, it has always to pass through the channel of Turkish and Persian Civilisation, and everything travels its customary snail's pace; the Persian imitates European institutions second hand from the Turks, and the nations in Central Asia adopt nothing but what reaches them through the medium of Persia.[66]

Henri Moser Charlottenfels travelled extensively in the region and was an avid collector of oriental weapons, but his collection at Berne has few firearms from this region, because very few were of any quality.[67] Indeed, the nineteenth-century examples lack decorative distinction or technical originality. Torben Flindt, writing on the arms of Bukhara, has little to say of the firearms and comments that the bow was used until very late in the nineteenth century. In Samarkand, during Bukharan rule, weapons were sold at fifteen shops, of which only six were considered to offer good quality. The difficulties experienced by the rulers of the Khanates in obtaining modern weapons from either Russia or Persia were in part responsible for the failure to modernise the armed forces. Following the Russian seizure of the Khanates restrictions were imposed on arms production and sale. This was consistent with Russian policy from the sixteenth century which prohibited private ownership of firearms except by the nobility. Towards the last quarter of the nineteenth century Sart muskets were described as generally having flintlocks, usually with a European barrel, but of antiquated pattern. Many were imported from India. Locally-made barrels, though produced, were few in number and these attempted to copy European examples. The firearms were described by one observer as falling into two categories: a heavy fort weapon known as a *jizail* or *salishkan*, a long gun with a massive stock and a large calibre (from 1-2 in.), usually firing cast-iron balls or sometimes lead; and a lighter weapon, known as *milteq*, with a long barrel. Both weapons had fixed rests.

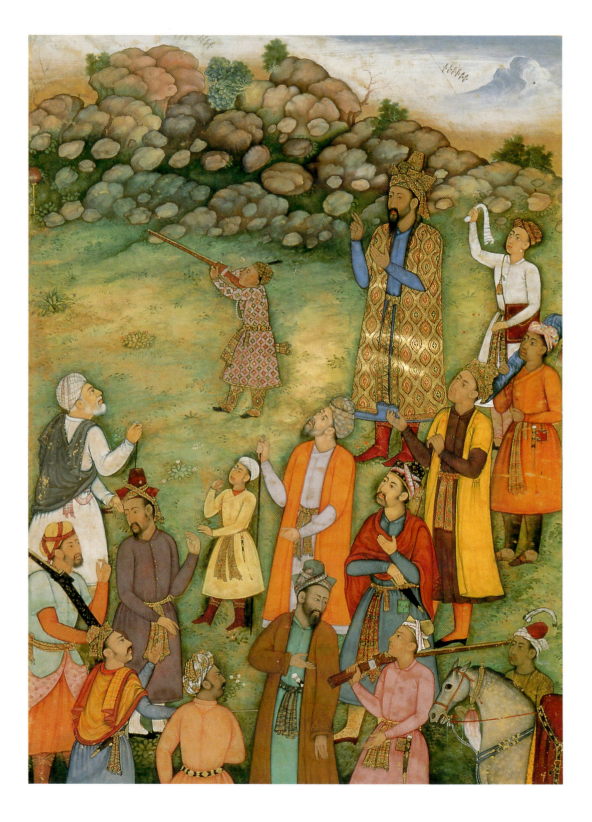

THE INDIAN SUB-CONTINENT

THE EARLY HISTORY of firearms in India is extremely obscure and dependent on how ancient Vedic texts are interpreted.[1] The suggestion that India was the home of the invention of gunpowder was made by Nathaniel Halhed in 1776 and Quintin Craufurd in 1790. In 1880 the Professor of Sanskrit at Madras University, Gustav Oppert, published his firm view, based on two Sanskrit manuscripts, that the ancient Indians had gunpowder and firearms. Two eminent historians of India, Eliot and Dowson believed that the ancient Indians had a knowledge of firearms[2] and that *agni shastra* or weapons of fire were certainly used in very early times though their precise nature is difficult to determine. They suggest that these were fire-tipped darts, discharged horizontally from a bamboo, and were used against cavalry. Some modern Indian writers on early India have made claims which are essentially fundamentalist in character and nationalistic in intent and are difficult to substantiate on the basis of good scholarship. However, when these are put on one side a residue of facts remain which have not been examined in recent years.

In the *Puranas*, ancient Indian texts compiled from oral tradition, the invention was ascribed to Vishvakarma, or Vishvakarman, whose name means 'all-accomplishing'. In many myths the name of Vishvakarman is linked with that of Tvashtri, a deity of ancient Aryan origin, once worshipped in north-east Iran. Tvashtri is similarly 'the divine artisan', the 'shaper' of all things animate and inanimate. One of Vishvakarman's roles, acquired through his link with Tvashtri, was as the Indian equivalent of Vulcan. At his forge he sharpened the axe of the priest-

Bairam Khan watching the young Akbar learn to shoot. Govardhan, c.1604. Bairam Khan acted as tutor and mentor until the young Akbar asserted his independence in 1560.

god Brihaspati, moulded the *vajra* or thunderbolt, and over a period of a hundred years forged all the weapons and distributed them between the good and bad spirits.

Oppert, writing in 1880 after a thorough study of the limited Sanskrit manuscripts available to him, in particular the *Shukranitisara*, which he refers to as the *Sukraniti*, was certain that India could claim the invention of gunpowder,[3] though he conceded the possibility that the Chinese had discovered it independently.[4] The extensive work on Chinese gunpowder and firearms by Needham strongly suggests that Oppert was wrong in his conclusions. The Vedic texts as cited by Oppert appear to parallel inventions credited by Needham to the Chinese. Thus it might appear that these distinctive weapons were known, and possibly used, in the Sub-continent before, rather than after, the Chinese. Unfortunately for Oppert, modern scholarship does not look favourably upon the *Shukranitisara*, regarding the text as either a forgery[5] or a 'late text which mentions the use of gunpowder and is of no value whatever as evidence for early Indian usage or philosophy.'[6] This is unsatisfactory, as the development of gunpowder in India, if at any time prior to the Chinese invention in the ninth century, would be considered extremely late in relation to the compilation of the Sanskrit epics. While the manuscript is of minor interest to Sanskritists, it remains of great potential interest to arms historians. We are left with three possibilities: that in the course of its transmission the *Shukranitisara*, assuming it to be genuinely early, acquired anachronisms and interpolations taken from the Chinese inventions; that it predated the Chinese inventions; or that it can be dismissed entirely as fake. The matter is not helped by the fact that Sanskrit scholars appear to be extremely reluctant to put a date to the *Shukranitisara*. Indeed, all early Indian Sanskrit and vernacular texts are impossible to date with any accuracy for a number of reasons, not least because they were not treated as static but were constantly subject to interpolations. Until further work is done by Sanskrit scholars the matter cannot be decided, so that the certainties expressed by Oppert should be noted rather than accepted. The use of firearms from an early date is well documented in China and supports the view that they developed there and not in India, which undoubtedly did develop 'weapons of fire'. These parallel some of the Chinese weapons, as might be expected in view of the known links between the two countries. In particular, it

seems to be widely believed by scholars that both India and China made use of rockets as weapons from very early times.[7] If this is correct, the presence of gunpowder as a propellant in India prior to the Muslim invasions is established.

The views expressed by Oppert are not without relevance to later firearms. According to him

> two kind of firearms are described in the *Sukraniti*, one is of small size and the other is of large size. The former is five spans long,[8] has at the breech a perpendicular and horizontal hole, and sights at the breech and muzzle end of the tube. Powder is placed in the vent, near which is a stone, which ignites the powder by being struck. Many dispense with this flint. The breech is well wooded and a ramrod compresses the powder and ball before the discharge. This small musket is carried by foot-soldiers.
>
> A big gun has no wood at its breech; moves on a wedge in order to be directed towards the object to be shot at, and it is drawn on cars.
>
> The distance which the shot travels depends upon the strength of the material from which the gun is made, upon the circumference of the hole, and the gun's compactness and size. The ball is either of iron or lead or of any other material. Some big balls have smaller ones inside. The gun itself is generally of iron, occasionally also, as we have seen in the *Nitiprakasika*, of stone. The gun is to be kept clean and must be always covered.[9]

The term used for gun, *nalika*, is derived from the word *nala*, a reed, a hollow tube, which is another form for its synonyms *nada* and *nadi*; in the same way, *nalika* corresponds to *nadika*.

Considering that the guns were in ancient times reputedly made out of bamboo, and that some bamboo guns were still reported used in Burma in the nineteenth century, the name appears both appropriate and original. That the idea of bamboo being the original material for guns was still in the mind of the author of the *Sukraniti* seems to be indicated by his calling the outside of the stock of a gun bark (*tvak*).[10]

The gun is in fact very seldom mentioned in Sanskrit writings, and even where it has been mentioned the meaning of those passages has been generally misunderstood.[11]

In China, guns made of bamboo were not immediately superseded by metal, and both existed side by side until the sixteenth century. A Chinese bamboo gun or small cannon is in the Museum of Mankind, British Museum, London.[12] The barrel is wrapped with raw-hide and rattan and shows evidence of considerable use. Marco Polo described bamboo in Tibet 'three palms in circumference'.[13] After looking at the Chinese evidence Zygulski wrote that

It was not until the Sung period that historical annotations for the year 1259 confirm the appearance of the first type of proper bullet-firing weapons, called tu-khotsian. Traditionally the barrels of these primitive cannon were made of bamboo, strengthened on the inside with clay and an iron disc; a cord was coiled round the outside and a touch-hole was pierced in the side. Such a barrel was capable of withstanding a pressure of explosive gases of eighty pounds per square inch; the bullets, probably made of stone, were projected to a distance of 150 paces.[14]

PRE-MUGHAL INDIA

Natural saltpetre is very rare in Europe but is found extensively in India. The Hindus were well acquainted with it and in the Sanskrit manuscript Sukraniti it is transliterated by Oppert as suvarcilavana or 'well shining salt'. In other Sanskrit manuscripts it was described as a tonic, good for stomach disorders. The availability of natural saltpetre in India was such that during the seventeenth, eighteenth and nineteenth centuries most of that used in Britain in the manufacture of gunpowder was brought from India,[15] and when the East India Company Charter was renewed in 1693 the Company undertook to supply the British government with five hundred tons of saltpetre from India annually.[16] According to Bernier, writing in the mid-seventeenth century, Bengal was the principal emporium for saltpetre. Large quantities were exported from Patna down the Ganges by the

Dutch and the English. The French, Dutch and Portuguese had factories at Chuprah about twenty-five miles from Patna, where the saltpetre was refined.

Sulphur was also found in Vedic India where, based on its smell, it received the name of gandha or gandhaka (literally, stench). It was also used as a medicine. Oppert states that in his time in some parts of India gunpowder was prepared without sulphur.

Opinion varied as to the best wood to use for charcoal, the third component of gunpowder. The arka or gigantic swallow wort was highly regarded and was considered to have powerful and useful qualities,[17] and was much used in the preparation of fireworks. The Sukraniti contains a formula for making gunpowder of five parts of saltpetre to one of sulphur and charcoal respectively. The Sanskrit word for gunpowder, given by Oppert, is agnicurna or medicine; and in all the Dravidian languages the word for medicine is the same as for gunpowder, as in the Arabic dawa' in the thirteenth century.

The knowledge of the manufacture of gunpowder and the use of firearms appears to have been lost in the post-Vedic period in India. Oppert nevertheless argues that the knowledge did in fact survive. If so, its use was very restricted and it played no known part in early medieval battles prior to the arrival of the foreign armies that re-introduced it into the Sub-continent. Only inflammable projectiles appear to have remained in use until the re-introduction of firearms from the Islamic countries to the west. This has been seen as the decisive argument by those who doubt the existence of firearms in India in the Vedic period. However, as this study shows, the availability of firearms elsewhere in the world has not always resulted in their adoption by Middle Eastern societies. Northern India suffered a series of invasions by nomadic horsemen from Central Asia in the millenium BC. In view of the efficiency of the reflex bow and the reverence with which it was regarded by warriors of nomad society, it would be strange if gunpowder weapons, if they existed in rudimentary form, had developed in a society that was likely to be unsympathetic to them in principle and unimpressed by their capabilities when actually used. Other, later, Middle Eastern societies of Central Asian origin decisively rejected firearms even after witnessing far more impressive demonstrations of their potential.

THE PORTUGUESE
IN INDIA

The earliest Muslim invaders were equipped with mangonels. As late as 1397, when Timur invaded Hindustan, the army of Sultan Mahmud of Ghazna does not appear to have had firearms, although they did have grenades (ra'd-andaz), fireworks (atish-baz) and rockets (takhst-andaz). The rocket remained in use in India until the nineteenth century, particularly in the Mysore army, and was adopted by the British army in the Napoleonic wars. Fiery arrows (tir-i atishin) were widely used, but firearms are not mentioned and it is reasonable to expect that they would have been if they had been available.

In the second half of the fourteenth century cannon were introduced into the Deccan and became common in the fifteenth century. Nicolo Conti, who travelled in India in the early fifteenth century, records that 'the natives of central India make use of balistae, and those machines which we call bombardas, also other warlike implements adapted for besieging cities'.[18] According to the late sixteenth-century historian Farishta, Sultan Mahmud Shah Bahmani set up an arms 'factory' in 767/1365.[19] Simon Digby points out the questionable nature of Farishta's figures, referring to 'a passage notorious in the controversy regarding the introduction of firearms into India' in which Mahmud Shah Bahmani captured three hundred gun carriages from the Ray of Bijanagar.[20] The spread of the technology was due to the trade links with Egypt, Iran and Turkey in particular, whence India received cannon and engineers.[21] It is clear that individual Turks played a considerable role in the region in casting and firing cannon. However, cannon were not mobile and do not appear to have played a significant part in Indian warfare until the arrival of the Portuguese at the end of the fifteenth century. The speed and the manner in which the large ports on the coast of India were forced by the aggressive presence of the Portuguese to equip themselves with cannon can be seen very clearly at Calicut. In 1502, when Vasco da Gama bombarded the town on his second visit, only two inferior cannon replied, very ineffectively according to Thome Lopes, an eye-witness. The lesson was quickly learnt by the Indians. While in Calicut in 1505 Di Varthema made the acquaintance of two Milanese, Ioan-Maria and Piero

Antonio, who had deserted from a Portuguese fleet but now wished to return home to Europe, having made fortunes from casting cannon for the ruler.

And you must know that they had made between four and five hundred pieces of ordnance large and small, so that in short they had very great fear of the Portuguese; and in truth there was reason to be afraid, for not only did they make the artillery themselves, but they also taught the Pagans how to make it; and they told me, moreover, that they had taught fifteen servants of the king to fire spingarde.[22] And during the time I was here, they gave to a Pagan the design and form of a mortar, which weighed one hundred and five cantara, and was made of metal.'[23]

Di Varthema himself claimed to be 'the most skilful maker of large mortars in the world',[24] but whether in fact his competence exceeded his vanity is not recorded. His sense of disapproval of outsiders making cannon is illustrated in his account of a Jew at Calicut 'who had built a very beautiful galley, and had made four mortars of iron. The said Jew, going to wash himself in a pond of water, was drowned,' a fate that Di Varthema appears to regard as his just desert.[25] Di Varthema also met four Venetian gun-founders who reached Malabar in 1505 having travelled by dhow from the Red Sea. Turkish gunners in the service of Sultan Mahmud Baykara sank a large Portuguese ship at Diu in 915/1509. Five years earlier Ludovico Di Varthema visited Diu and wrote that the town 'contains much artillery within it.'[26] Rumi Khan cast many cannon for Bahadur Shah of Gujarat, directly resulting in his success against the Portuguese. Nevertheless, the Portuguese succeeded in capturing the town in AD 1515.

The profession of artilleryman was as dangerous as it was unpredictable. At the first siege of Diu, for example, the two differing strengths of gunpowder used for arquebuses and for cannon got mixed, and several barrels burst. Aim was always erratic. A shot fired point-blank by the Portuguese at the hull of an Egyptian ship in the fight at Chaul in 1508 cleared the fighting top of its defenders. Direction and elevation could only be changed with great difficulty and on many occasions the Portuguese sailed past heavily defended positions unscathed at low tide because the defending cannon were set for high water-

mark. The gunners on the Portuguese ships were often Flemings and Germans who were much impressed by the skill of the Ottoman gunners, many from southern Europe, who they encountered in battle at Diu in 1546: They were both consistent and extremely accurate shots. The large guns became individualised and were given names. At the siege of Chaul in 1571, the Muslims had a large gun known to the Portuguese as the 'butcher', served by a Brahmin named Rama. Some months after the siege began a duel developed between the 'butcher' and the Portuguese 'lion'. Ruy Goncalves, the Portuguese gunner, appeared in gala costume and sat astride his cannon, grimacing and threatening his opponent who did likewise. The duel lasted three days and ended in defeat for the 'lion'.

Indian guns were generally of iron and the Portuguese usually destroyed these as useless. Iron cannon were heavier, larger and more dangerous to use than bronze. The Portuguese arsenal at Goa was a continuation of the former Indian one and was known as the House of Ten Thousand Matchlocks (*Casa das Dez Mil Espingardas*). It contained large quantities of war material and included foundries. Some of the arms proved to have been captured from the Portuguese in previous encounters. Letters sent by Albuquerque to King Manuel I in 1510 comment on the excellence of Goan gunsmiths and how they were co-operating with the Portuguese. A letter written in 1513 states: 'I send your Highness a Goan Master Gunsmith; they also make guns as good as the Bohemians and also equipped with screwed in breech-plugs.'[27]

In 1525 the arsenal contained 667 bronze and 406 iron cannon. By 1643 the bronze ones were stolen so frequently that the Portuguese government ordered that only iron ones should be cast in future. This was due in part to the cost of raw copper which was three times that of iron in the 1520s, rising to nine times by 1600.

As early as 1536, guns appear to have been mounted on camels and elephants and on bullock carts. The use of elephants in battle was an old tradition not confined to India, where it continued into the eighteenth century, and it was in keeping with the conservative nature of Indian warfare that guns should be thus mounted on them, since it was an obvious development of the ancient practice of filling the armoured *howdah* with archers, rocket men and grenade throwers. The Jesuits at Akbar's court in the sixteenth century describe how the elephants were equipped for war:

> To protect the head from blows, it is covered with a plate of iron, or tough hide. A sword is attached to the trunk, and a dagger to each of the long tusks which protrude from the mouth. Each animal bears on his back four small wooden turrets, from which as many soldiers discharge their bows, arquebuses, or muskets. The driver is protected by a cuirass, or by plates of metal overlapping like scales.[28]

Father Antony Monserrate, SJ, was sent on a mission to Akbar's court and from his daily notes wrote *Relacam do Equebar, Rei dos Mogores*, which he completed at Goa in 1582. Monserrate told the Father Provincial at Goa that the Emperor took on expedition 5,000 fighting elephants, exclusive of those used for baggage and that there were 50,000 in the empire for war-like purposes. The *Relacam* refers to an advance guard with 1,500 elephants; and on another occasion comments that 'He [Akbar] had also with him fifty elephants, each with four musketeers, placed on certain appliances, like children's cradles, with a balcony which they can turn in any direction they like. These musketeers discharge bullets of the size of an egg.'

Elephants also afforded Indian generals with mobile vantage-points from which they could view events and themselves provide reassurance by their presence for their troops. During his invasion of India in 1739, the Iranian Nadir Shah expressed amazement that Indian princes and generals should still place themselves on elephants in battle, a clear target for everyone armed with a gun. Abu'l Fazl describes how the Emperor Akbar experimented with bullet-proof plate armour, though this did not cover the body comprehensively.[29] Since one cannot suppose that the Indian aristocracy failed to notice the increasing accuracy and power of firearms one is left with *noblesse oblige* as the only explanation. On many occasions the animal was wounded and ran from the battle, trampling all who got in the way. However, the elephants themselves were on occasion surprisingly resilient, as an English observer made clear in the second half of the eighteenth century: 'Elephants bred to war, and well disciplined will stand firm against a volley of musquetry, and never give way

unless severely wounded. I have seen one of these animals with upwards of thirty bullets in the fleshy parts of his body, perfectly recovered from his wounds.'[30] In fact that account understates the capacity of elephants to withstand firearms:

In the year 1809, two ferocious or wild elephants made their appearance... Those animals, which were of an uncommon size, did much mischief, but were at length vanquished and put to death, after having made several furious charges on the two four pounder field-pieces which were brought against them: nineteen four-lb. cannon balls, discharged from those pieces, were taken out of the bodies of the animals after they fell, and it was supposed that eight or ten more were buried in their carcasses.'[31]

Cannon were certainly well known in northern India under the Lodi Sultans 850-930/1451-1526 and they played an important part in the Mughal victory over the Lodis at Panipat in 1526. Much less is known about the adoption of the arquebus in the period prior to the Mughals. In India it was referred to as a *banduq* or *bunduq* and as a *tufang*. Its great weight led to the use of a two-pronged rest called a *shakh-i-tufang*. This was attached to the barrel of the heavier guns, as can be seen in Mughal miniatures, and is part of the weapons tradition that the Mughals brought from Samarkand. As the weapon became lighter, the rest was no longer necessary and it largely disappeared in India, though it remained in use in the nineteenth century amongst the hill tribes in the north who referred to it as *banduq mah sipaia*; and it also continued in use in Afghanistan, Bhutan, Central Asia and in China, whence it probably emanated.

While referred to by these names, the matchlock was also called a *toredar*, from *tora*, a rope, a reference to the 'match'. The match was made from the dried fibrous stalks of elephant creeper (*tor*); the air roots of the pipal (*Ficus religiosa*) and of the bar (*Ficus Indica*) were also used.[32] The Sultan of Gujarat took gunners and arquebus men from Gujarat to attack the pirates of Bulsar in 1482, long before the Portuguese reached India round Africa.

Handguns from Europe were known as *tufang-i-farang*. Albuquerque himself began enlisting Indians in 1510 when he seized Goa for the second time, creating a corps of 300 pikemen, 50 crossbowmen and 50 arquebus men. The arquebuses were of German manufacture and arrived from Italy in 1512 with the officers intended to drill the new corps. It was claimed by a number of the Portuguese at that time that Goan craftsmen were capable of making better arquebuses and improving the design. These German arquebuses were said by Correa, secretary to Albuquerque, to be the first introduced into Portuguese India. German matchlocks were very frequently imported into the Iberian peninsula during the period of the Portuguese expansion into the Indian Ocean and it is hard to imagine that Correa meant that these guns were in themselves new in India in 1512.

The problem with the arquebus was that it took a very long time to reload, during which time the marksman was vulnerable. As late as 1526, the Portuguese tactic was to throw down their discharged arquebuses and revert to *armes blanches*. In consequence, the Portuguese developed the practice of taking their slaves into battle carrying reserves of weapons.[33] The rapidity of fire was greatly helped by the introduction in 1536 of cartridges containing the correct measure of powder and ball.[34]

MUGHAL INDIA

The attitude of the Rajputs to firearms at this time mirrored that of all those societies which prized the skills of the mounted warrior. Maharana Vikramaditya of Mewar (*c.* 1536) took more interest in his footsoldiers (*paeks*) and their firearms than was acceptable to the equestrian Rajput aristocracy and suffered for his perceptiveness as innovatory rulers in Mamluk Egypt had done. Tod, writing in the 1820s, refers to 'The Rajpoot, who still curses those vile guns; which render of comparative little value the lance of many a gallant soldier, and he still prefers falling with dignity from his steed to descending to an equality with his mercenary antagonists.'[35]

It is clear that an awareness of the destructive power of firearms was not widespread in India and Afghanistan in the early sixteenth century. For example, on 6 January 1519 Babur attacked the fort of Bajaur, north-east of Kabul.

The Bajauris had never before seen matchlocks (tufang) and at first took no care about them, indeed they made fun when they heard the report and answered it by unseemly

gestures. On that day Ustad 'Ali Quli shot at and brought down five men with his matchlock; Wali the Treasurer, for his part, brought down two; other matchlockmen were also active in firing and did well, shooting through shield, through cuirass, through kusaru,[36] and bringing down one man after another. Perhaps 7, 8, or 10 Bajauris had fallen to the matchlock-fire (zarb) before night. After that it so became that not a head could be put out because of the fire.[37]

Despite this account it was not always possible to shoot through a good shield. Manucci describes shields in the Mughal army made of rhinoceros hide which could 'resist a musket ball.'[38] No doubt this was in part due to the variable quality of the gunpowder available in the mid-seventeenth century.

The *Babur-Nama* makes it quite clear that at the battle of Panipat in 1526 the Mughal army 'had an abundance of *zarb-zan* (culverins) and matchlocks.'[39] These and the cannon all appear to have fired stones.

When Babur invaded Hindustan in 932/1526 cannon were already well established in India. The *Babur-Nama* describes Babur's artillery under Ustad Ali-Quli making 'a good discharge of *firingi* shots'.[40] The use of the word *firingi* is indicative of the imported nature of the firearm. The same word is used by the Turks to mean a matchlock from Eastern Europe and it seems likely that this is what the *Babur-Nama* refers to, especially as the artillery are under the command of a Turk and the manuscript has a Persian word to describe cannon. Beveridge treats the word as meaning cannon and suggests that it indicates the foreign origin of the invention of the weapon. The text in this instance talks of 'shots'. A good rate of fire of a cannon or mortar was only about 8-16 shots per day at this time, as can be seen in the diary entry for 27 February 1528. At the battle described on 28 April 1529 it was recorded that Ustad Ali-Quli should collect mortar, *firingi*, and *zarb-zan*[41] (literally, blow striker, which Beveridge translates as 'culverin – an extremely heavy musket') and refers to him 'having many matchlock men with him...'. It was not unusual for a weapon to be known by the name at its place of origin and it is quite possible that a matchlock could have more than one name at this time. Other names are descriptive of function. The *Babur-Nama* uses the Persian word *qazan* for a mortar; and

describes the casting of a mortar in 1526 by Ustad Ali-Quli which consisted of two pieces: a *daru-khana* or gunpowder chamber and the *tash-evi*, the house of stones, in other words the barrel.

Akbar, the Mughal emperor (ruled 1556-1605), was particularly interested in matchlocks and the history of the reign written by Abu'l Fazl entitled the *A'in-i Akbari* has a great deal of information about Indian guns. He considered that 'with the exception of Turkey, there is perhaps no country which in its guns has more means of securing the Government than this.'[42] The emperor was interested both in the construction of matchlocks and in using them himself. He used the word *narnal* for a matchlock, by which he meant any that could be carried by one man.[43] He also joined seventeen guns so that they could be fired simultaneously with a single match, and experimented with bullet shapes. His interest in their construction led him to devise a form of proof test. Abu'l Fazl tells us that while formerly the barrels would burst if more than a quarter filled with powder now they could be filled to the muzzle without bursting, due to a method of barrel construction devised by the emperor. The partially finished barrel (known as *daul*) was sent for inspection to the emperor, who determined its bore before it was sent to be polished. The barrel was then tested with a one-third charge of powder, and if satisfactory the emperor gave the order to finish the 'mouth piece' or muzzle. This indicates the practice common in Ottoman matchlocks at that time of ornamenting the muzzle with elaborate chiselling. After this the gun was fired to determine if it was accurate. Once passed, the filer would be instructed as to decoration on the barrel and the stock maker told the shape of the stock and the wood to be used. All the matchlocks were marked during production (for example with the weight of the raw and manufactured iron) and these marks were now taken off. The gun was then marked with the place where the iron came from; the maker's name; place of manufacture; date; and its number.

Sometimes the emperor broke the manufacturing sequence and sent for an unfinished gun, which was known as 'plain' (*sada*). Five bullets were sent with it to the harem. The emperor returned it with the fifth bullet and the order was given as to the colour of the barrel and stock. The stock might be one of nine colours; and the gun might be decorated with gold inlay and enamel. Again it was sent to the harem for trial and then for gold to be inlaid in

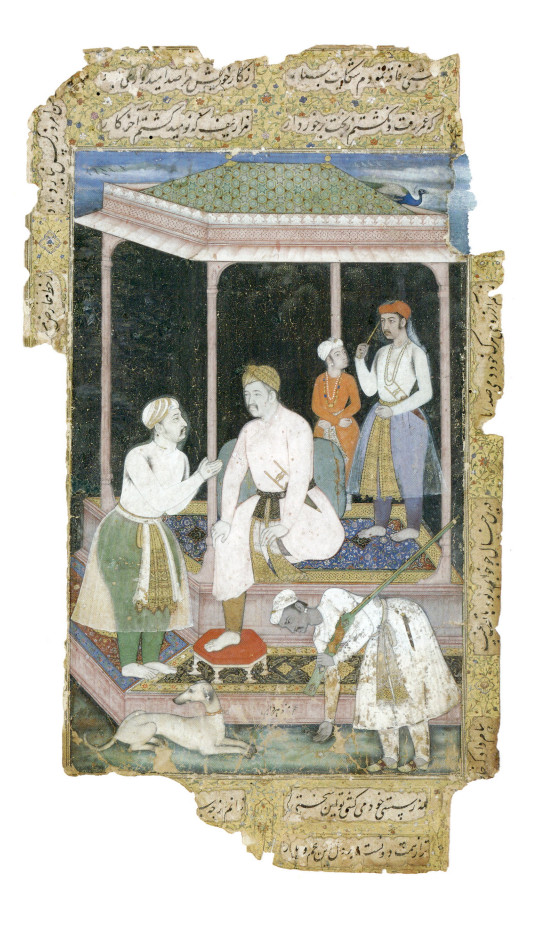

the muzzle and butt end. When ten such guns were ready they were handed over to the slaves. It is apparent from the account of Abu'l Fazl that this complicated routine could only be followed if the number of guns in production was very small.

The guns described in the *A'in-i Akbari* were of two lengths: the longer was equivalent to two yards; the smaller type, known as *damanad*, was one and a quarter yards long. For the longer guns the ball did not exceed 25 tanks, the small 15 tanks. Akbar, who was famous for his strength, was capable of firing the largest bore gun, unlike most other warriors.

Because of his interest in firearms design Akbar attracted many master gunmakers, such as Ustad Kabir and Ustad Husayn. Abu'l Fazl describes guns 'made in such a manner that they can be fired off, without a match, by a slight movement of the cock.' The means of ignition of these guns is not known but from the limited description available it would appear that Akbar owned a number of guns with miquelet locks at this early date. The earliest example of a flintlock is thought by Blackmore to be a snaphaunce gun in the Royal Armoury, Stockholm, which was ordered in 1556.[44] Gaibi refers to Italian records dated 1547 which distinguish between wheellock and flintlock guns,[45] while the Portuguese also had flintlocks in the mid-sixteenth century.

A device for cleaning sixteen barrels at a time consisting of a wheel turned by an ox was also invented by Akbar. Despite the apparent sophistication of Akbar's interest in firearms, the ordinary Indian musketeer remained wretchedly armed and trained, as François Bernier, a Frenchman resident in India from 1656-68, makes clear:

> ...the musketeers cut a sorry figure at the best of times, which may be said to be when squatting on the ground, and resting their muskets on a kind of wooden fork which hangs to them. Even then, they are terribly afraid of burning their eyes or their long beards, and above all lest some Dgen [jinn], or evil spirit, should cause the bursting of their musket.[46]

Akbar in old age listening to a courtier, by Manohar, 1602. The gun held by an attendant differs from the usual Indian matchlock in shape, suggesting mechanical innovation. Cincinnati Art Museum.

The Portuguese Manuel Godinho was equally scathing about the Indian matchlock men, saying that 'they do not take aim with the muskets but only fire at random without raising them up to the face'.[47] The low esteem in which these men were held can be seen by their rate of pay which varied from ten to twenty 'roupies' per month, a sum confirmed by Careri at the end of the century. It is interesting to contrast this with the earnings of artillerymen, often Portuguese, Dutch, German, English[48] or French and frequently fugitives from Goa or the European trading companies. In the past, when the Mughals were unskilled in the use of cannon, Europeans received two hundred rupees per month and some were still drawing a comparable salary in Bernier's time, though the Emperor Aurangzeb had set a limit of thirty-two rupees for new gunners. The status of gunners was declining, however. The pay of a Portuguese gunner in the service of the Marathas in 1753 did not exceed thirty rupees and many were paid considerably less.[49] Tod records the attack on the Mughal arsenal at Ahmadabad by the ruler of Jodhpur in 1731 in which each gate was defended by 'two thousand men and five guns manned by Europeans' and the defending general surrounded himself with a body of European musketeers. The Rajputs had demanded the surrender of 'the Imperial equipments, cannons and stores' and captured 'one thousand four hundred guns of all calibres'.[50]

The artillery, as described by Bernier, was of two types: heavy or light, the latter being called the artillery of the stirrup. Bernier describes the heavy artillery that accompanied the emperor when he went to Kashmir and Lahore to escape the hot weather on the plains as consisting of '...seventy pieces of cannon, mostly of brass, without reckoning from two to three hundred light camels, each of which carried a small field-piece of the size of a double musket, attached on the back of the animal, much in the same manner as swivels are fixed in our barks.'[51]

These swivel guns were widely known in Arabic, Persian and Turkish as *zamburak*, written *zanburak*, meaning wasp, bee or hornet. *Zambur* is a hornet and '*ak*' is the diminutive. Prior to firearms this name was applied to a crossbow or bolt. These guns were also known in Hindustani as *shahin*, the name for a falcon; and *shutarnal*, meaning literally a 'camel-gun barrel' is also less commonly recorded.[52] An Ottoman example of one of these guns mounted on a camel is illustrated by Marsigli in 1732. Irvine

appears to regard these names as describing the same object, accurately in so far as all are swivel guns. However, *falco moschetto* was the name given by Italians to a heavy form of musket in the mid-sixteenth century, which fired a ball of between six ounces and a pound[53] and remained in use until about 1660 in Europe. Describing the 'Companies of janissaries and nimble footmen' of the Ottoman army in the early seventeenth century, Knolles wrote that they were armed 'with certain Faulcons and other small pieces'. The Italian falcon was ideally suited to be mounted as a swivel gun and it seems very likely that the name was transferred to India.[54] A gun like a falconet in use in the Ottoman armies was a *darzana*, a word also used in Safavid Iran. The countries of the Near and Middle East tended to import the names as well as the technology of firearms. The strength of Ottoman influence in the dissemination of firearms can be seen in the adoption by her eastern neighbours of Ottoman terminology. *Bajalushka*, *darbzan* and *tabanja* were all words adopted by the armies of Mughal India.[55]

The 'artillery of the stirrup', referred to by Bernier, which also accompanied the Emperor on this journey, comprised

...fifty or sixty small field-pieces, all of brass; each piece mounted on a well-made and handsomely painted carriage, containing two ammunition chests, one behind and another in front, and ornamented with red streamers. The carriage, with the driver, was drawn by two fine horses, and attended by a third horse, led by an assistant driver as a relay.[56]

The Arab historian Ibn Zunbul, writing of the campaigns of Selim I in Egypt and Syria at the beginning of the sixteenth century, describes a very similar arrangement. He refers to the small Ottoman cannon, which he calls *darbzanat*, which are protected with covers of red felt and carried in waggons with a team of four horses. The ammunition boxes are suspended from the underside of the waggon and contain shot large enough to fill the palm of the hand.[57]

INDIA IN THE 17TH CENTURY

The Dutch East India Company was founded in 1602 and at once began to drive the Portuguese from their trading bases in the East; the wars in Europe were being extended to the East by the trading companies. Jan Pietersz Coen assured the Heeren XVII, the ruling Council of the Dutch East India Company in 1614, that 'Your Honour should know by experience that trade in Asia must be driven and maintained under the protection and favour of Your Honour's own weapons, and that the weapons must be paid for by the profits from the trade; so that we cannot carry on trade without war nor war without trade.'[58]

The Dutch built very few large forts and often reduced the size of the Portuguese forts which they captured to make them more economical in men and guns, as at Cochin and Colombo. The most expensive of their forts was Naarden at Negapatam (Coromandel), which cost the Company about a million and a half guilders and was nicknamed 'the castle with the golden walls.'[59] Far more typical was Fort Geldria at Pulicat on the Coromandel coast, built in 1612 and manned by a Dutch and Hindu garrison, described at that time by Schorer as containing '18 brass or iron guns, 4 falcons or bases,[60] and 4 stone mortars'.[61] Included on a Dutch list of articles suitable for import into India dated 1614 are pistols and muskets.[62] At about this time weapons, mirrors, clocks, jewellery and other items were sent to India from Holland to sell as curios or to present to princes and nobles. The weapons were in little demand, but cannon, sold by weight, brought a good profit.[63] Schorer describes the making of gunpowder at Masulipatam which became an important industry under Dutch supervision.[64] The Dutch brought hundreds of European craftsmen of all kinds, including armourers, gunsmiths and gun-founders, to their overseas possessions, particularly Batavia, from 1682. Several of the larger Dutch factories in Coromandel and Ceylon had their own Ambachtskwartier,

An Ottoman camel gun illustrated by Marsigli in *Stato Militare dell'Imperio Ottomano*, published in 1732. Various calibres of camel gun were used in the countries of the Near and Middle East, which took their lead from Ottoman military practice.

Planche XI.

Tom. II. P. 29.

Irvine refers to a 'long and heavy matchlock', possibly associated with Coromandel, which he names a *kaitoke* or *kaitok*; in another French phonetic spelling it becomes *cailletoque*.[68] It may be that this is a weapon introduced by the Dutch. Certainly the flintlock, *banduk-i-chaqmaqi*, was introduced into the Sub-continent by Europeans, though it was not until the eighteenth century, when Indian rulers modelled their troops on European armies, that appreciable numbers reached Indian hands. At the second battle of Panipat in 1761 twelve battalions of Indian infantry, in

Shah Jehan standinq on the globe. Inscribed Payag, c. 1630. Chester Beatty Library, Dublin.

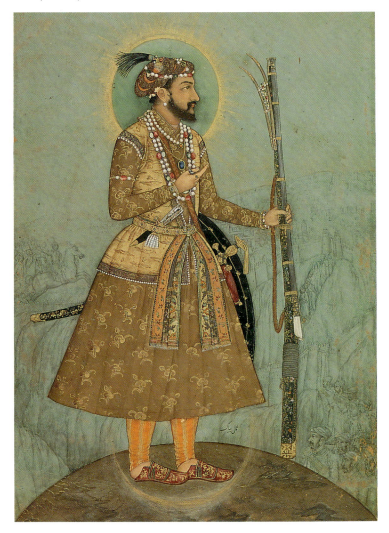

Shah Jehan using a matchlock. Drawing, mid-seventeenth century. Chester Beatty Library, Dublin.

where each craft worked and messed together under a foreman who supervised the European workmen and company slaves trained by them. Some of these craftsmen set up their own workshops on the expiration of their term of engagement and fine work was done by free Tamil and Sinhalese craftsmen.[65] European involvement with the political affairs of local rulers inevitably drew them into local conflicts which greatly hastened the spread of the latest European military technology. The Dutch merchants who came to trade found that it was necessary to protect their possessions and established private forces that were inevitably drawn from the local population,[66] though with a high proportion of foreign mercenaries – Germans, Swiss, English, Scots, Irish, Danes and Scandinavians. They merely reflected the state of the Dutch army in the Netherlands, of which a foreigner observed that 'It is remarkable that almost the whole Army of the States are Foreigners.'[67]

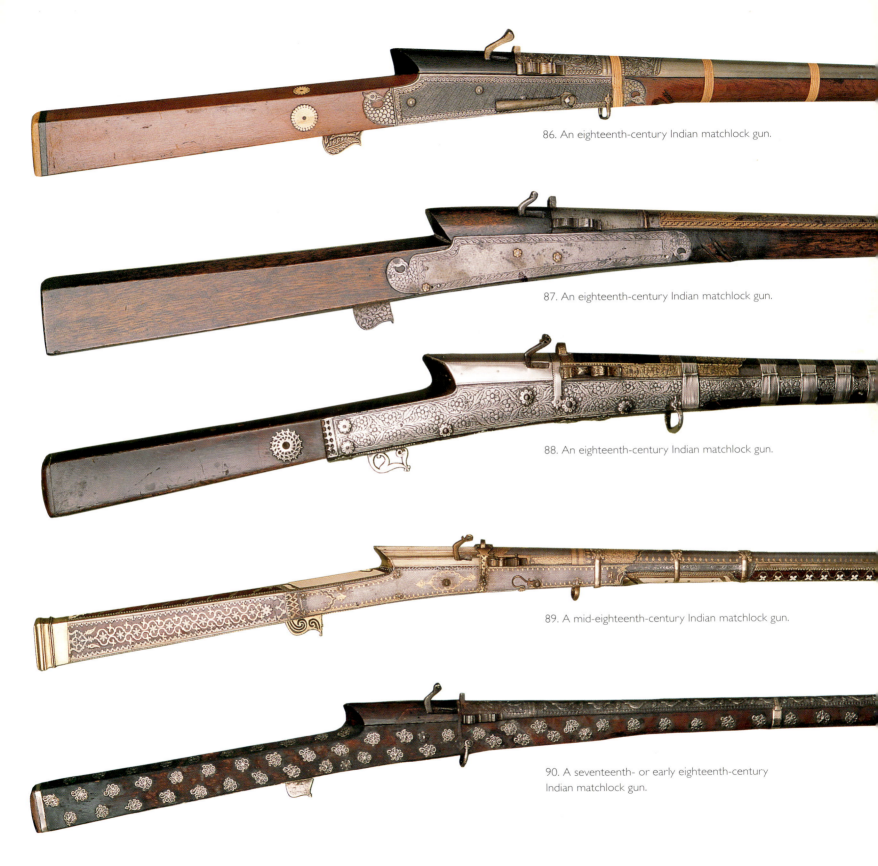

86. An eighteenth-century Indian matchlock gun.

87. An eighteenth-century Indian matchlock gun.

88. An eighteenth-century Indian matchlock gun.

89. A mid-eighteenth-century Indian matchlock gun.

90. A seventeenth- or early eighteenth-century
Indian matchlock gun.

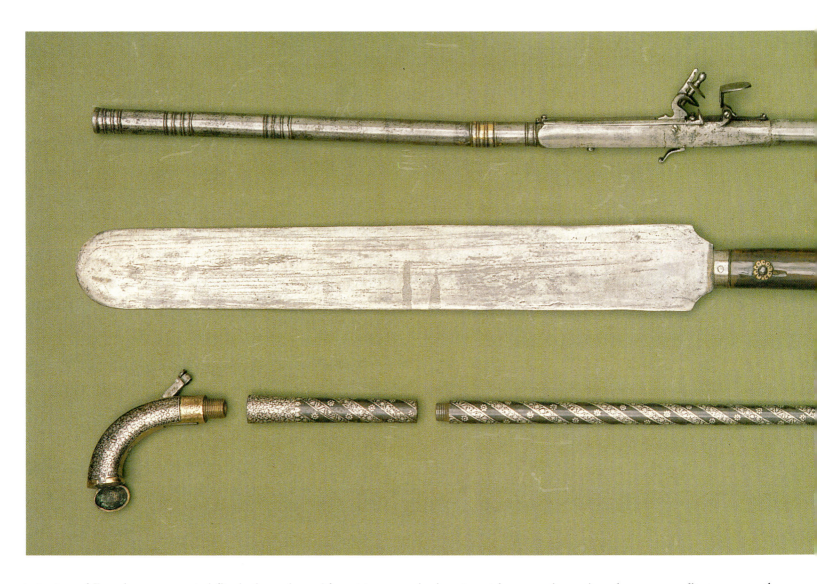

imitation of French *sepoys*, carried flintlock muskets. After citing various authors on the slow introduction of flintlocks into the Sub-continent, Irvine observes that 'to the end of the Moghul period the firearm in ordinary use was the matchlock'.[69] This is undoubtably correct. Indeed, one reason why the reflex bow remained widely used well into the nineteenth century was the condition of many of the guns, particularly the flintlocks, which made them unreliable and dangerous to use. An observer commented that the firearms used by the Marathas in the mid-eighteenth century 'were as usual defective'. 'Their arms are for the most part English, and out of twenty, two will be found without

locks, six without cocks and perhaps not a flint among the remaining twelve.[70]

However, the Indian craftsmen were capable of making fine copies of European firearms from an early date. Bernier describes how Delhi in the mid-seventeenth century was devoid of workshops occupied by skilled artisans but that 'handsome pieces of workmanship' were made by people destitute of tools:

Sometimes they imitate so perfectly articles of European manufacture that the difference between the original and copy can hardly be discerned. Among other things, the

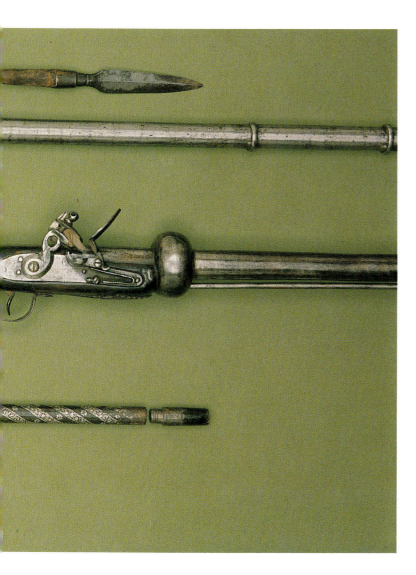

91. An Indian combination steel lance and boxlock flintlock gun, c. 1800.

92. An Indian combination sword and flintlock gun, c. 1800.

93. An Indian steel walking stick with concealed percussion gun, c. 1835.

doubt served as conversation pieces. In some cases, nevertheless, they were clearly made to be used. A fine early example of the type can be seen in the Rainer Daehnhardt Collection, attributed by him to Cochin.[72] Sinclair, writing about southern India in 1873, states; 'I have seen the mace and war-axe only in the armouries of great men. The axe sometimes has a pistol-barrel in the shaft.'[73] In the Tareq Rajab Museum this type of Indian firearm is well represented by a walking-stick concealing a percussion gun, a combination sword pistol and a steel lance containing a flintlock gun. (Catalogue nos 91, 92 and 93).

The Indians as a whole were curiously uninterested in the gains to be made by adopting Western technology. One of the few exceptions was their acceptance and manufacture of firearms, particularly cannon. Cannon were auspicious. The birth of a son was immediately announced by a discharge of artillery 'or by musketry in the lower grades of the Native population, even to the meanest peasant, with whom a single match-lock proclaims the honour as effectually as the volley of his superiors.'[74]

It was said that the purpose was to accustom the infant to the sounds of war where the future warrior might win glory and wealth, but the original intent was probably to scare away evil spirits. The idea in the East of firing off guns to announce the beginning or end of a day's fasting at Ramadan, the arrival of an important person, or to celebrate victory or good news was Turkish (*senlik*), corrupted into Arabic as *shanik*.[75] The thought that the adoption of new military technology might provide real assistance to the infant being announced to the world in achieving these goals was not considered. In part this was due to caste and hereditary skills which protected inefficient self-interest. For example, in 1672 the Dutch in Coromandel demonstrated a manufacturing technique which quadrupled the rate of production of nails and cannonballs. Far from welcoming the advance the local

Indians make excellent muskets, and fowling pieces, and such beautiful gold ornaments that it may be doubted if the exquisite workmanship of those articles can be exceeded by any European goldsmith.'[71]

In India firearms were often combined with traditional weapons. The usual result of this, as in Europe and Ottoman Turkey, was a weapon that was unbalanced and functioned badly either as a gun or as a close combat weapon. These objects are often extremely ingenious and well made – presumably extravagant creations for personages of importance in most cases – and no

powers banned a process that would have put local blacksmiths out of work. In fact, from the mid-seventeenth century cannon were regularly purchased from the Europeans by the Marathas and others, and iron and steel, particularly from England, was imported. (Locally-produced cannon balls were generally of poor quality.) There was also a great deal of specialisation so that every stage of production was the proud right of a particular group. Demarcation slowed production and increased costs, and certain 'industries' were part-time occupations. In Bihar, iron ore was mined and smelted by peasants who worked for five months of the year at this activity. The production of saltpetre and iron was largely a peasant occupation when the demands of agriculture allowed. The process of smelting was very primitive and required large quantities of wood for fuel. This rose in price in the 1850s, at a time when cheap imports of sheet iron from Europe put the industry into terminal decline. Moreover, the traditional Brahman education was based on theological learning by rote, which was not likely to encourage an enquiring interest in Western science and its application to business. As the traditional crafts were put out of business by Western imports, workers very rarely acquired new employment as a direct result.

THE BRITISH
EAST INDIA COMPANY

Sales of arms in the seventeenth century formed a part of the East India Company's activity. In 1613 the chief factor at Surat, Thomas Aldworth, listed sword blades and lead amongst the imports that he considered would prove profitable in the Indian market. When Sir Thomas Roe, the first British ambassador to the Mughal court, arrived in 1615, he was almost entirely preoccupied with acquiring trading options for the East India Company. In the furtherance of this, he presented a Mughal prince with 'a very delicate piece scrued, with a fier lock, made in Liège, that would carrie poynt blank as farr as a muskett and weighed not 4 li.'[76]

(Foster notes that 4 li is 4 pounds and from Roe's accounts that the gun cost the substantial sum of fifty-two shillings in

Liège.) Roe also describes a tantalising discussion about firearms with the commander of the Mughal troops at Delhi in 1616: 'Wee sate to see his souldiers shoote in bowes and pieces. Most of them with a single bullett did hitt the marke, beeing a hand breadth in a butt. Wee had some discourse of our use of such weapons; and soe I departed.'[77]

The Governor of Madras in 1662 asked the Company for good swords as their soldiers were armed only with butcher's knives. In 1665 they recorded the arrival of muskets. In 1666 the Emperor Aurangzeb requested that English gun-founders be sent to him, but the Governor countered this with a report that 'the factors had for sale several large brass guns, besides mortars and grenados'.[78]

The Maratha leader Shivaji was almost continuously at war with Aurangzeb. This placed the East India Company in a delicate position because of its trading interests in the territory of each. Shivaji had no means of cannon-casting and looked to the French factory at Rajapore to meet his requirements while encouraging the British to establish a trading base at the same port. On 5 September 1670 the Bombay factors wrote: 'we know that Sevagee may furnish himself with lead or guns from the French factoryes at Rajapore but wee will not bring ourselves into any intrigues, but keepe to such orders as you have and shall appoint us'.[79]

A letter of instruction dated 30 September 1671 sets out the East India Company's policy with regard to arms sales to Shivaji:

if he gives us such encouragement that wee againe settle in his port he may obtain from us those advantages that other nations doe in whose ports we trade, but we would not positively have them promise him those granadoes, mortar pieces and ammunition he desires, nor absolutely deny him in regard wee do not think it convenient to help him against Danda Rajpore which place if it were in his possession would prove a great annoyance to the port of Bombay, and on the other side our denyall is not consistent at present with our interest, in respect wee believe the keeping in suspence will bring him to a speedier conclusion of the treaty hopeing thereby to be furnish(ed) with those things he desires.[80]

The Company continued to offer the excuse that they could not afford to offend the powerful Mughal Emperor. Shivaji was perfectly happy to conceal the transaction by purchasing through Portuguese intermediaries, but the company remained unwilling to allow the sale. In 1673 he bought two thousand maunds of lead and eighty-eight iron guns from the French.[81]

In a Court Minute dated January 1672, the Shipping Committee was ordered to provide 200 snaphaunce muskets and bandoliers and 200 swords for Bombay.[82] Demands for supplies of swords and muskets are frequently found in the Company records in the seventeenth century. In 1687 the storekeeper at Fort St George reported the following items to be in his armoury:

150 Iron Ordnance [83]	70 Swords
220 Blunderbusses	3 Poleaxes
30 Muskets, firelocks	29 Pikes
890 Matchlocks	23 Suits of Armour for Horse
34 Halberts	28 Suits of Armour for Foot

He was ordered to provide 97 more poleaxes and 500 pikes to be made with bamboos. Bearing in mind that this is a British armoury in India, the absence of pistols is noteworthy. There are very few references to pistols in the hands of Indians in the literature prior to the nineteenth century, and they are even rarer in the miniatures. Thevenot, who was at the Mughal court in 1666, describes how the nobles are armed with conventional Indian weapons 'and sometimes the pistol.'[84] This is an early and isolated reference. Irvine provides no evidence for its use prior to 1720.[85] In consequence, the Indians developed great skill at firing the matchlock long gun from a moving horse and many accounts exist of demonstrations of this skill.

Swords and firearms were bought within India but there is often little indication as to their origin. For example, in 1731 the Bombay Council ordered the payment of 466 rupees for 60 muskets and bayonets received from George Breton. In 1742 the Council at Fort William bought 120 muskets and 500 sword blades, the latter at 2 Madras rupees each. They also asked Madras for small arms and because of an urgent need for firearms authorised the Master at Arms to purchase in the town, after proof, on the best terms possible. A similar situation occurred in June 1758 when arms were required so desperately that the inhabitants were ordered to hand in all firearms except fowling pieces to the military storekeeper, who would assess their value and pay for them.

The Select Committee at Calcutta applied to the Honourable East India Company in London in September 1765 for 10,000 stands of arms and 4,000 each subsequent year. They also suggested that in future the company should purchase muskets from the same persons who supplied the home government as the last consignment sent to India by the company was of poor quality, the locks badly finished and the metal badly tempered. The Company paid 18 shillings per firelock in contrast to the British government's price of 27 shillings each.

In 1766 the Calcutta authorities were requesting the H.E.I.C. in London to take every measure possible to halt the illegal private trade in small arms which had become very profitable to ships' captains and was arming the Indians. The trade was at its peak between 1760 and 1790.[86]

There is no evidence that the East India Company ever made muskets in India, though their arsenals in the three presidencies – Calcutta, Bombay and Madras – had extensive armouries for the storage and repair of small arms that had been captured and these were sometimes re-issued.[87] However, the Company was perfectly content in the late 1770s to sell the Nawab of Oudh British arms for the use of the three battalions of East India Company troops stationed in Oudh under the defensive alliance. The British Resident reported to Warren Hastings, the Governor-General, on 10 January 1778 that the Nawab refused to supply more arms 'until those which he has already obtained are accounted for; and I must do him the Justice to say that his objection is very reasonable; within these two years 14,000 Stand of English arms have been obtained on his Accounts all of which have gone directly to the Troops under British Officers.'

The Company relied primarily on imported British firearms and usually on imported edged weapons.[88] These were usually 'land service' arms, but some were 'sea service arms' ordered for the Bombay Marine, the forerunner of the Indian navy. The Company started ordering arms in 1664 from individual makers such as William Bolton, Thomas Gregory and John Williams. In the period between 1745 and 1773 John Bumford and Co. received most of the Company's custom. Later the Company received its supplies on an annual basis by public tender.[89]

1600 1610

The East India Company mark in 1600 was initially a 'bale-mark' in the form of an orb containing the letters GCE within three unequal segments, standing for 'Governor and Company of Merchants of London Trading in the East Indies' and surmounted by a vertical line with addorsed letter 'C' at the apex. This latter motif was replaced by a cross in 1610. This was used to mark Company property leaving England and with slight variation persisted until 1702. In 1698 a rival East India Company was formed which adopted the balemark of a heart with a '4' in the cusp, the heart containing the letters EEIC for 'English East India Company'. It is said that the figure four was derived from the Christian cross on the old balemark but, because this symbol was offensive to Muslims, two of the arms of the cross were joined. After the amalgamation of the two companies in 1702 a new balemark came into use. This was a heart, divided in a number of ways, most commonly an 'X', containing the letters EIC or more usually VEIC, the 'V' standing for United. A commonly encoun-

tered weapon with this mark struck on the lock is the India pattern musket which resembled the 'Brown Bess'[90] but had a shorter barrel, of 39 inches. According to Howard Blackmore, in about 1810 the old heart and cross trade mark was replaced on the lock by the figure of a lion rampant-gardant, supporting an imperial crown.[91] The lion rampant-gardant device appears as the crest on the arms of the (New) East India Company, granted in 1698. It appears as a motif on Bengal forty-eight rupee coins in 1793-4 and in 1809 on the half pie coin, though the old balemark also continued in use.[92]

From as early as 1615, outmoded or unserviceable small arms and cannon were shipped back as ballast to London for sale.[93] Arms that were better than scrap but inferior to those used by the East India Company were sold to the Marathas by both the Company and the Portuguese at Goa. When the authorities decided to stop this practice there was a vigorous protest by a Colonel Tone:

East India Company balemarks used to mark company property.

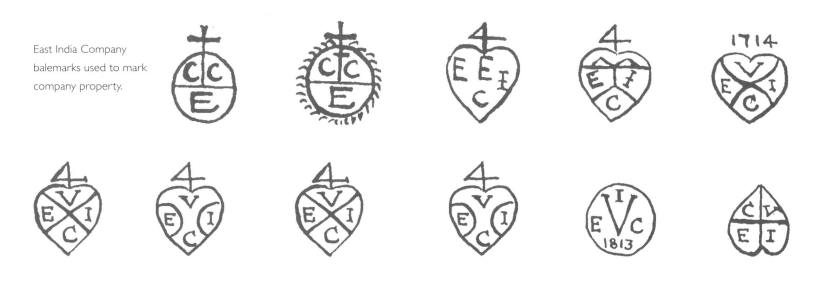

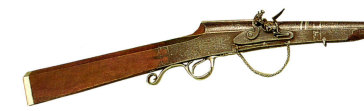

94. An Indo-European flintlock gun, c.1820, with pattern welded barrel and side plates.

The late regulations of the Company respecting the return to Europe of all unserviceable arms, may for a time prevent the increase of infantry corps, but then it will drive them to the expedient of making their own firelocks, as Scindeah has done, and his are very excellent ones, far superior to the ordinary European arms to be met with in the bazars. I for my own part very much doubt the policy of the orders in question. In the first place, I lay it down as a postulatum, that arms will be sold while a good price is given for them in defiance of all the regulations that can be made; and if they must be disposed of, the Company had better receive the value than any individual. In the next place, the arms purchased in the interior, are of that description which is denominated unserviceable, and generally are so. In this case it is of very little consequence in whose hands they are, since if they are useless to the Company, who have excellent Karkonnas to repair them, they can be of no great use to a native power, which has not the same means of mending them.[94]

The careful economies of the East India Company meant that troops were sometimes no better armed than their Indian enemies. Sergeant Pearman and a party of men from the 3rd or King's Own Light Dragoons had been issued with old Brown Bess flintlock muskets for their protection as they were marched up country to Delhi on their way to the Sikh war in 1845. Despite the 'hundreds of thousands of stands of arms in the [Delhi] arsenal' many of the men had to make do with the old guns. ' The gun I had was deficient of a cock to hold the flint; the gun of Private Goodwin had no screws to hold on the lock; the gun of Private Roberts had no ramrod, and several others were like them. With such arms we were taken into action.'[95]

Colonel Tone drew an important distinction between the *bunduq* and the firelock at the beginning of the nineteenth century,

effectively contrasting the locally made gun with the European import. 'The bandook takes a longer time to load than the firelock, as it is chambered, but then it carries a ball much farther and infinitely truer; and long practice enabled the nujeebs to load with a readiness sufficiently applicable to ordinary service...'[96]

A number of private gun makers established businesses in India in the nineteenth century. Best known was the London family firm of Manton and Co. In about 1825, Frederick Manton, nephew of John Manton, started the business in Calcutta on behalf of the firm at No.10 Lall Bazaar. It was subsequently managed in succession by John Augustus Manton (1828-33) and Edward Manton (1834-46) when it was purchased by W.R. Wallis, whose office in London at 116 Jermyn Street still exists. At some date after 1837 Manton and Co. moved to 63 Cossitollah, Calcutta and their present address is 13 Old Court House Street, Dalhousie Square, Calcutta.[97] A fine early nineteenth-century Anglo-Indian gun from the Tareq Rajab Museum (Catalogue no. 94) has a classic English flintlock on an Indian matchlock stock of exceptional quality. The lock is signed Seetaram and Sons. An interesting construction detail is that the lock is held in place with a single screw. Beneath the lock is a pricker for clearing the vent, a typically Indian feature. The stock is veneered with partridge wood, so called because of its resemblance to the breast feathers of the partridge. This is a South American wood[98] which probably reached India with a cargo of mahogany for the English furniture trade. The barrel and steel side plates are unique and a remarkable *tour de force* of the gun maker's art in that they display every possible Indian pattern weld design. Presumably this is an exhibition piece. A gun by this maker was exhibited in the Great Exhibition of 1851 and was bought by the Armouries, H.M. Tower of London, which also has a pair of percussion travelling guns (c. 1850) which unscrew into barrel, stock and lock, and are inscribed on the barrel as being made by Seetaram and Sons, Gunmaker to the Maharaja of Alwar.

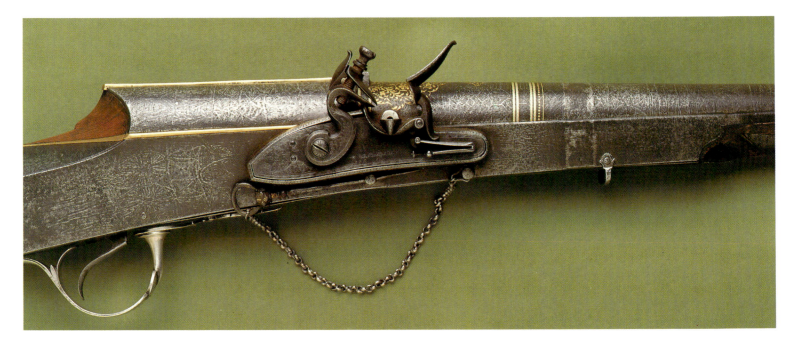

94a. Detail of lock, vent pricker and side plate.

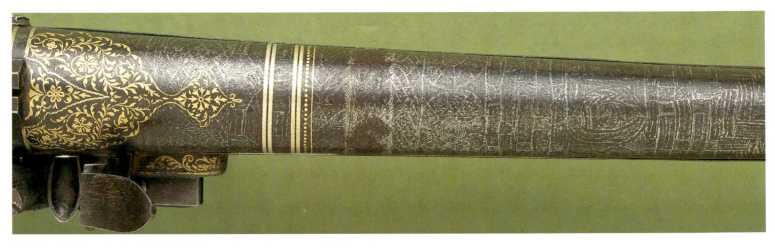

94b. Detail of breech showing *koftgari* decoration and pattern welded barrel.

94c. Detail of mid-section of pattern welded barrel.

94d. Detail of fore-section of pattern welded barrel.

95. An unusual Indian flintlock rifle with a Turkish barrel and an English lock, c.1820.

96. An Indian flintlock gun, c. 1825, with an English lock. This gun and no. 95 clearly show the transition from traditional Indian matchlock form to contemporary English style.

Parker, Field and Sons supplied firearms to the East India Company, first as John Field and Sons from 1841 to 1850, and as J.W.P. & W.S. Field (1851-8). It had been the intention in 1857 to equip the East India Company's infantry with the Enfield, the rifle of the Queen's battalions, and partial issue was made. It is well known that the loading drill required that the end of the cartridge be bitten off and that since this was coated with grease to assist loading, was offensive to both Hindu and Muslim religious and caste beliefs regarding defilement. Refusal to handle these cartridges brought to a head a list of deep grievances and fears in the *sepoys* of the Bengal army, which resulted in the outbreak of mutiny at Meerut in 1857.

Those units still armed with the old Brown Bess were at a severe disadvantage because of its limited range. Arthur Lang, a young lieutenant in the Bengal Engineers based on the Ridge above Delhi, records that when the 'Pandies' found that the picket of the 8th King's he was with were armed with the Brown Bess they 'treated us with contempt, exposing themselves to us.'[99]

As late as the mutiny in 1857 a revolver was a scarce and desirable article. '...I rode to an auction of poor Travers's property, to try and get a revolver, but did not, as the two for sale were not good ones. It is unfortunate that I should have lent my revolver to Elliot Brownlow, as he has no occasion to use it, while now revolvers in the plains are not to be had. Men refuse to sell theirs for 500 rupees.'[100] Among the results of the conflict was that Queen Victoria was declared Empress of India in 1858, there was a reform of the army in India, and military rule by the East India Company was ended.

British India did not establish a small arms factory until 1905 when it was agreed that rifles should be manufactured in part of the old gunpowder factory at Ishapore, where the first rifle was produced in 1907.[101]

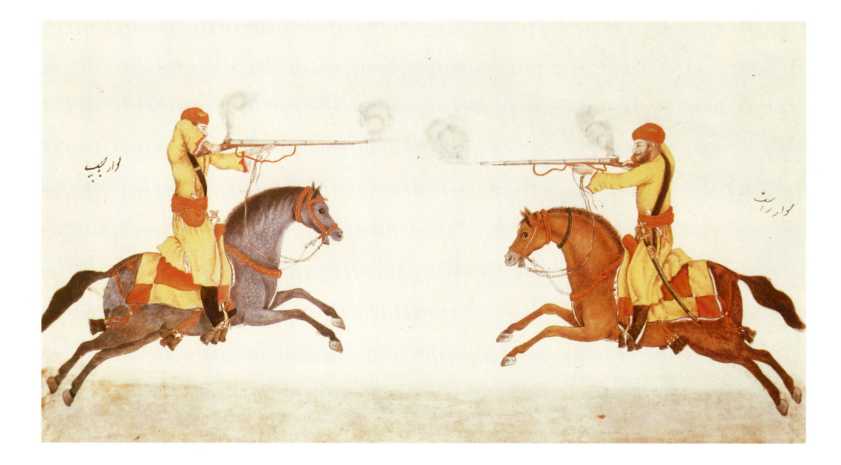

An illustration from 'The book of rules for the manoeuvres of the Hindustani Musket Cavalry formed by Colonel James Skinner Sahib Bahadur, Hansi cantonment 1824', entitled 'Method of attack when meeting enemy head on'. Gouache and watercolour, by an Indian artist. Courtesy of the Director, National Army Museum, London.

INDIA IN THE 18TH AND 19TH CENTURIES

BENGAL

The conflict between the British under Clive, Mir Jafar, the Mughal Governor of Bengal, and his rivals in the second half of the eighteenth century demonstrated the importance of controlling a weapons-producing centre in the exercise of political power and influence in India. The Dutch, based at Chinsura and anxious to improve their standing and trading prospects at the expense of their rivals, the British, sought to play on the Mughal Governor's dislike of his dependence upon the East India Company by sending him arms from Batavia. Although England was at peace with Holland, Clive adroitly placed the Dutch in the position of aggressors and destroyed the shipment, with the result that the Dutch subsequently limited themselves to trade. Mir Kasim replaced Mir Jafar as Governor and set about prepar-

ing himself for the inevitable conflict with the Company. He seized the Treasury at Bihar, began to raise an army of disciplined troops and moved his capital from Murshidabad to Monghyr in order to be further from Calcutta and the British. The fort at Monghyr was built in 1580 by Raja Todar Mal and the manufacture of arms was said to have started to service the Muslim garrison.[1] Mir Kassim was manufacturing firelocks there in 1763 and these were said to be better than the best Tower-proof muskets sent to India by the East India Company, especially in the metal of their barrels and their flints, which were made of agates found in the Rajmahal Hills. The utter defeat of Mir Kassim at Baksar in 1764 seemed disastrous for the local arms industry, though it continued, and in 1765 Monghyr was one of the strategically-

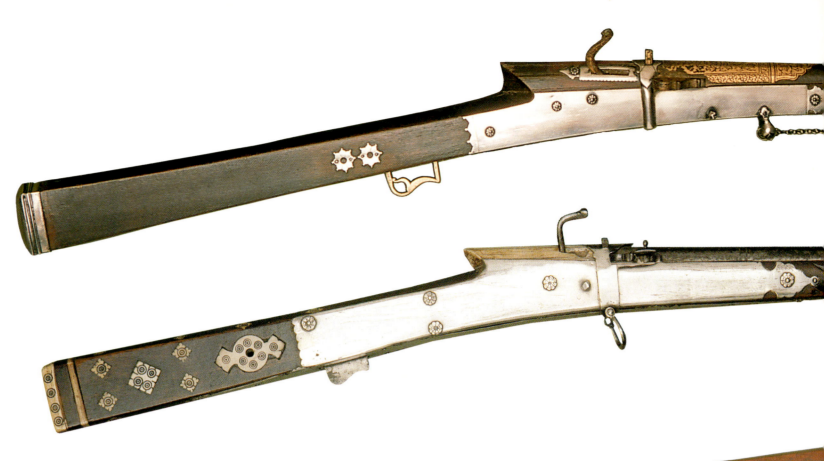

sited arms depots established by Clive and supplied from the Fort William Arsenal.[2] Egerton says that Monghyr was noted for the manufacture of pistols and Birdwood wrote in the late nineteenth century that Monghyr had been famous for good weapons.[3]

The industry declined and was extinguished in the nineteenth century according to Bhattacharya, who suggests that 'the demand for superior iron and steel for arms rapidly declined ... leading to the extinction of the small arms industry at Monghyr.'[4] The inability of the gunsmiths of Monghyr to compete on price or to copy Western arms technology seems improbable, though the introduction of multi-shot cartridge weapons called for precision and keeping abreast of the rapid European and American development of firearms must certainly have been difficult for the community. However, gun production either survived or was re-started. *The Imperial Gazetteer of India*, published in 1907, recorded that Monghyr was famous for its guns and stated: 'A serviceable double-barrelled gun can be obtained for thirty rupees, a single barrel for fifteen and a large double barrelled pistol for the same

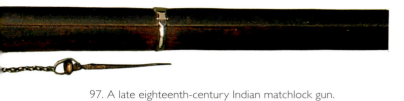

97. A late eighteenth-century Indian matchlock gun.

98. An eighteenth-century Indian matchlock rifle.

sum. 'It is pleasing to note that the British and Indian love of hunting resulted in a switch in the type of arms produced at Monghyr.

It seems likely that Bhattacharya was wrong in his belief that the metal-working industry at Monghyr was ever totally extinguished because the *Gazetteer* records that in 1907 'swords and iron articles are also made, of no special excellence'. One type of pistol which was produced in India (at Monghyr as late as 1907) and in Britain in considerable numbers, specifically for use in India, is widely known today as the *howdah* pistol. When hunting tigers or lions from an elephant it was not unknown for the enraged animals to attack the hunter on his elephant and at such times ownership of a large, double-barrelled pistol proved invaluable. These are generally eight or nine inches long with a bore of not less than half an inch. Most date from the period 1840 to 1890 and are percussion cap guns, though there are accounts of

99. An Indian two-shot superimposed loading small bore matchlock gun, *c.* 1760.

100. An Indian two-shot superimposed loading matchlock gun, *c.* 1800.

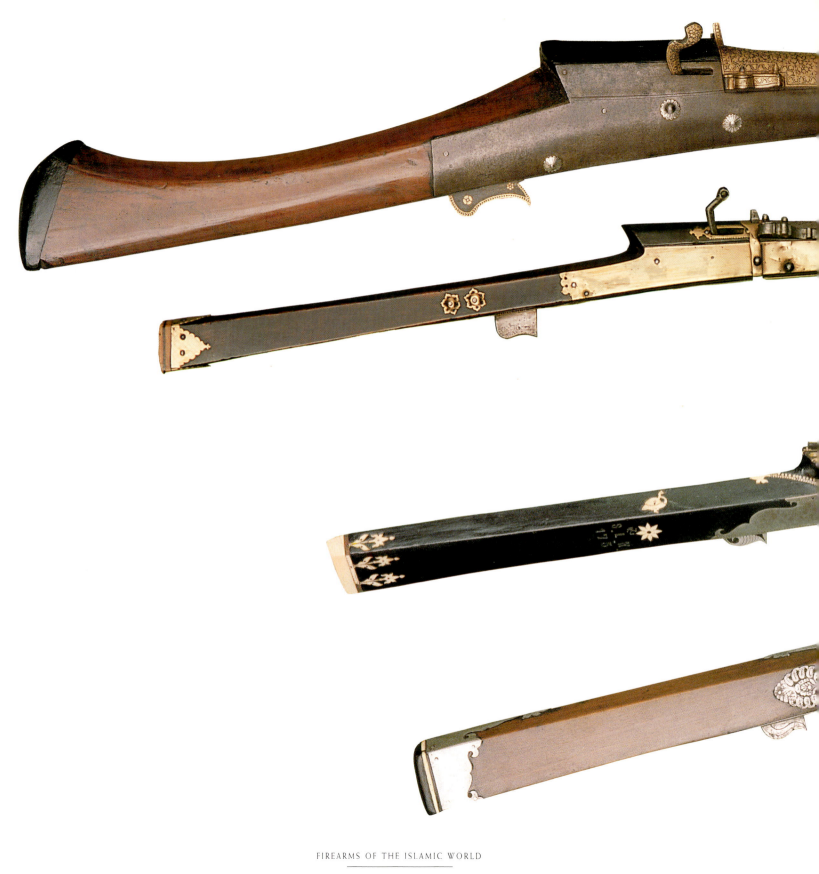

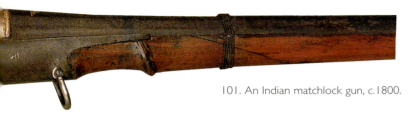

101. An Indian matchlock gun, c.1800.

102. An early nineteenth-century Indian matchlock sporting gun.

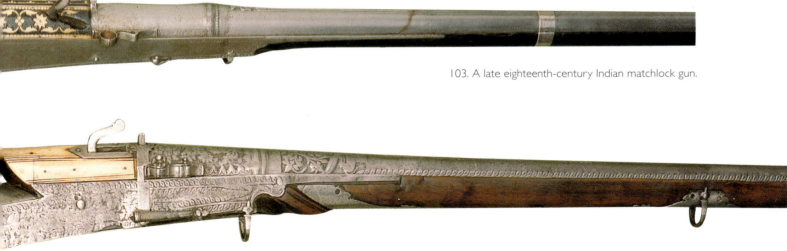

103. A late eighteenth-century Indian matchlock gun.

104. A late eighteenth-century Indian matchlock carbine.

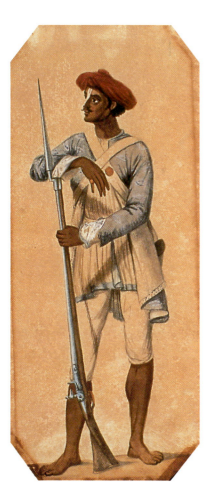

An infantryman in Tipu Sultan's army. Late eighteenth century. Watercolour formerly attributed to James Hunter, but now believed to be by Charles Gold. By permission of the Victoria Memorial Museum, Calcutta.

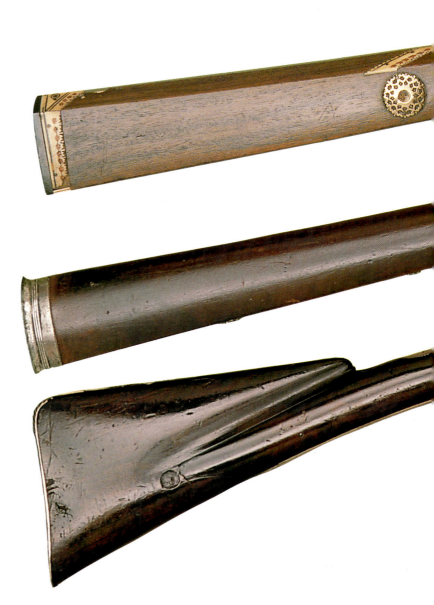

the Indian rulers using flintlock pistols in this manner in the eighteenth century. The French traveller Victor Jacquemont described this sport in his usual humorous style in a letter in 1830:

> As for lions and tigers, that is the most harmless of sports (for gentlemen, that is to say), since they are not hunted on horseback, but only from an elephant. Every huntsman is perched up like a witness in an English court of justice, in a very high box strapped to the animal's back. He has a small park of artillery at hand, comprising a pair of guns and a pair of pistols. It sometimes happens, though very rarely, that when the tiger is brought to bay it leaps on the head of the elephant; but that is nothing to do with the likes of us: it is the business of the mahout, who is paid twenty five francs a month to put up with this sort of accident.[5]

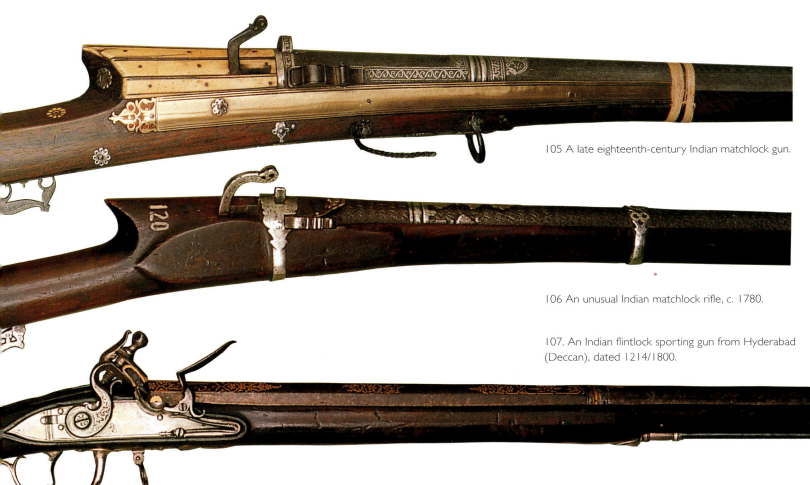

105 A late eighteenth-century Indian matchlock gun.

106 An unusual Indian matchlock rifle, c. 1780.

107. An Indian flintlock sporting gun from Hyderabad (Deccan), dated 1214/1800.

Jacquemont's friend William Fraser and Colonel James Skinner used to hunt lions for sport in the vicinity of Hansi in about 1815. They considered the safety of a *howdah* unexciting and hunted on foot and on horse. For these adventures they chose to arm themselves with Indian matchlocks. According to Jacquemont, Fraser alone accounted for eighty-four lions, being personally responsible for their extinction in the area, but lost a number of horses in the process.[6] Skinner also hunted tiger on horseback with a lance, as did his contemporary, the redoubtable General Lake. Thorn describes in his *Memoirs of the War in India* how 'a tiger of large size was shot with a pistol by General Lake, just as the ferocious animal was in the act of springing upon Major Nairne, by whom it had been previously speared.'[7]

PONDICHERRY

In India the Europeans contesting control of Indian trade established arsenals at their trading stations and these reflect the arms produced in the European country of origin. In 1674 the French established a settlement at Pondicherry. The fall of Pondicherry in 1761 and its total destruction resulted in hundreds of French soldiers offering their services to the British and to Indian princes and rulers, notably the Nizam and Haidar Ali. This accelerated the adoption of the flintlock and European military concepts by the Indian states. The town was restored to the French in 1763 under the Treaty of Paris and was rebuilt. Governor Law, who arrived in 1765, described the garrison as consisting of 500 European soldiers, including 130 invalids, and 400 *sepoys* recruited the previous year and scarcely capable of loading their guns. The report also describes the arms available to the troops for the town's defence:

We are very weak in artillery and musketry. Forty pieces of cannon, six to twenty four pounders, of which several very bad and all very badly mounted, constitute all the defence of the place. The guns of our soldiers are good, those of our sepoys are very old. That is all our musketry. There is not a single spare gun in the arsenal so that we do not know how to arm the employees and the inhabitants.[8]

A French gunsmith named Chalembrom (Hayward gives Chalembron) is known to have worked in Pondicherry in the second half of the eighteenth century. Chalembrom produced a number of repeating guns 'according to a system named after him, though it was, in fact, a version of an Italian breech-loading system, of which the earliest known example by T. Lefer dates from 1668.'[9] Nothing is known of Chalembrom's previous life but his apprenticeship was presumably served in France; it is therefore of interest that Jean Bouillet of St Etienne made several repeating guns of this type, including one in 1767 which fired twenty-four bullets. Hayward concluded that some of these Pondicherry flintlocks 'show definite signs of oriental workmanship, mainly in the ornament'. The comment is important because of the later appearance of Indian gunsmiths at Chintamani and Hyderabad making guns of this type who very probably learnt their trade under Chalembrom. One of two examples in the Musée de l'Armée, Paris, is 'said to have been presented to Louis XVI in 1785 bears the inscription "Fait Par Chelembrom Pondichery 1785". Other specimens by the maker, who usually spelt his name Chalembrom, all date to the 1780s.'[10] A gun made on this principle, catalogued by Blackmore in *Royal Sporting Guns at Windsor*,[11] bears a Mauludi[12] date of 1788-9 and an inscription showing that it was made at one of the two forts constructed by Tipu at the town of Chintamani, a good distance east-north-east of Seringapatam on the border of Mysore. The British captured the forts in 1791. However, production obviously continued because in the Tareq Rajab Museum (Catalogue no. 107) there is an extremely elegant flintlock sporting gun of European type, inlaid with the inscription *sakht sarkar i Asafiya karigar Chintamani 1214* (the Nizam's government workman at Chintamani 1214/1800), *i Asafiya* being a recognised title for the Nizam. This gun subsequently passed to the Jaipur Arsenal. There are also two pistols of the Chalembrom type in the Visser

Collection which have inscriptions showing that they were made in 1797-8 by an Indian gunmaker for the Nizam of Hyderabad.[13]

In the eighteenth century, the French made serviceable muskets at Chadarghat, a suburb of Hyderabad.[14] In 1787 Nizam Ali of Hyderabad provided the Frenchman Aumont with 5,000 rupees to buy muskets from Pondicherry, but the Governor did not allow it.[15] In 1793 Nizam Ali applied to the Governor of Madras for permission for his European advisor, the French mercenary Raymond, to be allowed to buy 3,000 condemned muskets, or muskets captured at Pondicherry, but the East India Company prohibited the sale.[16] Subsequently Raymond hired muskets for his men from a French merchant at a rate of eight annas per month each.[17] Increased demand led to a scarcity of firearms on the market. The result was that a number of local rulers and mercenaries accepted the necessity of freeing themselves from the control of the East India Company and set up their own arms production centres.

LUCKNOW

One Frenchman who successfully ran an arsenal in India was Claude Martin.[18] Born in Lyon, he went to India as a common soldier and is recorded in the ranks of the bodyguard of the French Governor of Pondicherry in 1755. Martin deserted in 1760 during the siege of Pondicherry, one of many professional soldiers to become disillusioned with French employment and prospects in India. He subsequently served the British, who in due course gave him a commission. Martin survived a shipwreck off the Indian coast and rose in rank in the Bengal army. A battalion of predominantly non-British troops in the service of the East India Company, including Frenchmen recruited and led by Martin, were induced by bribery to desert in 1764 by the Nawab and took refuge in Oudh. Martin himself declined to lead the deserters, though requested to do so by a Sergeant Delamarr, and stayed loyal to the British. The deserters are known to have remained in Oudh for some years and it seems that some of them turned their hand to gunsmithing. The Nawab of Oudh, Shuja-ud-daula, was said to have made amazing improvements in the manufacture of small arms in 1768.[19] The Nawab of Oudh's capital and arsenal at that time was Faizabad which the Comte de

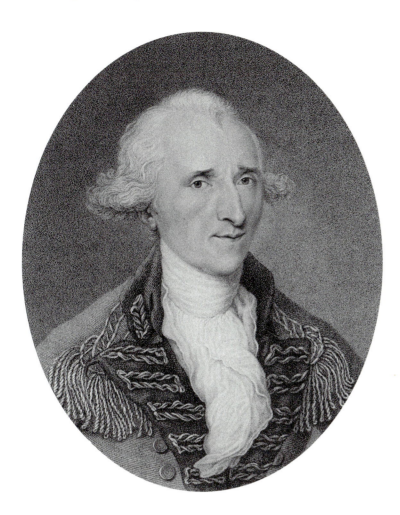

General Claude Martin: stipple engraving by L. Legoux after F. Renaldi. Published 1786. Courtesy of the Director, National Army Museum, London.

Modave visited in 1773.[20] He wrote that the guns and bayonets[21] manufactured there were 'almost as well as in our workshops in Europe'.

Martin was based for a time in Monghyr which was famous for arms production. However, it was as a surveyor that he arrived at Lucknow in 1774 and he rapidly seized the opportunity to ingratiate himself in Oudh. Martin's arms collection on his death lists several 'Matchlock Delhi made Ornamental Barrell' but besides one such entry is written 'a present from Sujah Dowla'; elsewhere on the list appears 'Tulwar, a present from Sujah Dowlah'; other entries name the same donor. Clearly Martin made a good impression in the last year of the life of Shuja-ud-daula. The Nawab, though nominally the Mughal emperor's provincial governor, was in reality dominated by the British in Bengal, who had guaranteed military protection and stationed troops in Oudh to be paid for by him.

In 1775 Shuja-ud-daula died and was succeeded by his son Asaf-ud-daula, who moved the court from Faizabad to Lucknow. The new court attracted many brilliant people from India, Europe and the Middle East, including armourers, and a fashion developed for luxury European goods, including de luxe weapons imported from Europe.[22] On his death the Nawab was found to have amassed a collection of fifteen hundred double-barrelled guns.[23] Martin was able to establish himself as a trader and agent for merchants wanting to trade in the Nawab's territory[24] because officially Oudh was closed to commercial enterprise by East India Company officials. In due course he was accepted by the Nawab-Wazir of Oudh as an unofficial advisor, one of many. John Bristow, the British Resident, was himself determined to exploit the commercial possibilities of his position. He initially hoped for the profitable monopoly on saltpetre which was found in abundance in Oudh. A huge quantity was in the armoury in Faizabad. Frustrated in this scheme, he applied to the Company for permission to supply weapons 'all of British manufacture' to the Nawab's ill-equipped army. The Resident had already informed the Company that the Nawab relied solely on him for arms because 'He has no muskets by him fit for service and no people capable of making them properly... the want of muskets is so great, that I have even been unable to procure them for the Body Guard.'[25]

The reason that the arsenal in Faizabad could not supply the Nawab's army was that the British had, on his accession, forced him to dismiss all the Frenchmen in his employment, many of them deserters from the Company's army, together with any British subjects residing without Company licence, on threat of withdrawal of military support. The Nawab agreed on the understanding that Hastings, the Governor-General would supply him with whatever guns and muskets he required. The British Resident in Oudh reported that with 'the Dismission of the Frenchmen, the Arsenal and Artillery are fallen into the most wretched State.

The making of musquets is intirely [sic] at a stand and I do not suppose in the Viziers Park...there are six guns our Officers would receive as fit for service, as much from the badness of the Carriage, as the Guns themselves.[26] The Resident proposed that a Company man should be appointed to supervise the arsenal, on the grounds that the Company's troops in Oudh needed access to a stock of decent weapons, and pressed Martin's suitability. He wrote that during the lifetime of the previous Nawab

> a great quantity of Materials were collected at Faizabad which are now lying at the Mercy of the Vizier's rascally Daroga, to rot and plunder. You would by putting the whole into Martin's hands save a great expense. You would get workmen who serve under this Frenchman and be used to the business. You would have many store houses ready built, and many aids which Captain Martin would with Difficulty and in time acquire by commencing his work entirely anew.[27]

In 1776 Martin, at the age of forty-one, was appointed superintendent of the new arsenal and it was agreed that it should supply both the Company's troops and the Nawabi army and that Martin should supervise the former while the *daroga*, Imam Baksh, should continue to control the arms for the latter at Faizabad. There was considerable debate as to which town in the Nawab's territories was most suitable for Martin's new arsenal, but finally Lucknow was decided upon and building commenced in the winter of 1776-7, paid for by the Nawab. Many of the Indian workmen employed in the new arsenal had trained under French supervision at Faizabad.[28] In turn, many of these Frenchmen had served originally at Pondicherry, where some must have worked with Chalembrom in the arsenal. Evidence of the association of Martin's craftsmen with arms production in Pondicherry can be seen in a Chalembrom-type magazine repeating flintlock, made with considerable skill when Martin was still a major and therefore an early production.[29] From 1780 onwards the luxury firearms made by Martin are usually dated, so the Chalembrom gun almost certainly predates them. By 1782 the arsenal was casting large cannon and bells. His promotion to Lieutenant Colonel was agreed by the E.I.C. on 4 March, back-dated to February 1782 with a special arrangement with the

Company which permitted him to remain at Lucknow and not be called up for active military service, though his pay remained that of a captain. The French mercenary Raymond wrote of him:

> Colonel Martine is a man desirous of all kinds of knowledge, and although he is at the head of a large fortune, which he owes only to his own industry, he works whole days together at all the arts that concern watch-making and gun-smith work with as much bodily labour as if he had his bread to earn by it...(he) has at Lucknow a manufactory where he makes pistols and fusils better both as to lock and barrel, than the best arms that come from Europe...Sir Elijah Impey...carried to Europe one pair of these pistols.[30]

In 1784 the Savoyard soldier of fortune de Boigne agreed terms of service with Madhadji Sindia and went to Lucknow to purchase arms for his force. No doubt other French and English mercenaries did the same. The extent of de Boigne's armament needs can be judged from a report of the forces under his command sent by Malet, British Resident in Poona, to the Court of Directors in 1793. At that time he had two brigades of infantry comprising about 12,000 men, 100 field pieces of artillery served by nearly 3,000 men, a great park of artillery served by 1,000 men and 800 cavalry. He also had the advantage of additional irregular forces under his command.

Hayward argued that Martin must have brought 'European, probably English, craftsmen' to work at Lucknow on the grounds that the design and quality of the pieces bearing his name were so sophisticated.[31] The firearms are European in appearance, inlaid with silver wire and engraved silver sheet with cast and chased silver furniture, without silver marks, decorated with mythological subjects in the European tradition. Blackmore considers that the firearms made under Martin's direction were,'nearly all based on English models, with the silver decoration and steel engraving closely copied from English patterns' and that 'the design of the silver barrelled pistols for which he is most famous can be traced to similar pistols made by the London gunmaker, Joseph Heylin'.[32] Blackmore also identifies an unusual feature on Martin's guns in English style which was almost a trade mark, 'a fretwork, floral motif cut out of the belly of the cock.'

Martin's own collection at the time of his death contained many guns made by the best English makers. In this he emulated the Nawab who, according to the British Resident, professed to be anxious to 'imitate the English in everything', dressing in English style, wearing a crown and having English furniture and books, which he could not read. The luxury firearms that Martin manufactured are signed Lucknow Arsenal, followed by the rank and name Claude Martin (who by this period had certainly lost the 'e' from his surname). Examples may be seen at the Tower Armouries, London. It appears that the standard arms, large numbers of which may have been made at the Lucknow arsenal, are not signed. An indication of the numbers and types can be seen in the 1801 inventory of Martin's property after his death. 'New muskets made by the General with Bayonets and Troopers muskets, Matchlocks, totalling 781.' Also 'gun barrels, gun locks, cartridge boxes, 4,615 bayonet sheaths and belts; 14 maunds of musket balls, 37,900 Flints, 143 maunds of gunpowder; 86 sword blades, 1,725 buckles for belts.'[33]

Although Martin became director of the arsenal when still a captain, no pieces signed by him at that rank are known. He became a Major on 11 September 1779, and as the pieces show, he rose in rank from Major to Lieutenant Colonel while managing the Lucknow Arsenal. In September 1786 Lord Cornwallis arrived in Calcutta to take up the post of Governor-General and Commander-in-Chief. Martin sent him 'a pair of pistol, Production of my office' and various other gifts.[34] Martin subsequently cast two cannon in 1786, one of which he called Cornwallis in honour of the Governor-General[35] and took care to see that Cornwallis was aware of the fact. His courting of the rich and powerful was a lifetime trait. Nevertheless, the peace and stability within Oudh and Bengal resulted in questions being asked as to the need to maintain the Lucknow Arsenal. Reforms in the Bengal Board of Ordnance, which became the Military Board in 1786, resulted in a more efficient system of supply depots from the Fort William Arsenal in Calcutta to up-country towns under direct British control.[36]

It was clearly in British interests that the Lucknow Arsenal should gradually run down, since they no longer had need of its products. The new Governor-General wanted to replace Martin though it transpired in his will that Martin actually owned[37] the arsenal, powder mill, magazine and quantities of military equipment. Martin had bought property, built houses and put down roots in Lucknow and had no wish to move. Without his position as director of the arsenal he would have been redeployed in British territory. It appears that Martin's cultivation of Cornwallis and his secretary, Colonel Ross, developed into a long association, with Cornwallis staying at Martin's large and comfortable house at Oudh, and resulted in an understanding between the three men. All were Freemasons, Cornwallis being Grand Master of the Lodge. The reduction in work at the armoury left Martin free to follow other more profitable interests, though he continued to supply materials to the arsenal as late as 1796.[38] Retaining his military position which gave him great pleasure, security and standing in Oudh, Martin quietly retired from his post at the arsenal in 1787, 'to begin the last stage of his career, that of a successful trader and financier.'[39] No letter has been found setting out the details of the new arrangement[40] but Martin is last recorded as superintendent of the arsenal in East India Company records from 1 January 1787 to 1 March 1787. It is very possible that the jade-hilted sword illustrated in *Splendeur des Armes Orientales*, no. 221, was a retirement present from the Nawab. It bears an inscription 'By order of His High Excellency Nawab Asaf-ud-daula, to be given to General Martin of the East India Company, the year of 1201 of the Hijra' (1786-7).[41]

In 1791, at the commencement of the war with Tipu Sultan in Mysore, he contributed enough horses for a troop of cavalry and took part the following year in the attack on Tipu's camp as an ADC to Lord Cornwallis, a calculated gesture to demonstrate his allegiance to the British and to Cornwallis personally, for which he was promoted full Colonel in 1793. In 1796 he was made a Major General. In the final bombardment of Seringapatam in 1799, the East India Company army used an 18 pounder cannon that he had cast.[42]

Claude Martin also formed a collection of Indian arms. A fine dagger with a gem-set rock crystal hilt of early seventeenth-century date in the Wallace Collection, London, has his name scratched on it.[43] A list of the arms in the ninety-four page inventory of Martin's possessions on his death in 1800 is given by Blackmore. Amongst his personal collection of European and Indian arms were four sets of musket and accompanying pairs of pistols by Grierson which the auctioneers selling his possessions regarded as particularly fine. Martin also kept enough arms at one of his houses for a troop of *sepoys*.

It is not known who took over the direction of the arsenal on Martin's retirement, but production certainly continued because he went on supplying materials. Correspondence from Martin shows that under his direction it had employed seventy-five men, including a number of Europeans. It is also clear that there were considerable stocks of material at the arsenal on Martin's death, as they appear in his will. Martin's taste and that of the Nawab was for high-quality English guns. All but a pair of pistols and a cannon with Martin's name on that are known or listed by Blackmore are dated prior to 1787. The exceptions are a pair of un-dated pistols in the National Army Museum, London.[44] One pistol has 'Lucknow Arsenal' on the barrel and the other 'Lt. Col. Claude Martin'. Blackmore describes these as 'Presented by Claude Martin to Lt. Col. Alexander Ross in 1792'. This is rather misleading. These guns are almost identical to the Lord Braybrooke pistols dated 1785 and it is probable that all were made at the same time. The information that they were a gift comes from a card in the case, on which is written in an early nineteenth-century hand that the pistols were presented to the late General Alex Ross. The information that they were presented in 1792 comes from the present owner of the pistols and is unsupported. Martin may well have made the gift in 1792 in connection with his rise to full Colonel in 1793. Alternatively, the fact that he had begun a long correspondence with Ross at the end of 1786, when his post at the arsenal looked likely to be abolished, provides an equally plausible reason for the gift.

The cannon in a private collection was published by Blackmore. He states that it bears the inscription 'General Martin Lucknow'. The absence of the word 'arsenal' which always occurs on Martin's pieces suggests that the words indicate ownership rather than manufacture.

The London art dealers Spink and Son possessed an Indo-European flintlock sporting gun with a silver barrel, the wooden stock carved with scenes of a lion attacking a gazelle amidst floral scrolls in typically Indo-Persian style. Its silver mounts had typical Lucknow enamel decoration. The absence of a signature clearly encouraged the cataloguer in the belief that it was made, or assembled, after 1800 since it has always been believed that Martin continued producing firearms until his death. Spinks therefore suggested a date of 1800-1810[45] though it may in fact date from after Martin's retirement. An alternative argument may

be made for the gun being one of Martin's first productions, possibly a gift for Asaf-ud-daula, since it was clearly made for a person of importance. However, Asaf-ud-daula's preference for European products makes this unlikely and the decoration bears no relation to Martin's taste. In view of the presence of other suppliers of arms in Lucknow at this period, the attribution to Martin is tenuous, though the silver barrel may have come from his workshops.

The post that the East India Company had been so concerned to fill in 1776 was not regarded with the same concern in 1787 and no European was appointed to replace Martin. The reason was the Company's establishment of arms depots up country, the nearest at Cawnpore, which made them indifferent to supplies from the Nawab's arsenal. Secondly, the Company was now willing to use its own Indian troops rather than rely on the Nawab's. At an early opportunity the Company took the opportunity to halt the activities of the many Europeans who were engaged in the profitable enterprise of manufacturing and selling military supplies to the Nawab. The East India Company prohibited such sales by any Briton to a native power. Frederick Maitland Arnott had a flourishing business of this type which he claimed 'was known in the Alleys and Bazars (of Lucknow) and no one prevented it'.[46] When finally challenged by the British resident, Arnott bolted but was captured, and amongst his possessions were 'a large brass gun, bags of scarlet cloths, 32 cummerbunds,

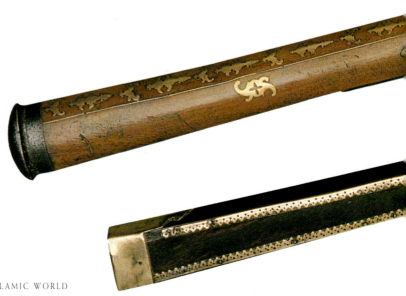

grape shot and tent pieces'. Arnott claimed that Asaf-ud-daula had commissioned weapons and uniforms and the Resident, G. Cherry, admitted in 1795 that 'it had been much the practice prior to my arrival here for the Europeans residing here to make arms and military stores, which were sold to the Vezier and wherever purchasers could be found... the late Mr Pott left many iron shot.'

AGRA

A Scottish mercenary, Colonel George Sangster, who previously served the Jat chiefs of Gohad, was employed by de Boigne in 1790 to establish an arsenal at Agra. Sangster, who had trained as a gun-founder and manufacturer before becoming a mercenary in India, cast excellent cannon and made muskets as good as the European models for ten rupees each, though one account states that his flintlocks were inferior.[47] Amongst the guns that he manufactured were matchlocks with bayonets[48] and an improved lock[49] in which the pan was automatically uncovered by a spring released when the trigger was pulled. De Boigne's forces included

Najibs, men of good family who adopted a semblance of European military practice and were much respected, Pathans, Rohillas and high-caste Hindus. They were traditionally armed with matchlock, shields and swords, but these were replaced by the new pattern matchlock, with a bayonet.[50] It was the custom for European mercenaries to supply their forces with arms and ammunition. Sangster also made gunpowder, the sulphur and saltpetre brought from Bikaner, and cannon shot of Gwalior iron. Eventually he ran five arsenals, each under a superintendent, at Mathura, Delhi, Gwalior, Kalpi and Gohad. The matchlocks were made at Faizabad.[51]

In due course Sangster employed Pierre Cuiller, better known by his nickname Perron, in the arsenal. In his youth Perron had worked in the cannon foundry at Nantes before twice enlisting in France and finally deserting on the Malabar coast. Thanks to Sangster he began his successful career as a mercenary. Thomas Legge also learnt cannon casting from Sangster.[52] Legge came from northern Ireland and was an eccentric who practised alchemy and divination. He married the daughter of the astrologist Favier de Silva, who had been sent by the King of Portugal to advise the Raja of Jaipur. Mother and son are believed to have died in India. Legge himself became a naked fakir, living in a

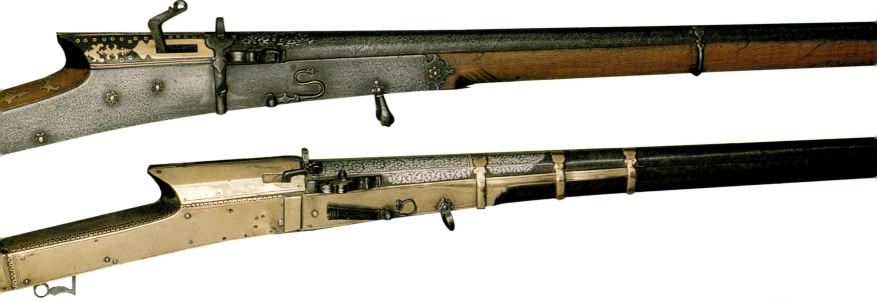

Two Indian matchlock guns, *c.* 1800: 108 (ABOVE) and 109 (BELOW).

desert tomb near Jaipur before dying in 1808.[53] It is difficult to identify any of the arms made by Sangster and Legge, but Lord Egerton refers to a brace of pistols with stub twist barrels, said to be from Agra.[54] Sangster died in 1792 in Lucknow. He had employed a number of Indians in his foundry in the compound of his house and he bequeathed the tools and books of his trade to his son who wanted to carry on the 'business of the Foundry for his Excellency the Vizier'.[55] However, the British Resident enforced the East India Company prohibition against selling arms to native powers and put an end to the lucrative and extensive arms trade by private Europeans in Lucknow.[56]

HANSI AND JHUJJUR

The Irish mercenary commander George Thomas established a factory for making flintlocks, matchlocks and gunpowder at Hansi when he was employed by Begum Somru.[57] He subsequently seized control of Hariana on the Punjab border and established a permanent base at Jhujjur in 1797. In his own words, he 'cast my own artillery, commenced making muskets, matchlocks and powder and in short made the best preparations for carrying on an offensive and defensive war...'. Thomas was experienced as a cannon-founder, at an early stage in his career taking as his share of the booty from a raid all the brass lotas and utensils to melt for this purpose.

MYSORE

The interlocking relationship between the states of southern India and British intervention can most easily be explained in relation to Haidar Ali who began his career in the 1740s as a common trooper in the Hindu kingdom of Mysore. His military abilities made him indispensable to the state, and in 1761 he effectively displaced the weak Wodiar rajas and began to transform Mysore into a dynamic expansionist state which rapidly became the most powerful in southern India. A tradition of conflict between Mysore and the neighbouring Malayali states of northern Kerala led to an invasion by Haider Ali in late 1765. Aided by Mappila (see p. 183) auxiliaries, the Mysore army dealt swiftly with the traditional Nair armies of the northern Hindu rajas. However, Haider Ali's conquests were disrupted by a hostile coalition led by the British in Madras and the area remained only fitfully under Mysore control until 1791-2.

The guns produced for Haidar Ali, Tipu Sultan and the elite of Mysore are well known, particularly since they have been elegantly and comprehensively catalogued by Robin Wigington. They display great quality and unmistakable individuality, most frequently a carved tiger in wood or metal, tiger stripes (*bubri*); and in the case of Haidar a heart-shaped motif, often together with an inlaid gold 'tiger mask' composed of entwined characters reading 'the lion of God is the Conqueror' (*asad allah al-ghalib*).

110. An early nineteenth-century Indian matchlock gun made for a boy.

The makers of these pieces have put their names to them – an uncommon characteristic of Indian arms manufacture – and the dates. A rare type of gun recorded in the army of Seringapatam is a musketoon known as a *bukmar*. An example is illustrated by Stone and is in the Metropolitan Museum. Stone describes it as having 'a blued barrel with gold "tiger stripes" and an Arabic inscription reading: "This matchless gun belongs to the King of Ind (Hyder Ali) which equals the flashing lightning; it can decide the fate of the enemy if it finds its mark on his forehead." Silver marks stamped Hyder Ali, and Seyd Ma Sun (the maker). Flintlock, the cock a tiger's head.'[58]

According to notes from the Codrington Collection, the *bukmar* was used by officers of the camel corps. Codrington also refers to a heavy carbine known as a *karol* which was used by the cavalry at the time of Haidar Ali. Another musket barrel with a small bayonet (*sangin*) is engraved with figures of tigers and tiger stripes and is inscribed in Arabic: 'Matchless musket of the ruler of India, may it be like burning lightning!' In the tiger stripe near the centre of the barrel is inscribed 'Royal Manufactory'. According to Egerton, these distinctive arms were used by the guard of Tipu Sultan. Asad Khan Muhammad and Sayid Ma'Asum are two more makers who worked for Tipu.

Besides these prestige pieces there was a large army to supply. Tipu established eleven armouries for making, repairing and finishing firearms at Seringapatam; four large arsenals; and three buildings with machines for boring guns. Colebrooke refers to large machines at Ramgherry, Bangalore, Conkanely and other places where fifty muskets could be bored simultaneously. A small number of guns were apparently made at the fort at Chintamani. Small quantities of arms were brought from France. Lieutenant Ewan Bushby described the Mysore troops in 1795: 'They are accoutred with black leather cross belts and commonly armed with muskets of French manufacture though some are made in their own country; over the lock is a leather cover to defend it from dampness.'

A curious and unexplained reversion to matchlock carbines made in the last decade of the eighteenth century for Tipu Sultan's armoury is discussed by Wigington.[59] Three are dated 1797/8, and the signature of the maker Muhammad Ali is on the lock. The barrels were made for flintlock and then used in this archaic fashion. Wigington cites contemporary accounts that tens of thousands of muskets were captured at the fall of Seringapatam so that scarcity or urgent manufacture is not an answer to this production. A likely explanation is that the irregulars who formed part of Tipu's army were armed with conventional matchlocks, but few of these guns have survived in recognisable form. The painted stocks of Tipu's locally made guns are particularly susceptible to wear and it was normal to repaint all matchlocks at frequent intervals. Furthermore, the matchlock continued in widespread use for at least another fifty years, par-

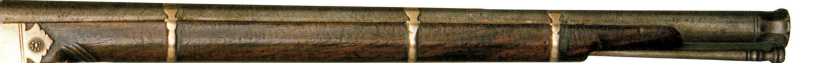

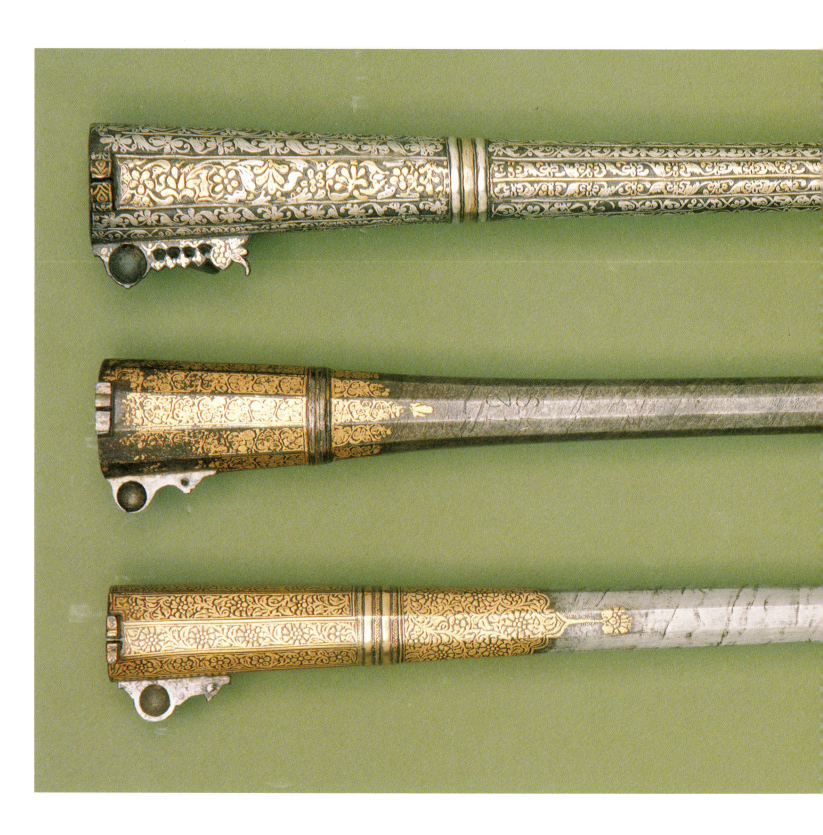

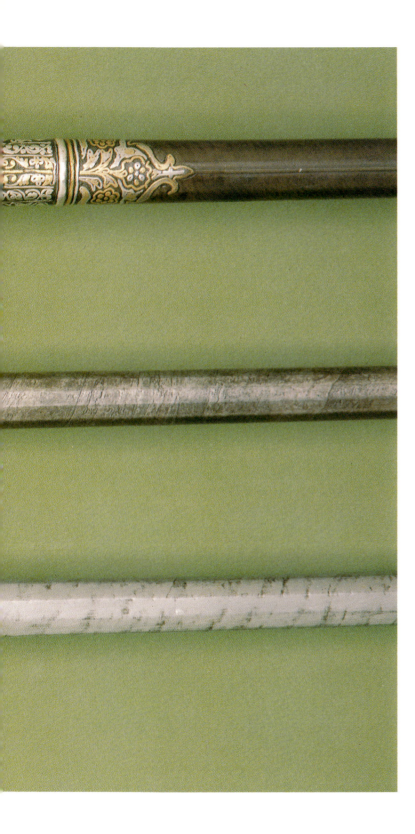

ticularly in the 'Native States'. The author of a pamphlet on irregular cavalry units in the Bengal Army in the 1840s commented that 'Perhaps it would be wrong to take their matchlocks from them, for although they cannot fire quickly with them, they make excellent practice. I have often seen them break bottles, galloping past at speed at a distance of 20 yards. I have also seen the front rank fire by troops, almost as well as infantry by platoons.'[60] The reliability and simplicity of the matchlock made it particularly popular, not merely in India. In eighteenth- and nineteenth-century Arabia, flintlocks were often converted to matchlock out of preference.[61] Haidar Ali had concluded an offensive and defensive alliance with Imam Ahmad of Oman and had appointed a resident ambassador to Muscat. The fighting qualities of the Omanis were much admired, and matchlocks would have been the firearm ignition mechanism of choice for Arab mercenaries serving in Mysore. The fact that these Mysore guns have been converted from flintlock to matchlock points to Arabs as the intended recipients. The automatic pan opener is a great improvement on Sangster's design, made at Agra a short time earlier.

The use of the bow as a weapon began to decline in the nineteenth century, but it remained popular as a form of exercise and sport. Writing in *Observations on the Mussulmauns of India*, which appeared in 1832, Mrs Meer Hassan Ali describes how 'all practise the use of the bow, as they fancy it opens the chest and gives ease and grace to the figure; things of no trifling importance with the Mussulmaun youth'.[62] In the Indian Mutiny of 1857 a number of incidents where British soldiers were killed by arrows are recorded. For example, at the second relief of Lucknow:

> In the force defending the Shah Najaf, in addition to the regular army, there was a large body of archers on the walls, armed with bows and arrows, which they discharged with great force and precision, and on a sergeant of the

Three eighteenth-century barrels from Indian matchlock guns: (FROM TOP) 111, 112, 113.

114. A flintlock musketoon from Sind dated 1213/1799, with an English-style lock.

93rd raising his head above a wall, an arrow was shot right through his feather bonnet. One man raising his head for an instant above the wall got an arrow right through his brain, the shaft projecting more than a foot out of the back of his head. In revenge the men gave a volley. One unfortunate man exposed himself a little too long and before he could get down into shelter again, an arrow was sent right through his heart, passing clean through his body and falling on the ground a few yards behind him. He leaped about six feet into the air, and fell stone dead.[63]

RAJASTHAN

As a member of a warrior caste it was a Rajput's *dharma*, or divine duty, to fight. Consequently weapons were held in particular esteem. Tod described from personal experience in the early nineteenth century how every prince or chief in Rajasthan had his *silleh-khaneh*, or armoury, where he passed hours viewing and arranging his weapons. Every favourite sword, matchlock, spear, dagger or bow had a distinctive name or title and the keeper of the armoury was one of the most trusted officers in the prince's entourage. These arms were beautiful and costly. 'The matchlocks both of Lahore and the country are often highly finished and

inlaid with mother-of-pearl and gold: those of Boondi [Bundi] are the best.'[64] The neighbouring state of Gujarat was famous for mother-of-pearl inlay work, particularly in the seventeenth century. Powderflasks, known as *kuppi*, offered particular scope for decoration. Matchlocks were also recorded as being traded from Bhawnlpoor[65] while matchlocks, swords and other arms were fabricated at Jodhpur and Palli.[66] Tod describes Palli as 'the entrepot for the eastern and western regions, where the productions of India, Cashmere and China, were interchanged for those of Europe, Africa, Persia and Arabia.' Arms were amongst the goods exported from Palli. Tod also writes that the Bikaneris worked well in iron, and had shops at the capital and all the large towns of the state 'for the manufacture of sword blades, matchlocks, daggers, iron lances etc.'[67] Egerton states that Patiala, Kotah and Bundi in Rajasthan were the principal centres of matchlock production.[68]

The most powerful oath of a Rajput, next to swearing by the throne of his ruler, was by his arms, the hand placed on the weapon. The shield was regarded as the only suitable salver on which to present gifts, and was always used for this purpose at the Rajput courts.[69] Tod regarded the Rajputs as good shots with a matchlock and wrote that they regarded the bow with reverence because of the importance given to it in the Hindu epics. A Rajput was not satisfied with his bow shot unless he had buried his arrow to the feathers in the earthen target or the buffalo.

115. A Sindi flintlock rifle with an English lock, c. 1820.

116. An early nineteenth-century Sindi matchlock gun with typical Afghan stock.

117. An early nineteenth-century matchlock gun from Sind.

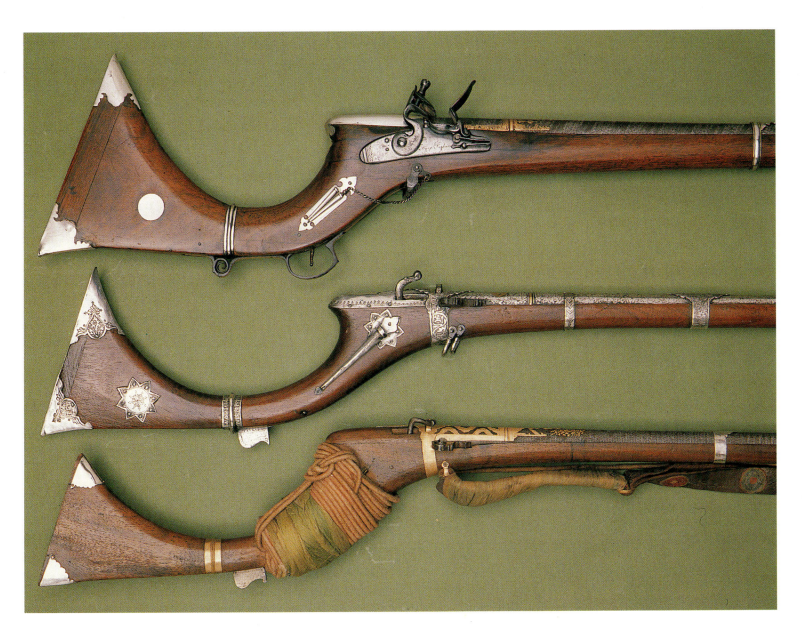

SIND

Sind was an isolated Mughal province, chiefly famous as the birthplace of the Emperor Akbar. Sindi merchants had played an important role in the Asian overland trade in the sixteenth and seventeenth centuries, but the economic and political collapse of Iran and Mughal India in the eighteenth century and the lengthy and ruinous wars between Marathas, Sikhs and Afghans destroyed the old trade patterns between the Punjab and Kabul. In 1786 the Baluchi Talpur emirs conquered Sind and interrupted trade on the Indus so that the ports of Thatta and Lahori Bandar, which had been of major international importance, were restricted to the products of the Punjab and southern Afghanistan. The emirs of Sind were famous for their appreciation of fine arms based primarily on a love of watered steel, contrasted with vivid enamel work, gold and jewels. On the evidence of the pieces that have come down to us their collection was magnificent. The court at Sind was visited by James Burnes whose account, first privately printed in Bombay in 1829 for his friends, proved to be a sensational portrait of the emirs in the best tradition of Moore's *Lalla Rookh*.[70] 'A great part of their immense treasure consists in rubies, diamonds, pearls, and emeralds, with which their daggers, swords, and matchlocks are adorned...'[71] The firearms frequently have rosewood stocks of a particularly rich hue. Indian rosewood (*Dalbergia latifolia*) is also known in India as blackwood, *sissu* and *shisham*, and is frequently used for gun stocks. The wood is widely exported from Malabar. Two Persian goldsmiths worked at court as enamellers and jewellers.[72] One can only agree with Burnes who remarks that 'the art of enlaying letters of gold on steel has been brought to the greatest perfection by these artisans'. Over the period when the dynasty flourished, more than two enamellists were employed, as the extent and variety of the enamel work and the signatures show. Burnes recorded that 'The Amirs have agents in Persia, Turkey, and Palestine for the purchase of swords and gun-barrels, and they possess a more valuable collection of these articles than is probably to be met with in any other part of the world.'[73]

Missillier and Ricketts illustrate two fine examples of the Sind *jezail*, one of which bears inscriptions on the barrel, including 'the work of Hajji Mirkhan' and the name of his patron Mir

Murad Ali Khan Talpur. The emirs were as conservative in their choice of arms as they were flamboyant, decorating their matchlocks with gold and jewels.[74]

They seemed to be fully sensible, however, of the superiority of our gun-locks, a number of which they entreated me to beg the government to procure for them. I saw several expensive and highly finished fire-arms which had been presented to them, from time to time, by our authorities in India, thrown aside as useless, without their locks, which had been removed to be put on their own fowling pieces. For the shape and appearance of the latter I must again refer to the frontispiece to Pottinger's Travels. Those belonging to the Ameers resemble the two there delineated, with the addition of being highly ornamented. The barrels, which are all rifled, are chiefly brought from Constantinople; they are about double the length of ours, and of a very small calibre.[75] The Sindhians never use small shot, and they place no value on pistols or detonating locks.[76]

Despite Burnes' remark about the emirs obtaining their barrels from Constantinople it is clear that barrels of a very high quality were made in Sind. The explorer Moorcroft, who travelled extensively in the provinces of northern Hindustan and beyond in the first part of the nineteenth century, gave the judgement that 'In Persia, Kabul, the Punjab and Sindh, the same general principles prevail but the matchlocks of the last are held deservedly in high esteem.'[77]

The evidence of travellers like Burnes, Pottinger and Elphinstone makes it clear that Sindi culture is essentially Afghan, as might be expected from their geographical position and trade pattern. The *jezail* used in Sind, with its distinctive butt, is in fact the chosen form of firearm used over a large area of Afghanistan. The name *jezail* itself indicates the strength of Persian cultural influence. The question arises as to how to distinguish between the firearms of Sind and Afghanistan and whether the shape of the butt varied on a tribal or regional basis. It would appear that guns were assembled and finished in Sind for the emirs and these are reasonably distinctive, particularly the etched and damascened barrels. It would be wrong to assume that all

high-quality guns of this form are from Sind as the court at Kabul would have shared a similar regard for the aesthetics of these pieces and would certainly have used enamel to decorate their guns, as did the Iranians and the Kashmiris. A French officer who travelled through Kandahar in 1826 described the local infantry as being armed with 'sword and matchlock, long but of small bore', a description that matches the Sindi barrels.[78] Fortunately, many of the Sind guns are inscribed with the name of their Talpur owner. In other instances it is not possible to be certain of the area of origin.

There are fine examples of Sindi guns, with their distinctive hooked butt, in the Tareq Rajab Museum. Catalogue number 114 is a rare, short-barrelled gun dated 1799, known as a musketoon. Because of their small size, such guns are usually regarded as children's or women's weapons, since hunting was a sport enjoyed by all ages and both sexes of the upper classes. However, the size of the bore, culminating in a blunderbuss muzzle, indicates that neither women nor children could cope with the kick of this weapon. Confirmation that the musketoon was commonly employed by men is provided by Bernier who describes Aurangzeb and his huntsmen killing *nilgae* with 'arrows, short pikes, swords and musketoons'.[79] A similar musketoon, though with a different stock, was carried by the officers of Tipu Sultan's camel corps and possibly this gun, too, belonged to some such elite group. Other weapons from Sind are Catalogue numbers 115, 116 and 117. Blunderbusses are recorded in India at an early date. Pietro della Valle describes an incident in 1624 when the ruler of Calicut examined the blunderbuss (*bollomarti* in the manuscript from the Portuguese) of a Portuguese soldier. Flintlocks were unknown to the people of Calicut, who were familiar with matchlocks, and the ruler was anxious to obtain the piece, but the soldier would not part with the weapon.[80] Fifty years later, the Abbé Carre was given an escort of armed slaves by the Portuguese, while travelling north of Bombay. These carried 'matchlocks, javelins, and some sort of a blunderbuss, so large and bulky that its balls must have weighed at least 2 lbs.'[81] In the nineteenth century Baden Powell refers to 'a short and somewhat wide mouthed piece' which he calls a *karabin* and is careful to distinguish from the *sher bacha*.

The impression given by the fine firearms made for the emirs of Sind needs to be seen in relation to the weapons carried by ordinary tribesmen, which were often wretched. A good account of life at a less elevated social level in this region is provided by James Lewis, an English deserter from the Bengal Artillery who pretended to be an American traveller from Kentucky, named Masson.[82] Lewis had the misfortune to be robbed repeatedly by the Pathans as he made his way from Kandahar to the Sikh court in 1830. Reduced to near nakedness and starving he was obliged to earn his daily bread by passing himself off as a Hajji, bestowing benedictions on the grateful and uncomprehending peasantry in the form of quotations from Shakespeare. The party with which he was travelling encountered a small tribe on the move.

> The men had most of them matchlocks, but I suspect no ammunition, as they begged flints and powder, and a small quantity of each given them elicited many thanks. Leaden bullets with the men of this country, I believe, are generally out of the question, having seen them in many instances making substitutes of mud, which they mould and dry, and with such projectiles they contrive to kill large fowls etc.[83]

PUNJAB

By the end of the reign of the Emperor Aurangzeb in 1118/1707 it appeared that Sikhism was finished as a military threat to the Mughals. The movement had been suppressed with great severity and its remaining adherents escaped to the foothills of the Himalayas where they built numerous small forts. In fact the experience turned the sect into a separate religious movement and militant community, dominated by the *akalis* who were armed ascetics. The worship of the one God remained, as did the disavowal of caste, but an initiation ceremony was added which stressed the apartness of Sikhs and they took the title 'Singh', meaning lion or champion.

In the eighteenth century, the decline of the Mughal state was hastened by invasions of Persians and Afghans. This reduced Mughal authority in the Punjab, and the Sikhs expanded into the vacuum created. They became loosely grouped into twelve tribes, or *misls*, which were predominantly of Jat origin. At the

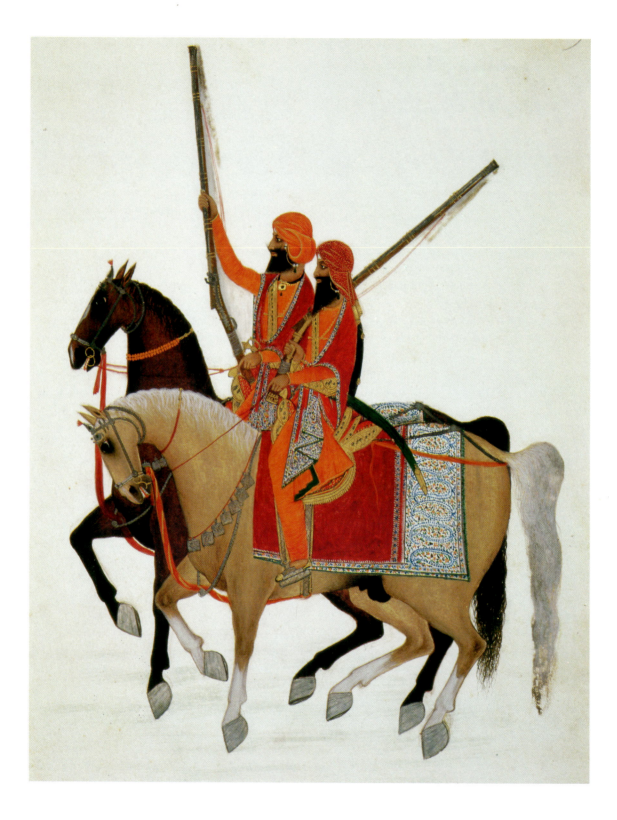

second battle of Panipat in 1761 the Afghans under Ahmad Shah Durrani defeated the Marathas in a contest for the political supremacy of northern India. The numbers engaged in the battle were large and the Maratha dead were put at about 200,000. The scale of defeat was conveyed to the *peshwa* in code: 'Two pearls have been dissolved, twenty-seven gold mohurs have been lost, and of the silver and copper the total cannot be cast up.' However, the Afghan troops mutinied and Ahmad Shah Durrani, with the whole moribund Mughal empire at his mercy, was obliged to return with them to Kabul. There remained virtually no one to oppose the Sikhs.

Lahore was occupied by the Sikhs in 1764. Patiala state, the chief Sikh power east of the Sutlej, was founded by Amar Singh in 1767, and Sikhs spread as far south as twenty miles from Delhi, the imperial capital. In 1792 Ranjit Singh was confirmed as head of his *misl* at the age of twelve, evidence of his exceptional qualities. Based in Lahore he had the good fortune to be officially confirmed in his *de facto* position by the Mughal Emperor Shah Zaman, who visited the city in 1798, making him ruler over Muslims, Hindus and Sikhs. Amritsar was under his control in 1802 and in 1806 he took Ludhiana, but further progress south and east was blocked by the British. The visit of the fugitive Holkar to Lahore in 1805 marked the start of a disciplined Sikh army while the ease with which Metcalfe's *sepoy* bodyguard beat off an *akali* attack was used as justification by Ranjit Singh to extend and Europeanise the army. In 1818-19 he took Multan and Kashmir, in 1833 Ladakh and the following year, Peshawar. Further advance into Afghanistan was blocked by Dost Muhammad while the British protected the emirs of Sind and prevented expansion south. When Ranjit Singh died in 1839 the Sikhs possessed the only army in India capable of meeting the East India Company forces on equal terms.

The Sikh army in 1839 consisted of about 75,000 men with additional auxillaries available.[84] More than half of this made up the *fauj-i-ain*, or regular army, which was organised on European lines with many European officers. The infantry was largely the creation of the Italian General Ventura and was comprised of

Sikhs and Punjabi Muslims. The cavalry consisted of 12,000 men under the French General Allard.[85] It was in artillery that the Sikhs excelled, organised by the French General Court and by Colonel Gardner. Infantry and artillery had a reputation for steadiness unsurpassed in India, but this was not mirrored by the Sikh state's political institutions which collapsed once the firm grip of Ranjit Singh was removed. In the chaos of assassination and intrigue the army gained power and either had to be disbanded or have its energies channelled into war. There was no one strong enough to carry out the former task and the reputation of British arms had been tarnished by the Afghan war of 1842, encouraging those Sikhs who favoured an attack upon the British. Furthermore, the British controlled rich territories which enjoyed a climate congenial to the Sikhs, who had little desire to trespass in the barren and icy territories of the Afghans. The Sikh army crossed the Sutlej on 11 December 1845. Then followed a series of bloody battles remarkable on both sides for the absence of competent generalship: at Mudki, Firozshah and Aliwal. The Sikh drive was contained and defeated. On 10 February 1846 the Sikh army was broken at the battle of Sobraon. As a result of these events the British formed a high opinion of the fighting ability of the Sikhs. Having won the war, the British were at a loss to decide what to do with the peace and settled for a reduction in the Sikh army, reparations and the imposition of a British Resident, all of which was understandably resented by the Sikh *sardars*, who took the first opportunity to renew the fight. Dalhousie, the Governor-General, expressed the British position as 'unwarned by precedent, uninfluenced by example, the Sikh nation has called for war, and on my word, Sirs, they shall have it with a vengeance.' Two inconclusive battles at Ramnagar and Chillianwalla were followed by the decisive battle of Gujrat in which General Gough for once made competent use of his artillery. In 1849 the Punjab was annexed.

The Sikhs are particularly important to collectors of Indian arms and armour. They represent the last major Indian state to oppose the British with Indian resources and though it must be conceded that European weapons were brought in for the *fauj-i-ain*, the numbers were relatively modest. For example, the carbine which was in general use amongst European troops was introduced by Allard and Ventura, but the order in 1840 was for a mere two hundred. On another occasion Allard imported five

Detail of a painting of the bodyguard of Ranjit Singh. Inscribed in Persian: *Sawaran i khass*; and in English: *Lahore Life Guards*. 1838. India Office Library, London.

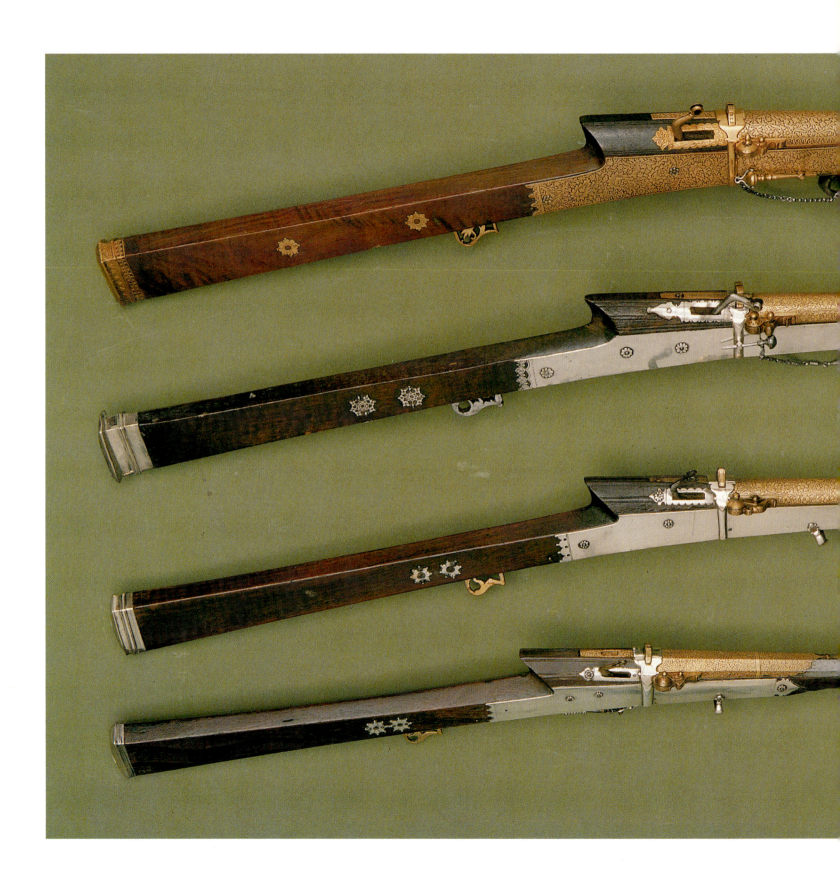

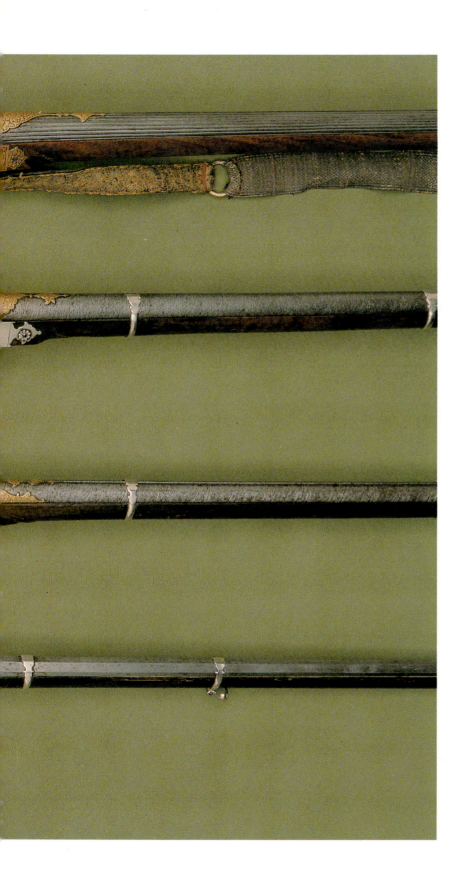

Four Indian matchlock guns, c. 1800: (FROM TOP) 118, 119, 120 and 121 (made for a boy).

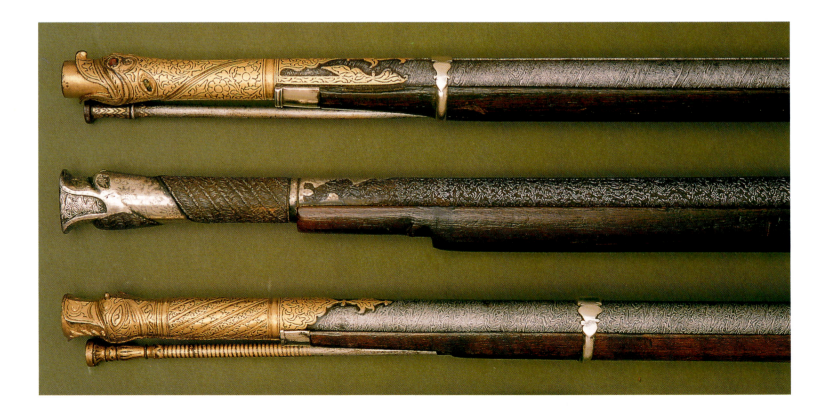

122. An Indian combination matchlock and flintlock gun, c. 1820.

119a. Barrel of an Indian matchlock gun, c. 1800 (see p. 175).

106a. Barrel of an unusual Indian matchlock rifle, c. 1780 (see p. 157).

120a. Barrel of an Indian matchlock gun, c. 1800 (see p. 175).

hundred pairs of pistols from France. The Sikh regular infantry had flintlock muskets known as the *banduk pather kalah* or long-barrelled flintlock gun, which were the same as those of the British troops opposing them. One of the cavalry regiments was known as the Dragoons Regiment because it was armed with dragoon pistols, sixteen-inch barrels of full musket bore with snaphaunce locks.[86] Ranjit Singh was persuaded by Allard to import two million percussion caps from France in 1836 but died before being able to force through the conversion of his armies' firearms. Long arms using caps remained rare and were called *banduk masala-dar* – a weapon fired with a cap or *masala*. The biggest of the Sikh arsenals was in Lahore in the *hamam* and the

Badshahi Masjid buildings, followed by the arsenal at the forts of Amritsar and Peshawar. There were large magazines at Multan, Srinagar, Attock, Kangra and Rohtas; and many minor stores.[87]

Sikh militarism ensured that the best weapons possible were produced in large numbers within the state. These were sometimes modelled on European firearms, but the Sikhs had nothing to learn from Europe in the construction of a good sword. An attempt at a double-barrelled flintlock gun by a Punjabi hill gunsmith was presented to Jacquemont[88] in 1831 by Raja Gulab Singh. Jacquemont wrote of it: 'I should have preferred one of their long matchlocks as a curiosity, but he considered this double barrelled gun a masterpiece of Himalayan skill. You will, however, see some day that it is not a brilliant specimen.'[89]

The work of Lahore is reasonably distinctive and its arms can frequently be seen in the hands of dealers and collectors today. Furthermore, the arms-producing centres largely survived the defeat and their markets outside the state remained intact. The arms tradition thus continued, though it was to fall victim to Western technological superiority and mass-production later in the century. The revival of Indian crafts in the second half of the nineteenth century under Lockwood Kipling, B. H. Baden Powell, T. H. Hendley and George Birdwood, to name but a few, ensured that industries on the brink of extinction, including those concerned with arms production, survived, though the arms were used as decoration rather than in anger. Sikh arms of all kinds, for the most part Lahore work, are to be seen in the Wallace Collection, London, many of them bought new and unused. All were acquired before 1875 and are a good indication of this evolution. The sheer volume of weapons which the British took control of after the annexation must be reflected in the proportion of Indian firearms which have survived to this day.

The decorative nature of the Sikh army is well described by Emily Eden, who with her brother the Governor-General visited Ranjit Singh's camp at Amritsar in 1837.

...I think that the entrance to the camp this morning was the finest thing I saw anywhere. There were altogether four miles of Runjeet's soldiers drawn up in lines...a great number...are dressed in orange turbans, tunics and trousers... made of gold and silver...cloth of every possible shade of colour. They have long black and white beards...

and a large expenditure of shawls and scarves are disposed in drapery about them. Their matchlocks are inlaid with gold or steel or silver...some of them with bows and arrows , some with long spears, and all the chief ones with...black heron's plumes. Everything about them is showy and glittering – their horses with their gold and silver hangings, their powder flasks embroidered in gold.[90]

Writing in 1880, Birdwood states (in the present tense) that in the Punjab good arms 'of the costliest description' are made at Lahore, Sialkote, Gujrat, Shahpur and Kashmir. Egerton also writes that in the Punjab the great centres of arms manufacture were Lahore and Gujrat. Fauja Singh Bajwa adds Kotli Loharan, Amritsar, Wazirabad and Kashmir. The Sikh state encouraged private production and sale and itself purchased from such sources while establishing state workshops in Lahore, the site of the principal Sikh arsenal, Amritsar and Shahzabad.[91]

A doctor of medicine, Honigberger was offered a series of exalted posts in the Punjab by Ranjit Singh, but 'this I refused, deeming that I had not sufficient abilities to execute such an office properly; but upon his giving me the choice, I accepted the management of a gun powder manufactory, and also a gun stock establishment.'[92] These were at Lahore. Honigman knew nothing of manufacturing gunpowder. Another European at the Sikh court at Lahore was Claude Auguste Court from Grasse who directed the manufacture of cannon in his own workshop. A cannon cast in 1830 and christened 'Lelan' bore an inscription describing him, presumably with mock seriousness, as 'possessing wisdom like Aristotle, the Plato of the age'.[93]

An Indian version of the Montecuccoli lock combining flint and match was invented at the time of Ranjit Singh by a Hindustani named Mirza Bharmar after whom the gun is named in India; an example of the weapon is described by Baden Powell as a *Bharmar lahori*, presumably from the place of manufacture.[94] (See Catalogue no. 122.) The gun was popular and Gurkhas were seen armed with this type in 1827. A good pair of percussion pistols from the second quarter of the nineteenth century or later, inscribed on the barrel tang 'made in Lahore', are in the Victoria and Albert Museum, London.[95] A pair of Spanish Ripoll pistols with miquelet flintlocks which are said to have been captured from the Sikhs at the battle of Chillianwalla in 1849 are in the

123. An Indian matchlock gun, c.1800.

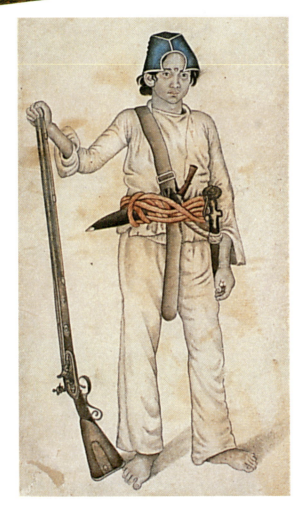

A Gurkha gun-bearer of William Fraser; c. 1815-16. From an inscription on another painting we learn that this is 'Mimmutt, a Khuttree, of village Koonur, Country Kaskee, west of Nepaul'. By permission of the Victoria Memorial Museum, Calcutta.

A Gurkha described by William Fraser as 'Booddheebul, cast Bisht, of the petty Rajship Tunnoo, subject to Nepaul.' Haryana c. 1815-16. By permission of the Victoria Memorial Museum, Calcutta.

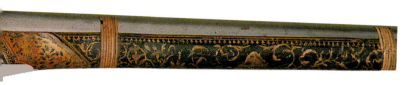

National Army Museum, London. A number of Sikh weapons, including firearms, were brought home to Scotland by the Marquess of Dalhousie after his term as Governor-General, though some of these were subsequently sold.[96] Five guns from this collection are now in the Tareq Rajab Museum – Catalogue nos 117, 118, 119, 120, 121. In Punjabi the word used for a pistol is the English 'pistol',[97] proof of the late adoption and origin of the weapon in that society. The English word rifle was corrupted to *rafl* or *banduk rakh-dar* – a long gun with a rifled barrel. *Kamr-khisa* is a shooting belt which may be accompanied by a powder horn or *shakh*.[98]

Excellent steel was used for gunbarrels at Panagar, Katangi, Jabera, Barela and Tenderkhera in the Central Provinces; at Dewulghat in the Berars; and in Mysore. Egerton says that the barrels of the matchlocks in Bundelkhand 'terminate in a lotus-shape muzzle'.[99] From this list, which is by no means exhaustive, it can be seen that barrels were produced at many locations in India. It is usually impossible to attribute a barrel, or for that matter a gun, to a specific area within the Sub-continent with any certainty. Attribution on the basis of stock shape offers only marginally better chance, since there are few types which can be firmly identified with an area or dynasty. Published attributions in auction or dealers' catalogues are usually intuitive, though offered authoritatively, current knowledge being rooted in the line drawings provided by Egerton, which merely record where a particular gun was bought rather than where it was made or in general use. The unreliability of an attribution arrived at in this manner can be seen in the wide variety of matchlock types to be found within the armouries of Rajasthan, which have clearly been received from all over the Sub-continent. Sinclair wrote that 'The matchlock is in common use throughout the (Madras) Presidency, and, as far as I am aware, there is no variety in its appearance or

mechanism, although some barrels are made of Damascus twist, and some are rifled.'[100] The entire edifice of attributed pieces established by successive arms historians is very largely without foundation. This state of affairs is unlikely to change. There is at present no means of differentiating between the barrels or stocks produced, for example, at Delhi, in Bengal, Rajasthan and Hyderabad (Deccan). Decoration may point to an origin but this may be added later, weapons changing hands as a consequence of the military adventures of powers as geographically diverse as the Mughals, Afghans, Marathas, Sikhs, Rohillas and Pindaris.

KASHMIR AND KASHGAR

Kashmir was conquered by the Sikhs in 1818. Moorcroft had travelled extensively in the region and his notes, published posthumously in 1841, describe the manufacture of excellent gun barrels there. He believed he knew the reason for this. 'It seems likely that upon the introduction of firearms the methods long known of manufacturing swords blades of peculiar excellence was transferred to gun barrels.'[101] This view may have received endorsement by his discovery that 'the fabrication of damasked blades is no longer practised in Kashmir'. With meticulous attention to detail he describes how the Kashmiris made gun barrels: he even had a forge constructed in front of him, at a cost of five shillings – which he considered very modest but more than the going rate. The forge, he noted, is used for no other sort of work and is usually established at the mouth of an oblong chamber, raised within the gunsmith's shop. Double bellows, made out of goat skin, blew air in a continuous stream onto the fire, as was general in India (and southern Arabia). The iron used in Kashmir, according to Moorcroft, 'is that of Bajour'.

Barrels are called plain, pechdar, or simply twisted, or jouhardar, or damasked. For the latter, the rods are disposed according to the brilliant or damasked lines intended to be produced, and which are distinguished by names taken from the country in which each variety is most

affected, or from the nature, or figure, in which the lines are disposed, – as Irani, or Persian, belongs to the former class, and Pidgeon's eye, Lover's knot, Chain, etc. appertaining to the latter.

Moorcroft describes the actual manner of construction very much in the manner of Mrs Beaton in her famous cookery book. 'To make an Irani barrel six or eight rods are required...' Four are twisted in one direction and four in the opposite direction.[102] At the end of a lengthy process of folding and hammering the barrel is fixed horizontally through a hole in an upright post and bored.

'The *jouhar* or damask is brought out through biting the whole surface with *kassis*, or sulphate of iron.' Any grease is first removed by rubbing the barrel with dry ash and then wiping it clean, after which all the apertures are carefully plugged with wood to prevent the entry into the barrel of the corrosive mixture, after which the barrel is coated daily for twenty days to a month, being hung in a trench in the gunsmith's floor which is covered over by a board. In Moorcroft's experience, 'chain damask' was the most generally preferred variety, 'excepting the silver twist' which was purely decorative and superficial, giving no strength to the barrel. In this it resembled the practice in Hindustan where the 'jouhar or damask' was initiated by lines traced in a coating of wax laid over the metal and the barrel exposed to a coating of sulphate of iron. The same treatment was sometimes accorded to Indian swords.

Bellew, who visited Kashmir and Kashgar in 1873-4, describes the Atalik's bodyguard in Kashgar: 'The arms of these men were the sword and percussion rifle with high sights. These last were manufactured in the Atalik's workshops in the Yangishahr of Kashghar and look very serviceable weapons.'[103] Bellew also encountered Chinese troops in Kashgar who put on a demonstration for him.

... the men were in sections of five, the complement required for the service of the tyfu, which was the only weapon they carried. This was a heavy wall piece, and not unlike a duck gun. It was carried on the shoulders of two men, and fired by the rear man, the barrel rested on the shoulder of the front man, who knelt for the purpose; whilst the other three in turn sponged, loaded, and primed the pan.[104]

The weapon which they call a *tyfu* is clearly a *jingal*. It is described in use in China in *Hobson-Jobson*: 'Gingals or Jingals are long tapering guns six to fourteen feet in length, bourne on the shoulders of two men and fired by a third. They have a stand, or tripod, reminding one of a telescope.'[105]

The Burmese used a similar weapon, which fired a ball of 6-12 ounces, was attended by two men and was sometimes mounted on a carriage. There is considerable variation in the size of the bore of these guns. Fitzclarence, in his *Journal of a Route Across India*,[107] wrote; 'They use large heavy wall pieces called gingalls which send a ball of two or more ounces to a very considerable distance.' Other sources suggest a range of a mile. This remarkable weapon was used in the following tactical fashion:

The evolutions consisted of marching and counter marching, forming column and line, and volley firing in the last formation. The skirmishing was done by a different set of men who were clad in a peculiar uniform. One company of these wore Grecian helmets, and carried bows and arrows. They discharged these last at the imaginary enemy, and then retreated behind the line, which now fired a volley into them. As the smoke cleared away a company of pikemen came forward, and piked the fallen enemy as they were supposed to lie on the ground. Then the whole line retreated covered by a company of shield men dressed in yellow clothes – jacket, trowsers, and cap all in one piece – with bars of black, and caps with ears to represent tigers. The buckler of their shield was a gun barrel,[107] and they loaded and fired it very dexterously in the midst of their performances. Their duty was to retard the cavalry by dispersing their charges. This they did by cutting antics and capers, and by flourishing their big shields (which were brightly painted with dragons' heads) and shouting, and then suddenly turning somersaults, or rolling on the ground and firing their gun barrels as they did so, or dropping torpedoes with slow matches which exploded all over the field. And finally, as they retired, they stopped here and there to sabre with their swords some fallen trooper.[108]

The Russian advance in Asia was regarded as a threat by the British to their possessions in India and the efforts by both sides to

124. An eighteenth-century Coorg matchlock gun from Malabar.

125. An eighteenth-century Indo-Arab matchlock gun.

126. An eighteenth-century Indo-Arab matchlock gun.

advance their cause was known as the 'Great Game'. Both sides took considerable interest in the firearms available to the indigenous peoples, often supplying more modern weapons in order to gain influence or military advantage.

In 1876-7 a Russian embassy was sent to Kashgar from the newly-conquered territory of Fergana, led by Colonel Kuropatkin. His report gives a brief history of the adoption of firearms in eastern or Chinese Turkestan and states that in 1857 firearms were scarce. An insurrection in 1863 against the Chinese had resulted in a military adventurer, Yakub Beg, taking over the region. According to Colonel Kuropatkin, Yakub Beg's army was greatly in need of cannon and firearms, having nothing better than flintlocks manufactured locally or obtained from neighbouring states. In 1868 he managed to procure a small supply of single- and double-barrelled sporting guns. Visits from the English explorers Shaw and Forsyth had made him acquainted with modern firearms and had left him with gifts of several hundred Snider breech loading rifles, Enfield muzzle loaders and revolvers. He was also persuaded to send a mission to the Ottoman sultan, via British India which, according to Kuropatkin, 'opened a road along which even now goes on a fairly active trade in arms with Kashgaria.'[109] In order to prevent the seizure of Kashgar by the Russians the British supported Yakub Beg by supplying him with arms.

A Russian envoy, Colonel Reintal, who brought gifts from the Tsar gained considerable military intelligence from his visit in 1875. According to Reintal the British had given Yakub Beg a large number of percussion rifles, but the example that he examined was so corroded that it was almost impossible to distinguish whether or not the gun was rifled. Yakub Beg had built a foundry in which muzzle loaders were converted into breechloaders and 4,000 had been altered in this manner. 'I saw one of these. Its breech block did not draw out, but opened from left to right. In the breech block there is a needle, which on the fall of the trigger is struck by the hammer. The foundry turns out sixteen rifles a week.'[110] The workmen in the arms factories were Afghan; and the army contained Afghans, Indians, a few Turks, Chinese, Kirghiz, local men and exiles from west Turkestan. One of the Turks from Istanbul made good percussion caps and excellent powder was made locally. The remnants of the Chinese forces which had gone over to Yakub Beg continued to use the *tyfu*.

Among the rewards they received for distinguished service in his army was the presentation of a double-barrelled sporting gun or revolver.

The greater portion of the firearms in use in Yakub Beg's army consisted of flintlock muskets of various lengths and bores. These, together with the small number of percussion arms, were, as a rule, of small bore. They were heavy, too, because of the Chinese sights that were fastened to the piece. In many of them the rifling consisted of a few straight incisions in the barrel and in loading it was necessary to force the bullet down with some sharp blows on the ramrod. The accuracy of these pieces was described as very fair up to 200 paces and their range sometimes exceeded 1,000 paces.

> In point of numbers the percussion arms, both smooth-bores and rifles, occupied the next place in Yakoob Bek's army. Amongst the latter that we chanced to see and hear of, there were about 8,000 Enfield rifles with bayonets, with a bore of about five eighths of an inch, stamped 'Tover 1864' [Tower] and in some cases '1867'. Yakoob Bek procured these rifles from India a few years ago.

The remaining percussion rifles were of two categories; imported sporting weapons with single or double barrels, many marked Joseph Brown and Son, London, and others from the Russian Tula factory.

The second category of these rifles were locally made percussion guns modelled on the Enfield and weighing ten pounds; and a carbine of six to seven pounds. Both had sights set for up to six hundred paces. The stocks on these weapons were not ornamented at all and they had a patch box on the side. The barrels of the guns were signed at the breech by the maker.

It appears that the Turks or the British sent some of their Enfields, converted to the Snider system, to Yakub Beg, while officers in the Kashgarian army were at this time increasingly armed with Colts and Lefaucheux revolvers, though the latter suffered from a shortage of ammunition and a mechanism that frequently failed.

127. A south Indian flintlock holster pistol, c. 1840.

Stone they vary in length from three to five feet. The iron parts of these guns are often supplied from China. Indeed, the form of this gun is derived from China. A fine example with horn prongs can be seen in the Musée de l'Armée, Paris (M2319), which has a pale green jade buttcap and inset in the stock a Chinese inscription indicating that it was the property of the Emperor K'ang-Hi who ruled from AD 1662-1722.

BHUTAN AND TIBET

The matchlock long gun from Bhutan is a clumsy and ornate weapon. The fullstock is made of wood, to which is applied pierced iron gilt plates chased with dragons and cloud symbols and embellished with turquoises. These guns almost invariably have a two-pronged hinged rest which is usually made of wood with metal points, though horn is sometimes used. The match holder is usually shaped like a monster's head and the barrels are frequently Indian. Tibetan matchlocks often have a leather bag attached to the stock to carry the match. A fine example of a Bhutanese gun can be seen in the Wallace Collection, London (no. 2003). In earlier times Bhutan was famous for producing the best swords[111] used in central Tibet, though eastern Tibet obtained high-quality weapons from the metalworkers of Derge. Gun barrels were imported into Bhutan and Tibet from India and Iran; one of the Tibetan names for a gun is me-da.[112] Tibetan and Mongolian muskets are generally of crude manufacture, with a straight wooden stock in contrast to the curved stock of western Asia. The stock is frequently covered with hide, sewn on tightly, while the two-pronged rest, made of wood or horn, can be found on these guns as well as on the guns of Turkestan. According to

THE ARABS IN SOUTHERN INDIA

Groups of people who claim Arab descent settled in Malabar over the centuries as a result of the annual arrival of the trading *dhows* from Arabia. The regular use of this trade route predates Islam and was in existence from 2000 BC or earlier.[113] The Moplahs or Mappillas are believed to be descended from Arab immigrants of the ninth century who took Dravidian wives. Mappillas is Mayali for Muslim.[114] The Mappillas were a fanatical Muslim sect which was responsible for forcible conversion of Hindus during the period when Tipu Sultan dominated Malabar at the end of the eighteenth century. In 1792 the area was ceded to the British at the Treaty of Seringapatam.

An early reference to firearms is provided by Ralph Fitch in his *Relation*, describing his journey from Syria to Ormus, Goa, Bengal and the East India coast in 1583-91. The Hindu Nairs 'be tall and strong and good archers with a longbow and a long arrow, which is their best weapon, yet there be some calivers among them, but they handle them badly.'[115]

The steady influx of Arabs brought the arms of Arabia to southern India, where they were copied by excellent Indian craftsmen whose work resulted in a hybrid Indo-Arabian decoration of

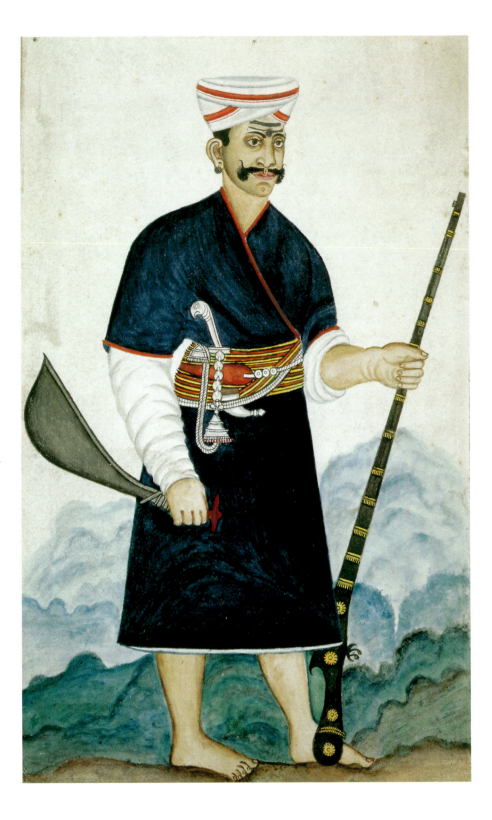

the essentially unchanged Arab form. The Arabs of southern Arabia were great travellers and took their guns with them so that the 'half grapefruit' stock may appear at any point round the northern half of the Indian Ocean littoral. The *dhows* contained carpenters who would make items to trade during the voyage, as did the crews, and anything, including the *dhow* itself might be sold.[116] As with Arabian edged weapons made in India, Zanzibar and elsewhere, the influence of the Arabs on local design led to a hybrid style being taken back to Arabia.

Many Arabs, particularly from the Hadhramaut, served as mercenaries, where their fighting qualities and their loyalty resulted in their being in considerable demand. They were particularly associated with the army of the Nizam of Hyderabad. Others settled as traders on the Indian coast. Guns from this society are to be found in the Tareq Rajab Museum, Catalogue numbers 124, 125 and 126. The large rounded butts of the latter two are directly derived from Arabian matchlocks though the use of ivory inlay in geometric design is uncommon in Arabia, the usual finish being a shrunk-on cover of gazelle skin. The purpose of this monstrous 'growth' was to absorb the shock of the recoil. Although referred to as 'Coorg guns' and used in that area, these are Arab guns carried into the region, though the rounded stock of number 124 shows south Indian influences.[117]

Costume drawings were occasionally made in Coorg, to the north of Malabar, a small state which came under British rule in 1834. *A Gazetteer of South India*[118] for 1855 states: 'The Coorgs are a fine manly race, much given to field sports, all are armed with the large Coorg knife or daa,[119] and a smaller one worn in the belt... most also have a matchlock.'[120] The men of Coorg were famous for their distinctive knives which are referred to as *ayudha katti*, or war knife, or *kodunga katti*, meaning curved knife. These were depicted by Indian artists in the mid-nineteenth century for purchase by British residents, many of whom owned coffee plantations. Because of the Mappillas' propensity to attack non-Muslims, the use of the knife was proscribed under Act XXIV in 1854. Conolly, the District Magistrate who enforced the Act by collecting these weapons, was hacked to death on his own verandah. In 1884, following another serious outbreak of violence near Malappuram, the government confiscated all arms, seizing 17,295 weapons of which 7,503 were firearms. The Madras Museum selected a small number of the best examples before the rest were dumped at sea.

The Raja of Coorg's capital was at Mercara, where he had an arsenal in the fort. Another 'Courg gun' with a markedly different butt, very short and pointed and utterly distinctive, is discussed and illustrated in Stone's *Glossary*....[121] The examples in the Victoria and Albert Museum, London, to which Stone refers were indeed presented by the ruler of Coorg. Beyond this, there is nothing to link these weapons with the state and no further information on the stock is known. However, the decoration of these three guns is consistent with that found on nineteenth-century arms in the region and on firearms from the Hadhramaut.

A man from Coorg, c. 1850. Coorg School, watercolour. The man holds a typical Coorg gun with its distinctive rounded butt and a Coorg knife. India Office Library, London.

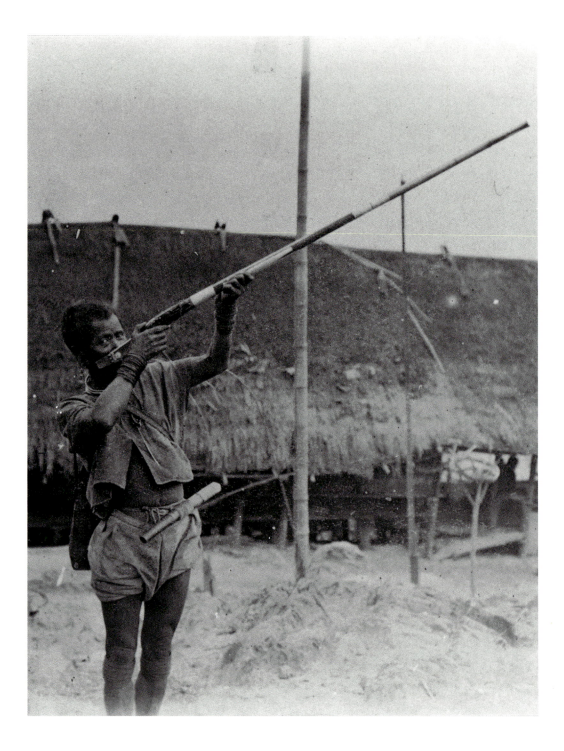

CEYLON AND SOUTH-EAST ASIA

LUDOVICO DI VARTHEMA visited Ceylon, now Sri Lanka, in 1505, the first year that the Portuguese had reached the island, and recorded that 'artillery is not used here; but they have some lances and swords, which lances are of cane, but they do not kill each other overmuch, because they are cowardly fellows.'[1] However, the Portuguese appear to have introduced these weapons to the island soon after Varthema's visit. In 1506 when D. Lourenco d'Almeida visited Ceylon, the Singhalese were terrified by the noise of the Portuguese cannon. Ribeiro mentions Sinhala cannon and handguns in 1519. Nevertheless the use of the word *bondikula*, clearly a corruption of the Arabic *bunduq*, suggests that the local population acquired their firearms from Arab rather than Portuguese sources.

The island was under Portuguese domination from the early sixteenth century until 1638 when the Dutch began to fight them for control. From this period dates a form of Portuguese miquelet lock known as *agujeta* which, fitted with a dog catch, was made for many years until the flintlock finally replaced it. Without the dog catch this lock was manufactured as late as the eighteenth century in southern Italy and Spain where it was known as *a la Romana*. Portugal was itself united with Spain from 1580 to 1640. In 1658 the Dutch succeeded in expelling the Portuguese from Colombo, their last stronghold, after a long siege.

A letter written in 1658 by the Dutch Commissary, van Goens, to the Governor-General and Council for India describes the sequence of events in Ceylon and makes recommendations in the event of the war being continued against the Portuguese in India the following season. Van Goens requests 3,000 heavy cannon balls of 12 to 24 pounds and 1,500 to 2,000 2-, 3- and 4-pound balls. He explains that the Portuguese had complained

Sawn Tung man (Head man, Dengklong village) with cheek gun. Southern Shan States. W.A. Robertson, 1919. Pitt Rivers Museum, Oxford.

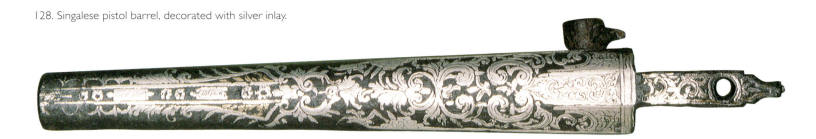

128. Singalese pistol barrel, decorated with silver inlay.

repeatedly about 'our way of warfare'. The Dutch had fired large pebbles and flints from their mortars at the castle. 'We only mention this to make you see the necessity for placing as ballast in the vessels sent to Ceylon as many pebbles as they can carry, for they are fearful engines of destruction. They were hurled from our guns on the roofs of the houses and went through the floors, burying themselves in the ground.' The Portuguese had themselves in 1644 fired grenades made of coconut shells and on another occasion blocks of wood from their large cannon, 'round and about an arm long'.[2] The latter 'made much noise, but did little damage'. The commissary reports that the gunpowder that they received from Batavia was much better than that from the coast of Coromandel and 'even superior to that from home'. 'We would further require 50,000 or 60,000 musket bullets or better still 100,000 pieces of shot, and 40 or 50 boxes of tinder, and at least 1,000 muskets or rifles, as most of our work against the Portuguese has been done with these weapons. They are especially useful in the trenches, and in dark weather.'[3]

To these events can be attributed the failure of the Portuguese/Sinhala gunlock of the early seventeenth century to evolve, although it continued in production during the Dutch period. A very rare sixteenth-century Sinhala matchlock based firmly on the Portuguese model was exhibited in Lisbon in 1983.[4]

The matchlock represented the cheapest and most reliable form of ignition available during the long wars of supremacy. Sinhala matchlock barrels are rare. An example is described and illustrated by Deraniyagala, who identifies but does not date the piece. The barrel is of early form, three feet ten and a half inches long, damascened, with longitudinal ridges and a swollen muzzle. This is very similar to the barrels found on Omani matchlocks. However it should be noted that the pan, integral with the barrel as in Persian barrels at this time, is on the right hand side. A characteristic of Sinhala firearms is that the lock is often found on the left of the stock, in contrast to European guns.

Ceylon has produced some fine long guns with a very distinctive bifurcated butt-shape. Linschoten, a Dutchman, wrote in 1592 that they made the fairest gun-barrels to be found in any place, and that 'these shine like silver'. Faria-y-Souza, a Portuguese writing in 1666, states that the Sinhala smiths 'make the best fire-locks in all the East' and Pyrard, a Frenchman, praised their skill in making and ornamenting arms, which he claimed were regarded as the finest in India. 'I never thought they could show such excellence in fashioning arquebuses and other arms...' In the seventeenth century the flintlock began to replace the matchlock amongst the upper classes, though flints are not naturally available in the islands. Deraniyagala noted that a study of sixteenth-

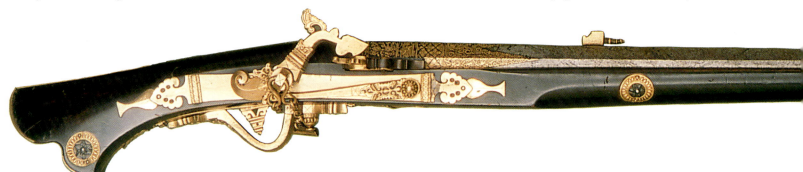

129. A gold-mounted Malayan matchlock gun, c. 1700.

and seventeenth-century frescoes revealed that the artists of the day were anxious to keep abreast of the times and frequently showed demon hordes armed both with traditional weapons and firearms of the latest patterns. Raja Sinha, who died in 1687, took particular pride in the rich decoration of his guns. Sinhala taste was for intricately worked ivory, tortoiseshell, silver and gold. An Englishman named Richard Varnham was in charge of his artillery for a while; while a Dutchman, who had come as an ambassador from the Dutch East India Company, remained to supervise the work of the king's silversmiths. The king's weapons were known as the 'Golden Arms', or *Ran Avudha*, and were made by a group of craftsmen known as the Navandanno. Most of the Sinhala guns were extremely heavy and were fired from a rest. The *Kavikalpa Tharuva* lists eleven varieties of gun.[5]

An example of the highest quality work produced in the islands is the flintlock purchased in Colombo on 3 July 1820 by the British Resident at Kandy, John D'Oyly, as a part of the regalia of the last King of Ceylon, Sri Vikrama, who had been deposed in 1815.[6] This gun dates from the late seventeenth century and is certainly grand enough to have belonged to Raja Sinha, as tradition claims. It is four feet six inches in length and weighs a remarkable thirty-one and a half pounds. The smooth-bore steel barrel and stock are wrapped in sheet silver gilt, richly ornamented with low-relief repoussé designs and filagree, with a design of balas rubies. The iconography and motifs of the sophisticated decoration are discussed in detail by Pieris. The lock is European, inlaid with gold and silver. Other early examples are in the W. Keith Neal Collection and in the Metropolitan Museum, New York (no. 91.1.907). The former has an early eighteenth-century toelock on an earlier stock. The Metropolitan example has a magnificently carved ivory stock.

There are large Muslim communities in South-East Asia and elsewhere that have their own distinctive firearms but which are not represented in the Tareq Rajab Museum. The Museum continues to expand its collection and its interests, but has rightly chosen to concentrate its efforts within certain historical and geographical confines. An exception to this decision is the magnificent Malayan gold-mounted matchlock gun of *circa* 1700 (no. 129), which demonstrates both the excellent craftmanship that was on occasion achieved in these regions, and is but one example of the very distinctive styles that developed. As we have seen elsewhere, firearms development was the product of a fusion of indigenous aesthetics and imported European or Muslim mechanisms.

The powerful Muslim state of Bantam in Java provides a good example of the manner in which local rulers exploited their control of the spice trade to obtain guns from Europe by linking the right to trade with the delivery of muskets, pistols and cannon.[7] The transfer of firearms technology was not always due to such crude considerations. For example, in 1663 the King of Bantam sent King Charles II of England a gift of ginger and pepper. This the king arranged to be sold by the East India Company and with the proceeds paid for an order to seven London gunmakers for 100 new muskets, 'well wrought with French stocks and polished barrels', which were sent to Bantam, leaving a balance of £130 in hand.[8] The commercial impetus that continued to bring traders from far distant lands also brought ever more sophisticated weapons of destruction until colonialism and the industrial revolution combined to extinguish the idiosyncratic local weaponry and the cultures that had produced them. Relatively little of quality survives in South-East Asia apart from the cast bronze cannon known as *lantakas* which were made in all sizes, from 10.5 inches to about seven feet long. These guns were very popular in Malaya and in Borneo were regarded as a form of wealth and even used as currency, which greatly assisted their preservation. Their decoration reflects the cultural and trading contacts of the region, with Chinese motifs as well as Portuguese, Spanish and Dutch. But long before the Europeans arrived, before the Chinese had invented gunpowder and even before the birth of the Prophet Muhammad, the Arabs had an established maritime trade in weapons with South-East Asia via the land of Serandib. However, in the words of Scheherazade, that is another story.

1 An unusual flintlock gun, *circa* 1820, barrel etched overall with arabesques and Qur'anic inscriptions against a blackened ground. Fullstocked, French military lock. Stock inlaid with mother-of-pearl shapes in geometric patterns, with a distinctive chamfer to the lower part of the butt. Syrian or Egyptian.
Overall length 139.5 cm, barrel length 99 cm.

2 A nineteenth-century Arab pistol barrel, the muzzle inlaid with brass eyes formerly mounted with glass or semi-precious stone. Inlaid overall with thick silver designs including knots, flowers and bands.
Overall length 21.5 cm.

3 An eighteenth-century Algerian miquelet gun with late sixteenth-century Ottoman silver inlaid barrel. Swollen 'tulip' shaped muzzle with silver channel fore-sight, inlaid at breech with silver arabesques in negative silhouette, maker's cartouche, and four foliate vignettes emanating from silver star. Lock foliate chiselled with some brass overlay. Stock profusely inlaid with shaped ivory, mother-of-pearl, coral, geometric stud work; one-piece ivory

buttcap. Wooden ramrod; button trigger.
Overall length 147.5 cm, barrel length 107 cm.

4 A very rare early eighteenth-century Scandinavian flintlock sporting gun fitted with a very heavy smallbore Turkish barrel, *circa* 1700. Barrel of twist forged pattern, partly octagonal and partly with flattened sides. Raised bands with chiselled zig-zag decoration and inlaid bands. Thickly silver damascened with later scroll work. Swollen fluted muzzle. Good quality Scandinavian lock, with hinged pan cover, ribbed frizzen face, horizontally acting sear through lockplate acts on tail of cock. Sliding patch box, down-turned butt inlaid with simple bone flower heads and scrolling foliage. The stock striped for effect.
Overall length 152 cm, barrel length 116 cm.

5 A fine pair of Austrian flintlock holster pistols, *circa* 1740, the stocks carved with rococo ornament. Heavy Turkish damascus pattern barrels of octagonal form in three stages with swamped muzzles, thickly inlaid with silver pattern, including flowers with coral centres. Plain locks and brass furniture.
Overall length 46 cm, barrel length 32 cm.

6 A fine nineteenth-century double-barrelled Turkish flintlock pistol with a concealed dagger. Walnut stock finely inlaid with silver wire scrolls and a few star-shaped devices. Part octagonal stepped barrels, gold damascened with trophies of arms, stylised stars and crescents and foliage. Lock extensively gold damascened with stylised trophy and foliage. The mechanism works as follows: both barrels are charged in the usual way. The cock is pulled back and the upper pan is pulled backwards, then both pans are primed. The sliding pan is replaced and the frizzen closed. Now the pistol is ready to fire and after the first shot, simply drawing the cock back pulls the fired pan away and reveals the primed pan for the lower barrel. Elaborate silver furniture engraved with stars, crescents, flowers, foliage and trophy. The silver grip when pulled reveals a straight double-edged dagger blade, gold damascened with foliage at the forte.
Overall length 49 cm, barrel length 27 cm, blade length 30 cm.
Formerly in the Draeger Collection

7 A large and heavy late seventeenth- or early eighteenth-century Turkish or Eastern Balkans miquelet flintlock rifle. Large bore

octagonal barrel with deep fourteen-groove rifling, of best damascus twist forging, the swollen breech and muzzle inlaid with thick silver flowers and foliage with some gold foliage. The inlay is sufficiently thick to receive extensive engraved embellishment. Silver foresight and inlaid muzzle band, barrel tang inlaid *ensuite* with breech, and with owner's name *Qara Osman* within square. Massive lock inlaid with silver foliage with engraved details, inlaid ribbed frizzen face, the bridle with applied sheet silver, foliate engraved. Stock inlaid with shaped bone plaques with brass piqué work and ornamental brass and ebony shaped studs. At the breech are inlaid two unusually large mosaic roundels of brass, bone and ebony geometric segments, each 1.5 cm diameter. The particularly bulky lines of this rifle are accentuated by the butt and lock, the frizzen measures 4.5 cm across the face, and the buttcap is 9 cm wide, whilst being only 9.5 cm tall.
Overall length 116 cm, barrel length 82 cm.

8 A heavy Turkish miquelet flintlock rifle, *circa* 1780, octagonal barrel silver inlaid at breech and muzzle. Fullstocked, large lock, back of frizzen inlaid with silver crescent and shrub. Applied silver to bridle foliate engraved, silver inlaid cock. Stock with later applied nickel sheet decoration.
Overall length 142 cm, barrel length 106.5 cm.

9 A very fine Turkish silver-mounted, gold-decorated miquelet flintlock rifle, third quarter of eighteenth century. Heavy octagonal barrel with deep seven-groove rifling. Maker's stamps including crowned *amal Yusuf* (work of Yusuf) in *nasta'liq*, foliate device and twelve small fleurs-de-lis, all of inlaid gold. The muzzle, breech, barrel tang and lock (which has a removable frizzen face) are extensively damascened *ensuite*, with thick gold in foliate arabesque designs. Tall peephole rearsight with four apertures. Dark walnut fullstock inlaid with white metal piqué work and tiny white metal and ebony studs of geometric design. (These studs are common but are usually made of brass.) The stock is extensively inlaid with very finely pierced and shaped silver plaques; around the butt and behind the barrel tang are pierced silver bands, with ribbed corals in high relief, secured by silver nails. Four shaped silver barrel bands, sheet silver fore-end cap. Two silver sling swivels, one screwed to stock, one using barrel wedge position. Steel-tipped wooden ramrod. Steel button trigger of bud form and large inlaid and pierced silver trigger plate. Unusual iron buttcap, pierced and inset with silver plate.
Overall length 139 cm, barrel length 103 cm.

10/11 A pair of silver decorated Turkish flintlock holster pistols, *kubur*, showing strong Italian and Balkan influence, *circa* 1770. Walnut stock carved in low relief with foliage. Italianate locks and steel furniture with some foliate chiselled ornament, traces of a copied signature, D. ZANONI. Silver muzzle sheath, barrel bands and grip plates embossed with traditional foliate scrolls. Silver wire bound grips. Silver-tipped steel ramrods. Barrels also in the Italian manner, chiselled with sunken aprons at breeches, and stamped in imitation of the Italian LAZARI COMINAS. D. Zanoni may refer to one of two Brescian gunsmiths, Diego (1689-1750) or Domenico (*circa* 1750).
Overall length 52 cm, barrel length 35 cm.

12 A Turkish miquelet flintlock gun, late eighteenth century, built for a youth. Close twist forged barrel struck with two makers' cartouches *imtihan* (tested), *amal Muhammad* (?). Raised rib, aprons chiselled at breech and behind muzzle, with swollen band at muzzle. Dark walnut fullstock extensively inlaid with white and green-stained bone strips, brass piqué work and brass and ebony shaped studs. The white bone trigger plate has tulip derived shape. Silver barrel bands, steel ramrod, green stained and inlaid bone fore-end cap, layered ivory and ebony buttcap. Button trigger, lock of traditional form with maker's cartouche stamped on bridle, *imtihan* (tested).
Overall length 99 cm, barrel length 66 cm.

13 A Turkish miquelet flintlock carbine from the second half of the eighteenth century with silver mounts. Fullstocked in Circassian walnut (*Juglans Regia*) artificially striped. Octagonal damascus twist barrel with seven-groove rifling, struck at the breech with maker's warranty *imtihan* (tested) in Arabic *naskhi* script. See no. 12. Stock inlaid with engraved silver plates of pierced foliate design incorporating strapwork. Barrel tang surrounded by foliate chiselled sheet silver.
Overall length 118 cm, barrel length 91 cm.

14/15 An exceptionally fine pair of gold inlaid, silver-gilt-mounted Turkish flintlock holster pistols, *kubur*, *circa* 1800. Locks and barrels thickly encrusted with flowers and foliage, chased and engraved in relief, the half octagonal barrels finely inlaid in gold with a Persian couplet; *mujalla khush sim zar ahan abad bideh Haq sahibak da'im farakhad* (brilliantly well done in silver, gold and iron;

may God give victory to its owner). Beneath the cocks lie serpents with a single flower issuing from their mouths. Silver-gilt furniture, longspur buttcaps cast and chased with knight's head bosses and panoplies of arms. Sideplates similarly cast and chased with flowers, foliage and trophies. Trigger guards chased with military trophies and stamped with star and crescent at the finials. Walnut stocks profusely inlaid with silver wire scrolls, pique work and silver leaves in foliate designs. Engraved silver-gilt muzzle bands and dummy ramrods.

Overall length 47 cm, barrel length 30 cm.

16 A Turkish hall-marked silver-mounted flintlock holster pistol, *kubur*, circa 1840. The furniture struck with the *tughra* of Abdulmecid (AD 1839-61) with the purity mark 90 added, and the *sahh* arsenal mark. The sideplate engraved with the owner's name '*sahibahu 'Ali al-Hafanduqi*' (its owner: 'Ali al-Hafanduqi) in Arabic *naskhi* script. Plain steel barrel lock struck with maker's name within cartouche. Roller-bearing frizzen spring, cock with unusually elongated jaws. Acorn finialled trigger guard. Stock inlaid with sheet silver designs, stars and silver wire work.

Overall length 47 cm, barrel length 34 cm.

17 A silver inlaid flintlock holster pistol, *kubur*, early nineteenth century. Walnut fullstock deeply carved with foliage. Unusual steel furniture chiselled overall with stylised human faces, including one on the sideplate which is smoking a pipe. Pierced buttcap and trigger guard bow. Barrel inlaid with silver foliage in thick relief *ensuite* with lock and cock. Lock surrounded by applied brass border chiselled with foliage. Ivory fore-cap,

vestigial wooden ramrod with pierced iron pipes. The silver decoration on the lock and barrel is Turkish.

Overall length 45 cm, barrel length 28 cm.

18/19 A fine pair of silver-mounted Turkish flintlock fullstocked holster pistols, *kubur*, circa 1800. Barrels chiselled with shaped aprons at the breech, with raised sighting rib. Flattened lockplates with bevelled edges, ribbed frizzen faces, foliate finialled frizzen springs. Steel trigger guards with ribbed bows. Longspur buttcaps cast with foliage in high relief, the lower ground and spurs nielloed with foliage, tall cylindrical nielloed bosses with flower-head finial. Embossed silver barrel bands; dummy ramrods with niello decoration. Silver sideplates and stockplates, entirely covered with filigree work in silver wire, shapes and tiny silver balls all in geometric patterns. Each pistol has three diamond-shaped nielloed silver escutcheons, each set with a pink coral. The buttcaps of these pistols are very similar to those of nos 20 and 21 and are probably from the same workshop.

Overall length 51 cm, barrel length 36 cm.

20/21 A fine pair of Turkish flintlock holster pistols, *kubur*, signed *Ibrahim Yakshi*, circa 1800. Hardwood fullstocks with particularly fine silver wire inlay in the form of stylised scimitars, scrolls and geometric devices. Large applied silver escutcheons decorated with filigree, niello and coral. Silver furniture, foliate chiselled trigger guards. Longspur buttcaps chiselled in high relief with foliage and with tall cylindrical nielloed bosses, having flower-head finials. Foliate engraved locks with gold damascened pans, ribbed frizzen faces. The barrels inlaid

with maker's silver poinçons, *Ibrahim Basha* in *nasta'liq* script; chiselled with three ribs and shaped aprons in relief, thickly inlaid with flush finished silver foliage and scrolls. The stock partly carved with scrolls.

Overall length 53 cm, barrel length 34 cm.

22 A European export flintlock blunderbuss, circa 1830. Fullstocked in naturally striped walnut. The lock and steel furniture thickly silver inlaid in Persian style with rows of dots in relief, simple foliage and scrolls. Buttcap with stepped swollen finials, star device in silver on heel *ensuite* with trigger guard. The lock is European in form but the frizzen has a removable face in the miquelet tradition. Swollen steel barrel inlaid with imitation maker's mark and various shaped sheets of brass and silver engraved with foliage. Steel saddle bar with lanyard ring and woven cotton carrying strap.

Overall length 77 cm, barrel length 48 cm.

23 A Liège export silver-mounted Turkish flintlock blunderbuss, circa 1840. The half octagonal barrel of damascus twist pattern with flared muzzle, profusely embellished with inlaid thick silver foliage including a pair of perched hawks; the barrel tang silver inlaid with the owner's name *Selim al-Talauni*. Silver furniture engraved with foliage incorporating two stylised lions. Silver side-bar for lanyard ring. Lock engraved with owner's name *Ilyas Bawwab Salim al-Talauni*, the first two names in plain *nasta'liq; amal Husayn 'Ata* (work of Husayn 'Ata) in ornamental *nasta'liq*. Walnut fullstock inlaid with brass wire and foliage overall, chequered grip, carved with a stag's head, inlaid mother-of-pearl eyes with infilled red pupils.

Overall length 51 cm, barrel length 26 cm.

24 A Turkish flintlock blunderbuss pistol, *circa* 1830, flared twist barrel inlaid with thick nickel silver bands and foliate designs with maker's stamp. Lock of European form engraved with stars and crescent, plain brass furniture.
Overall length 49.5 cm, barrel length 28.5 cm.

25 A Turkish flintlock blunderbuss pistol, *circa* 1840, flared barrel inlaid with thick nickel designs of foliage, brass maker's poinçon *sanah 57* (year 57). European export lock, plain brass furniture, chequered grip.
Overall length 51 cm, barrel length 26.5 cm.

26/27 A fine pair of Turkish flintlock holster pistols, *kubur*, entirely covered with chiselled silver-gilt, *circa* 1790. Half octagonal English barrels engraved London, with Tower of London private proof marks. Best quality English stepped locks engraved 'Grice', with sliding safety bolts and roller bearing frizzen springs. Silver-gilt furniture chiselled in relief, panoplies of arms to buttcaps; trigger guards, sideplates, lower parts of stocks, fore-ends and muzzle bands all chiselled with foliate arabesques *ensuite*, including silver gilt dummy ramrods. Silver-gilt plates on upper grips covered with punched decoration and nielloed with flowers and trophies of flags.
Overall length 46 cm, barrel length 29cm.

28 A Turkish flintlock gun in the French manner, the eighteenth-century barrel inlaid with silver foliage, scrolls and arabesques and a chiselled top rib for sighting. Stock, furniture and lock of later manufacture. Lock inlaid with silver foliage; brass pan. Engraved nickel furniture. Foliate carved stock inlaid with silver wire scrolls, a few corals and nickel leaves. Metal ramrod.
Overall length 122 cm, barrel length 81 cm.

29/30 A very fine pair of silver-gilt stocked Turkish/Greek flintlock holster pistols, *kubur*, early nineteenth century. Slightly rounded lockplates with engraved initials and scrolled, ribbed frizzen faces. Barrels chiselled with raised octagonal aprons and ribs, together with chiselled foliate ornaments. Heavy, high-grade silver-gilt stocks, very finely cast and chased with flowers and foliage in sharp relief, incorporating two stylised dogs on sideplate, chiselled escutcheon on stylised chequered grips as a vase with flowers. Integral buttcaps with sharp raised bosses. False baluster ramrods. Trigger guards and muzzle sheaths all in silver-gilt *ensuite* with stocks, shell finialled silver-gilt plates applied over the barrel tangs. High quality stocks with foliage crisply chiselled against a finely punched ground.
Overall length 52 cm, barrel length 33 cm.
Formerly in the Draeger Collection

31 A good and unusual Turkish/Greek silver-stocked and nielloed flintlock holster pistol, *kubur*, *circa* 1830. Barrel with chiselled apron, foliate devices and raised ribs, gold damascened with scrolls, flowers, foliage and within a cartouche, badly inscribed, *Al-Fard* in *thulth* script, possibly a name. Lock with roller-bearing frizzen spring and a little foliate engraved decoration, cock retained by a pierced screw. Heavy silver-gilt stock chiselled overall with bas-relief cartouches profusely nielloed with flowers, foliage and a stylised male dog at the escutcheon position.
Overall length 44 cm, barrel length 27 cm.

32/33 A superb pair of silver-gilt-stocked flintlock Turkish holster pistols, *kubur*, using old Italian locks and barrels of quality, the fine stocks probably Greek but possibly Turkish, *circa* 1750. Locks signed AZZONI IN BRESCIA and struck inside with maker's mark OA beneath fleur-de-lis within circle. Lock tails, cock screws and ends of pans chiselled with grotesque human faces. The frizzens and pans chiselled with foliage. Three stage barrels stamped LAZARO LAZARI with maker's stamp beneath F.G. within apple (?). Chiselled with grotesque masks in relief at breeches having entwined beards, with foliage at steps.

The locks and barrels date from early in the eighteenth century. Ottavio Azzoni worked between 1690 and 1710. The sites of staples beneath the barrels indicate that they had been fitted to an earlier pair of pistols with wooden stocks. The silversmith has stocked these pistols with considerable skill using the only two motifs provided by the locks and barrels, namely grotesque human masks and foliage. Grotesque human faces in relief are used on the trigger guard bows, at either side of the triggers, for the triggers themselves, in the sites of escutcheons (here horned, presumably as the devil), at either side of the buttcaps, for their boss, and upon the side nail areas. Foliage derived from the frizzens appears on the muzzle bands, buttcaps and where a trigger guard would have had two finials. Foliage derived from the cocks is used throughout the stocks. In addition to these ornaments, the silversmith has used a series of balls around the buttcaps, beneath the fore-ends and behind the trigger guards. Serpents appear on the side-plate areas and also in pairs around the escutcheons, having foliage issuing from

their mouths. A final detail is the zig-zag teeth in the open mouths of the grotesques on the buttcap bosses, an ornament found ubiquitously on Balkans silver-stocked pistols of the period. The use of the human face in this manner suggests a Christian silversmith, working for a Christian patron, therefore Greece, at this time part of the Ottoman empire. Alternatively these guns may have been commissioned in Italy in Balkans style as a diplomatic gift to a Muslim, hence the elements on the escutcheons, which might be construed as subtly offensive.

Overall length 50 cm, barrel length 32 cm.

34 A good quality Moroccan snaphaunce gun, *circa* 1800. Ebonised full stock with good quality silver wire inlay in floral and foliate designs with foliate and zig-zag borders. Fish-tail butt with large ivory buttcap incised with red and black paint-filled circle and dot decoration. Part octagonal barrel with slightly swollen octagonal muzzle, inlaid with three makers' brass poinçons and the Arabic word *inkhila* (uprooting), also inlaid for its entire length with foliate-shaped and engraved silver plaques, one inlaid with a small pink coral in relief engraved with foliage overall. Good quality lock of traditional Anglo-Dutch design, foliate engraved and inlaid with engraved sheet silver shapes overall. Floral and foliate engraved silver barrel bands, wooden ramrod, foliate engraved brass furniture.

Overall length 160 cm, barrel length 122 cm.

35 A Moroccan snaphaunce gun, adapted for a child, mid-nineteenth century. Lock derived from Anglo-Dutch seventeenth-century type, inlaid with brass discs, heavy

buffer screwed to lockplate, sliding pan cover. Octagonal breech engraved with foliage. Simple steel trigger guard. Fish-tail butt with bone buttcap and inlay, also inlaid with silver crescents, flower and foliage.

Overall length 71 cm, barrel length 39 cm.

36 A fine silver-mounted Moroccan snaphaunce gun, *bu-shfer*, probably early nineteenth century. *Afedali* type from the Taroudant and Oued Sous valley. Part octagonal, part polygonal barrel with swollen facetted muzzle. Walnut stock, typical fish-tail-shaped butt with thick ivory buttplate. Stock inlaid with shaped ivory plaques, engraved with fine red and black paint-filled geometric ornament. Foliate engraved silver barrel bands, brass trigger guard with applied foliate engraved sheet silver; and the usual hinged Moroccan coin, in this case dated AH 1181 (AD 1768), intended to ward off the evil eye. Engraved steel base plate to stock beneath lock. Decorated overall with silver studs, inlaid silver decoration and some red paint-filled scrolls. Butt with thick steel-framed edge, steel ramrod with swollen head, retained within slender brass tube. Lock of traditional form, copied from Dutch and English prototypes.

Overall length 159 cm, barrel length 123 cm.

37 A fine silver-mounted Moroccan snaphaunce gun, *bu-shfer*, probably early nineteenth century. *Altit* type from the Little Atlas Mountains. Part octagonal, part polygonal barrel, with an angle of the polygonal section forming a sighting rib, swollen facetted muzzle. Walnut fullstock. Stock inlaid with large ivory sheets, engraved with fine geometric ornament of

traditional design, including a twin comb design, heightened with red and black paint. Brass trigger guard faced with sheet silver decorated with geometric foliate ornament and with further red, yellow and black painted infill. Applied sheet silver decoration pierced and engraved with foliage, silver stud work. Steel-framed solid ivory butt. The hinged silver coin applied to trigger guard is a one-real piece of King Carlos IV of Spain. Lock of traditional form, with sliding pan cover copied from seventeenth-century Anglo-Dutch prototypes.

Overall length 160 cm, barrel length 123 cm.

38 A fine silver-mounted Moroccan snaphaunce gun, *bu-shfer*, early nineteenth century. *Altit* type from the Little Atlas Mountains. Part octagonal, part polygonal barrel, with an angle of the polygonal section forming sighting rib, swollen facetted muzzle. Lock of traditional form, derived from seventeenth-century Dutch original with sliding pan cover. Extensive engraved silver mounts, mostly foliate engraved, the plate beneath trigger guard pierced with scrolls and a comb device with cruciform finial engraved and filled with red and black paint. Profusely inlaid shaped ivory shapes engraved geometrically and infilled with red and black paint, with extensive silver raised stud ornaments. One-piece ivory butt with steel frame. Brass trigger guard faced with silver, chased with scroll work and filled with red and black paint. Foliate engraved silver barrel bands, steel ramrod. Compare with similar gun, no. 37.

Overall length 160 cm, barrel length 121 cm.

39 A fine nielloed silver-mounted Moroccan snaphaunce gun, *bu-shfer*, early

nineteenth century. *Taouzilt* type from Ras el Oued in the high valley of the Sous. Steel-framed stock entirely covered with sheet silver, partly embossed with raised nail-head design. Other sheets pierced and engraved with foliate and geometric ornament with broad nielloed bands. Shaped brass trigger guard applied with nielloed sheet silver and a raised, red glass rectangle. Side of stock with two raised, red glass rectangles upon blue and yellow enamelled plaques. Geometrically engraved steel butt frame, steel ramrod with applied brass sheet over retaining channel. Lock of traditional early Anglo-Dutch form.
Overall length 151 cm, barrel length 114 cm.

40/41 A magnificent pair of coral-inlaid silver-mounted Algerian flintlock holster pistols signed *Mustafa* and dated AH 1198 (AD 1784). Walnut fullstocks profusely decorated with large tulip- and leaf-shaped corals, each carved with a pronounced curved medial ridge. These corals are held in place by a frame of silver which is engraved with foliage and nailed to the stocks. Foliate chiselled trigger guards each struck with a pair of tiny hall marks. Longspur buttcaps, with stepped polygonal bosses also inlaid with coral shapes carved in relief. The locks and half-octagonal barrels are inlaid with thick plaques of silver, chiselled in relief with foliage. The silver inlay is particularly extensive, including the cocks, jaws, jaw screws and many sites on the frizzens. Pierced and engraved silver barrel bands. Wooden ramrods with engraved silver tips.
Overall length 48 cm, barrel length 32 cm.

42 A magnificent Algerian miquelet flintlock gun, silver-mounted and inlaid with

hundreds of fine shaped pink corals, dated AH 1207 (AD 1793). Thick steel lockplate faced with silver on the outside and brass on the inside. Lock of strong construction, inlaid with sheets of deeply foliate chiselled silver signed *amal Muhammad* and dated AH 1207. Hinged safety hook inlaid and set with two corals *ensuite* with silver crossbar. Ribbed integral frizzen face, the frizzen axle is a screw-headed bar held in place by a crosspin. Slender silver pan with raised edges. Stock entirely covered with large pink corals, carved in relief with medial ridge, and shaped as tear-drops and almonds, secured by silver frame work, foliate engraved and inlaid in stock. Foliate chiselled gilt fore-cap and large buttcap also inlaid with corals. Part octagonal barrel with Tower of London private proof marks. Foliate and floral embossed and chased silver barrel bands stamped with large Algerian hallmarks. Silver baluster trigger, wooden ramrod with massive floral and foliate embossed silver tip. Compare with gun no. 44.
Overall length 166 cm, barrel length 123 cm.

43 An early nineteenth century Algerian miquelet flintlock rifle, inlaid with corals. The heavy well-made lock signed *Must[afa]* has a brass-faced, thick steel lockplate. Hinged safety hook, lock parts inlaid with foliate chiselled sheet brass. Octagonal tapered barrel in the Italian manner, struck with decorator's mark within cartouche, over traces of LAZARINO, chiselled full-length ribs. Breech and muzzle thickly inlaid with silver foliage. Fullstock inlaid with shaped corals and applied with engraved and shaped silver framework. Pierced and embossed barrel bands, wooden ramrod, wooden buttcap.
Overall length 175 cm, barrel length 133 cm.

44 A good North African Arab miquelet flintlock silver-mounted gun dated AH 1231 (AD 1816), from Tunisia or Algeria. The heavy lock strongly made, thick steel lockplate faced on each side with brass. The cock, frizzen, safety hook and bridles all inlaid with silver, deeply chiselled with foliage. Rear of frizzen foliate chiselled and inlaid with silver crescent, ribbed integral frizzen face, long narrow pan, swollen jaw screw pierced twice and silver inlaid, swivel shaped cocking bar of silver. Underside of lock signed *amal Umar Ibrahim 1231*. The back of the lockplate is set into the stock, whilst the front fits flush with the surface, retained by three silver-headed screws. Hardwood fullstock with inlaid pierced and engraved sheet silver overall in floral and foliate incorporating stars. Silver baluster trigger, engraved silver buttcap, five large chased silver barrel bands. Long, octagonal tapered barrel, with some foliate chiselling. Behind the barrel tang is engraved the inscription *ayn yansurllaha fala ghaliba lakum* (no one can prevail over you if God comes to your rescue). *Qur'an*, 'The Imrans'. Ch.3:160.
Overall length 192 cm, barrel length 150 cm.

45 A fine Turkish miquelet flintlock rifle, eighteenth century. Octagonal barrel of curly damascus twist, deep seven-groove rifling, chiselled top rib with silver inlaid shaped apron. Three peephole standing rearsight. Breech applied with soft metal cartouche engraved in Arabic *naskhi* script; *sahib wa malik Uthman* (the owner and possessor: Uthman). Mountain maple fullstock with fine, striped, iridescent grain extensively inlaid with white and green-stained bone, in sheet and shaped plaques,

including stars and free foliate designs, all inlaid with ornamental brass studs and piqué work. Lock thickly gold damascened with incised detail on the floral and foliate designs. Bridle decorated with four pink coral beads, cock with fluted corals, large teardrop-shaped fluted coral within copper-gilt mount applied to mainspring. Cock screw and bridle both terminate in silver balls with applied pierced mounts. Foliate engraved silver barrel bands, gold inlaid button trigger and lock-retaining screws.

Overall length 114 cm, barrel length 79 cm.

46 A very fine French or Algerian coral-inlaid, silver-mounted flintlock holster pistol, with French gold-inlaid and chiselled lock and barrel, *circa* 1820. Walnut fullstock decorated with shaped pink corals in low relief, retained by a framework of foliate engraved sheet silver nailed to the stock. Silver furniture including longspur buttcap chiselled with flowers, foliage and stylised trophies in relief. Silver-tipped ramrod made from baleen (the flexible black plankton-filtering material of the baleen whale). Barrel chiselled for half length with flowers and foliage in high-relief against a gold ground. Lock with military trophies against a gold ground, roller bearing frizzen spring, signed VIGNIAT-MARSEILLES. Gold-lined pan and frizzen.

Early nineteenth-century pistols made for the Eastern market by this maker are also signed 'H. Vigniat à St Etienne'. According to M. Maurice Forissier of the Musée d'Art et Industrie, St Etienne, export pistols were made at about this date in Algerian style in St Etienne, signed Vigniat – Marseilles.

Overall length 51 cm, barrel length 33 cm.

47 A hallmarked, silver-mounted Algerian flintlock holster pistol, *circa* 1820. French export lock and barrel, the lock signed *Lamotte Ainé à St Etienne*, tail of lock and back of frizzen chiselled in bas-relief and inlaid with gold. The cock chiselled in high relief, with a trophy of arms upon similarly gilt ground. Barrel also chiselled in high relief with a trophy of arms. Hardwood fullstock inlaid with sheet silver pierced with flowers and foliage. Foliate chiselled silver furniture, sideplate chiselled as entwined serpents. Muzzle sheath and stockplates embossed with flowers and foliate arabesques. Ornamental silver ramrod, silver wire bound grip. The hallmarks are tiny and very numerous. Lamotte Ainé, or Lamotte the elder, worked briefly from 1750 to 1752, the head of a family of gunmakers.

Overall length 51 cm, barrel length 33 cm.

48 A hallmarked, silver-mounted Algerian flintlock holster pistol *circa* 1820. Lockplate with brass arabesques *ensuite* with cock. Barrel chiselled with foliage in low relief, with mock proof and maker's marks at breech. Hardwood fullstock inlaid with pierced sheet silver incorporating star and foliate designs. Silver furniture chiselled with flowers and foliage in relief. Silver muzzle sheath and stock plates boldly embossed with panoplies of arms, flowers and foliage in the manner of Ottoman silver *yataghan* scabbards. Silver wire bound grip, ornamental silver ramrod. The hallmarks are large, extensive and illegible.

Overall length 50 cm, barrel length 33 cm.

49 An Omani *abu fitila* matchlock gun, *circa* 1700. The barrel of 'architectural form', deeply struck on the barrel tang with maker's

cartouche *amal Niyazi* (work of Niyazi) and another cartouche, now with soft metal infill missing. Fluted breech and muzzle in the form of reeded 'architectural columns'. Hardwood fullstock, brass-covered fore-end and brass barrel bands. Pierced steel trigger with some brass inlaid ribs.

It is not known for certain where these barrels were made though large numbers ended up in Oman and are identical to the small number of surviving barrels found on early Singalese matchlocks.

Overall length 158 cm, barrel length 110 cm.

50 A seventeenth-century Omani matchlock barrel of 'architectural' form. Fluted breech and muzzle of the same form. The integral barrel tang struck twice with maker's poinçons *amal Muhammad* (work of Muhammad). Pan with stylised pierced zoomorphic finial. Silver and gold inlaid raised transverse bands, three escutcheons with their soft metal now removed.

Overall length 117 cm.

51 An Omani *abu fitila* matchlock gun fitted with early barrel of 'architectural' form, plain stock with brass barrel bands, sheet brass-covered fore-end, steel ramrod and pierced brass trigger. The barrel, probably sixteenth century, of swamped form in three stages, the breech and muzzle nicely fluted, traces of silver inlaid bands, chiselled saddle and maker's stamps, the tang cartouche reads *amal Mihr Ali* (work of Mihr Ali).

Overall length 169.5 cm, barrel length 124.5 cm.

52 An eighteenth-century Omani matchlock gun barrel. Of tapered form, with thick swollen breech and small swollen muzzle. Both muzzle and breech band are

polygonal, inlaid with silver woven wire bands, raised bands and pellets. Fluted breech section, site for cartouche (soft metal removed) and maker's stamp on barrel tang *'amal Muhammad Sa'id* (work of Muhammad Sa'id), dated 1211 (AD 1797).

53 An eighteenth-century Turkish rifle, now without a lock but exhibiting a comprehensive selection of decorative embellishments. Fullstocked in striped Circassian walnut. Tight, curly twist pattern damascus barrel with deep nine-groove rifling, extensively inlaid at breech and swollen muzzle with gold flowers, foliage and scroll work. The swollen muzzle shape is derived from sixteenth- and seventeenth-century examples from the early Ottoman Empire. Unusual rearsight in the form of a sprung plate, 7 cm, pierced with ten peephole sights and faced with sheet silver. Stock extensively inlaid with foliate pierced sheet silverwork, engraved details. Green stained bone fore-end cap. A butt extension of almost black hardwood is inlaid with variously shaped bone plaques, some green stained, and embellished with brass piqué work and inlays of tiny mixed brass and ebony roundels.
Overall length 130 cm, barrel length 95 cm.

54 A fine Balkan *boyliya* miquelet flintlock gun, *circa* 1800. The lock covered with foliate engraved sheet silver, mainspring partly covered with foliate engraved sheet brass. Barrel with chiselled top rib, inlaid with foliate engraved brass shapes, damascened with gold scroll work, foliate engraved silver covered rearsight and barrel tang. Muzzle and breech gold damascened *ensuite*. Hardwood fullstock, fore-end sides

and lock area covered with applied mother-of-pearl diamond shapes with brass divides and pewter nail heads. Each diamond shape has a red paint filled device to its centre. Green stained bone trigger plate and inlaid plaques to stock with profuse brass and ebony geometric shaped stud work, inlaid to form a diamond pattern to fore-end, a tight close-fitting mass of stud work under stock with no interstices, and in bands around the butt. Typical foliate embossed silver barrel bands and fore-end cover, steel ramrod, grip covered with embroidered cotton velvet. Compare with gun no. 57.
Overall length 125 cm, barrel length 87 cm.

55 A Balkans *boyliya* miquelet flintlock gun covered with silver-gilt sheets, *circa* 1800. Part octagonal Italian barrel stamped with maker's brass poinçon R.P. Di NAP[OLI]. Lock and breech covered with sheet silver, engraved with typical Ottoman foliage. Bridle decorated with single pink coral. Stock covered with silver-gilt sheets, embossed with geometric and foliate ornament on a punched ground, of European baroque inspiration and red cotton velvet embroidered with gold thread. Steel ramrod. The lock and barrel decoration is the work of one craftsman while the stock is clearly by another silversmith with an entirely different repertoire.
Overall length 145 cm, barrel length 108 cm.

56 A Balkans *boyliya* miquelet flintlock gun, *circa* 1800. Half octagonal barrel damascened in gold and silver with foliage at breech and muzzle, barrel tang gold damascened with owner's name *Sahib Shauqi*. Lock of traditional form, faced with sheet silver engraved with foliage, engraved with maker's name *Ahmed....* Embossed silver barrel

bands and fore-end sheath with foliate scrolls in relief. Fullstock part-covered with mother-of-pearl shapes, inlaid with geometric brass, ebony and silver centred stud work with red filled decoration, the sections separated by silver wire borders. Butt and part of fore-end decorated with geometric brass and ebony stud work, some with silver centres. Simple green-stained bone stringing, horn buttcap, brass button trigger.
Overall length 140 cm, barrel length 100 cm.

57 A fine Balkans silver-mounted *boyliya* miquelet flintlock gun, *circa* 1800. Lock entirely covered with thick sheet silver, lockplate stamped with maker's poinçon *beg* (a Turkish title). The cock of characteristic form. Part octagonal barrel with flat sighting rib, breech chiselled with foliage and inlaid with silver scrolls, plaques and foliate engraved breech plates. Lock area and fore-end entirely covered with sheet silver, embossed and chased partly with a regular diamond-shaped design struck with pellets in emulation of the more usual mother-of-pearl decoration. The fore-end and barrel bands with foliage in relief. Shaped hardwood butt covered with red cotton velvet embroidered with gold bullion thread. Horn butt section with silver buttcap embossed with foliage *ensuite* with fore-end. Octagonal facetted button trigger, stepped swollen steel ramrod.
Overall length 160 cm, barrel length 120 cm.

58/59 A good pair of Albanian or northern Greek miquelet flintlock holster pistols, *kubur*, entirely stocked in silver, *circa* 1800. The locks of Albanian pattern struck with the maker's stamp *amal nimach* (work of Nimach) in *nasta'liq* script. A steel cover plate

at the rear of the locks protects the user against trapping the web between thumb and index finger when using the guns. (A pad of leather is often used for this purpose on eastern Balkans, Turkish and Cossack guns – see pistol no. 70, for example.) These locks also have top jaw screws with baluster heads pierced for tightening with a bar and simply filed bridles. The stepped barrels of European form are deeply stamped with imitation proof marks. The stocks are of unusually pure silver and are cast and chiselled in relief with traditional scroll designs. At the fore-end these scrolls are chiselled as emanating from cornucopiae, a slightly unusual ornament for this type of pistol, suggesting Greek influence. Silver muzzle bands and trigger guards all *ensuite*.
Overall length 48 cm, barrel length 33 cm.

60 A slender Albanian miquelet flintlock gun, *circa* 1820. Italian-style part octagonal barrel struck with imitation maker's name, block rearsight, a little chiselled foliage at step and swollen muzzle. Steel fullstock, lock of traditional form struck with maker's mark. Stock inlaid with ebony discs with brass piqué work. Applied brass corners to butt, themselves inlaid with rectangular mother-of-pearl plaques. Mother-of-pearl inlaid fish-tail butt with eight large raised silver domed rivet heads. Stock deeply engraved overall with foliate decoration. Six brass barrel bands, steel ramrod.
Overall length 175 cm, barrel length 140 cm.

61 A well-made Albanian steel-mounted miquelet flintlock gun, dated 1852. Finely forged damascus twist Persian barrel, deeply struck with maker's cartouche *ustad Isma'il* (Master Isma'il) surrounded by silver inlaid

device. Thick silver inlaid breech, barrel tang and swollen muzzle with rows of beading, flower heads and foliage. Slightly raised rib, the twist pattern etched for effect. Hardwood fullstock, slender butt with swollen buttcap, the upper band at heel silver inlaid *ensuite* with barrel. Steel stock plates well applied and inlaid, boldly chiselled overall with repeated floral and foliate decoration. Dated in front of trigger guard 1852, with Arabic number 84. Three foliate engraved brass barrel bands, steel ramrod. Traditional lock with engraved decoration, including stylised bird on mainspring.
Overall length 155 cm, barrel length 122 cm.

62 A slender Albanian miquelet flintlock gun, *circa* 1800. Part octagonal barrel chiselled in low relief with foliage and ribs, swollen at muzzle. Foliate engraved lock of traditional form, mainspring engraved with stylised bird, the plate struck with maker's mark (worn). Foliate engraved steel stock, with applied green and blue glass beads. Slender fish-tail butt with applied mother-of-pearl inlay, and eight large applied ornamental flower-head shaped rivets. Three engraved brass barrel bands, steel ramrod.
Overall length 163 cm, barrel length 128 cm.

63 An Albanian miquelet flintlock gun, *circa* 1820. Octagonal barrel with swollen muzzle of Italian form. Stock covered with engraved steel and brass plates, slender fish-tail butt. Lock of traditional form struck with maker's poinçon. Engraved brass barrel bands, original trigger guard replaced by an English example.
Overall length 158 cm, barrel length 127 cm.

64 A fine mother-of-pearl inlaid western Balkan miquelet flintlock *dzeferdar*, used particularly in Herzegovina and Montenegro. Early nineteenth century, with late seventeenth-century silver inlaid barrel. Stepped barrel with transverse strengthening rings, inlaid for its entire length with arabesques, flower heads, stylised foliage and dots. The barrel forged of damascus twist pattern. Brass mounted stock covered with shaped mother-of-pearl inlay, secured by brass pins in geometric designs. Silver barrel bands and butt band embossed and chased with flowers and foliate arabesques. Engraved brass fore-end, brass ramrod tube with steel ramrod. Steel trigger guard, foliate engraved brass sideplate. The lock of traditional form, struck with maker's cartouche, and engraved with foliage, stylised bird under mainspring, addorsed stylised birds on frizzen. The lock is similar to nos 60, 61, 62 and 63.
Overall length 154 cm, barrel length 119 cm.

65 A very fine Balkan miquelet flintlock blunderbuss, nineteenth century. Half-octagonal flared barrel profusely silver damascened with foliate arabesques. Striped walnut fullstock, the swollen butt profusely decorated with shaped mother-of-pearl pieces, embellished with brass piqué work and geometric brass and ebony shaped stud work. Horn buttcap, silver damascened button trigger. Large silver barrel bands nielloed with arabesques against an engraved ground. Lock of traditional form, inlaid with bands of silver pellets, brass finial to jaw screw and bridle: bridle covered with engraved silver sheet, struck with maker's mark. Butts of this profile are usually to be found on the western Balkans long gun

known as a *rasak*.
Overall length 94 cm, barrel length 56 cm.

66 A Turkish or Balkan miquelet flintlock gun, nineteenth century, with seventeenth-century barrel. Twist forged Persian barrel inlaid with brass and silver arabesques and engraved *mursil i din Shah Khan sahib nazish zaman* (Shah Khan the ambassador of Islam the righteous and the eminent of his times), in praise of the patron for whom it was made, and *amal Baba 'a...* (work of Baba Ali?). Striped walnut fullstock, the butt profusely inlaid with shaped mother-of-pearl pieces, embellished with brass piqué work and geometrically shaped stud work. Horn fore-cap. Silver damascened button trigger and lock of traditional form with silver arabesques ensuite with barrel tang. Three pierced silver barrel bands, horn fore-cap inlaid with brass stud work, steel ramrod. Compare pearl inlay on butt with blunderbuss No. 65.
Overall length 152 cm, barrel length 117 cm.

67 A rare Balkan (Albanian or northern Greek) miquelet flintlock *rasak* or rifle, *circa* 1800. Stock covered with very finely nielloed sheet silver. Plain, octagonal, seven groove rifled Turkish barrel, swollen at muzzle and breech, and stamped behind block rearsight with maker's cartouche, *imtihan* (tested) and engraved with a prayer in Arabic: *subhanahu yastaskhir bika ma'sha 'Allah 1297.* (Praise be to God, may He grant you victory, as He wills, AD 1874). Lock with large plate struck with maker's cartouche *Wazous.* Border of lock and bridle struck with circular decoration. Fish-tail butt, sheet silver sides, nielloed with foliage, bands of geometric, floral ornament and net and dot

design. Sheet silver stock plates also finely nielloed with birds, flowering foliage, urns and vases. Sideplate nielloed with trophy of arms, small silver plate in front of lock engraved with military trophy. Silver trigger guard and barrel bands engraved and nielloed *ensuite.* The lock elements relate closely to nos 60, 61, 62, 63 and 73.
Overall length 144 cm, barrel length 109 cm.

68 A Caucasian miquelet flintlock ball butt holster pistol, with nielloed silver mounts. Fullstock covered with bright green stained leather (commonly found on the sheaths of Caucasian daggers – *kindjals, khanjars* and *qamas*). Lock of traditional form struck with maker's mark upon the bridle *amal 'Imad* (work of 'Imad) – twin *naskhi* script. Nielloed silver mounts, broad barrel tang plate signed *amal Husayn.* Barrel bands, extensive trigger plate, fore-end cap, grip sides and band above ball butt all nielloed *ensuite* with foliate arabesques. Barrel inscribed LAZARINO, chiselled with foliage and inlaid with a brass poinçon of a horse. One-piece walrus ivory ball butt with lanyard ring, silver button trigger.
Overall length 44 cm, barrel length 30 cm.

69 A fine slender Caucasian miquelet flintlock ball-butted holster pistol, *circa* 1800. The barrel of remarkably fine damascus twist pattern gold inlaid at octagonal breech. Gold inlaid shaped and chiselled devices to breech with raised ribs, swollen gold inlaid muzzle. Breech struck with gold maker's mark. Leather covered fullstock, large sheet silver mounts and broad gripstrap to barrel tang. One piece walrus ivory ball butt. Gold damascened lock struck on the bridle with maker's mark *Muhammad Khan.*

Overall length 46 cm, barrel length 32 cm.

70 A Caucasian fully silver-mounted ball-butted miquelet flintlock belt pistol, *circa* 1780. Lock of traditional form with maker's stamp and inlaid device both removed (see rifle no. 73 for identical mark). Black leather-covered fullstock. Barrel chiselled with top rib terminating in pointed ornament (stylised cypress tree). Breech stamped with imitation European marks. Silver mounts include three barrel bands almost the full length of the barrel, hemispherical ball butt cover, silver lanyard loop, sideplate, button trigger, elaborate trigger plate and tapered cylindrical mount above ball butt. All silver surfaces are decorated with niello, fore-end tip is chiselled with a little foliage with filigree borders. Barrel bands are nielloed with stylised cypress trees and chequered circular devices (precisely as on no. 73). Buttcap divided into quarters with foliate chiselled border and nielloed arabesques. One-piece walrus ivory ball butt. A leather pad covered with bullion embroidery protects the user's hand from the rear of the lock.
Overall length 42 cm, barrel length 30 cm.

71 An unusual Caucasian percussion miquelet lock ball butted holster pistol with extensive hall marked silver fittings, dated 1850 and profusely gold damascened. Lock and barrel finely damascened with gold arabesques and scroll work covering all surfaces of the hammer, lock bolster and exposed surfaces of the barrel. The lock bridle struck in gold with maker's cartouche. Leather covered fullstock, silver furniture comprehensively hall marked as follows: 84 standard mark, town mark of a horseman

(St George?) within a shield above date 1850 (for Vilno?) and initials 'E.B.' above date 18... Barrel bands nielloed with chequered circles (compare with no. 68) and with arabesque foliage *ensuite* with extensive stock mounts. One-piece walrus ivory ball butt with steel lanyard ring. This pistol was made as percussion, but the apparent awkwardness of the lock shows the maker's strong grounding in the flintlock tradition. Probably made for a Russian Officer.
Overall length 46 cm, barrel length 32 cm.

72 A fine Daghestan miquelet flintlock rifle, *circa* 1800. Striped maple fullstock with solid walrus ivory butt and horn spacer. Plain lock with inlaid maker's brass cartouche stamped *amal Ghaffar* (work of Ghaffar). Barrel with brass inlaid maker's cartouche, the breech and muzzle inlaid with fine quality gold arabesques. Large button trigger, barrel bands and ramrod tip of steel, with wooden ramrod.
Overall length 125 cm, barrel length 94 cm.

73 A miquelet flintlock silver-mounted rifle from Daghestan, early nineteenth century. Fullstocked in striped Circassian walnut, decorated with applied nielloed silver bands engraved with foliage. Part polygonal barrel with eight-groove rifling. Lock of traditional form inlaid with brass device, maker's cartouche removed from lock bridle. Silver barrel bands and fore-end cap nielloed with large chequered circles and foliate devices. Button trigger, one piece walrus ivory buttcap, with nielloed silver band. Wooden ramrod with swollen steel tip. Compare this rifle with pistol no. 70.
Overall length 115 cm, barrel length 85 cm.

74 A fine nielloed silver mounted Caucasian miquelet flintlock holster pistol, *circa* 1800. The fullstock of beautifully grained mountain maple in two parts, the splice carefully concealed beneath a barrel band. Plain undecorated lock, struck with maker's cartouche *Muhammad Khan*, removable ribbed frizzen face, ring top jaw. Barrel very finely forged with whirled damascus pattern incorporating bold, broad bands. Chiselled shaped aprons with broad top rib for sighting. Trigger plate, barrel tangs and stepped sideplate of steel faced with nielloed silver *ensuite* with furniture. Swollen buttcap, three barrel bands (two solid, one with open ribs), fore-end cap and lock surround all of sheet silver engraved and nielloed with flower heads and entwined foliage in typical traditional designs. Pear-shaped butt. Compare with no. 75.
Overall length 47 cm, barrel length 31 cm.

75 A good Caucasian miquelet flintlock holster pistol, with silver inlaid decoration, *circa* 1760. Fullstock in two parts of naturally striped mountain maple with a fine iridescent grain. Plain barrel of good form with chiselled shaped aprons and raised broad sighting rib. The lock, trigger, sideplate, long trigger plate and barrel tang all thickly inlaid with silver foliate arabesques and silver borders. The screw heads are silver inlaid, as is the facetted button for a lanyard ring on the buttcap. The mainspring is signed in *naskhi* script *fi aman Allah* 813 (?) (in the protection of God, meaning farewell in Arabic). Silver barrel bands, fore-end cap and small boss to buttcap all nielloed with flowers and foliage.
Overall length 51 cm, barrel length 35 cm.

76 A late seventeenth-century Persian gun barrel, forged from twist steel, originally etched for effect. Barrel of three stages, chiselled with three cartouches with traces of gold inlay remaining. Silver inlaid borders, circles, bands and designs. Polygonal section in front of breech; swollen muzzle. This barrel has been re-used, probably many times. The last included the addition of three staples to pin the barrel to the stock in the European manner and a flat barrel tang.
Overall length 106 cm.

77 A good mid-eighteenth-century Turkish rifle barrel of octagonal form, forged of a deeply etched tight damascus twist, with deep seven-groove rifling. Swollen breech and muzzle inlaid with gold foliate designs. Chiselled broad top rib, standing rearsight with single peephole.
Overall length 68 cm.

78 An early nineteenth-century north-west Persian miquelet flintlock blunderbuss pistol. Fullstocked in Circassian walnut. Barrel chiselled with raised shaped aprons, swollen exaggerated funnel-shaped muzzle. Gold damascened lock signed beneath mainspring and on lockplate. Back of frizzen damascened with gold rectangle divided into six squares, a traditional motif found on many similar locks; the shape of the cock is of typical north Persian form. Stock inlaid with shaped bone plaques, embellished with brass stud work. Bone buttcap secured by pierced nickel bands; a further band of bone and ebony chevrons divide the butt. Inlaid mother-of-pearl crescent, large pierced barrel bands engraved and nielloed with foliage. Nickel sidebar retains nickel chain

with ring finial, originally for a lanyard, wirebound grip.

Overall length 40 cm, barrel length 22 cm.

79 A nineteenth-century Persian miquelet flintlock musketoon, Circassian walnut fullstock, the lock of Caucasian type, silver damascened with foliage overall, the bridle struck with maker's mark in silver: *burdah* (a captive, a slave) in *nasta'liq* script. Octagonal barrel chiselled with foliate scrolls, oval flared muzzle chiselled on top with a cartouche containing a stylised lion within foliage. The stock profusely inlaid with tribal motifs in ivory, brass piqué work and ornamental brass and ebony designs. Horn buttcap and a band of horn and bone chevrons. Compare this gun with no. 78, which has similar stock decoration but a different form of Caucasian lock. For the lock, nos 72 and 73.

Overall length 82 cm, barrel length 60 cm.

80 A Persian flintlock rifle, *circa* 1835, browned octagonal twist barrel. Fullstocked, exported lock stamped T. POTTS LONDON. Steel trigger guard with pineapple-shaped finial. Brass barrel bands with applied silver decoration. Steel ramrod and large steel sling swivels. Butt with band of shaped ivory decoration.

Thomas Potts was apprenticed to Martin Brander in 1792. He was a contractor to the East India Co. from 1827 to 1842, when he died. His wife Mary Ann continued the contract 1843-52. She died the following year.

Overall length 129.5 cm, barrel length 89 cm.

81 A flintlock musketoon, *circa* 1820. The musketoon has a tapering barrel of slender

dimensions. The hardwood fullstock is carved in low relief with flowers and foliage and inlaid around butt and breech with mother-of-pearl shapes, including an escutcheon supported by stylised birds. The mother-of-pearl inlay is centred with brass and ebony roundels. These geometric roundels are frequently employed on guns from Persia, Turkey and the Caucasus. One-piece ivory buttcap. Steel trigger with twin lanyard rings. Lock made for the East India Company and engraved with their crest of a lion rampant holding a crown. Later French cock. Polished steel barrel with chiselled raised shaped aprons, facetted and carved steel ramrod. The one-piece ivory buttcap suggests that this gun was originally made in the Caucasus and exported.

Overall length 74 cm, barrel length 40 cm.

82 A north Persian miquelet flintlock rifle, *circa* 1800. The fine, very long octagonal barrel, forged with a tight damascus twist pattern and deep seven-groove rifling. Deeply struck and inlaid with the maker's cartouche *amal Umar Haidar* (work of Umar Haidar) in *nasta'liq* script. The pierced plate rearsight is integral with the breech and, *ensuite* with the muzzle, is thickly inlaid with gold foliate designs incorporating bands and scrolls. Walnut fullstocked with faux grain stripes, inlaid with pierced bone escutcheons for the fluted lotus bud-shaped trigger and lock-retaining screws (trigger retains traces of applied gold decoration), with plates for leather sling. A bone inlaid spacer surrounds the lock and barrel tang. Four large silver barrel bands, chased and nielloed with flowers, secure the barrel to the stock and a nielloed silver band retains the separate wooden buttcap which imitates walrus ivory.

Lock strongly constructed with gold damascened decoration, large ring to jaw screw, removable ribbed frizzen face. Polished black horn tip to fore-end; steel ramrod with octagonal tip, swollen and stepped.

Overall length 150 cm, barrel length 116 cm.

83 A late eighteenth-century Persian miquelet flintlock rifle. Octagonal barrel with raised narrow top rib, struck with maker's mark *amal Hamid* (work of Hamid). Traces of gold inlaid foliage and a long Persian inscription in verse. Lock of plain traditional form, struck with maker's mark. Striped Circassian walnut fullstock, metal barrel bands, one piece walrus ivory buttcap secured by steel band with pierced finial. Stock with some inlaid mother-of-pearl, bone and horn plaques. Horn spacer with some brass stud decoration and applied silver ornaments.

Overall length 145 cm, barrel length 112 cm.

84 A percussion rifle from Bukhara, mid-nineteenth century. The octagonal barrel of tight damascus twist, probably late eighteenth century with deep seven-groove rifling. Inlaid at breech and muzzle with bands of thick gold flowers, the top flat, barrel tang and adapted rearsight decorated *ensuite* with numerous gold inlaid floral sprays. Lock and trigger guard of best English manufacture, engraved in Bukhara and inlaid with gold foliage. Three silver barrel bands pierced with interlaced foliage and enamelled in typically Bukharan translucent green and blue. Silver fore-cap embossed with flowers and foliage against a blue enamelled ground. Fullstocked in finely grained Circassian walnut extensively

decorated with inlaid cabochon polished turquoise stones, including 'flowers' with green and red glass centres and turquoise petals, bands, geometric designs and stylised foliate sprays. One-piece walrus ivory buttcap retained by silver band. Stock inlaid behind barrel tang and around butt with mother-of-pearl design and some brass stud work. Silver wire bound grip retained by silver rivet heads. Original steel ramrod, the head inlaid with gold crosses and bands. Red sling faced with fine bullion embroidery.
Overall length 115 cm, barrel length 75 cm.

85 A north-west Persian miquelet flintlock rifle dated AH 1220 (AD 1805). The lock is thickly inlaid with engraved gold foliage, signed and dated on the mainspring. The bridle terminates with a shaped piece of pink coral. Octagonal barrel with deep nine-groove rifling, two-hole rearsight. Breech and muzzle inlaid with gold flowers and foliage and chiselled in bas relief with shaped aprons. Striped walnut stock stained for effect, inlaid with shaped bone plaques and some brass and ebony geometric stud work. Wooden buttcap retained by pierced nickel band. Wire bound grip. Button trigger, horn fore-cap, steel ramrod. A plain steel sideplate now bridles the lock-retaining screws. The stock resembles nos 82 and 83, in details such as the bone border inlaid round the lock.
Overall length 102 cm, barrel length 64 cm.

86 A well-made eighteenth-century Indian heavy matchlock gun. Swollen breech and lotus muzzle finely chiselled in sharp relief with flowering foliate designs *ensuite* with hinged pan cover and foliate chiselled trigger. Lockplates with peacock's head

finials, chiselled with feathers, foliate bordered and decorated overall with punched diamond-shaped designs. Red wood fullstock, ebony block behind breech inlaid with ivory stringing. Inlaid ivory rosettes, bone buttcap. Steel ramrod with octagonal tip.
Overall length 156 cm, barrel length 108 cm.

87 A large eighteenth-century gold-damascened Indian matchlock gun, *torador*. Twist forged barrel thickly gold-damascened in positive silhouette at breech with standing figure and supplicant, together with floral sprays, with very finely engraved details. Gold-damascened foliate borders and large area at swollen muzzle with a regular diaper pattern. Barrel secured to the full-length stock by woven leather band. Steel lock sides with foliate engraved borders, finials pierced and engraved as peacocks' heads. Steel trigger chiselled in bas-relief with flowers and foliage. Compare lockplate with gun no. 86.
Overall length 170 cm, barrel length 120 cm.

88 A good eighteenth-century Indian silver-mounted gold-damascened matchlock gun, *torador*. This heavy large-bore gun must have been fired from a rest, probably at big game. Tapered octagonal ribbon twist barrel etched for effect. Thickly gold-damascened at breech and muzzle with large bands and cartouches of foliage, including pan, standing rear-sight and barrel tang, which is screwed to the stock in the European manner. Hardwood fullstock, large steel lockplates thickly silver-damascened with flowers and foliage, silver flower-shaped ornamental rivet heads. Stock behind breech covered with sheet silver. Silver foliate

trigger and very finely foliate pierced silver trigger plate. Thick silver sling swivels, fine silver wire barrel bindings. Finely pierced silver roundels applied to stock, steel ramrod. Compare with gun no. 97, which is also mounted with plain silver and has a barrel tang screwed to the stock.
Overall length 145 cm, barrel length 95 cm.

89 A magnificent Indian matchlock gun, *torador*, probably mid-eighteenth century. Barrel of finest damascus twist pattern and of malacca form, the rib being uppermost, extensively gold-damascened at breech and muzzle with cartouches containing foliage, including full-length bands of foliage and central device. Damascened pan with pierced and shaped brass swivel cover. Steel lockplates of etched *wootz*, gold-damascened, the foremost slender portions damascened with silver. Hardwood fullstock comprehensively decorated with brass inlaid scrolls and foliage, with ivory flower heads and foliate borders. Fluted area behind breech and at top of butt applied with shaped sheets of ivory inlaid with brass. Underside of stock applied with finely pierced brass and ivory plaques, upon a red-painted mica ground. Pierced brass barrel bands, fore-cap, sling swivels and stepped swollen brass buttcap. Brass trigger finely pierced with scrolls. Octagonal shaped steel ramrod tip gold-damascened *ensuite* with barrel.
Overall length 162 cm, barrel length 110 cm.

90 A very unusual silver-mounted Indian matchlock gun, *torador*, probably seventeenth or early eighteenth century. The stock was originally covered with red silk velvet and applied with over a hundred silver foliate

devices all struck from the same mould. The pile has now worn from the velvet and the colour faded, but the original impression must have been one of great richness and almost dazzling brilliance. The gun has several subsequent alterations, a large engraved silver trigger plate having been added in the nineteenth century and the wooden block behind the breech even later. The unusual barrel is chiselled in high relief at the breech with a bouquet of flowers, at the swollen muzzle with stylised lotus foliage and overall with a repeated design of cartouches, with clouds between them. It is possible that the barrel may be earlier than its current mounting.

Overall length 168 cm, barrel length 118 cm.
Formerly in the Jaipur arsenal

91 A rare Indian combination all-steel lance and boxlock flintlock gun, *circa* 1800. The barrel, which unscrews for loading, has four raised ribs and the muzzle is plugged with a small, removable spear head. Simple boxlock mechanism with separate trigger.

Overall length 158 cm, barrel length 99 cm.

92 A rare Indian combination sword and flintlock gun, *circa* 1800, broad straight double-edged blade. Short wooden stock section, barrel with three swollen steel collars and steel ramrod.

Overall length 152 cm, barrel length 75 cm, blade length 56 cm.

93 An unusual Indian walking stick with concealed percussion pistol or gun, *circa* 1835. Steel barrel which unscrews for loading, having removable screw-in tip. The barrel is in two sections, the shorter one (14.5 cm) serves as a pistol barrel. Brass

frame with boxlock action, foliate engraved. Folding concealed trigger, hammer with folding cocking spur, hinged brass pommel for spare percussion caps. Two-piece steel grips and barrel silver damascened overall with spiral foliage and flower heads.

Overall length 74 cm, barrel tang 64 cm.

94 A fine Indo-European flintlock gun, *circa* 1820, of *torador* form; the barrel and steel side plates displaying every possible pattern weld design in what is presumably an exhibition piece. Platinum vent. Two-colour gold inlay at the breech, muzzle and round the lock plate all *ensuite* and contemporary. Good quality lock of English form signed *Seetaram and Sons*, secured by a single screw. Indian vent pricker secured to the stock with a chain. Fullstock of partridge wood with tortoiseshell strip under the butt. Steel ramrod with spiral fluting. Silver butt cap and scrolling trigger guard with pineapple finial.

Similar trigger guards can be seen on Manton guns from 1790. The design was copied, for example, on a Belgian early nineteenth-century blunderbuss made for the Honourable East India Company, sold by Sotheby's at Hever Castle, 5 May 1983, Lot 188.

Overall length 154 cm, barrel length 105 cm.

95 An unusual Indian flintlock rifle with Turkish barrel and English lock, *circa* 1820. Curly damascus twist barrel with slender chiselled raised rib, gold inlaid at breech and muzzle with vase and foliage. Hardwood fullstock extensively silver mounted, 15 silver barrel bands, engraved with flowers and foliage. Stock sides inlaid with silver tiger and antelope; silver trigger guard with

foliate finial. Square section butt profusely inlaid with engraved silver bands and shapes. Chequered grip, silver sling swivel, steel ramrod. Plain lock of good quality with roller bearing frizzen spring.

Overall length 145 cm, barrel length 104 cm.

96 A very fine quality silver-mounted, gold-inlaid Indian flintlock gun, *circa* 1825. Indian barrel gold-inlaid at breech and swollen muzzle with well-executed flowers, foliage, lotus foliage and a sun-in-splendour. Steel ramrod tip gold inlaid *ensuite*. Red wood fullstock, English best quality lock by H.W. MORTIMER & CO., gold-lined pan, adjustable set trigger, sliding safety bolt locks frizzen to pan. Detented action to lock, roller-bearing frizzen spring. Foliate engraved steel barrel tang cut with sighting channel. Four large and highly ornamental silver barrel bands engraved with foliage, each with five open ribs across barrel. Foliate engraved silver band around buttcap. Small chequered grip.

Overall length 145 cm, barrel length 104 cm.
Formerly in the Jaipur Arsenal; subsequently Sir Frank Bowden, Thame Park, Oxfordshire

97 A good late eighteenth-century Indian silver-mounted matchlock *torador*. The barrel of pattern welded damascus, forged in broad waves along the length of the barrel, with raised sighting rib. Both breech and muzzle have raised shaped aprons over which thick sheet gold has been applied and on which a flowering shrub design has been cut out in negative silhouette. This is particularly effective now that the iron ground has acquired an almost black patina. Barrel tang and rear-sight gold decorated *ensuite* with traces of gold to pan. Thick sheet silver lockplates, breech and barrel bands with

silver sling swivels; stepped rounded silver buttcap. Serpent and original vent pricker both with traces of gold foil decoration; the pricker retained by a silver chain, the serpent enclosed within a shaped silver plate. Pierced foliate shaped brass trigger. Hardwood fullstock with fluted block behind breech.
Overall length 178 cm, barrel length 126 cm.

98 An eighteenth-century Indian silver-mounted matchlock rifle. Dark hardwood fullstock with large sheet silver lock sides secured by ornamental silver rivet heads. Solid fluted ivory block behind breech, silver band surrounds rear-sight and holds barrel to stock. Damascus twist forged barrel with raised sighting rib, the rifling of eight grooves. The maker's soft metal mark now missing from its site at breech. Silver sling swivels. The stock inlaid with geometric ivory and bone shapes, themselves decorated with incised circular devices, layered ivory buttcap. Simple steel trigger and serpent, swivel pan cover.
Overall length 162 cm, barrel length 116 cm.

99 A fine and rare two shot, small-bore, superimposed loading matchlock gun, *torador, circa* 1760, probably for shooting at birds or small game. Extraordinary barrel forged from bands of curly damascus and straight ribbons in a continual, boldly meandering pattern, perhaps intended to imitate a river, deeply etched for effect. Breech and muzzle very thickly gold-damascened with bands of flowers and foliate ornament, including inscription *9288 Ranakh 4523* (Gurumukhi?). The gold is damascened in relief and is subsequently punched and engraved on the surface.

Muzzle deeply chiselled as a lotus bud. Breech with two gold-damascened pans including a bridle for the foremost serpent. Red wood fullstock, steel lockplates, with traces of etched *wootz* pattern. Some inlaid stock plates with pierced foliage. Pierced foliate trigger and serpents thickly gold-damascened *ensuite* with barrel. Roped steel sling swivels. Steel ramrod with gold-damascened tip. Compare with gun no. 100.
Overall length 152 cm, barrel length 99 cm.

100 A rare and very well-made two shot, superimposed loading Indian matchlock gun, *torador, circa* 1800, the barrel of the finest damascus twist pattern, having two touch-holes and two pans at breech for separate charges. Fluted and chiselled muzzle of good form; simple open sights. The fine quality of chiselling to the muzzle and breech band is echoed in the fluting of pan sides and of the bridle for the foremost serpent; note how the lock side is embossed at this point to accommodate the serpent. Hardwood fullstock with chiselled and engraved steel furniture. The steel lock sides are etched in imitation of a *wootz* pattern and are secured by simple silver rivet heads. The trigger, serpent heads and pan sides are all pierced. Steel stock plates have pierced and shaped borders, the butt plates with pierced foliate ornament. Buttcap of layered ivory and ebony. Ramrod tip and sling swivels with incised roped decoration. The efficiency of this system relies upon meticulous loading: first to ensure that the two charges line up with their vents; and second, to ensure that the second charge is not ignited during the discharge of the first.
Overall length 152cm, barrel length 99cm.
Formerly in the Jaipur Arsenal

101 An Indian gold-damascened matchlock gun, *torador, circa* 1800. Massive swollen breech and boldly flared lotus-shaped muzzle, both profusely gold-damascened with flowers and foliage, *ensuite* with ramrod tip, muzzle face, open rearsight, pan and trigger. Steel locksides with ornamental engraved dome-shaped silver rivet heads. Sheet silver fore-end cover plate embossed with foliage and scale pattern with pellet borders. Ebony block behind barrel tang with sighting flute, horn buttcap. Stock varnished, rear of lock with arsenal inscription.
Overall length 168 cm, barrel length 118 cm.

102 A slender and elegant small-bore Indian matchlock gun, probably used for hunting birds and small game, early nineteenth century. Tapered octagonal twist barrel of simple form, with hinged pan cover. Hardwood fullstock with plain brass fittings. The very thin butt terminates with layered bone buttplates, supported by brass mounts punch-decorated with a scale design.
Overall length 165 cm, barrel length 116 cm.

103 An unusual Indian matchlock gun, *torador*, late eighteenth century. Slender barrel chiselled with a raised sighting rib which emanates from the Hindu *trisula*; open sights, fluted and slightly swollen muzzle. Chiselled bands of foliage at breech and muzzle retain traces of gold inlay. Black lacquered fullstock, steel locksides etched in imitation of *wootz* patterns. Pierced foliate engraved trigger. The butt and block behind breech inlaid with ivory flowers, foliage, bands and two charming stylised geese. Ivory buttcap. Steel ramrod with chequered tip and sling swivels. It is interesting to note that the

lock side has never been fitted with a match holder, as the match end is secured by a hole drilled behind the wooden breech area.

Overall length 132 cm, barrel length 87 cm.
Formerly in the Jaipur Arsenal

104 An unusual late eighteenth-century Indian matchlock carbine. Barrel chiselled overall with flowering foliage and palmettes supported by two addorsed lions beneath a peacock, with Indian inscription. Swollen chiselled breech and lotus muzzle, swivel pan cover. Foliate engraved steel lock sides with pierced finials. Steel sling swivels, area behind barrel covered with reeded ivory plates. Steel-mounted black hardwood buttcap with ivory stringing.

Overall length 107 cm, barrel length 65 cm.

105 A fine late eighteenth-century Indian matchlock gun, *torador*. Very unusual barrel of tight curly damascus pattern, forged in bands almost parallel with the bore (as opposed to the normal method of being coiled around it), deeply etched for effect. Breech and muzzle inlaid with raised silver bands, with thick foliate silver damascened ornament. Hardwood fullstock, unusual slender brass lock sides with pierced finials filled with orange paint. Fluted ivory-covered area behind breech. Stock inlaid with some shaped ivory pieces, geo-metrically pierced and infilled with orange and black paint. Some small silver rivet heads and applied silver ornaments. Sides of stock applied with two geometric pierced brass discs. Rear of breech area pierced with brass rosette to hold match end, steel serpent and pierced foliate-shaped trigger, steel ramrod with shaped tip, horn buttcap.

Overall length 180 cm, barrel length 132 cm.

106 An Indian matchlock rifle, *circa* 1780. Finely forged eight-groove rifled barrel, with chevron pattern at breech and curly damascus twist for rest of barrel, deeply etched for effect, with raised sighting rib. Muzzle formed as a stylised monster's head, pierced eyes and nose, the open mouth with engraved teeth, chevron-filled behind. The muzzle thickly covered with sheet silver, *ensuite* with shaped aprons and bands behind muzzle and at breech all finely decorated with flowers and foliage in a pricked technique. Pierced trigger, serpent, buttcap, breech and barrel bands, barrel tang, sight and pan all silver-covered and decorated *ensuite* with barrel.

Overall length 158 cm, barrel length 107 cm.

107 An important silver-mounted, gold-inlaid Indian flintlock sporting gun dated AH 1214 (AD 1800) from Hyderabad, closely copied from an English example of *circa* 1780. Walnut fullstock, stepped lockplate gold inlaid *sakht sarkar i asafiya karigar Chintamani 1214 ah* (make: Nizam's Government workman: Chintamani) in Persian *nasta'liq* script. The Nizam's government in Hyderabad was called *i asafiya*. The same text is inscribed twice in two different styles, one of which is quite elegant. And on the tail is the same inscription as on the lockplate. Sliding safety bolt at rear of lockplate locks the cock. Part octagonal barrel very finely gold inlaid at breech and muzzle with flowers and foliage. Barrel tang gold-inlaid *ensuite* and engraved. Gold-lined vent. Full silver furniture, foliate and border engraved with unusual swollen finials. Steel ramrod and sling swivels, engraved oval silver escutcheon. Stock finely carved with shell

apron behind barrel tang, butt carved with stepped nose and decorative aprons.

Overall length 146 cm, barrel length 107 cm.
Formerly in the Jaipur Arsenal

108 An Indian matchlock gun, *torador*, *circa* 1800. Hardwood fullstock of distinctive grain inlaid with finely-cut geometric brass shapes and brass stringing. The foliate design of these shapes is echoed in the silver-damascened ornament on the barrel at breech and muzzle. Steel lock sides with traces of silver-damascened ornaments, the plates with foliate finials similar in design to the brass inlay and retained by brass rivet heads of floral design, including one on the swivel pan cover placed beneath the tiny lotus bud finial. Beneath the pan a snake-like finial remains from the match holder. Behind the barrel tang an ebony block is inlaid with brass shapes, circles and stringing, *ensuite* with the stock. Steel barrel bands, sling swivels, pierced trigger and serpent, unusual steel buttcap of oval form with swollen brim. The barrel is twist forged with fixed sights, the breech secured by a silver damascened band fitting over the rear-sight.

Overall length 177 cm, barrel length 127 cm.
Formerly in the collection of Sir Frank Bowden, Thame Park, Oxfordshire

109 An Indian matchlock gun, *torador*, *circa* 1800, of slender form, octagonal barrel thickly silver-damascened at breech and muzzle with flowers and foliage. Hardwood fullstock with brass lock sides, barrel bands and shaped brass reinforcing corners to butt. Steel ramrod, sling swivels, match holder and pierced trigger.

Overall length 170 cm, barrel length 119 cm.

110 A charming Indian matchlock gun, *torador*, built for a boy, early nineteenth century. Slender hardwood fullstock, the butt inlaid with ivory flower heads, foliage and stringing, bone buttcap. Large one-piece fluted ivory block behind breech, pierced for serpent. Brass lockplates with foliate borders secured by brass rivets of flower-head form. Pierced brass trigger, brass match holder, three barrel bands. Barrel of traditional form, swollen lotus-shaped muzzle, swollen facetted all steel ramrod tip. Hinged brass pan cover.
Overall length 80 cm, barrel length 44 cm.

111 A fine late eighteenth-century barrel from an Indian matchlock gun, *torador*. Twist forged with slender chiselled top rib. Barrel of five stages, with swollen breech and muzzle, fluted ribs to both breech and muzzle sections entirely covered with very thick gold and silver damascened designs of flowers, palmettes and foliage, including raised silver bands.
Overall length 123 cm.

112 A late eighteenth-century Indian matchlock barrel. Of polygonal section, forged twist steel design. Swollen polygonal breech and lotus-shaped muzzle, both gold-damascened with regular floral design.
Overall length 124 cm.
Formerly in the Jaipur Arsenal

113 A good quality mid-eighteenth-century barrel from an Indian matchlock gun, *torador*. Forged in a bold twisted design, once deeply etched for effect. Of octagonal section with swollen breech and muzzle, thickly gold-damascened with regular floral and foliate designs, including inlaid bands of

woven wire and raised ribs.
Overall length 122 cm.
Formerly in the Jaipur Arsenal

114 A very fine flintlock musketoon from Sind dated AH 1213 (AD 1799). Tapered octagonal breech chiselled in bas-relief with a large palmette repeated design struck within applied gold cartouche *Ya Ali* (Oh Ali). The muzzle, barrel tang, rearsight and borders of octagonal breech section all gold inlaid with flowers and foliage in negative silhouette against a dark iron ground. Shaped aprons chiselled with gold inlaid flowers. Rosewood fullstock of Sind form. Lock of English form, gold-inlaid on the tail in negative silhouette with invocation *Ya Allah. Ya Muhammad. Ya Ali*, deeply struck with gold maker's mark *amal Faiz Ali 1213* (work of Faiz Ali) – there is another word that could possibly be read as *idarniya*. Much thickened frizzen with sunken faces, roller-bearing frizzen spring; pan bridle to frizzen carved and pierced as two ducks' heads with gold-inlaid eyes. The trigger guard, trigger plate and trigger all of steel, thickly gold-inlaid with palmettes against a silver ground *ensuite* with serpent-headed side plate which has gold stripes and gold teeth. Twin silver pricker holders on an elaborately pierced background. Silver barrel band, fore-end cap, barrel tang surround and pierced silver shapes to stock, all chiselled with regular foliate designs in silhouette, the ground filled with black lacquer.
Overall length 84 cm, barrel length 41 cm.

115 A very fine gold-inlaid flintlock rifle from Sind, *circa* 1820. The magnificent eight-groove rifled barrel forged from alternate bands of tight damascus curly twist

and bands of ribbon twist. The ribbon twist bands themselves have a further central band of simple twisting. The decorative effect is enhanced by etching. Signed at the breech within a thickly gold damascened cartouche *nasrun minallahi wa fathun qarib* (Victory is from God and triumph is near): *Qur'an*, Battle Array, 61:13. Breech of malacca form; raised top rib. Breech and swollen muzzle with thick gold-inlaid decoration with some engraved details. Gold-inlaid steel ramrod tip. Silver-mounted Afghan hardwood stock of typical form. Thick silver barrel bands, shaped butt corners, applied circular silver discs and silver butt band. Thick shaped silver cap behind barrel. Steel trigger guard applied with thick sheet gold. Steel vent pricker retained by silver chain to its shaped, two compartment holder below lock. Stepped English lock signed *Theops Richards*, with roller-bearing frizzen spring.
Overall length 147 cm, barrel length 104 cm.

116 A fine early nineteenth-century silver decorated matchlock gun from Sind, the barrel entirely covered with silver decoration, with gold damascened cartouche and muzzle. Stock of typical Afghan form. The trigger, match holder and ramrod tip all decorated with silver *ensuite*. Foliate chased silver mounts against a ring-punched ground.
Overall length 161 cm, barrel length 123 cm.

THE FOLLOWING FIVE GUNS WERE FROM THE COLLECTION OF ARMS FORMED BY JAMES ANDREW RAMSAY, MARQUESS OF DALHOUSIE (1812-60) DURING HIS TERM AS GOVERNOR-GENERAL OF INDIA, 1848-56. THEY WERE HOUSED AT COLSTOUN, HADDINGTON, EAST LOTHIAN, UNTIL THEIR SALE IN 1990.

117 An interesting gold-mounted matchlock gun from Sind, fine etched damascus twist barrel. Thickly gold-damascened at breech and muzzle with shaped bands, maker's gold poinçon *Sarkar Mir Muhammad Hasan Khan Talpur* (Government of Mir Muhammad Hasan Khan Talpur) and gold inlaid inscriptions *Ya Ali* (Oh Ali) *amal Muhammad Salih haddad* (work of Muhammad Salih the blacksmith). Gold breech band, sling swivel, buckle and stock band. Silver corners to butt, three silver barrel bands, leather sling. Butt wound with long length of original match cord and green silk band.
Overall length 145 cm, barrel length 107 cm.

118 A remarkably fine gold-mounted and gold-damascened Indian matchlock gun, *circa* 1800, swollen barrel finely fluted for its full length, thickly gold-damascened at breech and muzzle with flowering foliage incorporating *botehs*. Chased gold buttcap, stock ornaments, breech band, sling swivel and match holder surround. Large lock sides gold-damascened *ensuite* with barrel. Trigger, serpent, vent pricker and ramrod tip covered with gold foil damascene. Sling of brocaded green velvet and gold bullion.
Overall length 172 cm, barrel length 123 cm.

119 A very fine Indian silver-mounted matchlock gun, *circa* 1800, with alternate bands of stub twist and curly damascus twist forged barrel thickly gold-damascened at breech and muzzle with flowering shrubs. Zoomorphic muzzle nicely formed and inlaid with ruby eyes and emerald ears. Gold-damascened trigger, ramrod tip, pan and cover, barrel tang with gold-damascened inscription *Devanagari*(?). Plain silver mounts and sling swivels, full stocked.
Overall length 164.5 cm, barrel length 117 cm.

120 A very fine Indian silver-mounted matchlock gun, *circa* 1800. Curly damascus twist barrel with chiselled animal's head muzzle thickly gold-damascened at breech and muzzle with flowering shrubs and geometric ornament. Zoomorphic muzzle preceded by a chiselled band of spiral twisting form. Gold-damascened pan, cover and ramrod tip, barrel tang with gold-damascened inscription *Devanagari*(?). Plain silver mounts and fullstock, foliate pierced steel trigger and chained vent pricker.
Overall length 173 cm, barrel length 123 cm.

121 A fine Indian silver mounted matchlock gun made for a boy, *circa* 1800. Tapered octagonal barrel finely gold damascened at breech and muzzle with tightly flowering shrubs, barrel tang with gold maker's stamp *amal Hayat Khurd* (work of Hayat Khurd) – Khurd also means Junior. Gold damascened serpent, pan and cover vent pricker and ramrod tip. Plain silver mounts, sling swivels and pricker chain. Pierced brass trigger. Compare with no. 110.
Overall length 113 cm, barrel length 71 cm.

122 An Indian gold-damascened, combination flintlock and matchlock gun, *circa* 1820. Barrel of traditional form, swollen breech and muzzle entirely covered with a repeated pattern of flower heads within a floral network, with foliate borders. The English lock now entirely covered with gold damascened and with silver chain secured to fitting on stock. The trigger, serpentine and trigger guard all gold-damascened *ensuite*, including tip of steel ramrod. Hardwood fullstock of traditional form, including fluted section behind barrel tang. Compare with gun no. 101.
Overall length 158 cm, barrel length 112 cm.

123 A fine Indian matchlock gun, *torador*, *circa* 1800. Massive barrel with swollen breech and lotus-shaped muzzle decorated with bands of silver-damascened foliage, fixed pan and open rearsight. Painted green stock, the butt showing a procession of wild animals including tigers and antelope; together with a series of colourful birds including storks, herons and ducks, separated by floral and foliate reserves upon a gold ground. The fore-end is painted by the same hand, with the same palate including flowers upon gold ground with gold arabesques. Steel lockplates with silver damascened borders. Steel trigger in the form of a stylised tiger, swollen octagonal steel ramrod tip, fluted ivory block behind breech, with incised red-filled lines, bone buttcap.
Overall length 173 cm, barrel length 127 cm.

124 An eighteenth-century Coorg matchlock gun from Malabar, extensively silver-mounted. Fore-end entirely sheathed in silver bands, with two larger bands chiselled with geometric and floral roundels and geometric borders, an engraved reinforcing silver plate where the ramrod

enters the stock is in the form of a peacock's fantail. Slightly tapered octagonal barrel with swollen muzzle, raised rear-sight with single peephole sight, swivel pan cover. Sheet silver lockplates, solid silver trigger and serpentine struck with circular decoration. Butt of traditional shape, with applied silver decoration. Steel lanyard ring, wooden ramrod with large silver tip.

Overall length 154 cm, barrel length 118 cm.

Formerly in the Jaipur arsenal

125 An Indo-Arab matchlock gun, probably eighteenth-century, part octagonal barrel, possibly Turkish, in three stages with swollen muzzle and single fixed peephole rear-sight. Fullstocked, silver barrel bands, lock sides and ornaments; the muzzle sheath with engraved inscription. Swollen wooden butt cap inlaid with geometric ivory shapes. Silver-tipped wooden ramrod.

Overall length 145 cm, barrel length 109 cm.

126 An Indo-Arab matchlock gun, probably eighteenth-century, octagonal barrel possibly Turkish, inlaid at breech and muzzle with silver scrolls and knot design. Later applied silver decoration chased with foliage, maker's poinçon *amal Majid* (work of Majid). Stock decorated with applied silver shapes, brass lock sides, swollen wooden butt cap inlaid with ivory shapes, steel ramrod.

Overall length 151 cm, barrel length 118 cm.

127 A South Indian flintlock holster pistol, *circa* 1840, swollen heavy octagonal barrel silver-damascened with scrolls and foliage. Fullstock covered overall with zinc nail-head decoration, brass mounts struck with simple circular designs. A little foliate engraving to lock.

Overall length 43 cm, barrel length 27.5 cm.

128 Singalese pistol barrel, probably eighteenth century. The barrel is decorated with silver inlay, and has been shortened, probably when the barrel was converted from flintlock to percussion in the nineteenth century.

Length 18 cm.

129 A remarkable gold-mounted Malayan matchlock gun, *circa* 1700, part octagonal, part fluted barrel very finely gold damascened at breech, muzzle and step with tight geometric floral foliate and scroll decoration. Ebonised fullstock, gilt brass lock and trigger guard deeply chiselled with scrolls. Chained match holder, swivel pan cover. Gold buttcap and stock ornaments of roundel form chased and embossed with foliage, roundels with silver star centres. Gold fore-end cap engraved *ensuite* with damascened ornament.

Overall length 171 cm, barrel length 146 cm.

BIBLIOGRAPHY

ABU'L-FAZL, 'ALLAMI, *A'in-i Akbari*, 3 vols, trans. H. Blochmann. New Delhi, 1988.

ABU ZAFAR NADVI, 'The Use of Cannon in Muslim India', *Islamic Culture*, vol. XII, 1938.

AIJAZUDDIN, F. S., *Sikh Portraits by European Artists*. Sotheby Parke Bernet and OUP, 1979.

ALEXANDER, DAVID, *The Arts of War: The Nasser D. Khalili Collection of Islamic Art*, vol.XXI: *The Nour Foundation*. Azimuth Editions and OUP, 1992.

ALLEMAGNE, H. d', *Du Khorassan au pays des Bakhtiaris*, 4 vols. Paris, 1911.

ALLEN, W.E.D.(ed.), *Russian Embassies to the Georgian Kings (1589-1605)*. 2 vols, trans. Antony Mango. Hakluyt Society and Cambridge University Press, 1970.

ALM, J., 'Handelsgevar', *Livrustkammaren*, V. Sweden, 1949-51.

ANON, 'A Description of Holland: or, the present state of the United Provinces. Wherein is contained a particular account of the Hague, and all the principal cities and towns of the Republick ...of the manner and customs of the Dutch, their constitution etc., etc.' London, 1743.

ANON, *A Rough Sketch of the Rise and Progress of the Irregular Horse of the Bengal Army by an Old Cavalry Officer* (probably General Charles Carmichael C.B.). Privately printed and undated.

ANON, Remington Catalogue, 1883.

ANON, *Islamiske vaben i dansk privateje* (Islamic Arms and Armour from private Danish Collections). Davids Samling, Denmark, 1982.

ARASARATNAM, S., 'The kingdom of Kandy: aspects of its external relations and commerce, 1658-1710', *Ceylon Journal of Historical and Social Studies*, Vol.III, 1960.

ARCHER, MILDRED, *Company Drawings in the India Office Library*. HMSO, London, 1972.

ARCHER, MILDRED and FALK, TOBY, *India Revealed. The art and adventures of James and William Fraser 1801-35*. London, 1989.

ASHTOR, E., *A Social and Economic History of the Near East in the Middle Ages*. University of California Press, 1976.

— *Levant Trade in the Later Middle Ages*. Princeton University Press, 1983.

AUGUSTIN, BERND, 'Arms', *Oriental Splendour. Islamic Art from German Private Collections*. Edited by Claus-Peter Haase, Jens Kroger and Ursula Lienert. Museum Fur Kunst und Gewerbe, Hamburg, 1993.

AYALON, DAVID, *Gunpowder and Firearms in the Mamluk Kingdom*. Vallentine, Mitchell, London, 1956.

— 'Harb', *Encyclopaedia of Islam (E.I.2)*. Leiden, 1960- .

AYALON, D., PARRY, V.J., COLIN, G.S., YAR MUHAMMAD KHAN,

'Barud', *Encyclopaedia of Islam (E.I.2)*. Leiden, 1960- .

BABUR-NAMA, trans. A. Beveridge. New Delhi, 1979.

BACQUÉ-GRAMMONT, JEAN-LOUIS, 'Les Ottomans, Les Safavides et leurs voisins' in *L'Histoire des relations internationales dans l'Orient Islamique de 1514 à 1524*. Nederlands Historisch-Archaeologisch Instituut Te Istanbul, 1987.

BADDELEY, JOHN. *The Russian Conquest of the Caucasus*. London 1908.

BADEN POWELL, B.H., *Handbook of Manufactures and Arts of the Punjab*. Lahore, 1872.

BAILEY, DE WITT and NIE, DOUGLAS A., *English Gunmakers. The Birmingham and Provincial Gun Trade in the 18th and 19th Centuries*. Arms and Armour Press, London, 1978.

BAJWA, FALIJA SINGH, *Military System of the Sikhs, 1799-1849*, Patna, 1964.

BAKHIT, MUHAMMAD ADNAN, *The Ottoman Province of Damascus in the Sixteenth Century*. Librairie du Liban, 1982.

BALBI, FRANCISCO DI CORREGIO, *The Siege of Malta*. Folio Society, London 1965.

BALSIGER, ROGER and KLÄY, ERNST, *Bei Schah, Emir und Khan. Henri Moser Charlottenfels 1844-1923*. Meier Verlag, Schaffhausen, 1992.

BARKER, S., 'Method of renewing the giohar of Persian swords' *Asiatic Journal*, May 1818.

BARRETO, A.M., BURNAY, J. E and DAEHNHARDT, R., 'A Mão que ao ocidente o véu rasgou armaria'. XVII Exposicao Europeia de Arte, Ciencia e Cultura, Lisbon, 1983.

BARTLETT WELLS, H., 'Lord Byron's Joseph Manton Rifle?', *Journal of the Arms and Armour Society*, Vol. VI, No. I, March, 1968.

BAUSANI, ALESSANDRO, *The Persians*, trans. J. B. Donne. Elek, London, 1971.

BEAUJOUR, F., *Tableau du Commerce de la Grèce*, 2 vols. Paris, trans. Thomas Hartwell Horne, London, 1800.

— *Voyage militaire dans l'Empire Ottoman*, 2 vols. Paris, 1829.

BELL, GERTRUDE, *Selected Letters of Gertrude Bell*, London, 1953.

BELLEW, H.W., *Kashmir and Kashgar. A Narrative of the Journey of the Embassy to Kashgar in 1873-74.* London, 1875.

BENJAMIN, S.G.W., *Persia and the Persians*. London, 1887.

BENT, J.T. (ed.), *Early Voyages and Travels in the Levant: Dallam's Travels 1599-1600; Covel's Diaries 1670-1679.* Hakluyt Society, London.

BERNIER, FRANÇOIS, *Travels in the Mogul Empire, AD 1656-1668.* Atlantic Publishers, New Delhi, 1990.

BHATTACHARYA, S., 'Eastern India', in *The Cambridge Economic History of India*, ed. Dharma Kumar, 2 vols. Cambridge University Press, 1982.

BIDWELL, SHELFORD, *Swords for Hire: European Mercenaries in Eighteenth-century India.* John Murray, London, 1971.

BIRDWOOD, G.C.M., *The Industrial Arts of India.* London, 1971.

BLACKMORE, H. L., *British Military Firearms 1650-1850.* London, 1961.

— *Firearms.* London, 1964.

— *Guns and Rifles of the World.* Chancellor Press, London, 1965.

— *Royal Sporting Guns at Windsor.* London, 1968.

— 'Guns for the Sultan of Batam', *Journal of the Arms and Armour Society*, Vol.X, No.2, Dec. 1980.

— *A Dictionary of London Gunmakers 1350-1850.* Phaidon/Christie's, Oxford, 1986.

— 'General Claude Martin, Master Gunmaker', *Arms Collecting*, Vol.27, No.1, Feb. 1989.

BLAIR, CLAUDE, 'A note on the early history of the wheellock', *Journal of the Arms and Armour Society*, Vol. III, 1959-61.

— *Pistols of the World.* London, 1968.

BLUNT, Lady ANNE, *Bedouin Tribes of the Euphrates*, 2 vols. London, 1879.

BOCCIA, LIONELLO G. and GODOY, JOSÉ A., *Museo Poldi Pezzoli: Armeria*, 2 vols. Electra, 1986.

BODUR, FULYA, *Turk Maden Sanati: The Art of Turkish Metalworking.* Istanbul, 1987.

BORSOS, BÉLA, *Staghorn Powder-Flasks.* Corvina, Kiadò,1982.

BOXER, C.R., *The Dutch Seaborne Empire, 1600-1800.* London, 1965.

BRAUDEL, FERNAND, *The Structures of Everyday Life.* Fontana, London, 1985. First published as *Les Structures du Quotidien: le possible et l'impossible.* Armand Colin, Paris, 1975.

BRAUNSTEIN, P., 'Le commerce du fer à Venise au XV siècle', *Studi Veneziani*, VIII, 1966.

BROWN, DELMER M., 'The impact of firearms on Japanese warfare, 1543-98', *Far Eastern Quarterly*, VIII, 3, 1948.

BROWN, RUTH RHYNAS, 'Guns carried on East Indiamen, 1600-1800', *International Journal of Nautical Archaeology and Underwater Exploration*, 1990.

BROWNE, Edward G., *A Traveller's Narrative Written to Illustrate the Episode of the Bab.* Edited in the original Persian and translated into English with introduction and notes. Cambridge University Press, 1891.

BUCHANAN, F., *A Journey from Madras through the Countries of Mysore, Canara and Malabar*, 3 vols. Madras, 1807.

BUDDLE, ANNE, *Tigers Round the Throne: The Court of Tipu Sultan (1750-1799).* Zamana, 1990.

BURCKHARDT, J. L., *Travels in Nubia*, London, 1822.

— *Travels in Syria and the Holy Land.* London, 1822.

— *Notes on the Bedouins and Wahabys.* London, 1830.

BURNES, JAMES. *A Narrative of a Visit to the Court of Sinde; A sketch of the History of Cutch.* Edinburgh, 1831.

BURRELL, R.M. 'Arms and Afghans in Makran: an episode in Anglo-Persian relations 1905-1912', *Bulletin of the School of Oriental and African Studies, University of London*, Vol. XLIV, Pt 1, 1986.

BURTON, RICHARD. F., *Pilgrimage to al Madinah and Meccah*, 2 vols. London, 1855.

BUSBECQ, G. de, *Life & Letters of Ogier Ghiselin de Busbecq*, Foster & Daniell, 2 vols. London, 1881.

CALVERT, A.F., *Spanish Arms and Armour.* London and New York, 1907.

CARRINGTON GOODRICH, L., FENG CHIA-SHENG, 'The early

development of firearms in China', *Isis*, Vol. XXXVI, Pt 2, 1946.

CAULK, R.A., 'Firearms and princely power in Ethiopia in the nineteenth century'. *Journal of African History*, Vol XIII, No. 4, 1972.

CHIRKOV, D., *Daghestan Decorative Art*. Moscow, 1971.

CIPOLLA, C.M., *Guns and Sails in the Early Phase of European Expansion 1400-1700*. 1965.

COMPTON, H., *A Particular Account of the European Military Adventurers of Hindustan*. T. Fisher Unwin, London, 1893.

CONTI, N., *The Travels of Nicolo Conti, in the East, in the Early Part of the Fifteenth Century*, trans. J. Winter Jones. Hakluyt Society, London, 1858.

CORREIA-AFONSO, J. (ed.), *Intrepid Itinerant: Manuel Godinho and his Journey from India to Portugal in 1663*, trans. from the Portuguese by Vitalio Lobo and John Correia-Afonso. Oxford University Press, Bombay, 1990.

CORUHLU, TULIN, 'Osmanli Tufek, Tabanca ve Techizatlari' (*Askeri Muzeden Orneklerle*). Genelkurmay Basim Evi. Ankara, 1993.

COURTENAY LOCKE, J. *The First Englishmen in India*. London, 1930.

DAEHNHARDT, RAINER, *Espingarda Feiticeira: A Introdução da Arma de Fogo pelos Portugueses no Extremo-Oriente / The Bewitched Gun: The Introduction of the Firearm in the Far East by the Portuguese*, Parallel Texts. Texto Editora, LDA, Portugal, 1994.

DALE, STEVEN. F., *Islamic Society on the South Asian Frontier: The Mappilas of Malabar, 1498-1922*. Oxford, 1980.

— *Indian Merchants and Eurasian Trade, 1600-1750*. Cambridge University Press, 1994.

DARLING, A.D., 'The India pattern musket', *Canadian Journal of Arms Collecting*, Vol.8, No.I.

DASKALOV, N. and KOVACHEVA, V., *Weaponry of the Past*. Sofia Press, Bulgaria, 1989.

DE COCA CASTANER, J.E.L., 'Institutions on the Castilian-Granadan frontier, 1369-1482', in *Medieval Frontier Societies*, ed. R. Bartlett and A. Mackay. Clarendon Press, Oxford, 1989.

DE LA BROQUIERE, BERTRANDON. *Le Voyage d'Outtremer* edited by Ch. Schefer. Paris, 1892.

DELHOMME, Capt., 'Les Armes dans le Sous occidental.' *Archives Berberes*, II, 1917.

DELMAR MORGAN, E. (ed.), *Early Voyages and Travels to Russia and Persia*, Vol II. Hakluyt Society and Oxford University Press, 1949.

DENISON ROSS, Sir E. (ed), *Sir Anthony Sherley and his Persian Adventure*. London, 1933.

DERANIYAGALA, P.E.P., 'Sinhala weapons and armour', *Journal of the Ceylon Branch of the Royal Asiatic Society*, Vol. XXXV, No. 95, Part 3, 1942.

DEROKO, A., *Najstarije vatreno oruzje u srednjovekovnoj Srbiji* (The Oldest Firearms in Medieval Serbia) *Glas SANU*, CCXLVI/9. Belgrade, 1961.

DE WARNERY, *Remarques sur le militaire des Turcs*. Leipzig and Dresden, 1770.

DIGBY, SIMON, *War-Horse and Elephant in the Delhi Sultanate*. Oxford, 1971.

DIKSHITAR, V.R., *War in Ancient India*. Calcutta and London, 1944.

DU JARRIC, PIERRE, *Akbar and the Jesuits. An Account of the Jesuit Missions to the Court of Akbar*, translated with introduction and notes by C.H.Payne. London, 1926.

DUNBAR, J., *Tigers, Durbars and Kings: Fanny Eden's Indian Journals*. London, 1988.

EGERTON OF TATTON, *Indian and Oriental Armour*. London, 1896.

ELGOOD, P.G., *Bonaparte's Adventure in Egypt*. Oxford University Press, 1931.

ELGOOD, R.F.W., *Arms and Armour of Arabia in the 18th, 19th and 20th centuries*. Scolar Press, London, 1994.

ELIOT, HENRY M.and DOWSON, JOHN (eds), *History of India as told by its Historians*. Vols I-VII. Reprinted Allahabad, 1964.

ELPHINSTONE, M., *An Account of the Kingdom of Caubul*. London, 1815.

ESTRADA, F.L. *Embajada a Tamorlan. Estudio y edition de un manuscrito del siglo XV*. Madrid, 1943.

EVLIYA CHELEBI, *Seyahatname, Narrative of Travels*, 2 vols, trans. J. Von Hammer. London, 1834.

FAROQHI, S., *Towns and Townsmen of Ottoman Anatolia. Trade, Crafts and Food Production in an Urban Setting, 1520-1650*. Cambridge University Press, 1984.

FAWCETT, Lady (trans.) and FAWCETT, CHARLES (ed.), *The Travels of the Abbé Carre in India and the Near East, 1672-1674*, 3 vols. Hakluyt Society. London, 1947-8.

FEHER, G., *Torok kori iparmuveszeti alkotasok Magyar Helikon* (Craftsmanship in Turkish-ruled Hungary) trans. Lili Halapy. Corvina, 1975.

FIGIEL, LEO. S., *On Damascus Steel*. Atlantis Arts Press, New York, 1991.

FISHER, HUMPHREY and ROWLAND,

VIRGINIA, 'Firearms in the Central Sudan', *Journal of African History*, XII, 2, 1971.

FLINDT, TORBEN, 'Some nineteenth-century arms from Bukhara' in *Islamic Arms and Armour* ed. Robert Elgood. Scolar Press, London, 1979.

FOLEY, V. and PERRY, K., 'In defence of *liber igneum*: Arab alchemy, Roger Bacon, and the introduction of gunpowder into the west' in *Journal for the History of Arabic Science* Vol. 3, No.2, 1979.

FORBES, JAMES, *Oriental Memoirs. A narrative of seventeen years residence in India*. 2 vols. London, 1834 (2nd edn).

FORBES MITCHELL, W., *Reminiscences of the Great Mutiny*. London, 1893.

FORISSIER, MAURICE., *L'Armurerie Stephanoise: Patrimoine et tradition*. Lyon, 1994.

FORREST, GEORGE W. *Selections from the Travels and Journals Preserved in the Bombay Secretariat, Bombay*. Printed at the Government Central Press, 1906.

FOSTER, Sir W. (ed.), *The Embassy of Sir Thomas Roe to India 1615-19*. London, 1926.

— *Thomas Herbert's Travels in Persia 1627-29*. London, 1928.

— *The Travels of Sir John Sanderson in the Levant 1584-1602*. Hakluyt Society, London, 1931

— *England's Quest of Eastern Trade*. London, 1933.

FRANCKLIN, Col. W., *The Military Memoirs of George Thomas*. London, 1803.

FRANZOI, U., *L'Armeria del Palazzo Ducale a Venezia*. Edition Canova, 1990.

GAIBI, A., *Armi di fuoco italiane*. Milan, 1978.

GAIER, C., *Four Centuries of Liège Gunmaking* (French and English edn). 1976.

GILLE, FLORIANT, *Musée de Tzarskoe-Selo, ou Collection D'Armes de Sa Majesté l'Empereur de toutes les Russies. Ouvrage composé de 180 planches lithographiées par Asselineau d'après les dessins originaux de A. Rockstuhl, Peintre du Cabinet de Sa Majesté.* Avec une introduction historique par Flort. Gille. Velten. St. Petersburg and Karlsruhe, 1835-53; facsimile edn, Graf Klenau, 1981.

GRANCSAY, S.V., 'An East India gun', *Bulletin of the Metropolitan Museum of Art*, XXVIII, 1933.

— 'A gun from the Caucausus', *Bulletin of the Metropolitan Museum of Art*, 1935.

GRAY, JOHN ALFRED, *At the Court of the Amir*. London, 1895.

GROSE, JOHN HENRY, *A Voyage to the East Indies...the Viceroyalties of the Deccan and Bengal, with their several subordinate dependencies...with general reflections on the trade of India*, 2 vols. London, 1772.

GUILMARTIN, J.F. Jnr., *Gunpowder and Galleys*. Cambridge University Press, 1974.

HAMMER-PURGSTALL, J. von, 'Memoir on the diplomatic relations between the Courts of Delhi and Constantinople in the sixteenth and seventeenth centuries', *Transactions of the Royal Asiatic Society*, II, 1830.

HANSEN, THORKILD. *Arabia Felix. The Danish Expedition of 1761- 1767*, trans. J. and K. McFarlane. London, 1965.

HARDING, D.F., 'Smallarms of the English East India Company', *International Journal of Nautical Archaeology and Underwater Exploration*, 19, 1990.

HATCH, ALDEN, *Remington Arms*. New York, 1956.

HAYWARD, J. F., *The Art of the Gunmaker*, 2 vols. London, 1962.

HILL, S.C., *The Life of Claud Martin*. Calcutta, 1901.

HIME, H.W.L., *Gunpowder and Ammunition, Their Origin and Progress*. London, 1904.

HOBHOUSE, J.C., *A Journey through Albania and other Provinces of Turkey in Europe and Asia to Constantinople during the years 1809 and 1810*. London, 1818.

HOFF, ARNE, *Dutch Firearms*. London, 1978.

HONIGBERGER, J.M., *Thirty-five Years in the East*, Pt. 1. London, 1852.

HOWARD, MICHAEL, *Warfare in European History*. Oxford University Press, 1976.

HUGEL, BARON, *Travels in Kashmir and the Punjab*. London, 1845.

HUNTER, W.W., *The Imperial Gazetteer of India*. (London, 1885, rev. edn 1909).

INALCIK, HALIL, *The Ottoman Empire: The Classical Age, 1300-1600*. London, 1973.

— 'The socio-political effects of the diffusion of firearms in the Middle East', in *War, Technology and Society in the Middle East*, ed. V.J.Parry and M.E. Yapp. Oxford University Press, 1975.

— 'Imtiyazat: Ottoman', *Encyclopaedia of Islam*, (*E.I.2*) Leiden, 1960- .

IRVINE, WILLIAM, *The Army of the Indian Moghuls*. Eurasia Publishing, Delhi, 1962.

IVANOV, A., *The Arts of Kubachi*. Leningrad, 1976.

JACQUEMONT, VICTOR, *Letters from India, 1829-1832*, trans. and introd. C.A. Philips. London, 1936.

JANOS, KALMAR, *Regi Magyar Fegyverek*. Budapest, 1971.

JOLY, A., 'L'Industrie à Tetouan', *Archives Marocaines*, VIII, XI and XVIII, 1906-12.

KAROLY, A., 'Magyar nyelbeutos szakallas puskak' *Folia Archeologica*, IX, 1957.

KEA, R.A., 'Firearms and warfare on the Gold and Slave Coasts', *Journal of African History*, XII, 1971.

KEITH NEAL, W., *Spanish Guns and Pistols*. London, 1955.

— and BACK, D.H.L., *The Mantons: Gunmakers*. Herbert Jenkins, London, 1967.

KENNARD, A.N., *French Pistols and Sporting Guns*, Country Life Collectors' Guides. London, undated.

KER PORTER, SIR ROBERT, *Travels in Georgia, Persia, Armenia, Ancient Babylonia etc. during the years 1817, 1818, 1819 and 1820*, 2 vols. London, 1822.

KINGLAKE, ALEXANDER, *Eothen – Traces of Travel Brought Home from the East*. Oxford University Press, 1982.

KISSLING, H.J., 'Balyemez' in *Encyclopaedia of Islam* (E12). Leiden, 1960- .

KLOPSTEG, P.E., *Turkish Archery and the Composite Bow*. Simon Archery Foundation, Manchester Museum, 1987.

KUROPATKIN, A. N. , *Kashgaria: Historical and Geographical sketch of the country; its Military strength, Industries and Trade*. Translated from the Russian by Walter E. Gowan. Calcutta, 1882.

LACACI, G.Q., *Armería del Palacio Real de Madrid*. Madrid, 1987.

LAMBTON, A.K.S., 'Imtiyazat: Persian', *Encyclopaedia of Islam* (E.I.2), Leiden, 1960-.

LANE, E.W., *The Modern Egyptians*. London, 1836, 1908.

LANG, ARTHUR MOFFAT, *Lahore to Lucknow: The Indian Mutiny Journal of Arthur Moffat Lang*, ed. David Blomfield, introd. Christopher Hibbert. London, 1992.

LATIF, S.M., *Lahore: Its History, Architectural Remains and Antiquities*. Lahore, 1892.

LAVIN, J.D., 'An examination of some early documents regarding the use of gunpowder in Spain', *Journal of the Arms and Armour Society*, IV, March, 1964.

— *A History of Spanish Firearms*. London, 1965.

LEBEDYNSKY, I., *Les Armes Cosaques et Caucasiennes, et les armes traditionelles d'Europe Orientale*. Paris, 1990.

LENK, TORSTEN, *The Flintlock: Its Origin and Development*. Trans. G.A.Urquhart, ed. J.F. Hayward. London, 1965.

LENTZ, T.W. and LOWRY, G.D., 'Timur and the princely vision: Persian art and culture in the fifteenth century', *LACMA*. Sackler, Smithsonian, New York, 1989.

LE STRANGE, G. (trans. & ed.), *Don Juan of Persia*. London, 1926.

— *Clavijo's Embassy to Tamurlane 1403-6*. New York and London, 1929.

LETTS, MALCOLM (trans. & ed.), *The Pilgrimage of Arnold Von Harff*. Hakluyt Society, London, 1946.

LEWIS, BERNARD (trans. & ed.), *Islam from the Prophet Muhammad to the Capture of Constantinople: I, Politics and War*. Macmillan, London, 1974.

LING, WANG, 'On the invention and use of gunpowder and firearms in China', *Isis*, Vol. XXXVII, 1947.

LLEWELLYN-JONES, ROSIE, *A Very Ingenious Man; Claude Martin in Early Colonial India*. Oxford University Press, 1992.

— *A Fatal Friendship; The Nawabs, the British and the City of Lucknow*. Oxford University Press, 1992.

LLOYD, CHRISTOPHER, *The Nile Campaign; Nelson and Napoleon in Egypt*. Oxford, 1972.

LOCKHART, L., *The Fall of the Safavid Dynasty and the Afghan Occupation of Persia*. London, 1958.

— *The Persian Army in the Safavid period*. *Der Islam* 35, 1959.

LUNDBAEK, TORBEN and DAM-MIKKELSEN, BENTE, *Etnografiske genstande i Det Kongelige danske Kunstkammer 1650-1800 (Ethnographic objects in the Royal Danish Kunstkammer)*. National Museet, Copenhagen, 1980.

LYBYER, ALBERT HOWE, 'The government of the Ottoman empire in the time of Suleiman the Magnificent', *Harvard Historical Studies*, Vol. 18, 1913.

MACKAY, A., 'Religion, culture, and ideology on the late medieval Castilian-Granadan frontier', in *Medieval Frontier Societies*, ed. R. Bartlett and A.Mackay. Clarendon Press, Oxford, 1989.

MALCOLM, JOHN, *History of Persia*. London, 1829.

MALLETT, MICHAEL, *Mercenaries and their Masters. Warfare in Renaissance Italy*. The Military Book Society, London, 1974

MANUCCI, NICCOLÒ, *Storia di Mogor*, 4 vols, trans. as *Mogul India* by William Irvine. London, 1907-8.

MARSIGLI, L.F., *Stato Militare dell' Imperio Ottomano*, 1732. Reprinted Akademische Druck-u. Verlagsanstalt Graz, Austria, 1972.

MAUNDRELL, HENRY, *A Journey from Aleppo to Jerusalem at Easter AD 1697*. 1749.

MAVRODIN, VALENTIN, *Firearms and Edged Weapons in the Hermitage, Leningrad*. Abrams, New York, 1977.

MAYER, L.A., *Islamic Armourers and Their Works*. Geneva, 1962.

MEEN V.B. and TUSHINGHAM, A.D., *Crown Jewels of Iran*. University of Toronto Press, 1968.

MEER HASSAN ALI, MRS, *Observations on the Mussulmauns of India*.1832. Reprinted OUP, Pakistan, 1973.

MENAGE, V.L., 'Devshirme', *Encyclopaedia of Islam*. (*E.I.2*) Leiden, 1960- .

MILLER, YURI (ed.), *Russian Arms and Armour*. Aurora Art Publishers, Leningrad, 1982.

MINORSKY, V., *La Perse au XVe siècle*. Paris, 1932.

— 'A civil and military review in Fars in 881/1476', *Bulletin of the School of Oriental and African Studies* (University of London), X, 1940-42.

MISSILLIER, P. and RICKETTS, H., *Splendeur des armes orientales*. Paris, 1988.

MODAVE, COMTE DE, *Voyage en Inde du Comte de Modave 1773-1776*, ed. Jean Deloche. Paris, 1971.

MOORCROFT, WILLIAM and TREBECK, GEORGE, *Travels in the Himalayan Provinces of Hindustan and the Punjab*, 2 vols. London, 1841.

MORELAND, W.H. (trans. & ed.), *Relations of Golconda in the Early Seventeenth Century*. Hakluyt Society, London, 1931.

MORIN, MARCO, 'The origins of the wheellock: a German hypothesis' in *Art, Arms and Armour*, ed. R. Held. Acquafresca Editrice, Chiasso, 1979.

MORIN, MARCO and HELD, ROBERT, *Beretta: The World's Oldest Industrial Dynasty*. Acquafresca Editrice, Chiasso, 1980.

MRVALJEVIC, Z. and DJURISIC, L., *Folk Art of Montenegro*. Catalogue of a loan exhibition organised by the Museums of Cetinje and shown at the Horniman Museum, London, 1983.

MURAV'YOV, N., *Journey to Khiva through the Turkoman Country*. London, 1977.

NACHTIGAL, G., *Sahara und Sudan*, 2 vols. Berlin, 1879-81.

NECK, RUDOLF; NADER, HELMUT, VONWILLER, CHRISTINE, and PETRITSCH, ERNST, 'Osterreich und die Osmanen', *Prunksaal der Osterreichischen Nationalbibliothek*, 31 Mai bis 30 Oktober, 1983, Katalog. Vienna, 1983.

NEEDHAM, JOSEPH, *Gunpowder as the Fourth Power, East and West*. Hong Kong, 1985.

— *Science and Civilisation in China*. Vol.5, pt.7: *Military Technology; The Gunpowder Epic*. Cambridge, 1986.

NICOLAY, NICOLAS DE, *Quatre premiers livres des navigations et peregrinations orientals*. Lyon, 1568.

NICOLLE, D., *Armies of the Ottoman Turks 1300-1774*. London, 1983.

NORTH, A., *Islamic Arms*. London, 1985.

OPPERT, G., *On the Weapons, Army Organisation and Political Maxims of the Ancient Hindus, with special reference to Gunpowder and Firearms*. Madras and London, 1880.

PALGRAVE, W. GIFFORD, *Ulysses or Scenes and Studies in Many Lands*. Macmillan, London, 1887.

PARRY, V.J., 'Warfare', in *The Cambridge History of Islam*, ed. P.M. Holt, A.K.S. Lambton and B. Lewis. Cambridge University Press, 1970.

— 'La Manière de combattre', in *War, Technology and Society in the Middle East*, ed. V.J. Parry and M. F. Yapp. Oxford University Press, 1975.

— 'Materials of war in the Ottoman empire', *Studies in the Economic History of the Middle East*, ed. M.A. Cook. Oxford University Press, 1978.

PARRY, V.J. and YAPP, M.E., *War, Technology and Society in the Middle East*. Oxford University Press, 1975.

PARTINGTON, J.R., *A History of Greek Fire and Gunpowder*, with a foreword by Lieut-Gen. Sir Frederick Morgan. Cambridge, 1960.

PATERSON, W.P. 'The Archers of Islam', *Journal of the Economic and Social History of the Orient*, IX, Parts I- II, 1966.

PEARMAN, JOHN, *Sergeant Pearman's Memoirs*, edited by the Marquess of Anglesey. London, 1968.

PETERSON, HAROLD L., *Encyclopaedia of Firearms*. George Rainbird for *The Connoisseur*. London, 1964

PETRASCH, ERNST; MAJER, HANS GEORG; SÄNGER, REINHARD and ZIMMERMAN, EVA, *Die Karlsruher Türkenbeute*. Hirmer Verlag, Munich, 1991.

PETROVIC, DJURDJICA, 'Fire arms in the Balkans on the eve of and after the Ottoman conquests of the fourteenth and fifteenth centuries' in *War, Technology and Society in the Middle East*, ed. V.J. Parry and M.E. Yapp. Oxford University Press, 1975.

PIERIS, J.F. 'A king of Ceylon's gun: An ornate Sinhalese flintlock gun of the 17th century' *The Connoisseur*, Sept. 1936, Vol XCVIII, No. 421.

PIERIS, P.E. (ed.), *The Dutch Power in Ceylon: Some Documents Relating to the Rise of the Dutch Power in Ceylon, 1602-1670 from the translations at the India Office*. London, 1929.

POCOCKE, R., *A Description of the East and Some Other Countries*, 2 vols. London, 1743-5.

PRIDMORE, F,. *The Coins of the British Commonwealth of Nations: Part 4 India.* Volume 1 *East India Company Presidency Series c. 1642-1835.* Spink, London, 1975.

PURCHAS, SAMUEL, *Purchas his Pilgrims.* London, 1625, ed. Maclehose, 20 vols. Glasgow, 1905.

RAM, SITA, *From Sepoy to Subedar; being the Life and Adventures of Subedar Sita Ram, a Native Officer of the Bengal Army, written and related by himself.* Lahore, 1873; ed. James Lunt, London, 1970.

RANKE, LEOPOLD, *The Ottoman and Spanish Empires in the 16th and 17th Centuries,* trans. Walter Kelly. London, 1843.

RAYCHAUDHURI, TAPAN, *Jan Company in Coromandel 1605-1690. A study of European Commerce and Traditional Economies.* Nijhoff, The Hague, 1962.

RAYMOND, ANDRE, *Artisans et commercants au Caire au XVIII siècle,* 2 vols. Institut Français de Damas, Damascus, 1973-4.

REINAUD, J., 'Description d'un fusil oriental', *Journal Asiatic,* 5E Ser.7, 1856.

RICHARDS, FRANK, *Old Soldier Sahib.* London, 1936.

RICHTER, G., *Manual of Courg. The Courg Gazetteer.* Mangalore, 1870.

ROGERS, J.M., *The Topkapi Saray Museum, The Treasury.* trans., extended and ed. from the Turkish. London, 1987.

ROSS, FRANK. E. 'New light on Charles Masson' *The Indian Antiquary,* Vol. 62. London, 1933.

ROUILLARD, CLARENCE DANA, 'The Turk in French History, Thought and Literature'. Paris (undated – 1938?).

RUNCIMAN, STEVEN, *The Fall of Constantinople, 1453.* Cambridge University Press, 1965.

RUSSELL, WILLIAM, *Russell's Despatches from the Crimea 1854-1856.* London,1970.

RYCAUT, P. and KNOLLES, R. *The Turkish History from the Origin of that Nation to the Growth of the Ottoman Empire.* 3 Vols. London, 1687-1700.

ST. CLAIR, ALEXANDRINE N., *The Image of the Turk in Europe.* Metropolitan Museum of Art, New York, 1973.

ST. OLON, M. DE, *The Present State of the Empire of Morocco.* London, 1695.

SANSON, N., *Voyage ou relation de l'état de Perse.* Paris, 1695.

SAVORY, R.M., 'Safavid Persia' in Vol. I of *The Cambridge History of Islam,* ed. P.M. Holt, A.K.S. Lambton and B. Lewis. Cambridge, 1970.

— 'The Sherley myth', in *Iran under the Safavids,* Ch.II, Cambridge University Press, 1980.

SAXENA, R.K., *The Army of the Rajputs.* Saroj Prakashan, Udaipur, 1989.

SCHAAL, DIETER, *Suhler Feuerwaffen. Exponate aus dem Historischen Museum zu Dresden.* Berlin, 1981.

SCHÖBEL, JOHANNES, *Fine Arms and Armor, Treasures in the Dresden Collection.* G.P. Putnam. New York, 1975.

SEN, S., *Military System of the Marathas.* Calcutta, 1928.

— *The Indian Travels of Thevenot and Careri.* Indian Records Series. National Archives of India, New Delhi, 1949.

SEN, S.P., *The French in India 1763-1816.* New Delhi, 1971.

SENGERS, L.G., 'A pistol of Prince Farhad Mirza', *Persica 2,* 1965-6.

SERCER, MARIJA, *Jatagani.* Zagreb, 1975.

— Turkische Waffen aus dem Historischen Museum von Kroatien, Zagreb. 15. Mai bis 10. Oktober 1982.

SERJEANT, R.B., *The Portuguese off the South Arabian Coast.* Clarendon Press, Oxford, 1963.

SETTON, KENNETH M., *The Papacy and the Levant 1204 - 1571,* 4 vols. American Philosophical Society, 1984.

SINCLAIR, W.F., 'List of weapons used in the Dakhan and Khandesh,' *Indian Antiquary.* London, 1873.

SINGH, SARVA DAMAN, *Ancient Indian Warfare.* Leiden, 1965.

SMALDONE, J.P., 'Firearms trade in the Central Sudan in the nineteenth century', *Aspects of West African Islam,* Boston University Papers on Africa, V, ed. Daniel F. McCall and Norman L. Bennett. Boston, 1971.

— 'Firearms in Central Sudan: a revaluation', *Journal of African History.* Vol.XIII, No.4, 1972.

SMITH, L.F. *A sketch of the Rise, Progress and Termination of the Regular Corps Formed and Commanded by Europeans in the Service of the National Princes of India.* Calcutta, 1805.

SPRING, CHRISTOPHER, *African Arms and Armour.* British Museum Press, London, 1993.

STEINGASS, F., *Persian-English Dictionary,* 1892; reprinted New Delhi, 1973.

STERN, WALTER M., 'Gunmaking in seventeenth-century London', *Journal of the Arms and Armour Society,* Vol.1, No. 5., March, 1954.

STOCKLEIN, HANS, 'Arms and armour', Ch.58, Vol VIB of *A Survey of Persian Art,* ed. A. Upham Pope. 1938-9.

— 'Orientalische Waffen aus der Residenzbüchsenkammer im Ethnologischen Museum, München',

Münchener Jahrbuch der Bilden den Kunst, IX, 1914-15.

STONE, GEORGE, *A Glossary of the Construction, Decoration and Use of Arms and Armor in all countries and in all times*. The Southworth Press, 1961.

STOWASSER, KARL, 'Manners and customs at the Mamluk court', *Muqarnas*, Vol.2: *The Art of the Mamluks*, ed. Oleg Grabar. Yale University Press, 1984.

SYKES, P.M., *Sir John Chardin's Travels in Persia*. London, 1927.

TARASSUK, L., *Antique European and American Firearms at the Hermitage Museum*. Leningrad, 1971.

TEMESVÁRY, FERENC, *Arms and Armour: The Treasures of the Hungarian National Museum*. Budapest, 1982.

TIBBETTS, G.R., *Arab Navigation in the Indian Ocean before the coming of the Portuguese; being a translation of Kitab al-Fawa'id fi usul al-bahr wa'l- qawa'id of Ahmad b. Majid al-Najdi*. Royal Asiatic Society and Luzacs, London, 1971.

TOD, J., *Annals and Antiquities of Rajasthan*, 2 vols. London, 1914.

TONE, Col.W.H., *Illustrations of Some Institu-tions of the Maharatta People*. Calcutta, 1818.

TWINNING, T., *Travels in India*. London, 1893.

UPTON, EMORY, *Armies of Asia and Europe*. New York, 1878.

VACHON, M., 'Les Industries d'art indigènes de l'Algerie', *Revue des arts decoratifs*, XXI and XXII.

VALE, MALCOLM, *War and Chivalry*. London, 1981.

VALLE, PIETRO DELLA, *The Travels of Pietro della Valle in India*, 2 vols, ed. E. Grey. London, 1892.

VAMBÉRY, ARMINIUS, *Sketches of Central Asia. Additional Chapters on my Travels, Adventures and on the Ethnology of Central Asia*. London, 1868.

VARTHEMA, LUDOVICO DI, *The Travels of Ludovico Di Varthema in Egypt, Syria, Arabia Deserta and Arabia Felix, in Persia, India, and Ethiopia, AD 1503 to 1508*, trans. J.W. Jones, ed. G.P. Badger. Hakluyt Society, London, 1863.

VERTRAY, M, *The French Army in Egypt*. London, 1899.

VILLIERS, ALAN, *Sons of Sinbad*. New York, 1969.

VISCHER, H, *Across the Sahara from Tripoli to Bornu*. London, 1910.

WATT, GEORGE, *Indian Art at Delhi, 1903*. Delhi, 1903.

WELLSTEAD, J.R., *Travels in Arabia*, 2 vols. London, 1838.

WIGINGTON, R., 'The Seringapatam Matchlock' *Journal of the Arms and Armour Society*, Vol. XII, No. 3, March 1987.

— *The Firearms of Tipu Sultan 1783-1799*. John Taylor Book Ventures, 1992.

WILKINSON, HENRY, *Engines of War*, London, 1841. Reprinted Richmond, 1973.

WILKINSON, THEON, *Two Monsoons*. London, 1976.

WILLIAMS, A.R., 'Some firing tests with simulated 15th-century handguns', *Journal of the Arms and Armour Society*, VIII, 1974.

WILLIAMS, JOHN, *The Bengal Native Infantry*. John Murray, London, 1817.

WITTEK, P., 'The Earliest references to the use of firearms by the Ottomans',

Appendix II in D. Ayalon, *Gunpowder and Firearms in the Mamluk Kingdom*. Vallentine, Mitchell, London, 1955.

WOOD, A.C., *A History of the Levant Company*. Oxford University Press.1935.

WOODS, JOHN E. (ed.), *Tarikh-i 'Alam-Ara-Yi Amini* written by Fadlullah b. Ruzbihan Khunji-Isfahani with the abridged English translation by Vladimir Minorsky: *Persia in AD 1478-1490*. Royal Asiatic Society, 1992.

WRIGHT, DENNIS, *The English Amongst the Persians: During the Qajar Period 1787-1921*. London, 1977.

YANG HONG, (ed.), *Weapons in Ancient China*. New York and Beijing, 1993.

YAR MUHAMMED KHAN, 'The use of artillery during the sultanate period', *Islamic Culture*, XXXV, 1961.

YOUNG, DESMOND, *Fountain of the Elephants*. London, 1959.

YOUNG, H.A., *The East India Company's Arsenals and Manufactures*. Oxford, 1937.

YULE, COL.HENRY and BURNELL, A.C., *Hobson-Jobson*. London, 1903.

ZAIDI, A. INAYAT S., 'Structure and organization of the European mercenary armed forces in the second half of eighteenth century India.' *Islamic Culture*, Vol. LXIII, Nos. 1-2, Jan-April 1989.

ZAKI, ABD AR-RAHMAN, 'Gunpowder and Arab firearms in the Middle Ages', *Gladius*, Vol. VI, 1967.

ZELLER, RUDOLF and ROHRER, ERNST, *Orientalische Sammlung Henri Moser-Charlottenfels*. Bern, 1955.

ZYGULSKI, Z., 'Oriental and Levantine firearms', in Pollard's *History of Firearms*, ed. C. Blair. London, 1983.

A NOTE ON TRANSLITERATION AND THE NAMES OF WEAPONS

READERS OF THIS BOOK will notice some variations in the spelling of weapons' names. One reason for this is the transference of the objects from one society to another, by capture or trade. For example, a specific type of gun may be created in Europe, pass to the Turks who in due course pass it on to Arab, Indian and Persian users who either modify the Turkish word to suit their own language or local pronunciation, or rename the gun entirely. Inevitably, descriptions by travellers vary and the manner in which they record an Arabic, Persian, Turkish or Indian word depends in the first instance on the level of their linguistic ability but usually reflects what they hear rather than the word as written in the original language. The word is then transliterated according to whatever system, if any, that the author followed. I am very aware that the diversity of spelling may point to variations in design or to the source of the named weapon. I have therefore standardised where possible within a given language but have left the variations of words like *tufek* or *tabancha* in the text. Readers will be aware that it is not considered proper to modify the spelling in a direct quotation.

Even in modern times there are a number of recognised and accepted transliteration systems which appreciably vary the spelling of a word. Islamic arms collectors tend to be conservative in their spelling, the generally accepted terms for weapons being based on a small number of mainly nineteenth-century authors such as Lord Egerton, whose book is widely available and remains a valuable source of information. His spelling of words from Near and Middle Eastern languages is frequently incorrect, or extremely old-fashioned by modern standards. The same applies to the excellent work of a fine Oriental linguist like William Irvine. Nevertheless, these spellings have gained widespread currency, particularly as a result of their use in auction house catalogues, giving them greater permanency than they deserve. I have tried to the best of my ability to correct this in the present book and trust that the reader will accept any apparently novel spellings of old familiar words.

NOTES

PREFACE

1 Blair, *Pistols...*, p.154.

2 G.T. Minadoi, *Storia della guerra fra Turchi e Persiani*, Venice, 1594, p.350.

3 David Harding's study of the firearms of the British East India Company is forthcoming.

INTRODUCTION

1 Ashtor, *Levant Trade in the Later Middle Ages*, pp.447-8.

2 Ayalon, p.94.

3 Klopsteg, p.12. As late as the early nineteenth century Mahmud II was also a great patron of the archers' guilds. For him Mustafa Kani wrote an important treatise on archery, *Telkhis Resail er-Rumat*, in order to revive the Tradition (*ihja' al Sunna*) in imitation of the Way of Muhammad. Kani cited forty Hadith or attributed sayings of the Prophet relating to archery before discussing every aspect of the bow.

4 Paterson, p.83.

5 Ayalon, 'Harb', *Encyclopedia of Islam*, 2ⁿᵈ edn, (*E.I.*2). The training of a janissary, designed to instil in the young icoglan absolute obedience to the sultan to the point of welcoming death for his sake, is described by Rycaut, a contemporary observer.

CHAPTER ONE

1 The same word is used in Arabic and Persian with different stress.

2 Mardi b. 'Ali al-Tarsūsi, *Tabsirat arbāb al-albāb fi kayfiyyat al-najāt fi'l-hurūb*. Translated and edited by Bernard Lewis in *Islam from the Prophet Muhammad to the Capture of Constantinople: I Politics and War*, p.218.

3 Henry Maundrell, p.156.

4 G.S. Colin, *E.I.*2, p.1055.

5 Partington, pp.32; 287-8.

6 Zygulski, p.427. After describing the Byzantine 'hand syphon' with its bronze tube, he writes: 'The Byzantine flame-thrower was the earliest of hand firearms...' The question of what constitutes a firearm is highly subjective but the assertion cannot go unchallenged, particularly since it comes from so learned a source. Zygulski's article was a pioneering work and remains one of very few to look at the subject in a scholarly and comprehensive fashion.

7 G.S. Colin describes how Hasan al-Rammah (died 694/1294) used the word *dawa'* (meaning remedy, drug, medicine) to describe the product of a formula he recommended to load a *midfa'*. His formula was 10 parts saltpetre (*barud*) 2 parts charcoal and 1.5 parts sulphur. Ayalon *et al.*, 'Barud', *E.I.*2, p.1056.

8 Needham, *Science and Civilisation in China*, Vol.V, pt.7.

9 Braudel, p.385, who refutes the views of Aldo Mieli expressed in *Panorama general de historia de la ciencia*, II, 1946, p.238, note 16. Braudel

describes European claims to have invented gunpowder as 'a kind of western nationalism'. This is consistent with the view taken in 1979 by Foley and Perry, (1979), who are dismissive of the pyrotechnic efforts traditionally attributed to Berthold Schwartz and Roger Bacon. Hime and Partington also dismiss Schwartz's claims.

10 Cipolla, p.104, records the earliest dated Chinese cannon known to him as 1356. Blackmore kindly informs the author that there is a Chinese cannon dated 1332 in the Museum of Chinese History, Beijing. Illustrated in Yang Hong, p.288.

11 For example, the metal stirrup originated in fifth-century China and passed to Europe via Central Asia and the Middle East. The Muslims had it in 74/694 (it appears in a fresco in the Umayyad castle of Qasr al-Hayr al-Gharbi near Palmyra in *c.* 730) and their armies went on to conquer Spain and invade France, reaching as far as Poitiers before recoiling in defeat in 115/733, when the Franks adopted it.

12 See Foley and Perry, who list other researchers.

13 My thanks to Graeme Rimer at the Tower Armouries with whom I discussed the implications of this event which is cited in 'Barud' by G.S. Colin in *E.I.*2. (See under Ayalon *et al.* in Bibliography.)

14 The earliest European illustrations of a cannon are to be found in the English manuscript of Walter de Milemete, chaplain to Edward III, written in 1326-7, which show arrows emerging from the barrels. The 'gun', a vase shape with a narrow neck, lies on a trestle table which is remarkably like those shown in Chinese illustrations from this period.

15 Lavin, *Spanish Firearms*, p.39, who cites Cayetano Rosell (ed.), *Cronicas de los reyes de Castilla* (Madrid: Imprenta de los Sucesores de Hernando, 1919), Vol.I (BAE Vol. 66), p.359: *Cronica de Alfonso XI de Castilla*.

CHAPTER TWO

1 This well known documentary evidence is discussed by a number of experts, including Ayalon, Zaki, p.54, and Braudel, p.387.

2 Conrad, from Basel, and an unnamed Dane, described by von Harff as Germans.

3 Letts, p.106.

4 Letts, p.104.

5 Serjeant, p.43.

6 Three Mamluk ship's cannons attributed to the fifteenth century are in the Military Museum, Istanbul. They are discussed by Zaki, p.52, and one illustrated by Bodur has a length of 73 cms and a calibre of 95mm. No A.148. According to Ashtor, the Venetian cogs which traded with Egypt had some cannon on board from the 1370s, while the Catalan galleys and Castilian ships had bombards from the early fifteenth century.

7 *Al-bunduqani* was one of the names by which the Caliph Harun al-Rashid was known – 'the man with the pellet-bow'; and the Mamluk

Sultan Baybars (reigned 1259-76) was so well known by his nickname *al-Bunduqdari* that Marco Polo refers to him by this name only, presumably in ignorance of his proper name.

8 Stowasser, pp.18,19. See also J.D. Latham's notes in *The Blowpipe in Europe and the East* by A.C. Credland, *Journal of Arms and Armour Society*, Vol.X, No.4, Dec. 1981.

9 Howard Blackmore tells the author that he has seen a fifteenth-century European tapestry which shows Western knights in a battle, with two negroes firing handguns in the centre.

10 Raydaniyya was used from the thirteenth century as an assembly point for Mamluk armies leaving or returning from the wars, and for the Meccan Pilgrimage.

11 See Bacqué-Grammont.

12 P.G. Elgood, 1931, p.86. Ayalon writes (p.138) that Mamluk sources provide no evidence of external influence on the development of Mamluk firearms, either European or Ottoman.

13 Ayalon, p.126, n.212.

14 *Sipahis* were light cavalry who held a *timar*, a designated grant of revenue from land owned by the Sultan. The *sipahi* provided his own horse and was armed with a bow, sword, shield, mace and lance. If the value of his *timar* was in excess of a certain figure he was also expected to wear armour and to provide a given number of armed horsemen (*cebelu*) – obligations such as the provision of a tent and additional men increasing with income. Provincial governors gained prestige by the numbers of *cebelus* in their retinues. In battle the *sipahis* took position on either wing of the army and encircled the enemy. A *sipahi* of the Porte was a member of the Ottoman sultan's regular cavalry. *Sipahi* were only recruited from the military class but included men of equivalent social standing from the newly conquered territories. From this term was derived *sepoy* by the British in India and *spahi* by the French in North Africa.

15 Raymond, p.346, details the various locations in Cairo where the arms-producing guilds and merchants sold their wares.

16 Windsor Castle; Vienna Waffensammlung; Victoria and Albert Museum; Musée de l'Armée; Real Armeria di Torino; Wallace Collection; Metropolitan Museum, New York; Askeri Museum, Istanbul, etc. and in private collections. See The David Collection, *Islamiske vaben i dansk privateje* Nos 40 & 41, p.84; and Alexander, No.73, p.128; and Messillier and Ricketts Nos 42 & 43, for illustrations of the type.

17 Planche CXXIII, 3.

18 Raymond, pp.344-6.

19 Pococke, I, p.175.

20 Wood, p.192.

21 Lane, p.319.

22 Hatch, pp.144-5, who records that after Samuel Remington's death the palace was sold to the British government who used it for entertaining official guests until 1952.

23 Egerton, p.158.

24 See for example Env. 8765 in the Askeri Museum, Istanbul.

CHAPTER THREE

1 Karoly, p.167.

2 Petrovic, p.169.

3 Wittek, Appendix II in Ayalon, *Gunpowder and Firearms in the Mamluk Kingdom*.

4 Daskalov and Kovacheva, p.9. The author has been unable to examine this piece, which is in the Museum fur Deutsche Geschichte, Berlin.

5 Mayer, p.82.

6 Petrovic, pp.179-80.

7 L.Beritic, *Dubrovacka artiljerija* (Dubrovnik Artillery), Belgrade, 1960, is cited by Petrovic.

8 Le Strange, in his translation of *Clavijo's Embassy to Tamerlane 1403-1406*, p.288, describes how Timur carried off to Samarkand the craftsmen of the countries he defeated and that after the battle of Ankara in 1402: 'From Turkey he had brought their gun-smiths who make the arquebus.' The original Spanish, as given by Francisco Lopez Estrada in *Embajada a Tamorlan*, is 'E dela turquia e lenó vallesteros' (p.207, line 31). How Le Strange, regarded as a competent Islamicist, came to confuse crossbows with arquebuses becomes clear from his Preface, in which he describes working from a secondary source.

9 Parry, 'Barud' p.1061.(See under Ayalon *et al.* in Bibliography.) It is interesting to compare the adoption of firearms in the Ottoman armies with the armies of France and England. At the battle of Agincourt in 1415 the French had some cannon but the battle was won by the English archers and there is no indication in this encounter of the future importance of the technology. The first regular unit of English troops, the Yeomen of the Guard, formed after Henry VII's victory at Bosworth in 1485, was armed with bows and arquebuses in equal part. Artillery first became a major mobile element in European warfare when Charles VIII of France invaded Italy in 1494. Henry VIII of England (1509-47) had a collection of hand-held firearms and the records tell of a target being set up for the king to shoot at. Henry VIII's personal guns were kept in velvet bags in similar fashion to the Ottomans' and Mughals'. The inventory of the king's guns describes very colourful weapons, covered in velvet with silver studs, or bright coloured varnish, and decorated with inset bone or stones. Some of these were Italian. According to Blackmore, Henry VIII imported Italian matchlocks for military use and some of these were recovered from the *Mary Rose*, which sank off Portsmouth in 1545.

10 Wittek, p.142.

11 Taliacozzo, cited by Petrovic, p.194. A cannon, now broken up, signed *Khidr who made it in 863/1458-9*, is recorded by Mayer.

12 Parry, 'Barud' p.1061.(See under Ayalon *et al.* in Bibliography.)

13 See Petrovic.

14 Petrovic, p.186. According to Mallett, the Emperor Sigismund had 500 *schioppettieri* in his entourage on his visit to Rome in 1430.

15 Petrovic, p.187.

16 Mallett, p.156.

17 With certain exceptions all the Christian youths of the European domains of the Ottoman empire, and later the Asiatic domains, were liable to *devshirme*, the term for the periodic levy of children to fill the ranks of the janissaries. The age of those taken ranged between 8 and 20. See Menage. For a fourteenth-century account of the origin of the janissaries or 'new troops' see Lewis, p.226. Though Muslims could not be made slaves, the Muslims of Bosnia requested that their children be eligible under the system. The best of the janissaries recruited through the *devshirme* system came from Albanian Christian families. *Devshirme* ended in the eighteenth century. The janissaries were members of the Bektashi Sufi order, which inspired an added indifference to death as a *ghazi* or warrior for Islam. See J.K.Birge, *The Bektashi Order of Dervishes*, 1994.

18 Mallett, p.157. Vale (p.136) states that the French army gave up the crossbow in 1567. As late as 1550 the crossbow was included in Regulations of the Casa de Contractacion of Seville, which specified the armaments required by law for merchant vessels sailing to the Indies.

19 See Braunstein.

20 Deroko, p.39.

21 Accounts of the numbers of the janissaries vary but the growth was approximately as follows: 27,000 during the reign of Murad III (1574-95); 45,000 under Mehmed III (1595-1603); 47,000 under Ahmed I (1603-17); 54,000 under Mehmed IV, according to Marsigli in 1680. Increasingly inclined to reactionary political interference and mutiny, the janissaries were wiped out on 15 June 1826 by Selim III and the name was proscribed.

22 *Suleymanname* Topkapi Sarayi Museum. H.1517. 45b ff. 219b-220a.

23 Guilmartin, p.147.

24 Codex MS. 3069

25 Cited by Ranke, p.20.

26 Blair writing in Peterson, *Encyclopaedia*, p.157.

27 Lavin, p.44.

28 Wittek, p.143.

29 Cited by Morin and Held.

30 See *Navigations...* published with various titles in 1568, 1576 and 1586. The author's illustration is from the first edition.

31 Nicolay, p.83.

32 See for example a Thuringian wheellock target rifle, dating from the last quarter of the sixteenth century. Lot 75 in Sotheby's sale of the Hever Castle Collection of Arms and Armour, 5 May 1983.

33 EMB9.

34 Copenhagen No.b.412. This gun is illustrated by Blackmore, *Guns and Rifles...*, No.52.

35 Mother-of-pearl also began to appear on European guns about 1580.

36 See, for example, Miller illustrations 53 a & b, and 66. A comparison with Ottoman inlaid wooden objects would make an interesting study.

37 Bailey and Nie, p.25.

38 The use of pear is cited by Zygulski, p. 432.

39 Ayalon, pp.96-7.

40 Mallett, p.158.

41 Parry, 'La Manière de combattre', p. 225.

42 Parry, 'Barud', p.1061.(See under Ayalon *et al.* in Bibliography.)

43 Victoria and Albert Museum, No.M.12-1949. The gun also has a French museum mark (MA 775) dating prior to 1815. Lenk lists items from the the 1729 inventory of known location. Under Inv. No.3 appears 'Trente quatre arquebuses toutes simples, de 6 pieds de long ou environ.' Louis XIII was born in 1601 and reigned from 1610-43. From an early age he was an enthusiastic gun collector.

44 Balbi, p.50.

45 Parry, 'Warfare', p.838.

46 *Discorsi Militari dell' Eccellentissimo Signore Francesco Maria I della Rovere Duca d'Urbino*, Ferrara, 1583.

47 Williams, A.R., pp.114-20.

48 These were renewed in 1569 and 1604.

49 The French population was ordered out and received a remission of taxes for ten years for the inconvenience.

50 Codex Austriacus, i, 248-9, cited by Parry, 'Barud'.

51 Nicolle, p.19.

52 The Swiss in the sixteenth century had a saying that 'it was not right he should ever want bread who had steel in his grasp'.

53 *Gendarmes* and *chevaulegers*. These formed into *batailles*, compact masses several ranks deep which charged *en masse* with the lance. Shock tactics, used in the Crusades, were effective against a rabble but against disciplined infantry resulted in a century and a half of defeats: Crécy, Poitiers, Agincourt against the English; Granson and Morat against the Swiss pikemen; and Nicopolis against the janissaries. The castle of Bonaguil in the Lot valley, built in 1480-1520, the last in traditional style but with some cannon and matchlock embrasures, is a symbol of French reluctance to acknowledge the firearms revolution in warfare.

54 See Forissier.

55 According to the French, the English bribed the sultan and his grand vizier, and also suggested that the queen and the sultan held common religious objection to Spanish Catholic idolatry.

56 Boxer, p.159.

57 *Chikinoes* – Venetian sequins – a gold coin.

58 William Parry, *New and Large Discourse*, 1601 (privately reprinted 1864), p.7.

59 Parry, 'Materials of War', p.226.

60 Foster, *Sanderson*, p.283.

61 Foster, *Sanderson*, pp.157 and p.262.

62 Rycaut, II, p.94.

63 See for example Marsigli, II, p.15.

64 Rycaut was secretary to the English ambassador at Istanbul during the sultanate of Muhammad IV (1648-87) and was the author of a history of Turkey.

65 Rycaut II, p.89.

66 Coruhlu, p.10.

67 Nr.72, S.1367. 'Ein Janizschar Rohr, mit silbern lund zündt strick, sambt beschlagen, Ladstecken mit silber'. My thanks to Holger Schuckelt for these details.

68 Inalcik, 'The socio-political effects...', p.200.

69 Daskalov and Kovacheva, p.17.

70 Inalcik, 'The socio-political effects...', p.198.

71 Rycaut, I, p.99.

72 Feher, p.13.

73 Rouillard, p.78.

74 Temesváry, p.40.

75 According to Luis Collado, *Pratica Manuale di Arteglieria*, Venice, 1586, 'the cannon founding of Genoa is the worst in Europe'.

76 Guilmartin, p.154.

77 Showcase 13, k-181.

78 Setton, IV, p.1076.

79 Arnold von Harff gives a very detailed description of the Arsenal in 1497, part of which is given here: 'a great hall thirty feet wide and quite a hundred feet long which is full of arms hanging on both sides in three rows, one above the other, very orderly disposed, with everything that belongs to a soldier, such as a coat of mail, a sword, a dagger, a spear, a helmet and a shield. In addition, as part of the arrangement of this hall, there are stored there more than 3000 or 4000 swords, daggers and innumerable numbers of long pikes, with many more accoutrements for war, and above in the roof are crossbows hanging side by side touching each other, six rows deep.' Von Harff continues, '...we went further into another building in which were very fine cannon, namely five main pieces of copper. They measured by one of my feet twenty-four feet long, and each cannon had three pieces which could be screwed into each other. As we were about to look into one of them, out crept a boy with a vegetable basket, who had hidden himself in it.' This cannon fired a thousand-pound stone ball. The Venetians obtained the stone from the island of Brioni. Other cannon are described.

80 *Bilanci della repubblica di Venezia*, Vol. I, Book I, pp. ccix-ccxv.

81 Serjeant, note J, p.171.

82 Rycaut, II, p.94.

83 Inalcik, 'The Socio-political effects...', p.197.

84 Bakhit, p.165.

85 See Faroqhi for information on Ottoman trade in the sixteenth and seventeenth centuries.

86 Evliya Chelebi, II, p.56.

87 Blair, *Pistols of the World*, p.5.

88 A firestone was iron pyrites, sometimes known as fools' gold, and not flint which came into use later and with a different ignition mechanism.

89 Hayward, I, p.79, who comments that the fact that the chronicler felt the need to explain the mechanical action of the lock is indicative of the newness and rarity of the invention. Hayward's sources are J. Schön, *Geschichte der Handfeuerwaffen*, Dresden, 1858, p.47; 'Pauli Jovii von Com, Bischofs von Nucera wahrhaftige Beschreibung'; Lyon, 1555'.

90 Busbecq, de, I, p.243.

91 See Neck and others.

92 Temesváry, p.31, citing Ignac Tragor, *Vác tortenete* (History of Vác), Vác, 1927, p.53.

93 Foster, *Roe...*, p.21.

94 The Turkish enjoyment of clocks and automata continued to the nineteenth century. The author was particularly amused in 1977 to note the presence in Konya, home of the whirling dervishes, of an English bracket clock which played the hornpipe.

95 An Indian example attributed to the second half of the eighteenth century from Central India (?) is published by Blair, *Pistols of the World*, No.788. The Japanese even produced matchlock revolvers; an example can be seen in the Metropolitan Museum of Art, New York.

96 Bent, *Dallam's Travels*, p.32.

97 Coruhlu, p.8, n.29 gives the reference: *Seyahatnamesi*, Istanbul, 1984, p.1076.

98 One is reminded of the reluctance of the British cavalry to give up their horses and replace them with tanks in the period prior to the Second World War.

99 Rycaut, II, p.88.

100 Correia-Afonso, p.147.

101 Correia-Afonso, p.145.

102 Correia-Afonso, p.139. This manner of carrying sword and axe or mace appears to have been widely adopted by the Turks. Dr John Covel describes a parade of janissaries at Adrianople in 1675 in which 'every horseman, let him be who he will' carries the sword fixed to the saddle under the left thigh and the axe fixed to the pommel 'over his right knee' (Bent, *Covel's Diaries*, p.199).

103 See Elgood, 1994.

104 Parry, 'La manière de combattre', p.228.

105 See C. Blair, 'A note on the early history of the wheellock'; also Morin, 'The origins of the wheellock: a German hypothesis'.

106 There is an inconclusive reference in Evliya Chelebi (II, p.48) which may indicate that combination weapons were produced in Trebizond. After praising the goldsmiths from the time of Sultan Suleyman for 'swords, daggers and knife handles in most wonderful perfection', the 'most famous in the world', Chelebi remarks that 'the hatchets of Trebizond are a new and clever invention'. It is difficult to conceive of any new form of axe that might justify the epithet of 'new and clever' except a combination weapon, a firearm being the most likely choice. Such a possibility remains entirely speculative and one notes European examples of combined axe and wheellock, for example in the armoury of the Palazzo Ducale in Venice (Inv. L 4.), which are dated approximately a century earlier. Another German example dated 1551 on the barrel belonged to Philip II of Spain and is in the Real Armería, Madrid (K.60). A selection of seventeenth-century European flintlock examples are illustrated by Blackmore in *Guns and Rifles of the World*.

107 Coruhlu, p.11. The *tughra* came originally from the Seljuks.

108 I am indebted to Tulin Coruhlu for sending me her published research on Turkish gun marks.

109 Bodur, Ao A.183, where the Christian date is given wrongly as 1667.

110 Keith Neal, 1955, p.9, remarks on the Kurdish miquelet locks, which are manufactured from Spanish prototypes.

111 Rycaut, II, pp.164 and 189.

112 Morin and Held, p.109. The lock was new only in that it was intended for general military use. Louis XIII owned a gun with flint and matchlock signed 'F du clos' (François Duclos, Paris) which dates from about 1636. It is in the Musée de l'Armée, Paris, M 410. See also M 411 for a plain example of the same date.

113 Gaier quotes (p.57) a note from Liège dated 3 April 1688. 'Our merchants have left for the fair at Frankfort with a great quantity of fire-arms, for which they expect there will be a very good market in view of the progress of the Imperial armies in Hungary and of the Venetians in the Levant, Frankfort being a place through which all the troops involved must pass.'

114 Marsigli, p. 25.

115 Elgood, 1994, p.46.

116 HMD G.G. 1174; Ehrenthal: G.G.1174. Schobel, p.227 and illus. 168.

117 Under Ahmed III European baroque and rococo had their first impact on Ottoman art and architecture. Inspired by the reports of his ambassadors to France, Ahmed III built a miniature Palace of Versailles outside Istanbul.

118 See Borsos.

119 The old system of transfer of population known as surgun or exile had been used on a large scale by the Seljuks, and the Ottomans encouraged immigration into the Balkans.

120 Daskalov and Kovacheva, p.45. This is the Balkans' equivalent of the German kolbenlade.

121 Rogers, plate 46.

122 Rogers, p.28.

123 The most famous object in this group is the dagger with three large emeralds as a grip and a clock set in the pommel. This can still be seen in the Topkapi Sarayi Museum Treasury. On the very day that these gifts crossed the border into Iran Nadir Shah was assassinated and the embassy hurriedly withdrew.

124 Gaier, pp.56-7.

125 Forissier, p.9.

126 Alm, pp.102-3.

127 Anon, A Description of Holland ..., p.125.

128 Ibid., p.236. 'And what is more, during the two last general Wars, Lewis XIV who thought to carry every Art and Manufacture to its highest Perfection, and particularly all that appertain to the Art Military, was obliged to the Gunsmiths and Founders of Amsterdam, the Metropolis of an Enemy, for Arms and Ammunition for his troops.'

129 Ibid., p.237.

130 The price ranged from 16 shillings down to one shilling and two pence.

131 Alm, pp.103-5.

132 Gaier, p.55.

133 Alm, pp.107-8.

134 Alm also states that in the early nineteenth century lazarinos were manufactured in Liège for export to Brazil and these often bear the inscription Rio Real Imperio do Brazil.

135 See Elgood, The Arms and Armour of Arabia, p.42.

136 Clement Bosson, writing in Peterson's Encyclopaedia.

137 The following names or marks appear on these guns. Nicolas Carteron's mark; P.Girard; I(?) Chapelon; Jourjon; Benoit Selion; PG; S.T.Rovlier; CG; D.Ladet. All these four arms are approximately 146 cm. long; the length of the barrel is 108 cm. and the calibre is 18 mm. Their weight varies between 3.5 and 3.75 kilos. The fifth gun was made by Jourjon and resembles the first two but is longer by 10.5 cm. and has a calibre of 19.4 mm. It weighs 4.54 kilos.

138 De Warnery, p.20.

139 In 1715 an amendment to the treaty signed by Sultan Husayn of Iran and Louis XIV in 1708 gave the Iranians the right to maintain a consul in Marseilles.

140 Beaujour, Commerce, ix. It is clear that in Beaujour's mind, Greeks and Turks are commercially one and the same.

141 De Warnery, p.82.

142 De Warnery, p.24.

143 See Nicolle.

144 National Army Museum, London. Acc. No.7711-107. Press No. 198-14. Costume militaires Turcs. 1826.

145 Coruhlu, p.33.

146 Morin and Held state that these were made in Gardone, which is perfectly possible, but the certain place of manufacture was Liège.

147 Gaier, p.81.

148 Gaier, p.58.

149 Gaier, p.103.

150 See, for example, Sotheby's Hever Castle Collection sale of Arms and Armour, 5 May 1983, Lot 82 for a presentation pair of Boutet pistols in Oriental taste, circa 1820.

151 7 March 1966, Lot 207. Philip Rundell was goldsmith and jeweller to George III. The partnership made highly decorated weapons for the Eastern market.

152 Gaier, p.103.

153 Forissier, p.24.

154 Wood, p.193.

155 Beaujour, II, pp.94-5.

156 Beaujour, II, pp.293-4 who estimates consumption of these arms, based on an annual average from 1787-97 at an approximate sum of 25,000 piasters, equal at that time to £5,000. A rough calculation based on all these figures suggests approximately 8,000 'firelocks' and 16,000 pistols per year were being imported into Greece from Brescia.

157 Marco Cominassi, 'Cenni Sulla Fabbrica d'Armi di Gardone in Valtrompia', in the Giornale dell' Imperial Regio Instituto Lombardo di Scienze, Lettere e Arti, 1845. Cited by Morin and Held, p.189.

158 Morin and Held, p.196.

159 Morin and Held, p.206.

160 Russell, p.184. Colonel Minié was an instructor at the French Military School at Vincennes. He devised a bullet with a hollow base intended to fit the barrel more efficiently when driven forward by the force of the charge on an iron cup set in the base. The rifle was immediately adopted by the French and shortly after by the British army where it was known as 'Rifle Musket, Pattern 1851'. Although it was superseded by the Enfield long before all the the British regiments had received it, most of the infantry battalions that left England for the Crimea in 1854 were equipped with it.

CHAPTER FOUR

1 Boxer, p.209.

2 *The Qur'an*, 'Battle Array', Sura 61:4.

3 See Mackay; and De Coca Castaner.

4 For an example see Real Armería, Madrid, K.126. Patrimonio Nacional, Madrid, illustrated in Lavin, p.177.

5 See, for example, Hoff, p.19, illustration 9.

6 Lavin, *A History of Spanish Firearms*, illustration 69.

7 Hoff, writing in Peterson, *Encyclopaedia*, p.18.

8 Better known in Europe as Leo Africanus, he had the misfortune to be captured by pirates who sold him as a slave to Pope Leo X (Giovanni de' Medici). The pope persuaded him to become a Christian and stood sponsor at his baptism in 1520.

9 Colin, 'Barud' p.1058.(See under Ayalon *et al.* in Bibliography.)

10 Balbi, p.111. Much the best account, however, of Moroccan firearms is an unpublished manuscript by H. Hopkins.

11 Colin, 'Barud' p.1058.(See under Ayalon *et al.* in Bibliography.)

12 Alarmed at the activities of Philip of Spain, al-Mansur approached Queen Elizabeth of England with a view to invading Spain, but the death of both in 1603 ended the project.

13 Lenk, p.33.

14 Hayward, I, p.128.

15 See Hayward, I, p.275.

16 Inv.2223. See Boccia and Godoy, II, p.534, No.1037, and illustration, p.790.

17 Hoff, citing F. ten Raa and F. de Bas, *Het staatsche Leger*, I, Breda, 1911, p.289.

18 Stern, p.83.

19 PRO. LC5/16, 51. Cited by Blackmore, *Royal Sporting Guns...*, p.2.

20 PRO. LC 5/44, 229-30. Blackmore, op.cit.

21 Hoff, writing in Peterson, *Encyclopaedia*, p.18. No reference is provided for this information.

22 St Olon, p.141.

23 St Olon, p.113.

24 St Olon, p.149.

25 See Hayward, II, p.260.

26 No.207, illustrated by Hoff, p.72.

27 Hoff, p.163.

28 No.58-1871.

29 Colin, 'Barud', p.1058.(See under Ayalon *et al.* in Bibliography.)

30 For example, Hasan Veneziano, who dominated Algeria at the end of the sixteenth century.

31 Kea, p.187.

32 Known as a 'flute' or fly boat by the English. Boxer, p.22.

33 See Niels Arthur Andersen, 'On some political Gold Yataghans from Algiers and Tunis', in *Vaabenhistoriske Aarbøger*, XIII, (Copenhagen, 1966) for an account of Danish arms deals with the corsairs of Algeria and Tunis in an effort to liberate Danish seamen and protect Danish merchant shipping.

34 Blackmore, *Firearms*, pp.71-2.

35 Armería Real de Madrid. Showcase E. M-56, 57, 58, 59.

36 Maurice Forissier to the author.

37 Illustrated in Lacaci, p.139.

38 In 1560 Thomas Lenche of Marseilles obtained a monopoly of the coral fishing between Cape Roux and Bougie and the right to establish a factory at the Bastion de France, west of La Calle. The Algerians seized this in 1568. Recaptured, it was lost again to the Algerians in 1604. A Corsican from Marseilles reached agreement with the Algerians in 1628, which lapsed on his death in 1633. A new agreement was concluded in 1640. At the beginning of the eighteenth century, the French companies of Tunisia and eastern Algeria united as the Compagnie d'Afrique.

39 4 pairs, North Corridor Catalogue, Nos. 741, 743, 745, 749.

40 HMD Y 341; Inv.3 Buchsenkammer, 1683, p.517; Ehrenthal: J245. Published and illustrated by Schobel, p.229. Length: 159.5cm. Barrel: 124cm.

41 My thanks to Holger Schuckelt for supplying the notes on this gun; and for confirming that notes were added to the 1683 Inventory, in this case after the presentation in 1697.

42 See Ashtor, 1983, for many references to the trade.

43 Gille, Plate CXVIII 2 & 3.

44 Sir Anthony Sherley, while serving as Spanish Admiral of the Levant Sea, devised a hare-brained scheme in which he attempted to recruit Ward and two other pirate captains to serve the King of Spain in an attack upon the Turks in 1608.

45 Letts, p.81.

46 Colin, 'Barud', p.1058.(See under Ayalon *et al.* in Bibliography.)

47 Fisher and Rowland, p.226, n.84.

48 Stone, p.258.

49 For a lock made by Mortimer, see Catalogue No. 96.

50 Blackmore, *Dictionary of London Gunmakers*, p.146.

51 Zygulski, p. 442, who does not give the source.

52 Morin and Held, p.206.

CHAPTER FIVE

1 See Spring, pp.31-2, for a discussion of firearms and Sudanic warfare. He makes the interesting point that weapons made obsolete by the adoption of firearms in the forest kingdoms of West Africa tended to survive only as ritual objects. This is not the case in the Islamic world

where the traditional weapons retained their original practical function until the twentieth century.

2 It has been suggested that in about 1425, Uthman Kalnama, a refugee from Bornu, brought the first gun to Kano.

3 Ahmed ibn Fartuwa, p.11.

4 The subject is discussed by Fisher and Rowland as part of an excellent and comprehensive article on Sudanese firearms.

5 See Fisher and Rowland, who discuss this point.

6 Nachtigal, III, p.370.

7 Nachtigal, III, p.367, cited by Fisher and Rowland.

8 Nachtigal, II, p.72.

9 See Smaldone, 'Firearms in Central Sudan', p.593.

10 The trade in guns with West Africa was huge. The Royal African Company between 1673 and 1704 exported 66,000 firearms and 9,000 barrels of gunpowder. Between 1701 and 1704, 32,954 small arms were sent. See K.G. Davies, *The Royal African Company*, London, 1957. In 1829 Britain exported 52,540 guns and pistols to West Africa. Trade guns also came from other nations including Holland and Brandenburg.

11 Kea, p.199.

12 Kea, p.199, n.95.

13 Bailey and Nie, p.114.

14 Smaldone, op.cit., p.593.

15 Burckhardt, *Travels in Nubia*, describes how three thousand Solingen sword blades were bought annually at Cairo by the southern traders who disposed of them at Shendy, a major market for the slave trade. Fifty years later they were trading in cheap Belgian percussion guns, also acquired in Cairo.

16 Fisher and Rowland, p.223.

17 Vischer, cited by Fisher and Rowland.

CHAPTER SIX

1 The author refers readers to his book *The Arms and Armour of Arabia*, where he discusses firearms in Arabia at greater length.

2 Cited by G. P. Badger in *The Travels of Ludovico di Varthema*, p.65, fn.1. The text comes from a history of the Yemen in Badger's possession entitled *Kurrat el-Ayun*.

3 Hansen, p.249.

4 Wellstead, I, p.52.

5 Burckhardt, *Bedouins*, p.134.

6 Lady Anne Blunt, I, p.339.

7 Bell, *Letters*, 14 April 1911.

8 Pococke, II, p.98.

9 Burton, II, p.239.

10 Kinglake, p.10.

11 Burckhardt, *Bedouins*, p.134.

12 Correia-Afonso, p.81.

13 Wyman Bury, *The Land of Uz*, London, 1911, p.299.

CHAPTER SEVEN

1 Guilmartin, p.139.

2 Morin, p.91.

3 Daskalov and Kovacheva, p.18.

4 Daskalov and Kovacheva, p.18.

5 Zygulski, p.436.

6 Steingass, p.774.

7 Colin, 'Barud', p.1058.(See under Ayalon *et al.* in Bibliography.)

8 See Elgood, *Arms and Armour of Arabia*.

9 Daskalov and Kovacheva, p.19.

10 Daskalov and Kovacheva, p.17.

11 De Warnery, p.30.

12 Temesváry, p.42.

13 Hobhouse, p.138.

14 Information cited here on Montenegro is taken from the catalogue written by Mrvaljevic and Djurisic (see Bibliography).

15 A *yataghan* is a kind of sabre which varies considerably in length but is shorter than the usual European sword and is worn thrust through the sash or belt. It was used throughout the Ottoman empire. See Sercer.

16 Petrovic, p.170.

17 See Bartlett Wells.

18 Bequest of George C. Stone, 36.25.2219, Length 62⅞ in.

19 Gift of Mrs William E. S. Griswold, Mrs William Sloane and John Sloane, 43.82.4. Length 67 in.

CHAPTER EIGHT

1 Stone, p.259.

2 See Ivanov.

3 Chirkov, p.128.

4 See Baddeley. *The Russian Conquest of the Caucasus*. 1908

5 Baddeley p150 n.1. 'Yet the most treasured blades were of foreign make – mostly Italian.'

6 A monumental study of the *Silversmiths and Armament-Makers of the Caucasian Region in the XIX and early XX Centuries* appeared in 1977-8, written by E. G. Astvatsaturijan and published in Russian in four parts by the Academy of Science, Caucasian Institute, USSR. The work lists all the principal craftsmen and gives details of their place of work and specialisation. Unfortunately the publication is not illustrated and it deserves to be re-published in a more accessible form when it would surely gain the scholarly recognition that it rightly deserves. My thanks to Dr. A. Ivanov for supplying me with these volumes when first published.

7 *Caucasian Weaponry*, published by the State History Museum, Moscow.

8 A band holding the barrel of the gun to the stock. The word is French but in the absence of an equivalent is used also in English.

9 Blair, 1968, illus. 812, taken from the Bernisches Historisches Museum, Bern. No. 406. This pistol dates from the late nineteenth century.

10 V & A Museum, 630-1911, cited by Blair.

11 Egerton, p.140 and n.3.

12 Grancsay, 1935. The word *Bab* means gate and is the title conferred on those who were believed to have had access to the Twelfth Imam

during his seclusion. Sayyid 'Ali Muhammad declared himself to be the long awaited Mahdi in 1260/1844 and led a popular movement against the incompetent Persian government. See Browne.

13 Palgrave, p.72.

14 Palgrave, p.85.

CHAPTER NINE

1 Burckhardt, *Travels in Syria*, Appendix 1, p.640.

2 Ker Porter II, p.487.

3 A more provocative and injudicious remark to drop into casual conversation in Kurdistan would be hard to conceive.

4 Burckhardt, *Travels in Syria*, Appendix 1, p.643.

CHAPTER TEN

1 Bausani, p.138, who unfortunately does not give any references for the origin of this information.

2 See S. Digby, p.80. I regret that I have been unable to obtain a copy of A. M. Belenitsky, 'On the appearance and spread of firearms in Central Asia and Iran in the 14th-16th centuries', published in the *Izvestiya* of the Tajik branch of the Academy of Sciences of the USSR, 1949, No.15, 21-33. A note of the content appears in Woods, p.99.

3 Mrs Meer Hassan Ali, p.49.

4 Le Strange, p.288.

5 Woods, p.98. My thanks to Dr Sandy Morton for bringing this publication to my attention.

6 Minorsky, *La Perse au XVe siècle*, pp.13-14. Mehmet Fatih took prisoner 3,000 Turcomans from the Aq Qoyunlu army and executed them in batches of forty at intervals on his march back to Istanbul.

7 Le Strange, p. 98.

8 See Minorski, *A Civil and Military Review...*

9 See *A Narrative of Italian Travels in Persia in the 15th and 16th centuries*, London, 1873, p.153. See Woods, pp.98-100 for other Aq Qoyunlu cannon references.

10 This unfinished painting is inscribed to the Timurid painter Bihzad but is more likely to be by one of his followers. It is to be found at Harvard University Art Museums (Arthur M. Sackler Museum), Bequest of the Estate of A. A. Rockefeller, 1960.199 and is published in *Timur and the Princely Vision*, L.A. County Museum, 1989, Cat. No.135.

11 See Ayalon, 1956 p.118, n.84 on the role of small arms and cannon at Chaldiran. Ayalon cites two historians' widely differing estimates of the numbers of Ottoman arquebusiers engaged in the battle. The figures are 13,500 and 4,000.

12 Described as the supreme manifestation of the Persian mind in the religious sphere.

13 Topkapi Archives, E 574.

14 Bacqué-Grammont, p.167.

15 Savory, 'Barud', p.1068. (See under Ayalon *et al.* in Bibliography.)

16 *Babur Nama*, folio 347, p.622.

17 'A chronicle of the Carmelites' 1, 29.

18 Savory, 'Barud', p.1066. (See under Ayalon *et al.* in Bibliography.)

19 D'Alessandri, Venetian Ambassador, who reached Persia in 1571.

20 Dale, 1994 p.78. The Russians were regarded as uncouth barbarians by the sophisticated Indian and Persian merchants who dominated the Astrakhan trade. Apart from Afanasy Nikitin, who visited India in the fifteenth century, few Russians travelled abroad and the first Russian embassy to India was sent as late as 1646. The degree of transference of arms technology is difficult to assess, but the Russians used large numbers of Swedish mercenaries in 1610.

21 A type of pistol.

22 Delmar Morgan, p.405. The shah also asked for 'six stone bowes that shoot lead pellets'.

23 Delmar Morgan, p.435.

24 The arms historian Z. Zygulski is critical of Hans Stocklein's remark in A. U. Pope's *Survey of Persian Art* that 'Firearms did not come into general use in Persia until very late in the sixteenth century and they were not highly valued...' As a statement of general principal Stocklein is correct. See Zygulski, p.444. Firearms were in limited use in Iran from the beginning of the sixteenth century. However, as modern Safavid historian Professor Savory asserts,'the Persians had an innate dislike of firearms, the use of which they considered unmanly and cowardly'.

25 Denison Ross, p.163.

26 Foster, *Roe...*, p. 259.

27 Lavin, p.266, No.61. Having discussed this with James Lavin he subsequently found a contemporary note in the 1594-1652 Inventory of the Real Armería which was not available in 1965 when he wrote *A History of Spanish Firearms*. His letter states; 'In the first section (1594), on fol. 76r., appears the entry, "In front of this Case above the recesss of the Window there is a lance rest that holds ten long arquebuses two of them with stocks of staghorn." Besides this, a marginal note states: "*Note* These ten arquebuses are among those that HM (Felipe IV) ordered taken (not sent) to Persia by decree of the Duke of Lerma dated 22nd January 1614 by which..." .' Unfortunately at this point the handwriting of the original note becomes indecipherable.

28 Denison Ross, p.163.

29 Lockhart, p.135.

30 Sanson, p.55.

31 *Purchas His Pilgrimes*, VIII, London, 1905, pp.409-10.

32 Foster, *Herbert*, p.298.

33 Savory, p.418.

34 Allen, II, p.268.

35 For example, see Abel Pinçon, *Relation d'un voyage de Perse...*, Paris, 1651; Denison Ross. p.163; and Allen I, p.268, where it is noted that Persian merchants were usually limited to 10-50 cuirasses, with one instance only of 120 being authorised by the Russian ruler for export to Persia.

36 Foster, *Herbert*, p.247.

37 Denison Ross, p.222.

38 Denison Ross, p.153.

39 Correia-Afonso, p.103.

40 Evliya Chelebi, II, p.152. The point is a fine one, but if the Persian guns were of similar length to those of the Turks there would appear to be no reason to comment on the length.

41 Rycaut, I, p.122.

42 Other writers have suggested that the Persian barrels were lighter than the Turkish ones, but there seems no evidence to support this.

43 Sykes, p.271.

44 Burckhardt, *Bedouins*, p.134.

45 Benjamin, p.304.

46 Col.Yule observes in *Hobson-Jobson* that *gingals* are in use with Europeans in China also. See Kashmir and Kashgar below.

47 T.E. Colebrooke, *Life of Mountstuart Elphinstone*, Vol. II, London, 1884, p.31.

48 Sita Ram, p.89.

49 Gray, p.81.

50 'Arithmetic on the Frontier', *Departmental Ditties and Other Verses*, Lahore, 1886.

51 Steingass, p.819; 'a slap or a blow; a pistol'.

52 Meen and Tushingham, p.91.

53 Wright, p.50.

54 Wright, p.53, quotes a suggestion by the crown prince that Iranian officers should be sent to India for training. Hastings, the governor-general, rejected the proposal on the grounds that they 'would afford to the Native Corps an example of arrogance, licentiousness and depravity which might produce a baneful influence on the discipline and moral character of these Corps'.

55 Malcolm, II, p.366.

56 In his *Geographical Memoir of the Persian Empire*.

57 Jakob Polak, *Persien, das Land und seine Bewohner*, Leipzig, 2: p.172.

58 See Sengers for photographs.

59 Bailey and Nie, p.92.

60 Wright, p.98.

61 Upton, p.93.

62 Burrell, p.10.

63 See Elgood, *The Arms and Armour of Arabia*, for details of this trade.

64 Muskets with the rest, two prongs hinged from the forestock, are known as *milteq*.

65 Murav'yov, pp.155-6.

66 Vambery, p.117.

67 See Balsiger and Klay; and also Zeller and Rohrer.

CHAPTER ELEVEN

1 See Dikshitar, pp.101-96, for a discussion of Vedic literary sources and interpretation. More recently, Sarva Daman Singh, writing in *Ancient Indian Warfare*, does not mention the subject.

2 Eliot and Dowson, VI, p.481.

3 Oppert's findings have been largely ignored by modern scholars, in part because of the difficulties of combining expertise in Sanskrit with the Islamic and Chinese languages.

4 The subject of Chinese gunpowder has been examined by Needham. His expert advisor on firearms was Howard Blackmore of the Tower of London.

5 cf. *L'Inde Classique*, ed. L. Renou and J. Filliozat, Paris, 1953, II, p.126.

6 cf. A. B. Keith, *A History of Sanskrit Literature*, London, 1966, p.464.

7 Tod, II, p.134, refers to the use of rockets (*bhan*) in Rajasthan in the early nineteenth century – 'a very ancient instrument of Indian warfare, and mentioned long before gunpowder was used in Europe'. In 1657 the fort at Bital surrendered when a single rocket caused a major conflagration.

8 A span (*vitasti*) is the distance between the extended thumb and the little finger.

9 See *Sukraniti*, Chapter V, lines 135-39 and 149-51.

10 See *Sukraniti*, Chapter V, line 139.

11 Oppert pp.65-6. His ideas are discussed by Partington.

12 Museum of Mankind, No.9572. There are also a number of occasions when wooden cannon were used, notably by the Sikhs, but these appear to be due to the absence of alternatives rather than through choice.

13 This was thrown onto fires by travellers to scare away wild animals and the noise of its popping and banging could be heard ten miles away at night.

14 Zygulski, p.427.

15 See H. Wilkinson, p.184.

16 Saltpetre, one of the commodities available for trade on the Coromandel Coast in 1606, is mentioned by Schorer in his *Relation*. See Moreland, p.52.

17 Particularly in the forging of steel.

18 Conti, p.31.

19 Yar Muhammad Khan, 'Barud', p.1068. (See under Ayalon *et al.* in Bibliography.)

20 Digby, p.56, n.168.

21 The links between the courts of India and Istanbul are poorly recorded. See Hammer-Purgstall.

22 One hundred *espingardas* were ordered in 1495 by Christopher Columbus, together with the same number of crossbows and other articles for infantry use. These are clearly handguns.

23 Di Varthema, p.262.

24 Di Varthema, p.50.

25 Di Varthema, p.262. His inference is 'serve him right', presumably because of his anti-semitism, but also because the Jew had broken the monopoly on cannon making in Calicut. There seems little point otherwise in recording the story.

26 Di Varthema, p.93.

27 Rainer Daehnhardt, pp.39-40, believes this relates to a matchlock with a screw in breech.

28 Du Jarric, p.7.

29 Abu'l Fazl, p.115. 'A sufficient number of such armours has been made so as to supply whole armies.'

30 Forbes, p.353.

31 Captain John Williams, Appendix N, p.383.

32 Baden Powell, p.286.

33 Correa, II, p.947.

34 Correa III, p.69.

35 Tod, I, p.248.

36 The meaning of this word is not known.

37 *Babur-Nama,* folio 217., pp.368/9. The unacceptable casualty rate shows the terrifying nature of a first contact with firearms.

38 Manucci, II, p.359. Grose describes Maratha shields: 'As to their targets, they are exactly round, convexing almost to a point on the outside, light and covered with so smooth and hard a varnish or lacquer, that if tolerably good, they will easily turn a pistol ball, and at some little distance a musket one.' Tod writes that the Rajputs also used rhinoceros-hide shields which 'offers the best resistance'. These are 'often ornamented with animals, beautifully painted, and enamelled in gold and silver'.

39 *Babur-Nama,* folio 322b, p.571.

40 Beveridge, p.473.

41 Cf. *darbzana,* pl. *darbzanat,* an Arabic word used in Turkish and Farsi at this time, meaning a small cannon, but also used for a handgun.

42 Abu'l Fazl, p.119.

43 Irvine, p.135, who comments that he has not seen the word used anywhere except in the *A'in.*

44 Blackmore, *Guns and Rifles of the World,* p.28.

45 Gaibi, p.40.

46 Bernier, p.217. His description is almost identical to that published by Careri who was in India in 1695, some thirty years later. See Sen, *Travels of Thevenot and Careri,* p.244.

47 Correia-Afonso, p.69. Godinho reports estimates of the size of the armies fighting for the throne, ultimately won by Aurangzeb. Each army comprised 150,000 horses without recruitment. 'The foot soldiers are countless. Those who saw it say that for each man on a horse there were seven on foot, fighting with bows and arrows, spears and muskets.'

48 Prince Khurram requested Sir Thomas Roe to supply him with gunners from the English ships at Surat in 1616, but there were no volunteers.

49 *Peshwa's Diaries,* Vol.III, p.177.

50 Tod, II, p.83.

51 Bernier, p.217.

52 These names are discussed by Irvine.

53 Morin and Held, p.124.

54 Many of the Ottoman words for firearms derive from European words. For example, *bajalushka* from the Italian *basilisco, kolonborna* from the Italian *columbrina,* a culverin.

55 Parry, 'Warfare', p.836.

56 Bernier, p.218.

57 Parry, 'Warfare', p.841. Cf. the cannon accompanying the Hajj caravan from Egypt in the mid-eighteenth century, described by Pococke, Vol.1, p.261 and cited in Elgood, which shows remarkable continuity in the use of these arrangements.

58 Boxer, p.107.

59 Boxer, p.231.

60 Falcons or bases were described as very small cannon which fired stone shot. See above.

61 Moreland, p.53.

62 Raychaudhuri, p.183, n.352.

63 Raychaudhuri, p.195.

64 See Raychaudhuri, p.168 ff.

65 Boxer, p.240.

66 Shortage of European volunteers forced the English in Bombay to employ Indian troops, the 'Decanies'.

67 Anon, *A Description of Holland...,* p.111.

68 Irvine, pp.107-8.

69 Irvine, p.105.

70 Lt. Moor, *A Narrative of the Operations of Captain Little's Detachment,* p.83. cited by Sen

71 Bernier, p.254.

72 Daehnhardt, p.36: the piece was obtained from a London dealer and bears an inscription showing that it was in the Seringapatam Ayudhashala or armoury in the early nineteenth century after the fall of Tipu Sultan. The attribution to Cochin is plausible but conjectural, but the early date of the piece cannot be doubted. The Ayudhashala is thought to have been established by Chamaraja Wodeyar V in 1635. Krishnaraja Wodeyar III (reigned 1799-1868) made an inventory with serial numbers to which he added his own name Srikrishna

73 Sinclair, p.217.

74 Mrs Meer Hassan Ali, p.211.

75 The tradition continues to this day worldwide in the practice of firing salutes to mark a birthday or an official visit, while in a less formal manner it can sometimes be seen at Arab weddings and was prominent when the Gaza Strip was handed back to the Palestinians.

76 Foster, *Roe...,* p.195. Sir Thomas may be considered a bad judge of a gun. While ambassador extraordinary at Hamburg in 1640 he was requested by King Charles I of England to purchase arms to the value of £20,000, which were so useless that after twelve months' deliberation they were returned to the Continent at a loss of £1,000. See Stern, p.67.

77 Foster, *Roe...,* p.183.

78 Brown, Ruth Rhynas. p.17.

79 Surat Factory Records, Vol. 105, Fols 20-1.

80 Surat Factory Records, Vol. 87, Fol.1.

81 Surat Factory Records, Vol. 87, Part II, Fol. 77.

82 There is a curious court minute in 1675 in which two sets of armour are to be purchased and sent to Bombay for disposal there to best advantage.

83 The superiority of brass ordnance at this time is clear. The Company bought the Maratha fort of Tegnapatam, twelve miles from Pondicherry, and 'also all the ground, woods and rivers round the said fort within the random Shott of a great Gunn'. The Madras Council instructed: 'And after you have fired your randome shott for which purpose we have sent ye a brass piece of Ordnance, the best we have in the Garrison, but it lyes in the Gunners art to load and fire it to the best advantage...' This was done in September 1690, the ball falling

about a mile from the fort.

84 Sen, *The Indian Travels of Thevenot and Careri*, p.61.

85 Irvine, p.111.

86 Harding, p.15.

87 The author wishes to acknowledge the use he has made of material contained in H. A. Young's study of 1937 and to thank David Harding for his comments on this specific point.

88 An inspection of the Patna magazine in March 1771 revealed 1,206 locally produced swords, referred to as 'country' and described as very good; and 2,206 European swords.

89 Blackmore, *Dictionary of London Gunmakers*, p.21, shows in Appendix VII the extensive purchases made from Henry Nock in the period 1777-1805; and Daniel Moore 1772-1802.

90 The name Brown Bess is now used to describe a variety of British muskets issued 1720-1840.

91 Blackmore, *British Military Firearms*, p.133; and Darling, p.15.

92 Pridmore, p.266.

93 The categories of small arms likely to be found on an East India Company shipwreck are listed by Harding.

94 Tone, pp.54-5.

95 Pearman, p.33.

96 Tone, p.47.

97 See Neal and Back.

98 *Caesar pina grenadillo*, also known as coffee wood, brown ebony and mesquita. It is a difficult wood to work.

99 Lang, p.60.

100 Lang, p.71.

101 Young, H.A, p.224.

CHAPTER TWELVE

1 Hunter, 1909 edition.

2 The others were Allahabad and Bankipore.

3 Birdwood, p.170.

4 Bhattacharya, p.281.

5 Jacquemont, letter of 17 March 1830, p.79.

6 Fraser was an important administrator with a compulsive enjoyment of danger which was best satisfied by battle, but because of his humanity would never kill a man. He was always the leader in an attack and according to Jacquemont 'had two fine sabre-cuts on the arms, a wound in the back from a pike, and an arrow through the neck which almost killed him'. He had six or seven legitimate Hindu and Muslim wives and was a fine linguist and scholar, devoted to the service of the Indian people; but military action always drew him from his civil duties. He was murdered in Delhi in 1835 and his tomb was erected by Skinner but destroyed in 1857. Recalling their lion hunting days together the memorial included a design of two reposing lions who compare Fraser's virtues with their own in an epitaph.

7 London, 1818.

8 S. P. Sen, p.63.

9 Hayward, II, p.188. The gun is signed 'T. Lefer a Valenza del Po.

1668' and was in the Renwick Collection, USA.

10 Blackmore, 'Claude Martin...', p.10.

11 L.430, plates 43-5.

12 The Mauludi system of dates was introduced by Tipu after 1784.

13 Blackmore, 'Claude Martin...', p.10.

14 H.A. Young, p.224. The name means sheet of water or where the sheets are washed. The river still serves this purpose at this point.

15 Zaidi, note 82, citing Persian correspondence sources.

16 Sen, pp.116-18.

17 Compton, p.382.

18 There is controversy over the spelling of the surname. Captain Williams of the Bengal Army refers to 'Martine' in his book *An Historical Account of the Rise and Progress of the Bengal Native Infantry*, published in 1817, and the French mercenary Raymond, also known as Hajji Mustapha, is cited by Hill in *The Life of Claud Martin*, as writing his name with the 'e'. As late as 1791 the *Calcutta Gazette* referred to him as 'Colonel Claude Martine'. Of modern authors Shelford Bidwell writing in 1971 also calls him 'Martine'. Hayward refers to him as 'Martin', from the inscriptions on his guns and it has been suggested by Blackmore amongst others that the 'e' was dropped by Martin in order to Anglicise the name. In 1785 he requested British nationality. Martin himself spelt his Christian name with and without the 'e'. For his life story see Llewellyn-Jones (1992), who states that the family today use the spelling 'Martin' and believes that their name has always been spelt in that manner.

19 H.A. Young, p.224.

20 Modave, p.155.

21 Bayonets occur with increasing frequency in the miniatures from the second half of the eighteenth century. A miniature painting of a boar hunt, catalogued as Nagaur, second half of the eighteenth century, shows Rajput princes using their long matchlocks with bayonets as spears. See Rosa Maria Cimino, *Life at Court in Rajasthan*. Florence, Italy, 1985, Illus. 97, p. 98.

22 Llewellyn-Jones, *Claude Martin...*, p.59.

23 Hill, p.78.

24 Amongst others he became a business partner of the French soldier of fortune, de Boigne.

25 Llewellyn-Jones, *Claude Martin...*, p.66.

26 Letter from the Resident, Sept. 1776, cited by Llewellyn-Jones.

27 John Bristow, British Resident to General Clavering 15 Sept. 1776, f.298. Cited by Llewellyn-Jones.

28 Llewellyn-Jones, *Claude Martin...*, p.70.

29 Illustrated by Blackmore, 'Claude Martin...', p.6. The gun is in a private collection and is signed 'Lucknow Arsenal Major Claud Martin'.

30 Hill, p.118, and cited by Blackmore. When Martin received a copy of the General Order of November 1781, issued by Warren Hastings the governor general, to leave Lucknow for British India it was to Impey that he turned. Impey was Judge of the Supreme Court at Calcutta, with access to the governor general, and came to Lucknow late in 1781 where Martin ensured that he had an agreeable visit.

Thanks to Impey the order was rescinded for Martin. Impey earned his pistols.

31 A magnificent pair of Martin's pistols were formerly in the collection of Lord Braybrooke. Christie's, 20 April 1977, Lot 166.

32 Blackmore, 'Claude Martin...', p.9, who writes that the silver mounts, barrels and locks are of almost identical design and bear the mark of the silversmith John King and London assay marks for 1768-9.

33 Bengal Inventories, 1801, No.75, India Office Library. Llewellyn-Jones, note to the author.

34 Llewellyn-Jones, *Claude Martin...*, p.150.

35 These are at La Martinière, Lucknow.

36 The *Report of the Special Ordnance Commission* of 1875 sets out the reasons for this change of policy.

37 Llewellyn Jones thinks it likely that Martin acquired the property from the Nawab and leased it back to him and that it formed part of Farhad Baksh, his town house.

38 Llewellyn-Jones, *Claude Martin...*, p.132.

39 Llewellyn-Jones, *Claude Martin...*, p.154.

40 Not all of Martin's Persian correspondence has been examined.

41 Missillier and Ricketts, the authors of *Splendeur des Armes Orientales*, offer an alternative reason for the Nawab's gift.

'La date 1201 mentionée sur ce sabre se trouve également portée sur un cachet grave par ordre du Nabab d'Oudh-Asaf ud Daula pour être offert au Major Martin. Il porte les initiales C.L. et les mentions: "L'honneur de l'Empire, l'Epée du Royaume, le Colonel Martin, brave et vaillant à la guèrre."

Ce sabre et le cachet furent certainment decernés à Claude Martin pour recompenser son action contre la rebellion du Rajah Chait Singh de Benares en 1781, et son arbitrage judicieux dans le conflit entre le Nabab et le Resident de la Campagnie de Indes en 1783.'

No explanation is offered as to why, if the reason for the gift arose in 1781 and 1783, the Nawab had taken so long to make the presentation. Furthermore, Llewellyn-Jones states (*Claude Martin*, p.135) that it is a misconception that Martin advised the Nawab on all matters relating to Company policy on Oudh. Claude Martin medals are discussed by Pridmore who notes in the list of Martin's effects in 1801, 18 gold and 176 silver medals with Martin's profile on one side and his titles in Persian on the other, together with the coining machine with which they were made. Pridmore concludes these were produced by Martin as gifts and that the smaller ones with C.L.M. under the bust may have been designed in Lucknow; the larger were the work of the London wax modeller Alexander Mackenzie, based on Renaldi's bust and engraving of Martin done in 1786 and copied at Boulton's Birmingham factory, which supplied the dies and machinery sent out to Lucknow. Llewellyn-Jones describes Martin's business relationship with Matthew Boulton.

42 Blackmore, 'Claude Martin...', p.4.

43 David Edge, Curator at the Wallace Collection, made this discovery.

44 Nos 6601-3. Michael Baldwin confirms this point.

45 Spink and Son, *Islamic and Hindu Jewellery*, London, 1988, No.60 pp.71-2.

46 The details of this incident are described by Llewellyn-Jones in *A Fatal Friendship...*, p.25.

47 Smith, pp.72-3.

48 The bayonets were of triangular section, like the European examples of that time. They were secured to the barrel by a spring catch and a screw. Blade length 13 inches.

49 See Stone's *Glossary*, Fig.564, for an illustration of the lock; and Fig.139 shows the bayonet.

50 Zaidi, p.17.

51 Twinning, p.187.

52 Compton, p.366.

53 T. Wilkinson, p.125.

54 Egerton, p.145, No.802 – (8563-'51).

55 Llewellyn-Jones, *A Fatal Friendship...*, p.25. In 1801 a Persian journal reports that 'Lakwa Dada has employed Mr. Sangster's son to raise and discipline a battalion for him'. Young Sangster was probably the cadet 'Songster' who surrendered to General Wellesley after the battle of Assaye. It would appear therefore that Sangster junior did not continue to manufacture arms.

56 My thanks to Dr. Llewellyn-Jones for bringing this to my attention.

57 Thomas, pp.132-3.

58 Stone, p.154, Fig. 196. Length 3ft. 1.6in.

59 Wigington, *Arms and Armour Journal*, March 1987.

60 Published anonymously, the author signing himself 'An Old Cavalry Officer'. However, a handwritten note on the title page indicates that it was written by General Charles Carmichael C.B., p.40.

61 See Elgood, *The Arms and Armour of Arabia...*, p.40.

62 Meer Hassan Ali, p.219. She also describes the pellet bow, using sun-baked clay pellets, as very useful in keeping the crows away from the house when food is being prepared or eaten. These pests would otherwise fly in through the door or window openings and seize the bread from the hands of the children. Frank Richards, a British soldier in India before the First World War, describes in *Old Soldier Sahib* how soldiers new to India would lose the food off their plates to the crows and hawks. There was a common Indian belief that when a British soldier died his soul transmigrated into a new-born crow, which accounted for the bird's cunning.

63 Forbes Mitchell, p.76.

64 Tod, I, p.512.

65 Tod, I, p.554.

66 Tod, II, p.126.

67 Tod, II, p.158: 'The sword handles, which are often inlaid with variegated steel, or burnished, are in high request, and are exported to various parts of India.'

68 Egerton, p.58.

69 Tod, I, p.471.

70 Thomas Moore's *Lalla Rookh* was published in 1817 and caught the imagination of the public. It was immensely successful, going through many editions.

71 Burnes, p.93.

72 Burnes, p.86.

73 Burnes, p.94.

74 Burnes, p.93.

75 Sinclair (p.218) describes the matchlocks in the Madras Presidency in 1873. 'The bore is invariably small... The best I have seen... were said to be Rumi.' Small-bore barrels (often Turkish) are frequently referred to in the nineteenth century.

76 See Burnes, p.96.

77 Moorcroft, p.195.

78 Forrest, p.15. The unnamed Officer was described as 'now in Sikh service'.

79 Bernier, p.377.

80 Pietro della Valle, II, p.371.

81 Fawcett, I p.172. The ms. gives *bacquemarde* from *bacamarte*, Portuguese for a blunderbuss.

82 See Ross, pp.221 ff.

83 Forrest, *Masson's Journal*, p.134.

84 Masson gives a detailed estimation of the Sikh army in 1830. See Forrest, p.174.

85 Allard, a French mercenary, purchased large numbers of French cuirasses for the Sikh army. He trained the Sikh cavalry from 1822 to 1839.

86 F.S. Bajwa, p.236.

87 F.S. Bajwa, pp.241-2.

88 Jacquemont was a French botanist who crossed India in the 1830s, visiting the Punjab and Kashmir prior to the British annexation. Though frequently critical of the English in India he wrote: 'One has to travel in the Punjab to realise what an immense benefit the domination of the English in India is to humanity. What misery eighty million people are spared by it.'

89 Jacquemont, II, p.34. The Scinde Horse, an irregular unit under British control, had double-barrelled carbines, the only unit to carry these during the Mutiny period.

90 Dunbar, p.180.

91 F.S. Bajwa, p.241.

92 Honigberger, p.56. He suffered the inevitable jokes from his contemporaries as to whether his gunpowder or his medicine had killed more people.

93 Latif, p.387.

94 Baden Powell, p.286.

95 India section, No. 3480, V & A.

96 Sale Catalogue of the Dalhousie Collection, Mr Dowell's Fine Art Galleries, 18 George St., Edinburgh, 7/8 December 1898. Sale Catalogue of Colstoun, Haddington, East Lothian, Sotheby's 21 and 22 May 1990.

97 Baden Powell, p.285.

98 Baden Powell, p.286.

99 Egerton, p.46. Some fine watered steel matchlock barrels are illustrated by Figiel.

100 Sinclair, p.218.

101 Moorcroft, p.195.

102 The gunsmith, author and expert on firearms William Greener (1806-69) declared that 'All Damascus barrels must be made of twisted rods'. Greener's description of how to make a damascus barrel is, as one might expect, very similar to the method used in Kashmir regarding the preparation of the metal, though he recommends that each rod should be made up of alternate iron and steel strands. The great difference between the two products is that Greener's barrel was made by wrapping the prepared riband of metal round a mandril whilst the Kashmiri barrel was bored. Colonel Hawker saw damascus barrels being made in Birmingham, the cost of which included '5/- for boring and grinding'.

103 Bellew, p.289. On p.290 he provides a very full description of the iron furnaces.

104 Cf. 'Jezail' under Iran, above.

105 Ball, *Things Chinese*, p.38 in *Hobson-Jobson*.

106 Fitzclarence, *Journal of a route across India 1817-8*, 4 vols, 1819, p.246.

107 The use of shields with a gun barrel as the boss or umbo can be seen in Chinese pictures of the sixteenth century, at the same period as Henry VIII's bodyguard were similarly equipped. See Needham, Vol. 7, 1986, p.414 and the illustration on p.423.

108 Bellew, pp.312-13.

109 (620 M/S p186)

110 Kuropatkin. p.193.

111 The Tibetans have a proverb: 'The scabbard of my blue steel sword is the liver of my enemy.'

112 Stone, p.443, who records that there are 'two extraordinary good specimens of these guns in the Art Museum in Honolulu'.

113 See Tibbetts, p.1.

114 See *Tribes and Castes of Southern India*, 1909, under Mappillas.

115 See Courtenay Locke, p.190.

116 See Villiers.

117 The piece was formerly in the armoury of the Maharaja of Jaipur.

118 Printed and published by Pharoah & Co., Madras.

119 This is incorrect. The *dha* is the national sword of Burma.

120 The population of the province was estimated at 81,647 in 1840.

121 Stone, p.262.

CHAPTER THIRTEEN

1 Marco Polo said of the Sinhalese that the men were unfit for soldiers and hired mercenaries when they needed them. Varthema comments, without apparent irony, that ' the people live longer than we do'.

2 Pieris, *Dutch Power...*, pp.99 and 104.

3 Pieris, *Dutch Power...*, p.259.

4 Barreto and others, p.118, No.160, P/2 Lisboa R.D.

5 Deraniyagala, p.121.

6 J.F. Pieris, p.153.

7 Howard L. Blackmore, 'Guns for the Sultan of Bantam', *Journal of the Arms and Armour Society*, Vol. X/2, Dec. 1980.

8 See S. Q. Fatimi, 'Malaysian weapons in Arabic literature. A glimpse of early trade in the Indian Ocean,' *Islamic Studies* 1964.

INDEX